What Can
and
Can't Be
Said

What Can and Can't Be Said

{ RACE, UPLIFT, AND
MONUMENT BUILDING
IN THE
CONTEMPORARY SOUTH

Dell Upton

Yale UNIVERSITY PRESS

NEW HAVEN AND LONDON

Yale University Press books may be purchased in quantity for educational, business, or promotional use. For information, please e-mail sales. press@yale.edu (US office) or sales@yaleup.co.uk (UK office).

Set in The Serif B2 and The Sans Roman type by IDS Infotech, Ltd.
Printed in the United States of America.

Library of Congress Control Number: 2015945014
ISBN 978-0-300-21175-7

A catalogue record for this book is available from the British Library.

This paper meets the requirements of ANSI/NISO Z39.48–1992 (Permanence of Paper).

{ CONTENTS

Images of the civil rights movement of the 1950s and 1960s made deep impressions on me when I was growing up in New York State. I remember seeing television coverage of the integration of Little Rock Central High School, which interrupted my mother's daily appointment with *American Bandstand*. The Birmingham demonstrations, the March on Washington, the bombing of Sixteenth Street Baptist Church, the murders of James Chaney, Michael Schwerner, and Andrew Goodman, and the Selma-Montgomery March were all lodged in my mind, often through photographs that appeared in *Life* magazine. Martin Luther King Jr. was assassinated while I was in college.

Thirty years later, as I traveled across the South for research, I visited the sites of the events that I recalled so vividly from my childhood. What I usually discovered, particularly at urban sites, was that the landscapes in which the dramatic scenes took place had been eradicated by urban renewal and replaced by monuments that recorded, in an abstract and context-free manner, those historic moments. The civil rights movement of the mid-twentieth century was a campaign to erase the legal and social structures that created the New South sixty to seventy years earlier, and they took place in a New South landscape that had itself been erased by the end of the twentieth century.

This absence prompted me to think about the monuments and their role in creating a New New South. That, not the civil rights movement itself, is the subject of this book. Simply put, I argue that the monuments are less about remembering the movement than they are about asserting the presence of black Americans in contemporary Southern society and politics. Despite claims that the South has transcended racial differences, they remain open sores. The construction of monuments to the civil rights movement and to African American history more generally frequently exposes those sores to view. Monument builders must contend not only with varied interpretations of African American history but with the continuing dominance of white

supremacy, both in its traditional forms and in the subtler, more modern assumption that such monuments must meet white approval and that whites are neutral arbiters of what is fair and truthful in such memorials. *What Can and Can't Be Said* explores the contentious origins of a number of these Southern memorials, as well as of the national memorial to Martin Luther King Jr. in Washington, DC, as well as examining their context—memorials to white supremacists of the past that are still cherished by many Southern whites.

{ **ACKNOWLEDGMENTS**

Among the compensations of the scholar's solitary life are the advice and assistance of friends old and new. That is one of the pleasures of research. My gratitude belongs first to Catherine W. Bishir, all-knowing scholar of North Carolina architecture. When I was working on another project, Catherine pointed out that it was really the monuments that interested me. It was a simple observation that quickly turned me around. Second, I am indebted to Karen Kevorkian and Betsy Cromley, who read the manuscript in an earlier form.

Over the years I have benefited from discussions of this material with Craig Barton, Michele Bogart, Erika Doss, Owen Dwyer, Dianne Harris, Bill Littmann, Maurie McInnis, Louis Nelson, Daves Rossell, Kirk Savage, Abby Van Slyck, and my colleagues at the University of California, Berkeley; the University of Virginia; and the University of California, Los Angeles, as well as the many audiences before which I have presented aspects of the project. I also owe more than I can describe to my longtime friends and scholarly interlocutors the late Barbara Carson, Cary Carson, Tom Carter, Paul Groth, Fraser Neiman, the late Orlando Ridout V, and Stephen Tobriner.

The staffs of the Alabama Division of Archives and History, the Birmingham Civil Rights Institute, and the Selma Public Library in Alabama; the Savannah-Chatham County Public Library; the New Orleans Public Library; the New Hanover County Public Library and the Rocky Mount Public Library in North Carolina; the South Carolina Division of Archives and History; the South Carolina State Library; the Richland County, South Carolina, Public Library; and the Bowling Green, Virginia, City Manager's Office were all generous with advice and guidance. Rebecca A. Baugnon, Special Collections Librarian of the Library at the University of North Carolina at Wilmington; Jim Baggett, Archivist at the Birmingham Public Library; Beckie Gunter of the South Carolina Lieutenant Governor's Office; Marsha Mullin, The Hermitage; Charles Reid, Clerk of the South Carolina Senate; Glenda Anderson, former

Archivist of the City of Savannah Research Library and Municipal Archives; and Michael B. Brown, former Savannah City Manager were especially helpful, as were Derek Alderman, Mayor Richard Arrington, Aaron Lee Benson, Robert M. Craig, Michael A. Dobbins, Walter Edgar, Pat Godwin, Robbie Jones, Abigail Jordan, Edward Lamonte Jr., Bruce Lightner, Faya Rose Touré, Ellen Weiss, and Perdita Welch.

Last, this project could not have been completed without the support of an NEH Fellowship and of research monies and sabbatical leaves from the University of Virginia and the University of California, Los Angeles, and a subvention for the publication of the photographs kindly granted by David Schaberg, UCLA Dean of Humanities.

And, as always, Karen.

What Can
and
Can't Be
Said

INTRODUCTION
What Can and Can't Be Said

[Southerners] want the New South, but the old Negro.

—RAY STANNARD BAKER, *FOLLOWING THE COLOR LINE*, 1908

In the spring of 1999 twenty members of Congress traveled to Alabama to visit sites and monuments associated with the civil rights movement of the 1950s and 1960s. Georgia representative John Lewis, a renowned veteran of the movement, had asked members of Congress of both parties to join him on the pilgrimage to inspire them with the "spirit of the movement that transformed the law and to start them talking together about race and reconciliation."[1]

Lewis's tour belonged to a remarkable process of rethinking and reinterpreting the cataclysmic events of the 1950s and 1960s and their implications for the present-day United States, a process that shows little sign of slowing since it began in the late 1970s. One finds counterparts of the congressional visit in tours offered to high schoolers, university alumnae, academics, and fraternal organizations. A more somber manifestation of the process can be seen in the trials of men accused of complicity in the Southern racial murders of the 1950s and 1960s. In 2006, the Federal Bureau of Investigation began its Civil Rights Cold Case Initiative, undertaken to investigate nearly one hundred cold-case killings in the knowledge that, as with the perpetrators of the Holocaust, the time for personal accountability is rapidly passing.[2]

As trial after trial has resulted in the convictions of aged white men, public commentators have used the occasion to emphasize that the South and the nation have changed, that a sordid chapter in American history has been closed with the imprisonment of those with blood on their hands. The corollary, sometimes explicitly stated but more often implied, is that race is no longer a significant element of American life. In the face of strong evidence to the contrary, the conservative majority of the United States Supreme Court

endorsed this rosy view in its 2013 decision striking down a key provision of the 1965 Voting Rights Act. To invoke racial injustice now is to demand special rights, to play the race card, to "go back and bring up the old problems," and to stir up "a simmering pot of hate," in the words of James McIntyre, an attorney who defended Ku Klux Klansman Edgar Ray Killen in his 1967 and 2005 trials for the murder of three civil rights workers in Neshoba County, Mississippi, in 1964.[3]

The Lewis tour, the FBI cold case trials, and the Supreme Court's decision mark a new stage in a struggle to define the civil rights movement's legacy. Even as politicians, museum curators, and filmmakers increasingly celebrate the goals and results of the movement, a new generation of scholars is reassessing the civil rights era unsentimentally, offering complex and not always flattering accounts of the motives and actions of its dominant figures. The proliferation of civil rights monuments in the past three decades is an important part of this reconsideration. Not only do they commemorate key events of twentieth-century America's defining moral drama, but they publicly articulate definitions of Southern society and the South's place in the twenty-first-century nation that have been arduously hammered out in local communities. The focus of monument building in the South, meaning for our purposes the states of the former Confederacy, has expanded from commemorating the "classic" or "modern" civil rights movement—the years between 1954 and 1968—to depicting the long history of black Southerners and their place in the region's life. With few exceptions these memorials depict a South purged of its troubled racial past and ready to compete in the new global economy. Yet it was rarely the intention of those who conceived these monuments to present such a whiggish interpretation. Most wanted a franker view of the past and sometimes a more open-ended interpretation of the present. Why they failed to achieve these goals is one of the subjects of this book.[4]

As these monuments have been contested city by city, state by state, the nature of the works themselves has changed in a way that makes it possible to trace three broad, overlapping periods of memorial construction. Monuments of the initial period commemorate leaders of the movement. They tend to be of two sorts. Many of the earliest are vernacular monuments borrowed from the private funereal tradition, such as that erected to the civil rights workers James Chaney, Michael Schwerner, and Andrew Goodman, for whose deaths Killen was tried, at Mount Nebo Missionary Baptist Church in Philadelphia, Mississippi. It is an ordinary granite gravestone, inscribed much

as a private grave marker might be. The monu-
ment, one of the earliest of the civil rights
memorials, even has sepia medallions carrying
the three men's photographs, a common fea-
ture in twentieth-century Southern cemeteries
(fig. 1). Like the Mount Nebo memorial, most
vernacular monuments are stock commercial
grave markers, but even some purpose-made
stones follow funereal conventions.[5] The tall
gray granite marker erected by the Southern
Christian Leadership Conference's female
wing, the SCLC Women, near the site of Viola
Liuzzo's 1965 murder in Lowndes County, Ala-
bama, has the Gothic pointed-arch shape com-

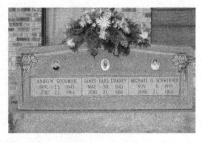

Fig. 1. Memorial to murdered civil rights
workers James Chaney, Michael
Schwerner, and Andrew Goodman (1976),
Mount Nebo Missionary Baptist Church,
Philadelphia, Mississippi. The memorial
was decorated for the forty-first
anniversary of killings, which had been
observed the day before the photograph
was taken. Photo: Dell Upton.

mon on nineteenth-century gravestones, inset with a pink marble rose that
recalls the inscribed tributes and physical offerings one finds in most ceme-
teries (fig. 2).

A second, more conventional type of memorial erected in the first period
was what I call the great leader monument. These represent the movement
through honoring prominent men—almost always men, and usually the
Reverend Martin Luther King Jr. Such standing figures or busts fit squarely
into an international nineteenth-century tradition created to honor the he-
roes of bourgeois republics.[6] They single out otherwise ordinary men as mod-
els of achievement in democratic societies. Often, as in the figure of Medgar
Evers (Thomas Jay Warren, 1991) erected near Evers's home in Jackson, Mis-
sissippi, only the pedestal separates the figure from its witnesses. In his dress,
scale, and demeanor, Evers could stand unnoticed in a crowd of onlookers. In
Raleigh, North Carolina, Martin Luther King Jr. (Abbe Godwin, 1989–91)
stands directly on the ground, but his somewhat-larger-than-life-size scale
differentiates him from visitors (fig. 3). Clad in his clerical robes, which seem
to be twisted around his legs by the passing traffic on a suburban road, King's
preacher's gestures strikingly evoke the Buddhist mudras (hand positions) for
peace, charity, and dispelling fear.

Around 1989, the beginning of a second phase of monument building,
which we might label that of populist memorials, was marked, though not nec-
essarily inaugurated, by the dedication of the Civil Rights Memorial (Maya Lin,
1989) in Montgomery, Alabama (fig. 4). Commissioned by the Southern Pover-
ty Law Center and attached to its (former) office building, Lin's monument also

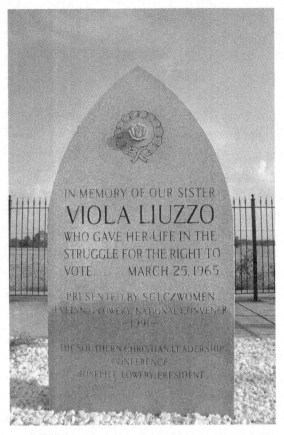

Fig. 2. Viola Liuzzo memorial (1991), Lowndes County, Alabama. Photo: Dell Upton.

belongs to the tradition of private funerary monuments. On the flat base of an inverted black marble cone, the names of forty men, women, and children who "lost their lives in the struggle for freedom" radiate from the center "like the hands of a clock" (fig. 5). They are arranged in chronological order of their death. Inscriptions recording the dates of the landmark case *Brown v. Board of Education* and the assassination of Dr. King, as well as other texts that tally prominent demonstrations, court decisions, and national legislation, are interspersed among the victims' names. By mixing famous names with obscure ones, Lin's monument exemplifies a new emphasis on rank-and-file participants in the movement that parallels a shift in civil rights historiography away from leaders and national movements toward "local people" and everyday organizing against and resistance to racial oppression.[7] Equally important, its creation coincided with a growing demand by former participants for recognition of all who contributed to the struggle. This in turn can be seen as one instance of the

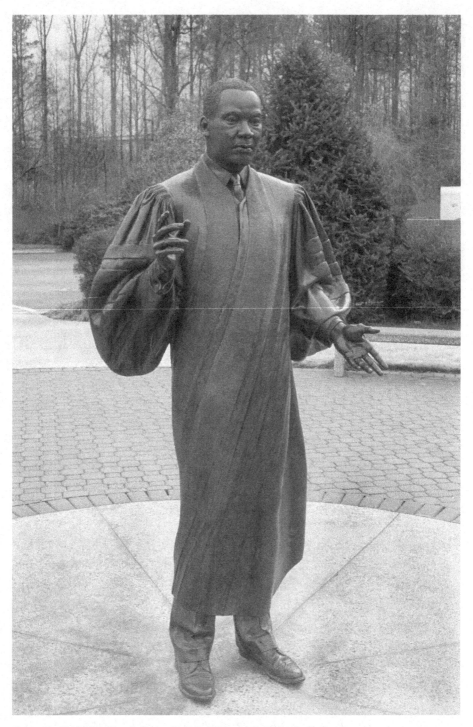

Fig. 3. *Martin Luther King, Jr.* (Abbe Godwin, 1989–91), Raleigh, North Carolina.
Photo: Dell Upton.

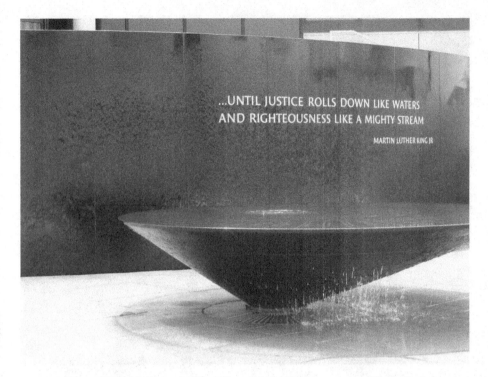

Fig. 4. Civil Rights Memorial (Maya Lin, 1989), Southern Poverty Law Center, Montgomery, Alabama. Photo: Dell Upton.

growing reluctance of Americans to settle for metaphorical representation of the participants in any major event by iconic, allegorical, or representative figures (fig. 6).

The civil rights campaigns of the 1950s and 1960s are now almost universally celebrated. Even the Trent Lotts and the Haley Barbours of the political world give them lip service. Yet the nature, the significance, and the outcome of these campaigns are by no means settled, and they remain the subject of covert and indirect debate outside official public discourse. Precisely because the civil rights movement is now sacrosanct and must be discussed in hushed and reverent tones, the varied interpretations of the black freedom struggle have increasingly come to be argued through the medium of African American history in general, which constitutes the third period of monument building.[8]

The periodization I have suggested refers to the initial appearance of certain kinds of memorials. They are supplemented, rather than supplanted, by subsequent kinds. It is also the case that this developmental trajectory is

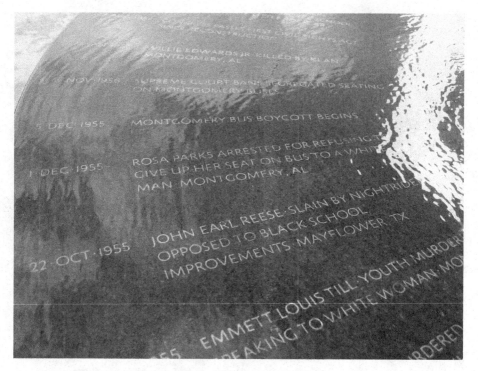

Fig. 5. Civil Rights Memorial. Detail of inscription. Photo: Dell Upton.

restricted to the South. In other parts of the country, memorialization has not proceeded beyond the Martin Luther King Jr. monument phase. This is a result both of the whitening of King that we will encounter in our examination of the new King memorial in Washington, DC, and of the mistaken belief that civil rights is strictly a Southern issue. Where Southerners have confronted, however evasively and contentiously, the implications of racial inequality for their society, other Americans have yet to do so. King statues are unthreatening and demand no uncomfortable thought.[9]

As the Southern monuments have evolved, their makers have continually confronted a central question: What can and can't be said in this medium? By this I mean, first, what is it possible to say using the inherited visual conventions of the Western monumental tradition that most monument builders prefer? Second, what is permitted to be said in contemporary American public discourse?

What is it possible to say? A monument is a very special kind of object. It has to present its case in a compacted manner, pressing familiar images and

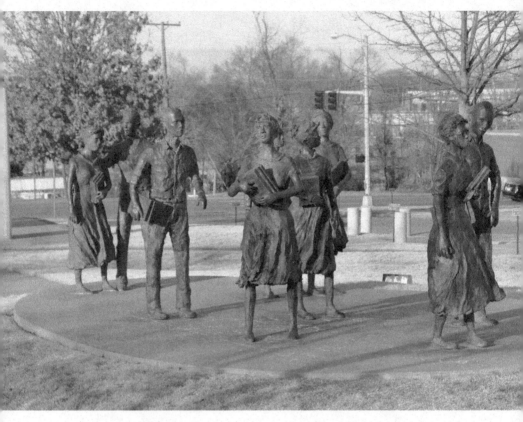

Fig. 6. *Testament* (John and Cathy Deering, 2005), Little Rock, Arkansas. Memorial to the Little Rock Nine, who integrated Little Rock Central High School in 1957. Photo: Dell Upton.

metaphors into its service. Such conventional imagery is necessary for monuments to be legible to a broad public. Equestrian monuments, for example, date back to antiquity in the West. Since horses were the economic and sumptuary prerogative of political and military elites, to show a man mounted on a horse is to suggest the command that he wields, the animal power of the horse and the imposing mass of horse and man together conveying an impression of majesty. The equestrian monument was a favored conventional form for representing political and particularly military greatness well into the twentieth century. Confronted with a statue of a man on a horse we understand, without knowing anything in particular about the subject, that he is probably a general or a king and probably not a scientist, a teacher, a cleric, or a woman.

Similarly, Maya Lin's renowned Vietnam Veterans Memorial of 1982 fashioned a contemporary monumental idiom out of the raw materials of disparate public and private commemorative practices (fig. 7). The use of

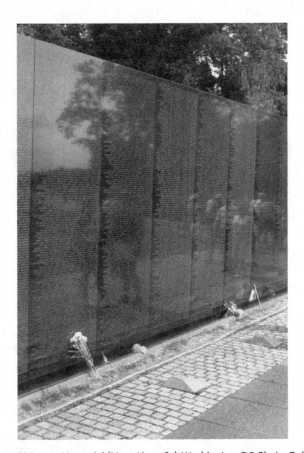

Fig. 7. Vietnam Veterans Memorial (Maya Lin, 1982), Washington, DC. Photo: Dell Upton.

polished black granite and somber inscriptions was familiar in upscale cemeteries before being adapted for this war memorial, and the often-noted emotional power of the long list of the names of the dead, required by the competition program, has been familiar to Americans since the Civil War. Where equestrian monuments rely on scale—their sheer mass and their separation from the viewer by a tall pedestal—to convey extraordinary power of an abstracted sort, name-laden memorials to both war dead and ordinary deaths convey the specificity of loss and, in the case of war memorials, the magnitude of sacrifice through multiplicity.

Civil rights and African American history monuments, from aesthetically ambitious ones such as Lin's Civil Rights Memorial in Montgomery to the ordinary vernacular markers erected by churches and local organizations across the South, derive their power from these same Euro-American traditions of funerary and public monument building. In doing so, they raise important questions about their suitability as visual representations of the black liberation struggle.

It is not an accident that, excepting the ubiquitous memorials to Martin Luther King Jr., most civil rights memorials stand in Alabama, Georgia, and other places where the great, telegenic mass demonstrations were held, rather than in, say, Mississippi, the scene of quieter, less visible efforts and of more sinister, more random, and less restrained violence. Similarly there are fewer in states around the periphery of the Deep South, from Maryland to Texas to Florida, where efforts were more local and less widely known. Another way to put it is that they tend to be found in what has been seen to be the domain of the Southern Christian Leadership Conference, a hierarchical, male-dominated, publicity-oriented organization whose women's branch, the SCLC Women, has sponsored many of the monuments in the SCLC's home territory. There are fewer in the areas worked most assiduously by the more radical, grass-roots-oriented Student Non-Violent Coordinating Committee or of older organizations such as the Congress of Racial Equality and the National Association for the Advancement of Colored People. Monuments in those areas tend to be locally sponsored and more modest in size and visual effect.

Remember that these monuments celebrate a social movement in which dramatic incidents such as those in Philadelphia, Mississippi, or Birmingham and Selma, Alabama, were anomalies. We understand increasingly that in most places, for most of the time, the freedom struggle was a social movement carried out through mundane, repetitive, distinctly nonphotogenic (however emotionally fraught and often dangerous) activities such as voter

registration, school teaching, and the refusal to observe the everyday protocols of segregation—the small indignities that in South Africa were lumped under the heading of "petit apartheid" (restriction of interpersonal encounters, as opposed to "grand apartheid," or racial sorting at the level of entire cities and of the nation itself). These kinds of antiracist actions were carried on long before and long after the dramatic, nationally reported events of the mid-1950s to the late 1960s. They involved women at least as often as men. They may be the closest the United States has ever come to a truly democratic movement.

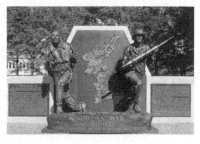

Fig. 8. Korean War Memorial (Russ Faxon, 1992), Nashville, Tennessee. Photo: Dell Upton.

Although monuments celebrate a movement that was, for most participants most of the time, ethically nonviolent and nonresistant, their makers draw almost instinctively on the visual forms and metaphors of war memorials. Action monuments, such as Ronald Scott McDowell's *Dogs* (1995–96; also known as the Foot Soldier Monument) in Kelly Ingram Park, Birmingham, resemble the images of hand-to-hand combat found in some Civil War memorials and in some of the modern war memorials erected in reaction against Lin's Vietnam Veterans Memorial (fig. 8 and see fig. 31). *Dogs*'s inscription, signed by then-mayor Richard Arrington Jr., refers to the youthful Birmingham marchers as "foot soldiers," a term quickly adopted by former rank-and-file demonstrators elsewhere. And Lin's use of the materials and formal language for which she had become famous in the Vietnam Veterans Memorial roots her Montgomery Civil Rights Memorial in the modern war memorial tradition that she did so much to shape. The emulation of Lin's vocabulary in lesser known works such as Raleigh's Civil Rights Monument (Horace Farlow, 1996–97), which is part of the same complex that includes Godwin's Martin Luther King Jr. and which borrows Lin's black marble and plain lettering, roots the civil rights memorial landscape even more deeply in the war memorial lexicon.

It is easy to understand why metaphors of war might be selected for these monuments and their many cousins. Compared to the long history of antiblack violence that has characterized American history from its beginning, the more theatrical, more photogenic violence of the 1950s and 1960s was recorded, distilled, and intensified on television along with similar scenes of violence in Southeast Asia. And to many of those on the ground, it

seemed like warfare. One movement veteran, Mack Freeman, related that during the voter registration drives in Jacksonville, Florida, in the 1960s, "Just like in battle, if you missed the rallying point, you had to figure out how to stay alive until someone could come to get you the next day.... It was a war. Men and women were killed. They were shot down."[10]

In addition, the military metaphor resonates in a militaristic society such as the contemporary United States, where many citizens believe that to die in battle is the highest patriotic act and that any military action, however sordid, is a defense of "freedom." This awe of death in the line of military duty is in turn reinforced by the traditional Christian veneration of martyrdom, whose iconography war memorials often appropriate. In contemporary war and civil rights memorials, as in religious belief, martyrdom is an act of legitimation. The self-sacrifice of the martyr imbues religious and political claims with a self-evident truth that makes any questioning of the act or of the cause that it supported illegitimate, even sacrilegious. The Vietnam Women's Memorial (Glenna Goodacre, 1993), a supplement to Lin's Vietnam Veterans Memorial that consciously echoes the Pietà format, likening the fallen soldier to Christ and his nurse to the Virgin Mary, is among the most explicit invocations of Christian themes of sacrifice and redemption in the service of politics. The monument to the students murdered by police at Jackson State College (now University) in

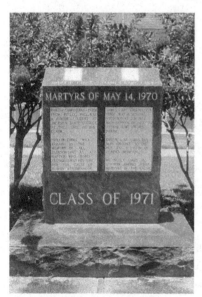

1970—the "martyrs" of May 14—makes the same claim more simply, using an inscription on an ordinary gravestone (fig. 9). Martyrdom is, moreover, a sign of worthiness, and since the Civil War African Americans have hoped that military service would demonstrate to white America their fitness for full citizenship.

Nevertheless, other aspects of the war metaphor are puzzling. Behind the rhetoric of military sacrifice lies the reality of combat: the military dead gave their lives, but they also took those of others. And whereas soldiers act with the aid of, and in service of, the state, civil rights demonstrators challenged the state to live up to its professed values. In the process, they faced violence that was often state-sanctioned and sometimes state-instigated. Thus violent civil rights conflicts seemed more

Fig. 9. Memorial to the Jackson State martyrs of May 1970 (ca. 1971), Jackson State University, Jackson, Mississippi. Photo: Dell Upton.

like European pogroms or the 1989 confrontation in Tiananmen Square, Beijing, than like battles between two armies.

Last, war memorials indict the depredations and celebrate the defeat of specific enemies: the Union, the Confederacy, the Axis Powers. The civil rights "war," as far as nearly every memorial except those in Birmingham is concerned, was a war without an enemy, or more accurately a war with an enemy who still cannot be openly named. The combatants are still neighbors, and many of the defeated remain bitter about their failure to thwart change. Despite the demographic oddity that the opponents of civil rights tended to be older than the proponents, and thus are dying more quickly, their relatives and progeny often continue to carry the torch of white resentment.

My point is that the dramatic incidents and conspicuous leaders that Euro-American monuments customarily celebrate and for which a familiar visual language has been developed were scarce in a movement that was centered first of all around restructuring everyday life and ordinary landscapes. Even the dramatic events are difficult to commemorate in part because they were so thoroughly contextualized in a time and a place and because they were already in themselves a kind of stylized enactment of ordinary, less visible everyday conflicts. For example, the demonstrations of April and May 1963, memorialized in Kelly Ingram Park, Birmingham, were ritual enactments of black life in the city. Violent as these encounters were, they dramatized for outsiders the dangers, indignities, and prohibitions that made everyday living and working in "the most thoroughly segregated city in America" so burdensome for African Americans. Thus, when memorable moments of the demonstrations, familiar to most Americans through their abstracted representations on television, in periodicals, and even in art, were turned into monuments, they became representations of representations of the reality they were intended to expose.[11]

The nearly instinctive turn to depictions of leaders, on the one hand, and to representations of representations, on the other, raises a vital question about memorialization: Are Americans, as citizens of an ostensibly democratic nation, able to understand a truly democratic movement, much less to find a language to commemorate it that can successfully incorporate it into our national myths in an effective way? What can and can't be said within the established visual conventions of the Euro-American monument building tradition, which were created to celebrate signal leaders and momentous, temporally and geographically constricted events such as battles, rather than long-term struggles by diffuse masses of people?

The problems of visual representation lead directly to the second aspect of the issue of what can and what cannot be said: *What is permitted to be said?* Civil rights and African American history monuments have been colored by four key preconditions. One is the tidal wave of monuments of all sorts, dedicated to countless numbers of people, events, and causes, that has inundated the American landscape in recent decades. There are many reasons for this proliferation. They are a product of the political, economic, and demographic disruptions that have characterized the United States since the 1960s. In the years following the Vietnam War, waves of new immigrants entered the United States, encouraged by the abolition of country-of-origin restrictions in the 1965 immigration act. The collapse of the traditional industrial order, the outsourcing of manufacturing to Asia and Latin America, periodic energy crises, and economic deregulation leading to repeated episodes of financial chicanery destabilized the economy. The debacle in Vietnam and the intensification of militarism and xenophobic nationalism in reaction to it raised questions about the United States' role in the world. Social changes ranging from the renewed vigor of religious fundamentalism to the reordering of gender and racial norms generated "culture wars" over "values." Americans of all political persuasions were troubled by these changes and attempted to fix the national narrative in a manner congenial to their own views. Monuments became an important, if expensive, medium for doing so.

The late-twentieth-century surge in monument building was also the product an accident of history: the great, unexpected popular and critical success of Maya Lin's Vietnam Veterans Memorial (see fig. 7). All subsequent monuments—especially, but not only, war memorials—stand in its shadow. They take their cues from the visual vocabulary that Lin employed or, as in the cases of the additions to the original memorial and to such newer works as the Korean War memorials in Washington (1995) and Nashville, Tennessee (1992), or Washington's National World War II Memorial (2004), they vehemently reject it (see fig. 8).

Both supporters and opponents of Lin's memorial saw in her work the great potential of monuments as didactic tools. Lin's audience viewed her monument with considerable sophistication, understanding that a memorial is an interpretation of the past, although not with enough sophistication to accept that the interpretation might arise as much from the viewer's mind as from the artist's, and they were either persuaded or outraged by what they saw. Nevertheless, critics and defenders alike recognized the potential of monuments not merely to commemorate or to remind but to argue one's

particular viewpoint. Monuments, however, are very blunt tools for these purposes, especially in light of what might be called the democratization of monument building. The erection of monuments was once the closely held privilege of political and economic elites who were able to commandeer public land and often public resources to honor their heroes, unimpeded by the objections of others. The many statues of white supremacist politicians and Confederates in the South offer vivid examples. Now more people have the opportunity to erect monuments, but they also risk a louder, more varied, and more potent opposition than the monument builders of earlier eras did. For that reason, contemporary monument builders employ lengthy inscriptions, explanatory books and pamphlets, interpretive centers, and other devices to fix the interpretation of the past to accord with their views.[12]

The popularity and contentiousness of contemporary monument building engulfs the new Southern civil rights and black history monuments in a very particular way, which creates the second of our preconditions: The new memorials stand in the context, and often within the view, of older monuments that present a white Southern view of history, a history that celebrates white supremacy (fig. 10). The ubiquity of white supremacist monuments means that black history memorials must adopt a visual language that is similar to that of the older monuments in order to make their challenge legible to viewers. Most Confederate and other white supremacist monuments were put up in the late nineteenth and early twentieth centuries, the era when elites could celebrate their heroes unchallenged, and in this respect they stand in contrast to the black history monuments, whose planners sometimes chafe at the demands that their own works undergo a scrutiny and criticism that their white predecessors escaped.

The white supremacist monuments also demand that the new generation of monument builders and the political authorities who oversee them grapple with the vivid contrast between the racial messages of the two groups of monuments. Do they cancel each other out? Does the endorsement of the newer message implied by the monuments' placement in public space mean that the older monuments are obsolete or offensive? Should they be ignored, altered, or removed? Most often, the answer is, *None of the above.* Southern politicians, many whites, and some blacks have worked out a convoluted ideology that I call *dual heritage*, which treats white and black Southerners as having traveled parallel, equally honorable paths. "White history" and "black history" have their own integrity and work out their Hegelian destinies independent of the other. This is particularly true of white history.

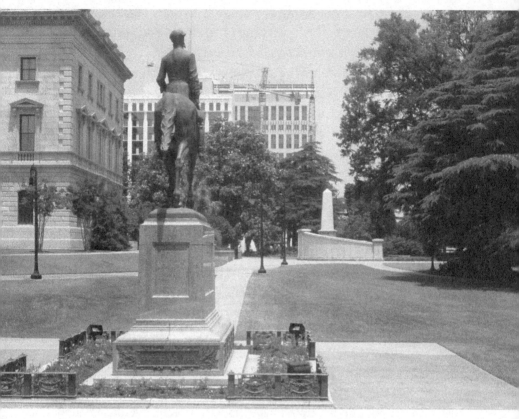

Fig. 10. Confederate general Wade Hampton gazes at the African American History Monument, South Carolina State House grounds, Columbia. Photo: Dell Upton.

Whereas commemorations of black history require some account of the impact of slavery on black life, if not necessarily of slavers, the black presence is treated as incidental to the "historical logic of whiteness" as understood by white Southerners. Some Southerners attempt to find a common thread that links the two, but historically the success of one relegated the other to failure, so the celebration of both is at best paradoxical. To function properly, then, the dual-heritage ideology necessitates that celebrants of each heritage refrain from criticizing, expatiating upon, or even directly acknowledging, the other. Yet it is not possible to separate them: the historical developments of the two are inseparable. Their juxtaposition and the arguments among their disparate advocates are the medium through which a debate over race in Southern society and in American society generally takes place. To understand the new civil rights and black history memorials, one must take into account, as I do in chapter 1, the nature and current status of the white history monuments.[13]

The third precondition is that of day-to-day politics, meaning the operating modes of urban, county, and state governments. Scholars of American urban politics emphasize the necessity for relatively weak American public officials to form governing coalitions, or regimes, of public and private parties to accomplish their goals. It is no surprise that these regimes are usually dominated by powerful businesspeople, so local governments' agendas are typically focused on economic growth. At the same time, regimes are inherently unstable, and they must be continually repaired and remodeled to bring in new partners, mollify some, and compensate for the desertion of others. They also require consideration of the relatively weak as well as of the economically powerful, since even the weak can vote, and they sometimes do. In the peculiar setting of the contemporary urban South, where blacks usually hold political power while whites retain economic power, the formation of a successful regime requires considerable ingenuity, as well as an ability to avoid alienating large portions of the electorate.[14]

Thus civil rights and black history memorials get caught up in the specifics of local symbolic and patronage politics and of economic development efforts, and particularly in the effort of Southern urban and regional growth machines to create a New New South, a parallel to and a successor of the New South of the late nineteenth and early twentieth centuries. The New South was an invention of journalists and businessmen who sought to modernize the South through urbanization and industrialization, reintegrating it into the political and economic life of the United States. In the course of

this campaign, they needed to confront the "Negro problem." Paradoxically, one strategy was to create of a memorial landscape commemorating the Civil War. Confederate monuments recast the war as a violent contest among white men over high principles having nothing to do with slavery. In its most abstract form, the soldiers' cause was reduced to a single word—duty—devoid of specific content. Implicitly, African Americans (and everyone else who was not a white man) had no place in such a debate. In the New South, blacks would be relegated, legally and extralegally, to a permanent, nonpolitical underclass, a compliant labor force for an industrialized urban region.[15]

In contemporary Southern cities, the civil rights monuments serve something of the same purpose. To draw the South into the global economy, to attract outside investment and corporate relocation, depends in part on the rehabilitation of the region's reputation. Even today, scenes of the beatings of freedom marchers or the firehosing of high-school students spring first to the minds of many people outside the South when one mentions Selma or Birmingham. Thus Southern political leaders must confront these images and lay them to rest by portraying the New New South as a deracialized society.

Civil rights memorials, then, signal official acknowledgment of the changes that have occurred in the past half-century. The public officials who approve these monuments prefer to see the movement as a reform movement that righted imperfections in a fundamentally just system through peaceful political action leading to legislative and judicial reforms. This is a viewpoint that is most comfortable with celebrating leaders who guided followers toward concrete, now-achieved goals—hence the lasting popularity of monuments to Martin Luther King Jr. The civil rights movement is a "won cause," as historian Glenn Eskew has called it. The South had paid in full what the Montgomery Chamber of Commerce called the "price we had to pay for our history." This view strictly confines the movement to the years between *Brown v. Board of Education* and the assassination of Dr. King and sees it as a movement with the limited goal of achieving political rights. A century and a half after the painful experience of the Civil War, Reconstruction, and the New South era of "racial capitalism," to borrow historian Jacquelyn Dowd Hall's term, Southern leaders frame the classic civil rights movement as a second, painful, but circumscribed rebirth.[16]

Monuments and the ceremonies that focus on them have become key symbolic tools of this effort. The memorials are tombstones of racial strife and heralds of a rebirth. Taking their cues from the spectacular economic

success of Atlanta, which billed itself during the years of the civil rights movement as "The City Too Busy to Hate," Southern urban leaders herald the birth of a (non)racial order that fulfills the "nation's commitment to liberty and justice for all" and forms the social basis for a reinvigorated, globalized regional economy.

The niceties of day-to-day politics are further complicated by the intense *personalism* and *localism* of Southern society. American political ideology has long reduced structural socioeconomic problems to questions of personal morality, a theme that links early American commentators on poverty to modern rightist politicians. This is compounded in the South by widespread evangelical belief in personal sin and redemption. The possibility of transformation through grace trumps history, so that a sinner as egregious as Alabama's ex-governor George Wallace could be embraced at the end of his life by his former African American adversaries after a suitable expression of penitence.

The transcendence of family over principle, or the inability to see how principle applies to family, in Southern socioeconomic hierarchies also powerfully shapes the discourse. It led Essie Mae Washington-Williams, the daughter of Senator Strom Thurmond and one of his father's African American employees, to keep her father's secret throughout his life. In general, the continuing significance of personal and familial honor and shame, magnified by the intricate bonds of everyday life, particularly in rural communities, draw the bounds of what can and cannot be said even tighter. The familiarity among blacks and whites that anti–civil rights whites formerly cited to show that blacks were comfortable with the old racial order were real, even if they did not mean to blacks what the whites thought they did. Experienced civil rights advocates such as attorney J. L. Chesnut Jr. of Selma, for example, often tell of the personally cordial relationships they formed with hard-line segregationist judges and politicians who repeatedly rejected their efforts to achieve changes in the racial order.[17]

A striking manifestation of the personalism and localism that are inseparable from this story can be found in the bizarre postscript to the 2005 trial of Edgar Ray Killen. Killen spent the entire trial in a wheelchair, ostensibly unable to walk as the result of a logging accident that had broken both of his legs. At one point he was hospitalized during a day of testimony. After his conviction, Killen asked for release on an appeal bond claiming that "the rules are too strict for my [physical] condition." Judge Marcus Gordon granted a compassionate release. Would such a release have been granted to a black man convicted of a similar crime? It is difficult to tell, but Killen was a man

who, in his role as Baptist cleric, had buried Gordon's parents and officiated at his marriage, but whom Gordon had also convicted several years earlier of making telephone threats. I am not suggesting that Gordon was either corrupt or racially biased in granting Killen compassionate release on bond while his case was being appealed. He was unforgiving of Killen's crimes in his concluding statement and in sentencing Killen to three consecutive maximum sentences in the murders. Yet in the context of a small community, Killen was a neighbor as well as a criminal, and that surely affected Gordon's judgment. It did not, however, lessen his anger when soon after his release Killen was seen walking around a gas station with no apparent difficulty. Gordon immediately revoked the bond.[18]

The political and developmental agendas of public officials are powerful forces in shaping the content and siting of the black history memorials erected in recent decades. Yet there are other actors, too, whose goals sometimes intersect with officials' but more often challenge them. Overattentiveness to the established voices of public officials, the mass media, and self-appointed community leaders, for example, can mislead one into believing that this particular story of the civil rights movement—of a largely successful campaign, conceived and carried out by signal leaders, notably Martin Luther King Jr., to achieve relatively limited goals of access to political participation for African Americans, of racial progress and reconciliation, of a deracialized contemporary South—is more widely accepted than it is. This narrative has congealed in public discussions of the movement, and it suits some members of the public, black and white, to endorse it, but around the edges most of its assumptions remain disputed among many of the civil rights movement's participants, opponents, and successors.

Consequently, a fourth precondition that affects the new civil rights and African American history monuments has to do with tensions and concerns among African Americans who are not public officials. Those who initiate civil rights and black history monuments, whose imaginations conceive the ideas, and whose energy and tenaciousness drive the projects to completion often have additional or entirely different agendas from those of officials. Many see the movement in the context of the longer history of racial politics in the United States and are not comfortable with treating the issue as one so neatly resolved in a nonracialized New New South. They wish to interpret the 1950s and 1960s as one episode in an ongoing struggle and are less willing to allow it to pass as a triumph of good over nobody. They are also unwilling to allow the entire blame to fall on a few people, however guilty, at the

bottom of the social order while granting a pass to the higher-ups who tolerated their behavior, and they refuse to ignore the continuing socioeconomic inequalities of the South. Yet even in the most recent monuments the necessity to claim broad public consensus offers a powerful incentive to suppress difficult aspects of the past and to offer a rosy assessment of the present.

Despite the diversity of the new monuments, they share several qualities. First and most important, the proponents of these monuments seek to inject an African American *presence* into the public commemorative landscape. Most organizers' narratives of their efforts begin with "There are no ..." or "I was struck by the absence of...." Since Reconstruction, black Americans have been highly conscious of the material landscape as proof of African American accomplishment, of membership in civil society, and have carefully pointed to buildings and landscapes as evidence of social progress. Now African Americans also want to be full participants in civil society and to have that acknowledged in the landscape of civic commemoration.

Second, scholars currently prefer to interpret monuments in terms of collective memory and to distinguish between history and memory as varieties of recording the past. Although memory certainly plays a central role in the creation of monumental narratives, to understand them it is important to take seriously the builders' belief that they embody *history*, defined as objective reality, not an interpretation or a memory. Monument builders emphasize the *truthfulness* of their representations. Sometimes this claim extends to the physical artifacts, which are assumed to be history in themselves rather than simply records of it. Through their veracity monuments are believed to have the power to enlighten their audiences and to instruct future generations. This perception is not restricted to the creators of black-themed monuments. Defenders of Confederate monuments and memorials often claim that to alter or remove them would be to "erase history." At the same time — and this sometimes leads to uncomfortable verbal and visual contortions — monuments are treated as explanations of the current nature of American society. They must not make any assertion that contradicts the makers' view of things-as-they-are, nor should they raise any issue that would upset the current social and political equilibrium, usually through alienating some group of viewers. Art historian Michele Bogart has recorded the dictum of a New York City official that public monuments on city property should not express an opinion "that could be offensive to another public constituency." Because race remains an open sore in Southern society (and American society generally), that attitude reinforces the dual heritage fiction.[19]

For African Americans, particularly for the middle-class black people who are responsible for most monuments, history has a deeper meaning than it does for the general population. Historian Manning Marable argued that most blacks understand, at least intuitively, that "their moral claim on American institutions is inextricably bound to the past." It demonstrates the centrality of African Americans to American society and culture, a centrality that was often ignored or denied as part of the white-supremacist effort to exclude blacks from civil society. Early African American historians—meaning black historians of the black past—shared the "racial vindication" goal of other black leaders of the late nineteenth and early twentieth centuries, seeking to write a "functional and pragmatic" history that would create a positive racial consciousness among African Americans and demonstrate to whites that blacks were worthy of full citizenship.[20]

This historiographical tradition began soon after Emancipation, and it reinforces the emphasis on positive achievement. Middle-class African Americans found themselves trapped between the disapproval of whites whose genteel values they shared and the behavior of lower-class blacks, which they thought violated those values and exposed all African Americans to blanket condemnation. They believed themselves charged to demonstrate through their own demeanor and accomplishments that blacks were capable of gentility and to instruct their economic inferiors in proper conduct. It followed that accounts of black life, including the historical experience of African Americans needed to be relentlessly upbeat, accentuating the transcendence of hardship, rather than hardships themselves—accomplishments rather than injuries. This attitude has been shared by many historians of the African American experience and of the civil rights movement, and it guides most monument builders. "We don't need to deal in horrors, we need to deal in honor," is the way one black South Carolina legislator put it. In the monument building process, uplift also takes the shape of assertions that monuments are for "the children" or coming generations, as a record of black accomplishments that might otherwise be forgotten.[21]

The demand for uplifting African American–themed monuments is also a corollary of more broadly held American attitudes toward commemoration. Since the early nineteenth century, Americans have demanded that their public monuments evince a positive outlook: that they honor achievement more than mourning loss. The latter has been, and remains, understood as more appropriate to private memorials in cemeteries and to impromptu ones at the sites of disasters. When mourning seeps into formal public monuments, as

critics of the Vietnam Veterans Memorial in Washington and of the recent September 11 memorial in New York believed it did at those sites, it becomes controversial. Public monuments ought not to remind us of social divisions or serious wrongs committed by one group of Americans against others, much less of continuing injustices. Monuments should speak to everyone's condition and represent values or goals shared by everyone in the public as it is commonly defined. They ought to be forward looking, not backward looking. They should inspire rather than remind. They should promote self-esteem and mutual regard. And above all, particularly in the case of civil rights and African American history monuments in the South, they must not offend white people.[22]

While African American history monuments are usually initiated by black people, it doesn't mean there is a single "black" viewpoint about them or about black history. There has been a significant component of social class and color consciousness in the promotion of these monuments. Like other projects of uplift, they are usually initiated by middle-class, educated African Americans. Lower-class and politically radical or nationalist blacks are often hostile or uninterested, as when some African Americans accused the black fraternity that created the Martin Luther King, Jr. Memorial in Washington, DC, of doing the white man's work, or when a dark-skinned, homeless man in Birmingham told me in 2005 that the monuments in Kelly Ingram Park are for "the near whites," not people like him. Differences of viewpoint also arose over the degree of frankness or reticence about racial oppression and conflict, about the use of historicist, abstract, or mythic (Afrocentric) visual language, and about the inclusion or exclusion of particular individuals and incidents.

Few nonblack people evince openly racist or white supremacist views of the new monuments (with conspicuous exceptions discussed in chapter 1). Instead, much white opposition or obstruction can best be classified under the historians' rubrics "color-blind conservatism" or "color-blind structural racism—a racism without overt racists." It is a conservatism that praises individual African Americans' achievements while refusing to acknowledge how economic and political structures constrict most Americans of color and protect white dominance. In monument building, color-blind conservatism is willing to acknowledge African American "contributions"—the word itself connotes a marginal addition to something larger and more important— while refusing to relinquish the centrality of white agency in "freeing" slaves or in "granting" rights. And it insists on having the last word wherever there is disagreement over the appropriateness of a monument or an inscription.

At the same time, however, controversies over the monuments cannot be divided into simple "black" and "white" sides, any more than members of either race can be assumed to have a single viewpoint. Whites and blacks and occasionally Native Americans and Asian Americans have been found at every position in every controversy.[23]

What makes the monuments most interesting, then, is not only the varied positions of the protagonists but how they transform. As the intellectual historian David Hollinger has written, "To focus . . . on a belief or value attributed to an individual or to a collectivity of individuals is at once to move back from . . . authentic, contingent relationships; where historical subjects are said to hold a belief or value, those subjects are endowed with merely abstract, static characteristics." Instead, Hollinger says, we should see conflicts — or, to put it more grandly, political or philosophical differences — as starting points of debates in which all parties' positions are defined and redefined in contact with those of their antagonists. Even those who seem doggedly to cling to a single position repeatedly edit and modify it under criticism from interlocutors.[24]

In examining the new civil rights and African American history monuments, then, the process is as important as the product, which only rarely matches the initial proposal. One examines a statue or memorial, not as an embodiment of a singular viewpoint, but as a less than seamless manifestation of disparate ideas. It is in the negotiation that the historical and political qualities of monuments emerge, not from a static memory. Monuments have stakeholders who claim a right to determine their content, as the drawn-out process of creating the September 11 memorial in New York so vividly demonstrated. Most debates over black history monuments deal explicitly or implicitly with the question of stakeholders. Who are the stakeholders? Who has a rightful claim to that authority? With whose voice will a monument speak? Who is the primary audience? Whom should it be? These key questions should be kept in mind in viewing the monuments discussed in this book.[25]

The issues, though, are more complex than the simple matter of uplift, personal relations, or the delicacy of white sensibilities. As I show in chapter 1, the continuing political power of white supremacist symbols, evinced by the deference accorded to them by civic authorities, imposes a significant limitation on expression in the new African American memorials.

CHAPTER 1 DUAL HERITAGE

We of my generation have lost one line of fortifications after another, the old South, the old ideals, the old strengths.

— WILLIAM ALEXANDER PERCY, *LANTERNS ON THE LEVEE*, 1941

One morning in November 2007 residents of Montgomery, Alabama, awoke to discover that the century-old Confederate Memorial Monument adjacent to the state capitol had been defaced. "N.T. 11 11 31" was spray-painted across one of the original inscriptions, and the hands and faces of the four creamy white marble figures had been painted black (fig. 11).[1]

At first, wrote a reporter, the Sons of Confederate Veterans believed the embellishment to be the work of high school students (always understood to mean white high schoolers). "Their theory changed, however, when they realized the significance of the date." They decoded the spray-painted tag as a reference to Nat Turner, the organizer of a slave rebellion in Virginia, who was hanged on November 11, 1831. In newspaper accounts, this SCV reading of the inscription as a reference to Nat Turner quickly morphed into "officials believe." To the monument's devotees, the Turner connection added a sinister overtone to the vandalism: 'I just don't think your run-of-the-mill vandal would know about Nat Turner's rebellion," said SCV member Alan Parker, who did not reveal how the SCV itself came to be so well informed about African American history.[2]

A "heinous thing for somebody to vandalize a soldiers monument particularly on Veterans Day weekend . . . a kind of slap in the face to all veterans really," was soon recast as a "hate crime." The commander of the Alabama Division of the SCV, who was also a member of the neo-Confederate League of the South and a former leader of the [White] Citizens' Council, declared, "We have some ignorant people in our midst who have a Taliban mentality." To

Fig. 11. Confederate Memorial Monument (Alexander Doyle, 1886–98), Montgomery, Alabama. View after vandalism of November 13, 2007. AP Photo/Robb Carr.

Selma neo-Confederate Pat Godwin, "This speaks loudly to me as a white person that whoever defaced this monument must hate all whites by honoring Nat Turner, who slaughtered innocent white children by decapitating them in 1831." Letters to the editor quickly endorsed this reading. "That this was a hate crime, there is no doubt," Godwin's frequent ally Ellen Williams wrote. "The vandals wrote N.T. 11 11 31, a reference to the death date of Nat Turner, who bludgeoned to death 57 white people as they slept."[3]

In fact, the vandalism was not the work of the black militants whom the SCV suspected but of high-school students as initially assumed. Three seventeen-year-old boys were arrested on a tip from the SCV's Leonard Wilson. Their attorney assured reporters that "these are not terrorists, they're not extremists," but "good kids from good families . . . who have never been in trouble." Not only were they not black, but "their youth also surprised those who thought the vandals would be older and better educated, given the apparent Turner reference." But the culprits had "learned this stuff in school. . . . Folks are wondering what was going on, what the message was and it was a statement against slavery."[4]

Not every white Southerner was as offended as the SCV and the United Daughters of the Confederacy, who were more or less honor bound to be outraged. As one reader commented on a newspaper's website: "I thought they improved that second place trophy." Another said, "They did a good job painting the face and hands of the statue. . . . The statues did look nice with the black paint." Most whites were probably indifferent to the symbolic nature of the crime. Nevertheless, the boys' actions at the Montgomery Confederate memorial was not just vandalism or even well-intentioned but youthful folly—"something stupid and [he] wished it hadn't happened," as the lawyer for one of the boys said—but a brilliant piece of political theater that exposed complex attitudes about race and heritage in the modern South. These are important for understanding African American memorials, which have been inserted into a landscape already densely populated by monuments that, like the Montgomery monument, celebrate the Confederacy. The earlier monuments' presence—their forms, messages, and constituencies—shapes what can and cannot be said in civil rights memorials in subtle and not-so-subtle ways, and the two types of memorials are nearly always discussed in comparison or opposition to each other.[5]

The Confederate Memorial Monument was dedicated on a cold, clear-blue December day in 1898, twelve years after Jefferson Davis had laid its cornerstone (fig. 12). Like most such memorials, it was the work of the local Ladies Memorial Association, the successor of earlier women's groups that had tended wounded soldiers during the war. Caring for graves was the only way many ex-Confederates felt free to honor their dead, since federal authorities in the South during Reconstruction were wary of more open displays of loyalty to the failed rebellion. Decoration Day ceremonies thus became, at first quietly and later more openly, occasions for the declaration of continued loyalty to the Southern cause. As the political climate became more favorable to ex-Confederates, they began to erect monuments in cemeteries, where the very evidence of defeat provided by the graves suggested martyrdom in the cause of righteousness. "There is grandeur in graves, / There is glory in gloom" reads the inscription on the monument to "Our Confederate Dead" erected in Selma, Alabama's Old Live Oak Cemetery in 1878–79.[6]

In the years following the Civil War, ex-Confederates compared their own relatively minor political disabilities to the liberties enjoyed by newly emancipated blacks, who openly vaunted their freedom and even paraded bearing arms to emphasize their military role in the Union victory. While

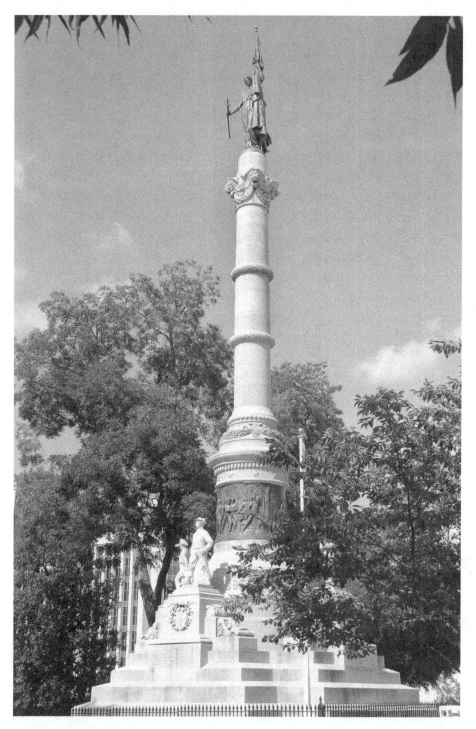
Fig. 12. Confederate Memorial Monument. Photo: Dell Upton.

some whites granted, or at least grudgingly acknowledged, ex-slaves' right to celebrate their own freedom, they were aggrieved that African Americans were allowed to exult in the South's defeat, as when blacks in Richmond, Virginia, paraded on the first and second anniversaries of the Confederate withdrawal from the city in April 1865. In some respects, this distinction between emancipation and Confederate defeat, between acknowledging blacks' feelings while demanding that whites not be offended, marked the beginning of the tradition of dual heritage that has enjoyed a resurgence in the aftermath of the civil rights movement of the mid-twentieth century. Over the course of the half century after 1865, Southern apologists worked strenuously to deny that the Civil War was about slavery, or indeed had anything to do with black people, a claim that they succeeded in embedding in American popular memory. The erasure of African Americans from history went hand in hand with their elimination from the political arena. Although most white Southerners eventually accepted emancipation, they did so in the context of an unwavering belief in white supremacy and in their own right to set the terms of political and social engagement. They could not believe that any "resident, whether white or black," could rejoice at the fall of Richmond. They denied that blacks were citizens and demanded that African Americans be sensitive to the wounded feelings of their "best friends," defeated white Southerners.[7]

The Montgomery memorial was one of many built in response to a "call to erect monuments to our fallen heroes" issued by the Southern Historical Society, an organization founded in the late 1860s to propagate "a true history of the war." Most of the first monuments outside cemeteries were organized on a statewide basis and were intended for display at or near state capitols. Most also required a certain amount of arm-twisting to persuade reluctant legislators and an indifferent public to fund the projects, and so took time to reach fruition. In Montgomery, the male Historical and Monumental Association, which had first approached the women for help in the 1860s, carried the Confederate memorial project to the laying of the cornerstone by Jefferson Davis in 1886. However, they "realized it would be a slow task to raise the money for the Confederate Monument, so this association turned over to the Ladies' Memorial Association of Montgomery their work begun and money raised," which amounted to $6,777 of the eventual $46,000 cost of the work.[8]

Twelve years later, the monument was completed. The eighty-five-foot-tall shaft, one of the most elaborate in the South, features a central column

supported by a stepped base and crowned with Corinthian capital that sup-
ports a bronze figure, "typifying Patriotism," and holding a sword and a furled
flag. Encircling the base of the column is a bronze relief that depicts a column
of soldiers urged on by an officer (fig. 13). Four plinths, each inscribed with a
florid verse, celebrate the heroism of "the knightliest of the knightly race," as
Georgia poet Francis O. Ticknor put it. Each supports a life-sized marble figure
representing a branch of the Confederate military—the infantry, cavalry, ar-
tillery, and navy.[9]

The memorial project sounded all the themes of the mature Confederate
interpretation of the Civil War, cloaked in symbols and metaphors that by
then were already standard, even clichéd. The monument itself embodied the
ambiguously gendered nature of Lost Cause politics. Brought to fruition by
women, it was framed, on the one hand, as a female tribute to the patriotism
and valor of Confederate military men. One inscription by Ina Maria Porter
Ockenden assured readers that even after the monument had crumbled, "in
woman's heart shall be / A folded flag, a thrilling page unrolled, / A deathless
song of Southern chivalry." Since the earliest postwar months, white South-
erners had deflected the accusation that ex-Confederates retained their old
loyalties to secession by treating memorialization as a feminine tribute to

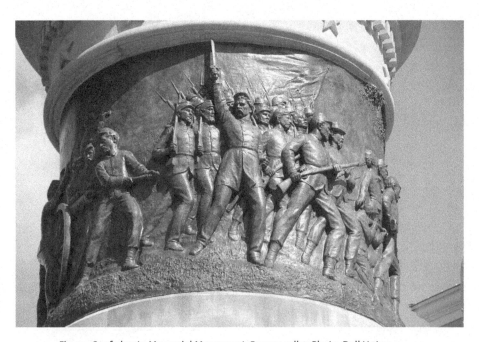

Fig. 13. Confederate Memorial Monument. Bronze collar. Photo: Dell Upton.

apolitical valor. By focusing solely on the personal heroism of the common soldier, white Southerners also hoped to defuse political divisions among themselves in a manner that would create a united racial front in support of white supremacy. If valor alone was a criterion for honor, then there was no need to look too closely at the causes that valor served. As art historian Kirk Savage has shown, this became the fundamental premise of all military monuments after the beginning of the twentieth century. The single stand-ing soldier became the universal symbol of the Civil War in both North and South—so much so that monument manufacturers sometimes inadvertent-ly delivered statues wearing the uniform of the wrong side.[10]

The dedication speakers' task was to articulate the ex-Confederate position on the war and reunion as it had evolved by 1898. Colonel W. J. Samford of Opelika argued that while all present were now loyal to "a re-stored union, and to a common flag," there was no need "to degrade the memory of the Confederate States, in order to exalt the Union—or to deify the New by anathematizing the Old South." The war was a war of principles, with the Southern states fighting "in defense of that glorious product of this western world, the great right of local self-government, and in defense of the principles of American Constitution." Ex-governor Thomas G. Jones, who had carried one of the flags of surrender at Appomattox, defended the South against charges of treason and explained at length that the slavery was "of a purely political significance" in raising principles of "local sovereignty": "It is just as absurd to say that the war was fought over the justice or morality of slavery, as it would be to declare that the conflict with the mother country, was a dispute about tea thrown overboard in Boston harbor." Jones rehearsed common arguments that slavery had been imposed on the South by the North. He sketched the homecoming of the defeated Confederate soldier, who "found the slave his political master, his home in ruins and his field in weeds and waste." Having been "trained both to obey and command" in a strongly hierarchical society, the repatriated rebel could not accept this rever-sal of social relations. Jones reminded his readers that Southern slavery "was mildness itself" compared with conditions in other slave societies, since it in-volved the enslavement of a race of people who had not been free before they were brought to the United States. The absence of slave rebellions during the Civil War was proof that slaves had been grateful for the kindness of their masters.[11]

There was nothing original about any of these remarks. Their thesis had been shaped very quickly after the end of the Civil War. The war was cast as

a conflict over high principles among honorable white men. The Confederate loss was the product of greater Union firepower rather than of worthier Union values. The valor of soldiers on both sides was the basis for national reconciliation, but white Southerners were adamant that the old racial hierarchies had to be reestablished. Although God had apparently decreed that slavery should end, it was equally true that the racial segregation and "the clear and unmistakable domination of the white race" were "the fiat of the Almighty," in the words of Southern modernizer Henry W. Grady.[12]

In short, the Confederate Memorial Monument, like so many other Southern gestures of the last quarter of the nineteenth century, vowed reunion on Southern terms. Patriotism, the tender ministrations of women, the chivalry and valor of men—all rested squarely in the white realm. There was no room for African Americans in this universe. The Civil War was a white affair, and despite the Fourteenth Amendment to the Constitution, blacks were neither citizens nor members of Southern society in the view of most ex-Confederates.

The abstractions of Montgomery, with their understated but unmistakable foundation of white supremacy, pointed toward the future. The celebration of generic, apolitical valor—or honor or duty or service or patriotism—in turn contributed to an uncritical view of the military, its costs, and its actions that has pervaded American culture since that time. Simply to be a soldier, no matter in what cause or to what effect, is to represent the highest ideal of American culture. As W. E. B. Du Bois wrote, "Only murder makes men." These assumptions help to determine what can and what cannot be said in civil rights memorials as well. Despite the professed nonviolence of most factions of the civil rights movement of the mid-twentieth century, those who memorialize it commonly fall back on metaphors of military valor and sacrifice to signal its importance.[13]

Montgomery's monument was accepted as a given as long as the racial order established in the New South seemed secure, so much so that the memorial seems to have been an afterthought to many Alabamans from the time of its dedication. Neither the governor of the state nor the mayor of the city bothered to attend the dedication; both sent surrogates. As the state capitol was enlarged, it pushed up against the monument, turning it from a freestanding work to something relegated to the side yard, where it is largely obscured by trees. In 1930 the Olmsted Brothers landscape architectural firm recommended moving the monument to the intersection of Dexter Avenue and Decatur Street in Montgomery, but financial constraints prevented it.

The proposal was raised again in 1947. Some of the memorial's fans endorsed the proposal. One asked "Can we not have a monument Avenue of beauty just as [in] Richmond, Virginia?" In 1966, the issue was raised again, on grounds of the monument's invisibility in its location on the north side of the capitol. It was proposed to move the memorial to the front of the building, or three blocks behind it, as part of a projected mall. Those who objected recalled that the cornerstone had been laid on the original site by Jefferson Davis, "and so far as is ascertainable there is no other monument anywhere whose cornerstone was laid by the President of the Confederacy."[14]

Nothing was ever done, and the memorial stood in relative obscurity until the vandalism of 2007. The incident exposed the nineteenth-century assumptions that continued to shape the monument's interpretation among many Alabamans. That the Civil War was about a principle—self-determination—rather than slavery remains an article of faith among Confederate apologists. While nineteenth-century polemicists had argued that slaves had been faithful defenders of the home front during the war, thus demonstrating their loyalty to the Southern order, by the beginning of the twenty-first century those who argued that their esteem for the Confederacy was based on principle and "heritage" had begun to imagine legions of black Confederates, "thousands of devoted, courageous black men and women who supported, loved and fought for the Confederacy," as one letter to the editor writer put it. The teenagers' brilliant act of redecoration revealed the transparency of this claim. If "thousands" of blacks fought for the Confederacy, what was wrong with recasting generic Confederate soldiers and sailors as black?[15]

The problem was that the Confederacy remains unambiguously white in the minds of its admirers. It is the white half of the South's dual heritage. The same correspondent who lauded black Confederates equated the attack on the monument with an attack on Southern whites, "a race that is unique in every respect. We have unique customs, culture, etiquette, ethics, food, music, dialect, religion, politics and patriotism. Our rights are constantly attacked and invaded. We have always been a minority and deserve the same respect, opportunities, recognition and freedom to be ourselves as any other minority in the country." From this point of view, to attack the monument was equivalent—as many correspondents noted—to vandalizing a civil rights memorial. It was a "hate crime." "Had the MLK statue [there is none in Montgomery] been so defamed, all possible law enforcement agencies would descend upon Montgomery to join in the massive hunt. However, since it is only

a mere Confederate memorial to our beloved and honored ancestors, not much attention is being given to this heinous act."[16]

Many of the class and gender assumptions of the memorial's creators have also faded, as historian Thomas J. Brown has argued. Yet the primacy of whiteness survives in the assumption that those who fought for the white cause in the Civil War fought for "their" state in a "second war for independence," that the Confederacy constitutes the state's "heritage"; that the monument to it is "sacred"; that "self-government" was not about the right to own and control black people; and that soldiering is inherently honorable whatever the cause. The parallels that discussants so readily drew to civil rights memorials underscored the implicit whiteness of Confederate remembrance as well resentment of contemporary African Americans and the white elites. These characteristics were common both to openly racist campaigns and to more circumspect defenses of "heritage."[17]

Even among today's most outspoken racists, the white supremacist claims that the genteel builders of Montgomery's Confederate memorial uttered are rarely voiced explicitly. Instead, the late-twentieth-century language of multiculturalism, heritage, and history conveys their message. On October 7, 2000, neo-Confederate groups under the leadership of Pat Godwin and City Councilman Cecil Williamson dedicated a monument in Selma, Alabama, to the Confederate general Nathan Bedford Forrest (fig. 14). One African American police officer who was present to maintain order described the dedication as "a Klan meeting without the hoods," and the event was targeted by protestors who called the monument "a slap in the face."[18]

Originally planted at the edge of a black neighborhood, the bronze bust of Forrest sat on a granite base inscribed on the front "Defender of Selma / Wizard of the Saddle / Untutored Genius / The First with the Most." The monument was "a testament of our perpetual devotion and respect for Lt. Gen. Nathan Bedford Forrest, CAS, 1821–1877, one of the South's finest heroes," and "in honor of Gen. Forrest's unwavering defense of Selma, the great state of Alabama and the Confederacy." The inscription was bracketed with the Confederate battle flag and the motto "Deo Vindice" (variously translated as "God will vindicate us" or "God as our protector"), derived from the 1864 great seal of the Confederacy, which appeared on the rear of the pedestal. The monument's sides listed Forrest's battles throughout the Civil War. The rear panel credited the work to the local chapter of the SCV, the Alabama Society of the

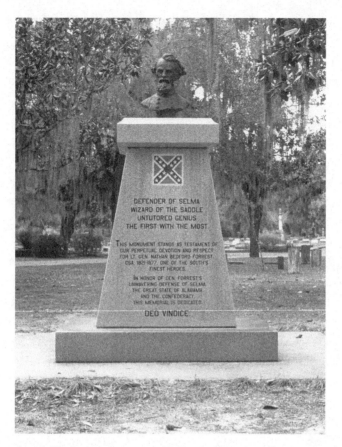

Fig. 14. Nathan Bedford Forrest monument (Paul D. Spaulding, 2000), Selma, Alabama, 2000. Stolen 2012 and never recovered. Photo: Dell Upton.

Order of the Confederate Rose, a self-described "nonprofit, nonracial, nonpolitical and nonsectarian" ally of the SCV that is dedicated to the "preservation of Confederate symbols"; the Selma chapter of the UDC; and "private contributions from those who love the South."[19]

To many black residents of Selma, the monument's message was obvious. It stood on the grounds of the Joe T. Smitherman Historic Building, a local museum named after the city's long-serving mayor. Smitherman was first elected just before the momentous civil rights demonstrations of 1965 and held office with only a short break for the following thirty-five years. In mid-September 2000, however, Smitherman was ousted by African American candidate James Perkins Jr., a computer consultant who had run unsuccessfully against him twice before and who had been campaign manager for Smitherman's black challenger in 1984. Perkins had just assumed office when

the monument went up, so it was interpreted as a rejection of black political power. "You lose control of your city government and a week later you put up a statue of a Confederate general?" a white school administrator noted rhetorically. "How Southern. These [Confederate] heritage guys are basically saying what a lot of white people around here feel: The fight goes on. The war never really ends."[20]

Journalists, historians, and political opponents have speculated about Mayor Smitherman's racial views and the degree to which they had or had not evolved in the three and a half decades he held office, but the question is irrelevant. Smitherman understood Selma's political and demographic climate thoroughly, and he was able to use his expertise to his advantage. First elected in 1964 as a reformer who overthrew a closely knit political machine that had ruled Selma for more than three decades, Smitherman accused his opponents of failure to pursue economic development aggressively, and he won on that basis, as well as on his record of working for infrastructural improvements during his service on the city council. Many of the white businesspeople who supported Smitherman were distinguished for their white supremacist views in the face of the impending changes of the 1950s and early 1960s. The local [White] Citizens' Council, organized in Selma less than a year after the regional group's founding in Mississippi in 1954, was closely intertwined with city government and was determined to enforce a united front among whites in resistance to racial change. During his campaign Smitherman called attention to his membership on the Citizens' Council's board while at the same time appealing to "moderate" white businesspeople who were afraid that the racial intransigence of the Citizens' Council would harm business.[21]

The city's electoral system, which assigned councillors to wards but chose them through at-large voting, allowed whites to retain a majority on the city council as long as black voter registration and black voting were low. White politicians could expect to capture all the white vote and, through judicious dispensation of favors and jobs, enough of the black vote to assure victory. Black candidates could expect to receive almost none of the white vote, and African American voters, assuming that blacks stood no chance of success, were often uninterested in the contests. State law and court orders forced changes in 1971–72 to district elections, but whites were still able to retain a majority because the council president was elected at large. Through the council, whites also controlled the school board, which was self-perpetuating until 1977 and then was appointed by the city council until 2009.[22]

Mayor Smitherman was particularly adept at manipulating this system. As Selma's population approached parity between whites and blacks and as increasing numbers of blacks registered to vote, he devised a modus operandi that involved strong appeals to whites on the basis of racial fears and enough concessions—urban improvements and city employment—to blacks to keep the black electorate divided with a small segment loyal to him. J. L. Chestnut Jr., a black Selma attorney and long-time Smitherman adversary, recounted a telling incident in which the mayor, angered that his closest black ally on the city council had voted against certifying his victory in the 1988 election, fired the man's daughter from her city job. Chestnut observed to Smitherman that by firing the woman, "he was sending a message to whites that he (Joe) stands up and a message to Lorenzo about who's in charge." Smitherman replied that he could "get Lorenzo back this afternoon. Just pave a sidewalk in his district."[23]

As Chestnut's anecdote illustrates, the legal structure of Selma's politics was reinforced by the small size of the town's political world, which created a climate strongly inflected by personal alliances and animosities. During Smitherman's decades in office, his main antagonists were J. L. Chestnut and the members of his firm, now known as Chestnut, Sanders, Sanders, Pettaway and Campbell. Chestnut was raised in Selma and returned to practice law there in 1958 after being educated at Dillard University and Howard University Law School. As the only African American to practice law in the Black Belt for many years, he constantly confronted political authorities at every level. Smitherman was his regular antagonist, although Chestnut described their relationship as a kind of ritual combat that benefited both parties.[24] "Our confrontations became a pattern. I'd sue or threaten to sue. He'd denounce me, build up the issue in the press, and come off to the white community as a tough guy. Then he'd sell them on a small concession: 'Chestnut's gonna have the Justice Department breathing down our necks,' or, 'Those damn people will be out in the streets again if we're not careful. I'm gonna give 'em such-and-such. It won't amount to a damn thing.'" Then, according to Chestnut, Smitherman would go before a black organization and tell them how much he had done for African-Americans, adding, "If J. L. would quit these damn lawsuits and carrying on all this crap, we could get a hell of a lot more done."[25]

Chestnut's major allies were state senator Hank Sanders and Sanders's wife, Rose (now known as Faya Ora Rose Touré). The couple came to Selma fresh out of Harvard Law in 1972 and quickly formed a professional

partnership with Chestnut, who described Rose Sanders as an activist, "a good person, dedicated to helping the underdog, and very outspoken. When Rose sees a wrong she attacks. She is sensitive, volatile, emotional, and idealistic.... She has a tendency to fight every war.... She ruffled feathers not only in white but in black Selma." This is a fair assessment of her career., In addition to pursuing her goals through the courts, Sanders organized a school, the McRae Learning Center, the Black Belt Arts and Community Center, and other community organizations, as well as several museums, including the well-known National Voting Rights Museum. She also spoke passionately and often out of order at city council meetings. Through assiduous cultivation of African American political ties, the Chestnut law firm came to have a powerful voice in choosing which black candidates would run in local elections. Many white Selmians believed that they were bent on eradicating all white participation in local government, a charge that Smitherman often repeated during and after the 2000 election.[26]

Rose Sanders's particular interest in education, as well as the rising power of African Americans in Selma politics after the mid-1990s, led to a conflict that in many minds defined the transformation of Selma. Shortly after a black school superintendent, Norward Roussell, had been appointed in 1987, a group of African American parents formed Best Educational Support Team to argue for improvements in the city's public education. A convoluted conflict over the academic tracking of black students led to Roussell's firing and to a series of demonstrations that culminated in the occupation of the high school cafeteria by protesting students and of city hall by a group that included Hank Sanders.[27]

While personal relationships and regime politics complicated Selma's electoral alliances, it is clear that Smitherman associated his own future with that of continued white domination of Selma, and he was not afraid to manipulate racial fears to retain his seat. During the 2000 campaign, Smitherman warned white voters that "you're looking at your last white mayor" and told a *New York Times* reporter that "everywhere that you've gone all black, the towns have gone down."[28]

The racial polarization of the election was exacerbated by Smitherman's choice of Cecil Williamson as his campaign manager. Williamson was pastor of a local congregation of the Presbyterian Church in America, an ultraconservative offshoot of the mainstream denomination formed in the 1970s by disgruntled Presbyterians opposed to "liberalism" and integration. He had been a member of the Selma city council off and on since 1980, and in the late

1990s he was a member of the Dallas County school board. He was also a close political ally of Smitherman's. In the years just before the mayoral election, the Sanderses had sued Smitherman and Williamson for defamation. The case went to the Alabama Supreme Court, where it was decided in favor of the defendants just as the 2000 mayoral election was getting under way. Since the mid-1980s, when he had organized a white voters' registration campaign to counter black registration efforts, Williamson had become an increasingly vocal opponent of black political power in Selma and increasingly open about his neo-Confederate beliefs. Smooth and polished in his public performances, Williamson is fond of debunking "myths" about the Selma civil rights movement, particularly the notion that anyone had been killed in Selma proper, as well as those about the Civil War, the Old South, and "the despot Lincoln."[29]

Rose Sanders and Williamson came to represent for their adversaries the worst-case scenario of rule by the opposition. Godwin described Sanders as a "terrorist" who had destroyed the city's schools. A letter to the local paper described Williamson as someone who wished to restore the Old South, slavery and all: "[He is] a Jim Crow throwback. He hates all non-Southern white[s], be they black, white, Hispanic or Jewish who can look him in the eye and tell him 'No.'"[30]

Thus for many black and white Selmians the 2000 mayoral election was a power struggle between blacks and whites, generaled by Rose Sanders and Cecil Williamson, respectively. Sanders rallied her troops around the slogan "Joe Gotta Go," and Smitherman was soundly defeated by a margin of 57 percent to 43 percent. After his loss, Smitherman complained that Mayor-Elect Perkins had brought "people from California, the NAACP, Al Sharpton, all this crowd into Selma to try to affect the outcome of the race." The outgoing mayor had "thought bringing these people into town would bring out the white voters, which [it] did, but it turned out the black voters, too, including those from low-income areas, as you can tell by the totals." Smitherman blamed his defeat specifically on Rose Sanders, and he was bitter about it. She "won this election," he told a local reporter after his defeat. "You can always say something about Rose Sanders—whenever she uses her influence the town goes down," he then told his white supporters.[31]

And so when the Forrest monument appeared just after the election, it was read as Smitherman's thumbing his nose at the new black leadership, particularly given his campaign manager's key role in the bust's creation, and at Rose Sanders, who became the leader of the opposition to the monument. The connection between the monument and Selma's contemporary racial

strife was drawn explicitly by one writer of a letter to the editor. He claimed that Perkins's "obstinate [sic] removal of the Gen. N. B. Forrest monument" was "arguably the greatest racially divisive act since Faya Rose Touré … single handedly segregated the Selma Public School System in 1991."[32]

The monument was probably not specifically a reaction to Smitherman's defeat. Pat Godwin argues, credibly, that such a major undertaking could not have been accomplished in a little over two weeks, and at the time of the dedication, she said that it had been in the works for over a year. It is more likely that it was a response to the ongoing tension in Selma politics between blacks and whites and between the Smitherman-Williamson and Chestnut-Sanders factions. But the Smitherman campaign was certainly in the thick of it. As the city's population became more African American in the post–civil rights years, the Citizens' Council's grip loosened, but city politics remained so divisive that, as historian J. Mills Thornton III has noted, virtually all political change in the city has come as a result of court orders, a pattern that continued to hold true as the saga of the Forrest monument unfolded.[33]

Three days after the Forrest monument was dedicated, the city council addressed the matter. The new mayor acknowledged having been "asked in passing what his reaction would be to a statue being erected of a Confederate soldier at the Smitherman Building and he responded that it was a museum." However, Perkins said that the city had not been notified of the intended dedication, nor had city representatives been invited. A white council member proposed exhibiting the monument inside the museum, while a black one insisted that it be removed altogether. The council passed a resolution, "Nathan Bedford Forrest," that took a both-and stance toward the general. On the one hand, it recorded that he "is noted, by some historians, as one of the military geniuses of American History" and "one of the most effective Confederate Generals during the American Civil War," who "lead [sic] many successful battles" but was defeated at the Battle of Selma. On the other hand, one of Forrest's victories was at Fort Pillow, Tennessee, where his troops slaughtered many black Union soldiers after they had surrendered, a crime that a postwar congressional committee found and many modern historians believe he ordered or condoned. He was a slave dealer and owner and served as one of the heads of the Ku Klux Klan, although he "is noted by some historians to have attempted to disband the organization because of its increasingly violent practices." The council resolved that the Forrest bust be either moved inside the museum, "as part of history, provided a more balanced representation of the historical significance of the monument be pre-

sented at the new site," or removed. This resolution was not the final word but merely the opening salvo in a bitter, years-long struggle. As the city's leaders wrestled with the monument's fate, neo-Confederate and African American activists watched closely.[34]

Like Smitherman, Mayor Perkins was a practical politician who attempted to build a regime that bridged white-black differences in Selma. His electoral majority was based on an unusually heavy turnout of black voters, but he had campaigned as a businessman who accused Smitherman, as Smitherman had accused his predecessor, of failing to pursue new businesses actively. So although he was sensitive to the feelings of the large African American majority that had elected him, it is significant that the decision about the monument was also driven by the anxieties of businesspeople who worried about the effects of the controversy on their prospects for outside investment. The conjunction of Perkins's election and the erection of the Forrest monument, whether coincidental or not, was widely read by outside sources as a sign that Selma's racial troubles, exemplified by the Bloody Sunday police riot at the Edmund Pettus Bridge on March 7, 1965, had not passed. Local businesspeople were disturbed about the potential consequences of this reportage.[35]

As the struggle proceeded, Mayor Perkins tried to shift the discussion from the propriety of erecting a monument to Forrest to the technical legality of erecting it on public property without the consent of the city council. Perkins gave the owners of the monument three options: to place it inside the museum without its pedestal, which he said the building's structure could not support; to move it to Riverfront Park, where a reenactment was held every year of the Battle of Selma; or to relocate it to Old Live Oak Cemetery, where it would become part of Confederate Circle, a cluster of monuments and soldiers' graves centered on the Confederate monument mentioned earlier in this chapter. But Perkins and the council also said that if the monument were placed in any of these publicly owned sites, the inscription would have to be changed in accord with the dictates of "a special committee . . . [that would] perform the necessary authentication of the history, and [ensure] that the language be both balanced and factual." This committee consisted of a city councilmember; the vice chairman of the Friends of the Selma/Dallas County Selma-to-Montgomery Historic Trail Association, an organization dedicated to the commemoration of the 1965 civil rights march; Alston Fitts, a local historian who was the son of a die-hard segregationist but who had become a vocal critic of the old white supremacist order; the director of Selma's

National Voting Rights Museum; and the director of the Old Depot Museum, Selma's general museum of local history.[36]

The monument's supporters, who organized themselves as the Friends of Forrest (FoF), resisted any change on the grounds that they had followed proper procedures in requesting permission to place the monument on city property. They argued, and Smitherman confirmed, that the mayor had granted their request on January 14, 2000, pending the agreement of the Smitherman Building trustees, who unanimously granted it on February 17. "We followed every instruction we were given and we did all we had to do to place the monument," said FoF spokesman Benny Austin. Godwin also argued that the dedication ceremony had been scheduled before Perkins was chosen mayor. Later, the Friends of Forrest claimed that they knew they had erected the monument during Perkins's administration and so kept the ceremony under wraps to avoid embarrassing him or his supporters.[37]

The lines of contention altered little throughout the engagement. The Friends of Forrest insisted that they had proper authorization to erect the monument, that Perkins had known that it would be erected before the fact, and that they could not afford to move it. City authorities questioned Smitherman's and the Smitherman Building trustees' authority to grant permission without notifying the city council. They insisted that the monument had to be moved but repeatedly altered the deadline to allow the FoF to comply voluntarily.[38]

The larger struggle took a dramatic turn during the Martin Luther King Jr. Day march in January 2001. About a hundred of the marchers, led by Rose Sanders, left the official parade route and marched to the statue. There was a silent prayer for the black soldiers massacred by Confederates at Fort Pillow. Sanders then denounced those African American council members who had agreed to delays and compromises in the removal of the monument, accusing them of having "voted with the enemy," and she invited group members either to return to the parade or to help her fasten a rope to the monument and topple it. As it happened, the monument was too heavy to move, but Sanders promised to return every day until she brought enough supporters to overturn it.[39]

These events seem finally to have stirred the city council to act. In mid-February Mayor Perkins offered again to move the Forrest monument inside the Smitherman Building or to relocate it to the battle site at Riverview Park, to be renamed "Heritage Memorial Park." The mayor, members of the council, and representatives of the Friends of Forrest visited the proposed site,

where Perkins and FoF spokesman Benny Austin had a heated argument over the "fairness" of moving the statue at all. After Perkins left, the remainder of the group visited Old Live Oak Cemetery. There Councilwoman Jean Martin told the Friends of Forrest that she had "a list of 53 bankers and businessmen who want this thing put in the cemetery and let it be done." She argued that the new location would increase the cemetery's appeal as a tourist attraction and put Forrest in the company of other memorialized Confederate leaders and soldiers buried there. The next day, February 27, the council voted five to four to move the statue to the cemetery, and the deed was soon done. The FoF filed suit in US District Court in Mobile seeking to force the city to return the monument to the grounds of the Smitherman Building (by then known as the Vaughn-Smitherman Museum). The suit was dismissed by the Eleventh Circuit Court of Appeals in October 2003.[40]

The public discussion that colored the city council's decision was carried out in two registers. One engaged a fairly small number of black and white antagonists who were active in city politics and who debated the significance of erecting a monument to Forrest in a majority-black city just as the first African American mayor took office. The activists' conflicts addressed the nature of commemoration and of symbolic meaning, although neither side framed it explicitly in that manner. This discussion in turn reflected broader interpretations of the history of Selma since 1965 and had to do with symbolic and everyday power to control the city's destiny.

Rose Sanders led the opposition to the Forrest monument, objecting not only to its site but to its very existence. For Sanders and her allies, Forrest's actions at Selma were one with his broader role in Southern history. He was a man whose entire career, most of which harmed African Americans, was inseparable from any honor extended to his memory. Even the Confederate battle flag on the monument, in the eyes of Clarence Williams, chair of the local chapter of the Southern Christian Leadership Conference, "represents white supremacy, and as long as it's that way, [he was] against" the monument. It was a "shame," Touré told me, that such a thing could be found on the "sacred ground" of Selma.[41]

For the Friends of Forrest, the general's actions outside Selma were irrelevant to the monument, which "honors nothing but Forrest's military achievements and his defense of Selma" from (as one letter writer put it) "a murdering, thieving horde of yankee socialist[s]." One might reasonably ask whether Selma's Civil War era black residents wanted the city and its Confederate armory to be "defended."[42]

This narrow interpretation of the monument lay at the heart of the Friends of Forrest's strategy: everything they asserted was factual, "true" history that could be correctly interpreted in only one way. In the simplest version of the argument, the monument to Forrest was simply an acknowledgment of something that had happened, so that to commemorate other aspects of Selma's history—the civil rights movement was the invariable example—without commemorating Forrest and the Civil War was to distort history. "The question is whether we are going to let history be history regardless of its content," wrote the author of one letter to the editor. To some of the monument's supporters among the public at large, the monument itself became "correct history" as soon as it was erected and was thus sacrosanct.[43]

The attempt to circumscribe meaning surfaced in another way. Forrest was described on the pedestal as the "Wizard of the Saddle." Opponents, naturally, read this as a veiled reference to his role in the Ku Klux Klan, and they singled it out for scrutiny by the committee appointed to certify historical truthfulness. Pat Godwin asserted that this was simply a tribute to Forrest's horsemanship. Yet she was known to sign her e-mails "Wizardess," which suggests that the monument's opponents had understood the inscription's intent correctly.[44]

In fact, the Friends of Forrest exhibited a remarkably postmodern understanding of the malleability of language that served them well in the debate. The diction of the monument's inscription and of the group's public statements was skillfully composed to facilitate both implication and deniability. Their statements implied their message, but in words that allowed the apparent meaning to be disavowed when convenient. Those who listened carefully, particularly those who inquired closely about the origins of the language and arguments the FoF employed, could not be confused. The FoF constantly described the city's actions as discriminatory and violations of civil rights by attacking "the integrity of the Confederate heritage." "This issue is much larger than our attempt to erect a monument," said FoF spokesman Benny Austin. "There is a 14th Amendment issue here." The FoF appeal to the Fourteenth Amendment, a Reconstruction era measure intended to protect the civil rights of newly freed African Americans in a South determined to curtail them, and the organization's framing of its position in terms of civil rights in general was intended to frame "Confederate (or white Southern) Americans" as a racial category deserving of protection. This was the gist of a letter from the group's attorney, Charles E. Yow, to Selma city attorney Jimmy Nunn: "The

threatened action [to move the monument] poses serious constitutional questions surrounding the non-race neutral motivation of the proposed action." Supporters of the Forrest monument picked up the theme, denouncing attacks on Confederate monuments as "hate crimes" and as "the ethnic cleansing of our Southern History and Heritage."[45]

These racial arguments are grounded in the white nationalist allegiances of the Friends of Forrest. In 2000, both Godwin and Williamson were members of the League of the South, a neo-Confederate group founded in 1994. The league espouses a philosophy of social organicism, localism, and agrarianism similar to that of the Southern Agrarians of the 1930s. But it also advocates Southern secession from the United States, as well as "the cultural, social, economic, and political well-being and independence of the Southern people." League president J. Michael Hill told his followers that "we here in the South are a people." Specifically, Southerners are descendants of "the Anglo-Celtic peoples ... [who] gave [the South] its dominate [sic] culture and civilisation. Should this core be destroyed or displaced the South would be made over in an alien image."[46]

Following this logic, Godwin explained to a group of visitors to Selma, neither blacks nor non-Southern whites belong to or contribute to Southern culture but are actively subverting it. In the view of the league, the South suffers under a "society imposed upon it by an alien occupier. American society today is egalitarian and Marxist." While neo-Confederates bemoan "multiculturalism," they have mastered the pluralist, relativist language of tolerance and ethnic victimization in their public statements. In equating the perceived oppression of white Southerners with that of African Americans, appeals to "tolerance" are meant to argue that white Southerners and blacks can live together harmoniously. Indeed, the League of the South "disavows a spirit of malice and extends an offer of good will and cooperation to Southern blacks in areas where we can work together as Christians to make life better for all people in the South," even though "historically the interests of Southern blacks and whites have been in part antagonistic."[47]

The nature of black participation in such a society is left to the imagination, but the league, whose official statements employ implication and deniability in an even more sophisticated manner than the Friends of Forrest's, has carefully thought the matter through. According to league president Hill, the group seeks a social system "based on kith and kin rather than an impersonal state wedded to the idea of the universal rights of man. At its core is a European population." Its vision "is structured upon the Biblical notion of

hierarchy. In short, a recognition of the natural societal order of superiors and subordinates." These words read very much like those of white supremacists of the turn of the twentieth century, who argued that blacks were happiest and functioned best under white tutelage. They also mesh somewhat uncomfortably with the league's current constituency. Originally founded as an intellectual and patrician organization, the league has become increasingly radicalized in its politics and working class in its makeup. Grady McWhiney, a historian who was among the league's founders, is said to have resigned when the organization was taken over by the "dirty fingernail crowd," as did Cecil Williamson, a key member of the FoF, who says that he left the league in 2001.[48]

In less public statements, the league's racial views are more openly expressed. They see the civil rights movement as a "second reconstruction" that paved the way for the South's subjection to "the interests of international business and banking." League cofounder Jack Kershaw observed, "Somebody needs to say a good word for slavery," and Hill raised the specter of a South "overrun by hordes of non-white immigrants." To Hill, these views are not racist but "natural" ethnocentricism.[49]

The Friends of Forrest linked their web site to those of the League of the South and the Southern Independence Party. In communications among neo-Confederates, the victim pose is abandoned. In 2004, the FoF paid to erect two billboards on the Selma-Montgomery road, billboards that remained visible through 2006 (fig. 15). One, about eight miles outside town, invited visitors, on behalf of the FoF, to see Selma's "War Between The States Historic Sites," while the second, posted on the Montgomery side of the Edmund Pettus Bridge just outside Selma, thanked visitors for doing so. This second sign looked down on a small, informal park marking the site of the Bloody Sunday attack of March 7, 1965, on civil rights marchers. Both billboards featured a painting by Lafayette Ragsdale depicting Forrest on his horse King Philip. Beneath the images was the phrase "Keep the Skeer on 'Em," which Forrest reportedly advised his men after defeating a larger Union force at Brice's Crossroads, Mississippi, in 1864. The phrase has been widely quoted in recent years by neo-Confederates, survivalists, and other extreme rightists. The full pronouncement, according to Ragsdale's web site, was "Git 'em skeered, and then keep the skeer on 'em." There could be little doubt about the pronoun's antecedent in Selma.

There was one difference between the billboards. On the welcome sign, the Confederate battle flag formed a washed-out, watermark-style background

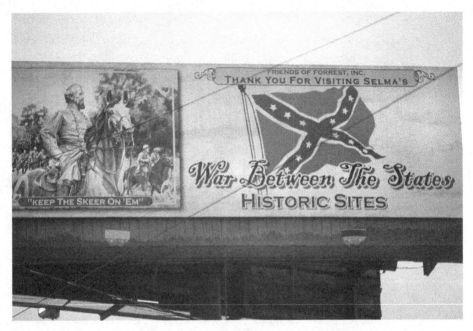

Fig. 15. Friends of Forrest billboard (2004), Selma, Alabama. Photo: Dell Upton.

for the text and image, whereas at the bridge the billboard featured the Confederate battle flag prominently. "I just know our lovely mayor [Perkins] and his Siamese twin (Rose [Sanders]) are just going to love it!!!" Godwin wrote in an e-mail posted on the Southern Independence Party web site. "THINGS ARE CERTAINLY LOOKIN' BETTER IN ZIMBABWE ON DE ALABAMY!"[50]

The neo-Confederate views and racism of the Friends of Forrest alienated some potential allies. Early in the debate over the monument, the United Daughters of the Confederacy wrote to Mayor Perkins "denouncing any direct involvement in this project as an organization." Even though Pat Godwin argued that the UDC—*her* local chapter—*had* supported the project, Benny Austin explained more forthrightly that there was disagreement in the UDC "about whether there was a vote" on the project. Austin's statement reflected a growing rift in Confederate filiopietistic organizations such as the UDC and the SCV. Some members adhered to the groups' stated mission of honoring the memories of ancestors, while a newer cohort of hard-line rightists, some associated with the League of the South and others with the Council of Conservative Citizens, the successor of the [White] Citizens' Council, wished to carry the group in a more openly political direction. Less militant members of the two descendants' societies believed that the new strategy was racist.[51]

A second, successful line of argument by the Friends of Forrest shifted the discussion from specifics to abstractions. By playing to popular ideas of the innocuously positive value of heritage and of the objectivity of history, they were able to avoid intense scrutiny of the particular heritage they claimed. The Civil War and the Battle of Selma were "history," and to remove the Forrest monument constituted revision or censorship of "true history." This struck a chord. In announcing his determination that the statue would be moved, Perkins said that he would form a committee "to form the necessary authentication of the history, and [to ensure] that the language be both balanced and factual." Months later, after the decision was made to move the statue, Councilwoman Bennie Ruth Crenshaw, a vocal black activist, again "asked that a committee be formed to authenticate controversial wording on the statue."[52]

Neither side distinguished historical events from their commemoration, although some difference was implied in Mayor Perkins's statements. Early in the battle over the Forrest monument, he reiterated that it "is a representation of the past" and urged citizens "not to let our personal feelings about this situation destroy the fabric of unity and tolerance that the city needs to move ahead. 'Images of our past belong in museums, [and] museums should also be held to truthful accounts of our history.'" This would facilitate the construction of the political regime he needed to govern successfully. In his inaugural address, Perkins urged that both the Civil War and the civil rights movement be relegated to museums, rather than allowing them to continue to color the city's political life.[53]

By their success in positioning the Forrest monument as simple history and an expression of heritage that was above scrutiny, the Friends of Forrest were able to shift debate outside the circle of activists to a different register that centered on their basic right to erect any monument. This was the frame in which many residents of Selma, black and white, engaged the controversy. Ethel Smith, a black woman who lived near the Smitherman Building, told a reporter, "You (Friends of Forrest) have a right to a statue, [but] not in this neighborhood. . . . It's an insult to see this statue everyday. . . . It's a nice statue, but it doesn't belong here." She then placed a black paper bag over Forrest's head.[54]

As was clear in the defacement of the Montgomery Confederate memorial, the underlying assumption was that civil rights is a "black" issue and the Confederacy is a "white" one. Both supporters and opponents of the Forrest monument operated on this premise. "I think it is a crying shame that the

white race is not allowed to have any of their heritage shown anywhere, yet the black race can and do put anything they want, anywhere that pertains to their heritage," wrote one newspaper correspondent. "My opinion is that it's their heritage, they have a right to it just as we have a right to ours," Eva Cunningham, an African American woman, told a reporter. One black opponent suggested, perhaps with a touch of irony, that the monument be moved to the white-dominated country club or to the site of the Battle of Selma (which Forrest lost). Certainly the choice of Nathan Bedford Forrest as honoree emphasized this racial assumption. Historically, Forrest has been a favorite subject of white supremacist commemoration in the South. The concept of dual heritage allowed these citizens to see the Forrest monument and the Selma monuments to Martin Luther King Jr. and James Reeb, a Unitarian minister murdered in Selma during the 1965 protests, as complements, an equivalence that the Friends of Forrest argued in their legal suit and public statements. If there could be a National Voting Rights Museum detailing the history of the civil rights movement in Selma, why could there not be a monument to a Confederate general?[55]

In March 2012, the Forrest bust was stolen, and it was never recovered. The Friends of Forrest began to prepare the site for a new, larger monument, but the work was halted by the city. Again, the controversy focused officially on legalities rather than on the suitability of such a monument for a twenty-first-century, racially mixed city. In 1877, Selma's city council gave the site of the Confederate monument in Old Live Oak Cemetery to the Confederate Memorial Association, but it failed to confirm the grant by deed. Did the CMA's successor, the United Daughters of the Confederacy, now legally own the land where the Forrest monument stood? Eventually the courts ruled that the city had violated the construction company's right to due process. The city deeded an acre of cemetery land to the UDC.[56]

The conflict over the Nathan Bedford Forrest memorial draws together many of the threads of monument building and commemoration in the contemporary South. These memorials are always created in the context of, and conditioned by, evolving local politics in the post–civil rights South. But the Confederate monuments illustrate the continued vitality of white supremacist interpretations of the Civil War and Reconstruction. In the past thirty years, white supremacism has been cloaked in the more neutral armor of heritage, history, military valor, and the veneration of ancestors, which deters the open examination of its premises. Those who challenge it explicitly can be deflected by the language of implication and deniability and painted, as Faya

Rose Touré (Rose Sanders) has been in Selma, as radical, even unbalanced. At the same time these meanings and implications are also permeated by the culture of personalism in the South—by the way that personal relationships deflect attention from structural issues, as they have since slavery times, when the "peculiar institution" was defended in terms of mythical personal relationships between slaves and masters. White supremacy is thus the white elephant in the room that civil rights memorial builders must tread carefully around.

Despite the blatantly racist nature of the Forrest monument, the organizers felt compelled to cloak it in the protective veneer of heritage. In most instances, though, that veneer has to be much thicker and the white supremacist foundations of Confederate "heritage" vehemently denied, as at the so-called Liberty Monument in New Orleans. The memorial commemorates the Crescent City White League's insurrection against the elected mixed-race government of the city and state in 1874. New Orleans's Civil War history was more ambiguous than Montgomery's or Selma's. While Montgomery could call itself the "Cradle of the Confederacy," the place where Jefferson Davis was first inaugurated, and Selma was home to one of the rebel government's major arsenals, New Orleans was captured early in the war and treasonous sentiments were quickly suppressed. Nevertheless, the city established one of the first Confederate museums and erected one of the grandest Confederate monuments to honor Robert E. Lee.[57]

Frustrated Confederate sympathizers actively opposed federal efforts to reconstruct Louisiana's political and social structure as soon as they could. In 1866, a white mob attacked black attendees at a constitutional convention in New Orleans, an early example of the violence that was the whites' preferred tactic in what one newspaper referred to as a "war of the races." These conflicts culminated in 1874 with the organization of the White League, which was determined, its platform said, to maintain "our hereditary civilization and Christianity menaced by a stupid Africanization, . . . [and] to re-establish a white man's government in the city and State." The league terrorized rural African Americans and Republicans and murdered several Republican officials upstate. On September 14, 1874, 3,500 members of the Crescent City White League, formerly the Crescent City Democratic Club, attacked a force of black militiamen and Metropolitan Police commanded by former Confederate general James Longstreet and drove them from the field, leaving eleven Metropolitan Policemen and sixteen White Leaguers dead. The insurrectionists removed

the governor and other elected state officials from office and installed the unsuccessful Democratic candidates. On September 19, federal troops restored the elected government briefly to power.[58]

New Orleans's white elite liked to think that the fifteen-minute confrontation had "liberated" Louisiana for home rule, meaning for rule by elite whites. The league's modern apologist, Stuart O. Landry, compared the affray to the Battle of Concord Bridge and the Battle of New Orleans. The uprising, he said, "changed the tide of opinion, brought the end of Reconstruction in the South, and started the Southern people on their way to the great prosperity which they now enjoy." September 14 became a rallying cry for New Orleans's powerful whites. The ground around the Henry Clay statue, where the White Leaguers had gathered on the violent day, was renamed Liberty Place in 1882. As former White Leaguers and their progeny struggled with the immigrant-dominated Democratic machine, they periodically met at Liberty Place to launch vigilante actions. In 1891, one of these, organized by veterans of September 14, led to the lynching of eleven Sicilian immigrants who had been acquitted of murdering the police chief. That same year a monument was dedicated on the anniversary of the 1874 confrontation (fig. 16). A granite obelisk, embellished only with a wreath, stood on a multi-stage base that bore the words "September 14th 1874" in block letters. On one side of the pedestal were listed the officers of each section of the White League, on the second, leaguers who "Fell in Action," on the third, officers of the First Louisiana Infantry who had led their men in support of the league, and on the fourth, "De Facto La. State Executives" and staff whom the White League had installed in office on September 14.[59]

The White League was open about its racial agenda. The group's manifesto guaranteed blacks their proper rights, but this did not mean the same rights as whites. As one member acknowledged, "The name White League was assumed as a protest against the unification humbug," referring to a movement among some conservatives to reach political accommodation with African Americans to promote economic development and political peace. The *Weekly Louisianian,* an African American newspaper, wrote that "the 14th of September must always be a red flag shaken in our faces." The city was eventually inspired to reinforce the monument's message with new inscriptions. On September 14, 1932, "the 58th anniversary of [the] pitched battle between an outraged citizenry and Yankee-hired police," Mayor T. Semmes Walmsley laid a wreath of white carnations at the monument and announced that he would sponsor an ordinance to turn the care of the monument over

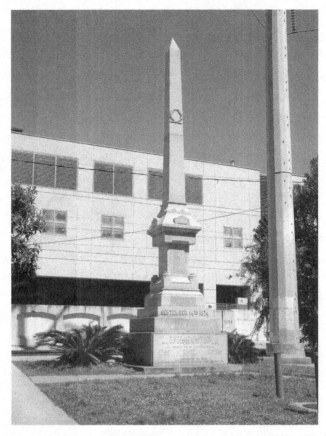

Fig. 16. Monument to the Crescent City White League insurrection of 1874 ("Liberty Monument") (1891), New Orleans, Louisiana. Photo: Dell Upton.

to a new Liberty Place Commission, "whose 28 members are descendants of men who fought for white supremacy." At this ceremony, "those making their yearly pilgrimage . . . read for the first time the names not only of those who died in conflict but also the names of the leaders in the battle and brief statements of what the day's struggle accomplished." The account of "what the struggle accomplished," contained in the new inscriptions, was not quoted in the newspaper. One said that "McEnry and Penn having been duly elected governor and lieutenant governor by the white people, were duly installed by the overthrow of carpetbag government ousting the usurpers, Gov. Kellog (White) Lieut. Gov. Antoine. (Colored)." A second inscription added that "United States troops took over the state government and reinstated the usurpers but the national election November 1876 recognized white supremacy and gave us back our state."[60]

Following Walmsley's announcement, S. A. Trufant Sr., a veteran of the battle and head of the committee that composed the new text, laid a wreath of white chrysanthemums in the name of the White League. Then the Ladies' Confederate Memorial Association, a sister organization of that in Alabama and others across the South, placed crossed palm leaves at the four corners of the monument, as was their "yearly custom." Other tributes were offered by the various chapters of the UDC and the Junior Confederate Memorial Association.[61]

The conflation of Liberty Place and the Confederacy, or rather the battle's role as a surrogate for New Orleans's nonexistent Confederate glory, was reinforced the next spring when the council passed an ordinance creating a board of commissioners for Liberty Place. In its initial form the ordinance directed that the appointees be selected from "the men and women of the Confederacy or from the sons and daughters or grandsons and granddaughters of those who fought in the Confederacy on the Confederate side." The act was soon amended to specify that members were to be chosen from among "citizens who took part in the battle for white supremacy at Liberty Place . . . or descendents of such citizens."[62]

Through the middle of the twentieth century, the monument was both a place of reverence for New Orleans's elite, many of whose ancestors had participated in the events of September 14, 1874, and a rallying point for white supremacists. The 1949 anniversary commemoration, for example, featured Dixiecrat Frank M. Dixon, the former governor of Alabama, who compared the Battle of Liberty Place with the modern states' rights movement and "criticized advocates of housing controls, public housing, socialized medicine and social security 'from cradle to grave.'" Local congressman F. Edward Hebert added that "it is one of history's tragedies that we are gathered here at a time when the ideals for which the men of 1874 fought are being viciously attacked again on all fronts."[63]

The white press did not bother to report African American reactions to the monument until the 1970s, when many New Orleans blacks and some whites began to press for its removal. Defenders of the monument attempted to dissociate it from white supremacy, arguing that the racist inscriptions were added in 1932 and had nothing to do with the monument's original intent or with the battle's goals of ending corruption and reclaiming home rule. This argument required a narrow reading of the history of the White League and its monument. White supremacy was not mentioned in the 1882 ordinance authorizing the monument, nor did it appear in Stuart O. Landry's 1955

history, which most took to be authoritative. Landry's book, however, was an apology for the White League that studiously avoided quoting any of its white supremacist passages, including the passage in the league's platform that presented corruption as a black attribute arising from having been elevated to political office without qualifications: "their increasing arrogance, which seems to know no bounds; their increasing dishonesty, which they regard as statesmanly virtue; their contemptuous scorn of all the rights of the white man." According to the league and its supporters, these ills arose from the Reconstruction government's enfranchisement of blacks through Louisiana's 1864 constitution and from the machinations of Republican "carpetbaggers." To the White League and its supporters, these assumptions were matters of white common sense that needed no explicit statement. By 1932, in the aftermath of the increased racial paranoia and apartheid practices of the early years of the century, they did, perhaps, need to be emphasized, although Dixiecrat Dixon's 1949 audience certainly understood the subtext. By the time Landry wrote his history, as the demand for black rights grew louder, it was less politic to recall the racial underpinnings of the battle of September 14, even though Louisiana's legislature was a hotbed of white supremacist resistance to change. So although Landry emphasized black depredations during Reconstruction, he blamed these on the federal government—not coincidentally the villain in the struggles of the 1950s as well. The elisions of the White Leaguers and of Landry allowed monument defenders to blame the 1932 Mayor and Monument Commission for perverting the original intent of the monument. "It is regrettable that the noble purpose of this monument has been contravened by association with statements about white supremacy, states' rights and segregation," according to the anonymous author of a 1970s manifesto "To Restore the Monument of Liberty Place to Its Original Intent." The monument "by no means supports any type of racist or segregation point of view," wrote one correspondent to the *Times-Picayune*. An interpretation closer to that of the White League and its original memorializers was offered by William E. Theodore of Metairie. After affirming the traditional neo-Confederate dogma that "slavery was never truly the issue behind the Civil War," Theodore wrote that "the Reconstruction Period was a criminal conspiracy to destroy the Southern Christian, white property owner. . . . Illiterate Negroes were rounded up by the military occupying forces and compelled to register and vote. The black rule of the Southern states was absolute. In state after state there was no white man in office, the policeman, the judge, the jailer, the jury was composed of black men who looted the state treasury."[64]

What should be done about this white supremacist monument? While its supporters argued unequivocally that nothing should be done, that "like the Confederate flag, it's all part of our history, like it or not," even some who objected to the message supported leaving the monument in place as a history lesson. A letter writer who identified himself as a young black man opposed to white supremacy argued that the monument should stand as "a constant reminder of what can happen if blacks should become zeal-less in their efforts to gain and keep the rights that so many have paid the price for." A spokesman for the administration of Mayor Moon Landrieu told Councilman Frank Friedler that Landrieu did not believe he had the authority to remove the monument although "it serves as a constant reminder of the racism that once plagued this city, and the progress that has been made to eradicate it." To make the mayor's point, the city attached a plaque to the monument in 1974, when the controversy erupted, declaring that "although the Battle of Liberty Place and this monument are important parts of New Orleans' history, the sentiments in favor of white supremacy expressed thereon are contrary to the philosophy and beliefs of present day New Orleans." Shrubbery was planted around the base of the monument to hide its racist text.[65]

Yet local and national leaders of the National Association for the Advancement of Colored People were now determined that the monument should go, arguing that it celebrated not only white supremacy and the suppression of African American rights but also "the killing of police [and that it] supports armed violence," aspects of the battle that conservative supporters of the monument ignored. Disappointed that nothing had been done, the president and adviser of the New Orleans branch of the NAACP Youth Council assured Councilman Friedler in 1976 that the organization would continue to press for the removal. The *Times-Picayune* supported Landrieu's decision to install a plaque that "would clearly present [the monument] as a historical exhibit, not an expression of active community policy or feeling." But in the light of the contemporary survival of racism, "the black community can understandably take the monument as a public affront that preserves or promotes the sentiments of the earlier time" and "can judge the monument the record of a downturn in their progress of recognition." Consequently, the editors advised, the best course would be to put it into storage or into a museum that would make clear its "fossil character . . . until enough time and generations have passed to thoroughly neutralize it."[66]

The issue flared up again during the administration of Ernest "Dutch" Morial, New Orleans's first black mayor. In early 1981, Morial made a series

of symbolic gestures, including proposals to rename a major street after A. P. Tureaud Sr., a prominent civil rights attorney who had recently died, to erect a monument to Martin Luther King Jr., and to remove the Liberty Monument. Political insiders of both races interpreted Morial's actions as efforts to repair his fraying relationship with black voters in anticipation of his 1981 reelection bid. Two years into his first term, growing black discontent with Morial had been exacerbated by an incident in the Fischer housing project in Algiers, a poor neighborhood on the west bank of the Mississippi River. In retaliation for the shooting of a white officer by an unknown assailant, New Orleans police rampaged through the project for a week, culminating in a violent raid in which police raided two apartments and killed the four people who lived in them. Ultimately seven officers were charged in the killings and three were convicted. At the beginning of 1981, however, not much progress had been made, and Morial was under pressure to respond to black concerns.[67]

The mayor put the removal project out to bid without informing city council or the newspapers. He hoped that he could make the monument disappear quietly into a city-owned warehouse, a step that his predecessor, Moon Landrieu, regretted not having taken when the memorial had been removed temporarily for repairs a few years earlier. Word got out and protests began. Some of the same Confederate and White League nostalgia that characterized earlier controversies over the monument was heard again. One letter writer argued that if the Liberty Monument was removed, then so should "plaques, etc., to the Emancipation Proclamation . . . because to some this historic act was a bitter pill to swallow." Another said that the marker "allows us to recognize and remember a real and cherished part of the South's history." However, this writer argued that the monument opponents' motto was "'Damn free speech for white people.'" A similar paranoia gripped a letter writer who thought the city was careening down a slope that began with changing the name of a high school team from the Rebels, continued with renaming Melpomene Street Martin Luther King Boulevard, and gained speed with the proposed disposal of the Liberty Monument. He feared that the next steps would be to remove the statues of Generals Robert E. Lee and P. G. T. Beauregard and US Supreme Court Justice Edward Douglass White (whom he called William Douglass White) "and then change the name of White Street to Black Street." Like his White League predecessors, this correspondent saw the newly elected black city administration as an antiwhite cabal.[68]

The most striking aspect of the 1981 episode, even compared with that of the mid-1970s, was that this time few bothered to assert the "true" meaning

of the Battle of Liberty Place. The only exceptions were two White League descendants, the only members of the traditional elite to weigh in publicly in the post–civil rights debates over the monument. Betty Wisdom wrote to support Morial's decision to remove it. The White League, she said, "was nothing to be proud of." It had committed terrorist acts throughout Louisiana, and its monument in New Orleans commemorated "the slaughter of policemen." Another White League descendant, J. W. Frankenbush, wrote to "refute" Wisdom's letter, citing Landry's book to argue that the battle "was the culmination of excesses and illegalities perpetuated by the carpetbag rulers of Louisiana who were place in power by federal bayonets and voting irregularities."[69]

Now the meaning and historical interpretation of the events of 1874 were of less importance than the simple fact that the events had occurred. The Battle of Liberty Place and the White League were "history," and as such they could not be changed. History is factual, transparent, true. Often the monument itself was included under that rubric: it was neither a reminder of history nor a celebration of history but history itself. Morial argued that the Liberty Monument was "not of sufficient historical value to warrant its position at the present site . . . as a source of divisiveness within our community," while Betty Wisdom challenged its historical value altogether:

> Nothing is a "part of history" unless it truthfully represents that history. The White League monument does not do that. Perhaps those who want it retained would consent if a new plaque were affixed saying it was a memorial to whites who assaulted a police force led by a former Confederate general and that what that assault accomplished was an increase of racial hatred on both sides. It decided nothing else. . . . Take the monument down, for it represents a lie, no matter how unwilling we are to admit it. The Confederacy lost. It deserved to lose.[70]

African American judge Israel M. Augustine Jr. took a slightly different tack: it was a question, not of whether the history was correct, but of whether it was positive. "If it's negative history, it ought to be removed," he said at the dedication of the Martin Luther King memorial. "If we had a statue that represented black folks who preached violence and hatred it should be removed."[71]

Augustine pointed to the central theme of the 1981 discussion. All agreed that the monument was a lesson, and most conceded that, either originally or as a product of the 1932 additions, it celebrated white supremacy. Could it still have public value? The editors of the *Times-Picayune* and many letter writers argued that it did. "The fact that it is there reminds us of something about our city's past from which we can profit. . . . [White supremacy] is an unfortunate

chapter in the history of this country, but a part of history nonetheless." Felix Paul, an African American visitor, agreed that the monument was valuable to all locals and visitors and "should remind young black people of our long and arduous struggle for freedom and equality . . . [and] remind young white people of their vainglorious past." Yale historian Robin Winks said that to destroy the monument would constitute an Orwellian revision of history, while to leave it in place offered a daily insult to black citizens. He proposed moving the monument to a museum. Perhaps the most bizarre suggestion called for moving the monument to a site adjacent to the new Martin Luther King memorial, as its complement, to "remind everyone that this skirmish was fought for all who believe in equality above a life of oppression."[72]

Most correspondents who identified themselves as black, however, agreed with Judge Washington that the monument was offensive. M. D. Smith ridiculed the idea that it could be a marker of how far New Orleans had progressed. Why not bring back "White" and "Black" signs on public spaces or reinstitute segregation altogether to remind people of the sins of the past? "Only after the grinding up of the 'white supremacy' monument and the prosecution and conviction, if warranted, of those responsible for the Algiers killings can we begin to talk about 'our progress in human relations,'" Smith argued. "If white people need these reminders of our repugnant past," added Valward Marcelin, "then erect them in your churches and synagogues." The Reverend Horace Dyer made the distinction, rarely heard in any of these debates over monuments, that there was a difference between knowing about historical events and commemorating or celebrating them. "This memorializes one of those moments in history we citizens of New Orleans would rather not be reminded of or see re-emphasized," he wrote.[73]

In addition to those who framed the monument as a history lesson, others began to raise the issue of heritage. The implication was that although history is debatable, heritage is not: it is the possession of a particular group of people who define its content and cling to it as a part of their identity that cannot be challenged but must be respected at all costs. In this way the issue of dual heritage was injected into the discussion in a manner that allowed white supporters of the monument to evade the question of the nature and meaning of September 14, 1874, and the White League or of their implications for contemporary civil society. State legislator David Duke, an ousted Ku Klux Klan leader who brought six members of his National Association for the Advancement of White People to demonstrate at the monument, first raised the issue. "We're just trying to protect our heritage and preserve a part of history,"

Duke said in a demonstration at the monument in early January 1981. Oddly, Duke likened the threatened removal of the Liberty Monument to the destruction of monuments to the recently deposed shah of Iran by revolutionaries.[74]

The mayor and the council, then, were presented with a dilemma similar to that faced by Selma's city council. The monument stood on public ground and it was city property. The city council had authorized its construction in 1882. City officials had presided over anniversaries of September 14 many times over the preceding century. The city performed the day-to-day task of maintaining the site, and at least twice, in the 1950s and 1970s, it had removed the monument for repair. Was this a proper use of city funds?

More important, what about the monument's message and the city's role in propagating it? Although monument advocates often raised the issue of free speech, no one proposed suppressing anyone's right to speak. Few people objected to the monument's standing on private land or to its being placed in a museum. Rather, the issue was what speech, if any, public authorities should promote. Should the White League monument be held forth by the city as either a positive or a negative lesson? If it were to remain, how should it be presented?[75]

African Americans, an increasingly vocal political constituency in New Orleans, were almost unanimously against continuing to display the monument on city land. An equally outspoken group of whites wanted to retain it, and the white members of the city council acted unwaveringly on their behalf. Initially the council voted to remove all inscriptions that had been added after the original erection of the white supremacist monument. This would include not only the 1932 additions but Landrieu's apologetic 1974 plaque. Ultimately, the pro-monument council members resorted to a tactic that has since become widespread in Southern states as a way to stave off the possibility that African Americans might alter the memorial landscape: they passed an ordinance that forbade the removal without the city council's permission of any public monument that had the council had originally approved. At the same time, the council added an amendment that would allow the mayor, "with the concurrence of the council, to remove from any statue 'any wording that is demeaning or derogatory to any racial or ethnic groups.'" Jim Singleton, the councilman who proposed the amendment, also suggested that the names of those killed by the White League should be added to those of dead insurrectionists.[76]

The decision, which the *Times-Picayune* declared "a reasonable solution of a divisive controversy," was actually a double victory for supporters of the

White League monument. Not only was the monument saved, but in simply removing the "bigoted language" added in 1932, the council implicitly accepted the claim that white supremacy was an unfortunate distraction rather than intrinsic to the significance of the White League and the Battle of Liberty Place. In fact, as local columnist James Gill pointed out, "Nobody at the time would have recognized the distinction." Nor did anyone acknowledge that the monument had accumulated meanings over time, not only through the addition of the 1932 and 1974 inscriptions, but as the chosen site of commemorative rituals and public gatherings over nearly a century. Instead, the monument was assumed to have a simple, original meaning that could be separated from subsequent interpretations. The "original" meaning that the city council endorsed was the one defined by whites. So white New Orleanians' reverence for their ancestors prevailed over African American interpretations, which were better grounded in the historical record, and African American sensibilities, which most people acknowledged were legitimately offended by the monument.[77]

Less than a decade later the issue arose again. This time it received broad national coverage, although little new was said. After a struggle between the African American mayor, Sidney Barthelmy, and Peggy Wilson, a conservative white city councilwoman, the city had removed the Liberty Monument from its site—not the original site but a new one chosen in 1967 to allow the construction of the World Trade Mart at the foot of Canal Street—to permit construction in the Canal Street neutral ground (median). In 1981, when he was a councilman, Barthelmy told a reporter, "Whether that monument is removed or not, it will not change the life of anybody," but as mayor he took a different position. Now Barthelmy hoped that the monument could be left in the warehouse, but monument supporters thwarted him. Drawing on the early 1980s arguments about history and heritage, they appealed to the State Historic Preservation Office (SHPO) for support. Because the improvements to the monument's site were undertaken partly with federal funds, the SHPO had jurisdiction over historic sites in the work area. Leslie Tassin, the state historic preservation officer, extracted a promise to return the monument to a site "within the area determined to be historically appropriate to the site of the battle."[78]

The city, the SHPO, and the national Advisory Council on Historic Preservation wrangled over the monument's fate for four more years. The city agreed in 1990 to reerect the statue in May 1991 but in the meantime asked the Louisiana State Museum to take it. The museum refused. A series of deadline ex-

tensions followed, along with a suit initiated by Francis J. Shubert, a David Duke ally, seeking to force the reerection of the monument on its original site. This led to an order from the Federal District Court to pick a site by December 9, 1992, and to reerect the monument by January 20. It was finally restored to public view on February 10, 1993, after years of contention between the SHPO and the city over an acceptable site.[79]

The reinstalled monument will perplex anyone unfamiliar with its late-twentieth-century vicissitudes. It retains most of its earlier inscriptions, except that the 1932 texts explicitly celebrating white supremacy have been replaced by conspicuous, highly polished, blank marble inserts that contrast with the color and texture of the original stone. A new panel at the front of the base dedicates the monument to "those Americans on both sides of the conflict who died in the Battle of Liberty Place." It records the names of the metropolitan police who were killed, then concludes that this was "A Conflict of the Past That Should Teach Us Lessons for the Future." As with the reduction of the Civil War to an abstract exercise of duty and valor on both sides, the plaque removes all content from the events of September 14 and reduces them to an unspecified lesson. In this manner, the White League descendants' refusal to see the battle as a racialized struggle continues to be respected. Yet this was not enough for monument supporters, who saw the added inscription as an "insult." Attorneys for Shubert and for the Louisiana Landmarks Society objected to the attachment of additional inscriptions to the monument, and one correspondent, using a trope common among neo-Confederates, called the new inscription an insult "equivalent to placing a memorial to the British army to [sic] the base of the Washington Monument."[80]

The monument's siting tells a different story. The new location at the river end of Iberville Street is close to the White League monument's original site but not visible from it. It stands in a small space bounded by an enormous tourists' parking lot, the entry to a shopping mall's parking structure, and the Public Belt Railroad track. The rear of the mall and the rear of the Audubon Aquarium of the Americas, a tourist attraction built near the Mississippi River levee, overlook it. Chain-link fence surrounds the obelisk on three sides in such a manner that it appears to be inaccessible until one is quite close. In contrast to the pusillanimous inscription, the site and presentation of the monument seem to be a petulant response to the preservationists' and supremacists' legal victory. As Mayor Barthelmy's aide noted, "At least we got it somewhere out of view."[81]

The reinstallation of the monument was not the end of the struggle. Vandals quickly responded, twice covering the monument with sheets that evoked Ku Klux Klan robes, spray-painting it, and eventually knocking off one of the four corner colonnettes that bracketed the original inscription panels. (All are now gone.) On March 7, 1993, the Friends of the Liberty Monument staged a "rededication ceremony" at the new site. Again conflating the Confederacy and the 1874 battle, the ceremony began with the waving of the Confederate, Louisiana, and United States flags, followed by prayers and speeches. David Duke was the featured speaker. About forty protesters confronted the fifty attendees and scuffled with police who attempted to keep them away from the demonstration. In the struggle, the Reverend Avery Alexander, an eighty-two-year-old state representative and icon of the New Orleans civil rights struggle of the 1950s and 1960s, was dragged away in a choke hold. At the end of the day, the Friends group announced its intention to revive the September 14 ceremonies at the monument.[82]

The black-majority city council was no more willing to concede defeat. At its April 15 meeting Council President Dorothy Mae Taylor introduced an ordinance that would create a procedure for removing monuments or works of art of any sort "that honor violence or ethnic prejudice." The measure passed five to two over the opposition of three white members, one of whom ultimately voted for it. The ordinance established a series of criteria by which a monument could be assessed, including whether it " 'honors, praises or fosters' ideologies in conflict with Constitutional guarantees of equal protection, whether it has or might become the site of violent demonstrations or be regularly vandalized," and whether it would therefore become a security risk that outweighed its historical or architectural value. The council would then consult with various historical and preservation agencies and make its decision. Under the auspices of the new ordinance, the city council referred the case of the White League monument to the city's Human Relations Commission for adjudication.[83]

At two public hearings in which experts, interested parties, and members of the public at large (including some of each category, such as David Duke, who spoke at both) were invited to comment on whether the White League monument met the criteria set forth in the new law to be declared a nuisance. Historians from most of the city's universities commented, as did Tassin, by now the former state historic preservation officer, a public-school teacher, and a representative of the Louisiana Landmarks Society. Historian Lawrence Powell's "Concrete Symbol" article on the malign significance of the

monument was entered into the record, as were historian Judith Schafer's more mixed assessment and a newsletter of the South Louisiana [White] Citizens Council that averred that "The constitution of the White League . . . made no reference to 'White Supremacy,'" citing Landry's carefully edited account as evidence. The customary arguments—dual heritage, the inviolability of history, the White League's moral imperative—were rehearsed. The only surprise arose when Duke argued that the attempt to remove the monument was "Nazi-like," which provoked the rabbi who chaired the hearing to ask incredulously, "Were you condemning acts of Nazism?" Duke replied that he "freely condemn[ed] Nazism . . . Nazis are the ones that try to change history. The monument is part of our history and should be preserved."[84]

While most commenters either supported the monument's retention as an innocent symbol of valor or argued for its removal as a racist relic, the Landmarks Society representative tread a middle line, arguing that it should be left in place as the centerpiece of an "urban park for racial justice. Use it to explain, learn and remember." At the end of each hearing, the Commission took a vote of the audience. At the first, 20 people, all but one from New Orleans, wanted the monument removed. Among the 12 opponents of removal were four people from suburban Metairie, including Duke. At the second meeting, 25 people (all but two from New Orleans) voted for removal, while 17 supported its retention, including 5 from Metairie, 1 from Slidell, and 1 from Washington, D.C.[85]

The Commission concluded that the White League monument met all of the council's criteria for nuisance status. It celebrated racist ideologies, white supremacy, the denial of equal rights, and violence against established authorities, and it posed the potential for attracting violence and incurring costs that outran its historical or aesthetic value. "The stone obelisk that remains a visible symbol [of racism, white supremacy, and segregation] should enjoy no greater immunity than the [Jim Crow] laws themselves," the Commissioners concluded. "The citizens of the 1890's [sic] and 1930's were free to pick and choose their own heros [sic] and select the manner in which they were to be memorialized. The citizens of the 1990's [sic] should be free to exercise their own judgement [sic] in the same manner. Their rights are not fewer for having come later." Thus, they concluded, the White League monument should be dismantled and placed in a warehouse until a museum could be found that would accept it.[86]

Armed with the Human Rights Commission's findings, the city acted to remove the monument. City officials believed that the federal requirement

to display it did not stipulate the length of time for which it must be visible. "It wasn't intended to be a ruling for all time," said a Deputy City Attorney, who concluded that the few months between its re-erection and the Commission's report was enough to satisfy the court order. On July 15, the Council voted 6 to 1 to remove the obelisk but acknowledged that nothing would happen soon, since the city would have to consult historical and preservation agencies as stipulated in the ordinance. City attorneys then filed suit in federal court seeking a judgment allowing the city to remove the monument. The council vote and the suit defused conflicts at the revived Battle of Liberty Place ceremony in September, since opponents believed that the monument's removal was imminent. But that was not to be. In December 1993 the suit was effectively consigned to limbo when the African American judge who was hearing it recused herself on the grounds that she had participated in the 1974 demonstrations against the memorial. "I could not in good conscience sign a judgment that would allow the monument to say," Civil District Judge Yada Magee wrote. The following March, a new judge ruled on several technical motions, but there was no prospect of a trial in sight. The White League monument continues to occupy an obscure corner of New Orleans for those who care to make the effort to seek it out. They will find a battered, sad-looking column with patches in incongruous colors, visibly missing parts, and a large, ambiguously worded plaque at the base.[87]

At the White League monument, as in Selma, debate was grounded in the assumptions established by white Southerners in the late nineteenth century that de-racialized conflicts whose inescapable origins lay in racial domination and hierarchy. Ex-Confederates in the post-Civil War years worked hard to establish their interpretation as the "true" history of the Civil War and Reconstruction, an endeavor shared by the defenders of the white-supremacy monument in the late twentieth century. At that time, older arguments based on abstract claims to principle and military valor were reinforced by a new set of abstractions revolving around the immutability of "history" and the inviolability of "heritage." Some white Southerners began to claim the Confederacy and its legacy as a cultural heritage separate from, parallel to, and of equal value to African American culture, or possibly equally offensive as African American culture. At the city council meeting at which the procedure for removing monuments was enacted, Friends of Liberty Monument head Hope Lubrano argued that if the White League monument were to go, so should the monument to Martin Luther King Jr., which was " 'offensive to the white community.' "[88]

The idea of separate heritages, which had arisen in the nineteenth century when whites claimed the Confederacy as their own, was then transformed in the late twentieth century by the language of multiculturalism. Unable to ignore African American culture altogether, and tacitly acknowledging that the Confederacy was not something that blacks could embrace (despite the contradictory claim that thousands of African Americans fought for the South), African American culture was acknowledged as a second major heritage of the modern South. A few, like the South Carolina legislator who saw the civil rights movement and the Confederacy as comparable and intellectually and politically compatible struggles for freedom, sought to bridge the two. Most, however, saw it differently. They were willing to acknowledge that there were different views of the past: one supporter of the White League held out Landry's white supremacist apology as a source for the "facts" and for "Northern, Southern, white people and black peoples' sides to the story." Nevertheless, whites' interpretations of their forebears' motives and actions were not to be challenged. *History* and *heritage* were framed as content-neutral terms to deflect criticism. In this regard, the apparently objective inclusivity of historic preservation law and administration served, usually inadvertently but occasionally intentionally, to bolster the monument supporters' case. It allowed a political problem—the question of which aspects of history deserved the public celebration and official approbation implied by display on public land—to be deflected by legal technicalities. This is the climate within which civil rights and African American history memorials are created.[89]

CHAPTER 2 **ACCENTUATE THE POSITIVE**

Monuments are supposed to inspire.

> —DOW HARRIS, AT THE UNVEILING OF THE SAVANNAH AFRICAN AMERICAN
> MONUMENT, JULY 27, 2002

In the past half century, Caroline County, a rural county in northeastern Virginia, has been drawn into the orbits of Washington, DC, and Richmond. Only 1.4 percent of the working population now farms in a county that was once primarily devoted to agriculture. The largest segment of employed people—33 percent—work for the many government agencies in Richmond and Washington. The population reached just under 30,000 in 2010, the largest it had ever been, and it has grown rapidly, by 15 percent in the 1990s and 29 percent in the 2000s. This marked a dramatic reversal over the first half of the twentieth century. In 1950, after decades of steady population loss, Caroline reached its lowest recorded population since the United States Census began in 1790, bottoming out at 12,471.[1]

As the population grew, its racial composition changed. Caroline was once a majority-black county, but by 2000 whites comprised 56 percent of its 22,000 people. In that year members of the county's newly appointed Tourism Advisory Committee proposed a monument for the courthouse lawn that would celebrate Caroline's rich African American history. As often happens, the commemorative impulse was linked to economic development concerns. If the Tourism Corporation of Virginia were to accredit the county, it would receive increased state support for tourism, and the Tourism Corporation was known to be interested in promoting Virginia's African American past. But the Caroline committee members were also genuinely interested in local black history, and they persevered in their quest ardently enough that the county abolished the committee after three eventful months of official and public conflict over the monument's inscription.[2]

The proposed design was modest. Two sides of a four-sided stone of undetermined shape would recount events in the county's African American past, one focusing specifically on Gabriel's Rebellion, an abortive slave uprising that was to have occurred in Caroline and other parts of Tidewater Virginia (although organized in Henrico County) in August 1800. A third side would be devoted to the 1959 conviction of Mildred Jeter, a woman of mixed black and Native American descent, and Richard Loving, a white man, for violating Virginia's Racial Integrity Act of 1924 by marrying. The Caroline County Circuit Court expelled them from Virginia for twenty-five years under threat of imprisonment. The Lovings' conviction was overturned by the US Supreme Court in 1967, a decision that struck down laws against "miscegenation" nationally. The fourth side of the proposed monument would remain blank, available to commemorate future events.[3]

Almost immediately, longtime county residents voiced objections to the proposed monument. The inclusion of the Lovings provoked the first resistance. "We learned that there were some folks, black and white, who did not agree with interracial marriage, and that at this moment in history we were not prepared to jeopardize the entire project to argue that point," said Stan Beason, one of the monument's prime movers. One conspicuous opponent was Garnett Brooks, who told a reporter that the monument would "divide the county. There's going to be a race riot." Brooks was the sheriff in 1958, when he was "glad" to obey the county commonwealth's attorney's request to raid the couple's home and arrest them for violating "the peace and dignity of the Commonwealth." "I was acting according to the law at the time, and I still think it should be on the books," he told a reporter on the twenty-fifth anniversary of the Supreme Court decision. According to some accounts, Brooks threatened to shoot Beason for wishing to honor the Lovings. The county supervisors decided to place a plaque commemorating the decision in the courtroom in which the Lovings had been convicted. Brooks opposed that as well.[4]

The Lovings were shunted aside more easily than Gabriel, whose proposed inclusion on the monument sparked a debate that lasted from October to December of 2000. Gabriel, a trained blacksmith and a literate man, was born near Richmond in 1776 and enslaved to Thomas Prosser. Inspired by the rhetoric of the American revolutionary era and the example of Haiti's revolution, Gabriel planned an uprising against the merchants of central Virginia. An ill-timed storm prevented the revolution from beginning, and the plan was betrayed by a slave who had refused to participate. Gabriel and nearly

thirty other men, free and enslaved, including five from Caroline County, were hanged.[5]

Both Thomas Jefferson and James Monroe were discomfited by the execution of men seeking freedom. "The other states and the world at large will forever condemn us if we indulge a principle of revenge, or go one step beyond absolute necessity," Jefferson told Monroe, who was then governor of Virginia. "They cannot lose sight of the rights of the two parties, and the object of the unsuccessful one." The Caroline County Board of Supervisors was similarly nonplussed. While the most vocal county residents—those who attended and spoke at two hearings, as well as writers of letters to the editor and the editors of the Fredericksburg *Free Lance-Star,* the largest newspaper in the region—supported the inclusion of Gabriel, the county's supervisors voted four to one against it on November 16, 2000. All of the board's whites voted no, although one said that he supported the idea but didn't want the project to be abandoned altogether in the face of demands for Gabriel's inclusion. But the spokesman for the anti-Gabriel majority throughout the controversy was Calvin B. Taylor Jr., a junior high school vice principal, a Democrat, and an African American supervisor serving a majority white district.[6]

The proponents initially argued on the standard grounds of historical truth, or the "whole truth," and, as in other such controversies, equated the proposed monument with "history." "The denying of Prosser's name on the monument is denying him his place in history," according to one letter to the Fredericksburg paper. Another referred to Gabriel's inclusion as "the true representation of African-American history in Caroline County." They could only attribute Taylor's contrary position to fear of his white constituents' wrath or to his being as out of touch with black concerns as "a white racist from Mississippi." Neo-Confederate opponents offered the complementary argument that the inclusion, and the monument itself, were intended to obscure the county's Confederate glory. It was part of a plot by the NAACP, a "grander, multi-state scheme to detract from or ban recognition of Confederate soldiers and sailors." Beason, the Tourism Advisory Committee chair, responded that he was a white Southerner (and although he didn't mention it here, a noted antiabortion activist) and a Confederate reenactor. Yet he believed that the new monument would treat history "evenly and fairly [and] would protect everyone's monuments."[7]

Calvin Taylor's arguments against the inclusion of Gabriel shifted the debate to the role of violence in achieving social change. Taylor argued that

while the goal of freedom was admirable, the means Gabriel chose were not. "The building of a monument brings glory and honor to an individual or a group," he explained in an op-ed column that showed a grasp of the difference between history writing and monument building that often eludes participants in such controversies. "I have a grave concern about the bestowal of an honor on a group that planned to take human life and destroy property."[8]

Each side framed violence in a particular, sometimes unarticulated, always unexamined way. Those who wanted Gabriel's Rebellion mentioned located it in an American history filled with violent conflicts over an undefined "freedom." The American revolutionaries and the Confederates were both examples, as were Gabriel's followers. "America was started on violence," Irene Fields reminded the supervisors after the vote. "George Washington fought in the Revolutionary War and went down as a hero. . . . No freedom was ever won without violence." "During Gabriel's lifetime, Patrick Henry was lionized for saying . . . 'give me liberty or give me death!' " Milton Carey, a retired army lieutenant colonel and an African American, reminded readers of the *Free Lance-Star*. A columnist for the same paper pointed out that the Confederate monument on the courthouse lawn honored men who also imagined that they were fighting for freedom, albeit the freedom to enslave others.[9]

The incommensurability of the three freedom struggles did not disturb many of those who wished to recognize Gabriel, because they were all treated implicitly as heroic episodes in settled conflicts. The American colonies had won their independence, the Confederacy had been defeated, and the slaves were free. They were all now "heritage," a marketable commodity that had little to do with living human beings. Moreover, they could be subsumed under the uncritical admiration of all things and people military that has characterized American political culture since at least the late nineteenth century (see chapter 1). In that sense the disparity of the fights could be seen as a uniting factor. "We are a nation of rebels, Spartacus-sprung, a family of mutinous cousins who ought to respect each other's particular quests for freedom," the editors of the *Free Lance-Star* instructed their readers. To see contradictions between, say, the Confederate cause and Gabriel's cause constituted a "failure to recognize spiritual kin through the camouflage of foe. Thus, today's stewards of the Stars and Bars should be in the forefront of those fighting for Gabriel's place in bronze, and Gabriel's defenders should protect the images of Lee and Jackson and Mosby."[10]

Such a view assumes that righteous violence is directed outward (toward British or Yankees) or toward foes no longer living (slaveholders). It does not

recognize, for example, that many colonists opposed the Revolution or that to their own detriment many white Southerners opposed secession and slavery. This view defines freedom fighting as violence that is not really violence. It overlooks the many wars the nation has fought for less exalted purposes over the course of its history. No one on any side mentioned those. "We teach the youth of this community to avoid violence," Taylor said, although those who enlist in the military are commonly celebrated as heroes. Many supporters of Gabriel's recognition, that is, could condone the intended violence of the uprising because it fitted into received categories that did not provoke critical scrutiny. Moreover, as the text was initially to have read, "The only violence that ensued . . . was the execution of slaves." They were "influenced by instincts that may have unintentional tentacles in our history," as the retired army officer Carey put it.[11]

Carey's statement was actually directed toward the members of the supervisors—Calvin Taylor and white supervisors Wayne Acors and Robert Farmer—who opposed celebrating Gabriel's Rebellion on the monument, implying that they shared a residual, perhaps unconscious loyalty to white supremacy. Taylor, the most (and nearly the only) outspoken member of this group, implicitly saw Gabriel's plan as a different, internal kind of violence: it represented the disruption of bonds of community and authority that he thought set a bad example. "We should have no part as a county in glorifying someone who wanted to kill whites and kidnap the governor," he told a reporter. In common with his opponents, Taylor saw Gabriel's Rebellion as a black-versus-white conflict. By contrast, historian Douglas Egerton portrayed it as an uprising of radical against conservative republicans. In his view, Gabriel and his associates hoped that working-class whites as well as enslaved blacks would rise against their mutual oppressors. According to testimony at his own and other conspirators' trails, Gabriel believed that a quick and effective strike on Richmond would lead sympathetic whites to join his band and would lead the Federalist "merchants," whom he identified as his principal foes, to negotiate with him and ultimately to admit blacks into the republican polity. As Egerton argued, "He dreamed of overturning his central class relationship in his society, but not that society itself." As it marched behind a flag to be inscribed "death or Liberty," Gabriel's army was to spare Quakers, Methodists, and French people, all of whom Gabriel believed would be friendly to his cause. Another rebel told those who condemned him that he had "nothing more to offer than what General Washington would have had to offer, had he been taken by the British and put to trial."[12]

Egerton's interpretation of Gabriel's Rebellion was published in 1993 in a very readable book that was readily available at the time of the Caroline County controversy. Had it been introduced by the monument's proponents or by the newspaper editorialists and columnists who professed to sort out the matter, the pro-Gabriel forces might have carried the day. Certainly the discussion would have taken a different turn. The point is not that this is the "truth" about Gabriel's Rebellion—a more recent book by another historian challenges it—or that the Caroline County debaters *should* have referred to it, but that none chose to follow the historical record that far. The issue was not really Gabriel's Rebellion but conceptions of contemporary Caroline County's racial relations and their implications for politics in a rapidly changing county. It was about ongoing tensions between blacks and whites, natives and newcomers, and ways to defuse them.[13]

To Taylor as a politician seeking consensus, as a school administrator perhaps worried about the socialization of his charges, and as a citizen himself, government should strive to reinforce communal bonds. Part of this consensus building was to avoid offending any portion of the body politic. "I... have a concern about the negative feelings that would be generated among various groups of county residents," he wrote in his op-ed column. "The governing body should promote peace and harmony among residents rather than separation and conflict."[14]

Monuments were part of government's project of political education and communal conciliation. They should not offer "contents that citizens find offensive," even if the potential offense was to those who still did not accept interracial marriage or even the end of legal segregation. More than that, monuments should offer a positive vision of the community. They should "speak to achievements and contributions, I would not view a failed rebellion in which 26 people were executed as an achievement or a contribution."[15]

Taylor's view, then, was somewhat more pessimistic than that of the supporters of Gabriel and the Lovings. Both sides saw the planned monument as a unifier, but the pro-Gabriel party thought it would do so by reminding viewers of common dreams of freedom and of old wrongs overcome. Taylor assumed a society whose racial fabric was still fragile, in which the mention of past wrongs or of violent efforts to confront them could lead to "havoc and unrest."[16]

A third position, one that differed from the wishful or pessimistic portraits of communal unity that the main contestants articulated, also emerges in the published accounts of the debate. A vocal faction of the supporters

of the monument and of the inclusion of Gabriel saw it as an important acknowledgment of the African American presence in Caroline. They wanted blacks to be recognized visibly on the courthouse lawn in Bowling Green, where only a memorial to the county's Confederates stood. These citizens moved to the forefront when the board of supervisors abruptly devised a new solution to the problem. The board ruled Gabriel out for good by observing that he did not live in Caroline and that his actions were only tangentially related to the county. (When a reporter pointed out to Taylor that Captain John Smith, who had even less to do with the county, would be listed, the supervisor replied, "That might have gotten by me.") The board majority, which again comprised Taylor, Acors, and Farmer, ruled that instead of a black history monument, the new memorial would be "multicultural." Two sides would be devoted to African Americans, one to the county's Quakers, who were early abolitionists, and one to other ethnic groups who lived in the county, including Native Americans. No one had asked the Quakers or the Native Americans how they felt about this inclusion. There had been no Quaker congregation in the county since the nineteenth century, but the nearest member of the denomination reporters could find was delighted by the Friends' inclusion. Local Native Americans, who did still live in the county (Mildred Loving considered herself one), wanted nothing to do with the plan. "Get it right," said Rappahannock tribe member Alfred Parker. "Don't put us on as an afterthought. We do not want to be part of their dilemma."[17]

At this point those who wanted African Americans to be emphasized entered the debate with renewed energy. They requested that they be allowed to erect a monument at their own expense that would be equal in size to the Confederate memorial, but the supervisors were now firmly set against markers that honored single groups. "The courthouse lawn does not belong just to African Americans," Taylor asserted. "It belongs to the whole county. I don't think we should be sponsoring separation on public property." In addition, Taylor and Acors added, the multicultural solution was an economical one for a county that could barely afford one monument.[18]

After county staff could not devise a satisfactory text for the revised monument, the supervisors attempted to forestall criticism by turning the task over to an all-black Multi-Cultural Monument Committee. Each of the five supervisors appointed one person from his own district. The group included two of the most prominent advocates of the original monument, Mark Garner and local NAACP head Linda Thomas, as well as three other people who averred that they had no preconceptions about the result. After

two months' work, they delivered their find-
ings to the board of supervisors, which accept-
ed their proposal by a vote of four to one, ex-
cept for three unspecified "invalidated" items
whose veracity was questioned by the county
administrator's staff researchers.[19]

The final text was predictably bland (fig.
17; and see appendix 1). One face stressed the
presence of people of African descent in colo-
nial and nineteenth-century Caroline County,
pointing out that many had fought for the
Union and that after the Civil War, "people of
color became landowners, entrepreneurs and
government officials." Gabriel was not men-
tioned, although the monument noted that
"many slaves of Caroline County were execut-
ed for their participation in slave uprisings or
rebellions." A second face was devoted to Caro-

Fig. 17. Untitled ("Multicultural Monu-
ment") (Carroll Memorials, 2004), Bowling
Green, Virginia. Photo: Dell Upton.

line Quakers. Although it mentioned their opposition to slavery, half of the
text recounted Friends' economic accomplishments. The third side carried the
"multicultural" text. It noted the presence of Native Americans (situating
them in the contact period) and the arrival of English, Scots, Irish, Italians, Hu-
guenots, Germans, Jews, and Slovaks over the centuries.[20]

The fourth side, "dedicated to the history, culture and heritage of African-
American citizens of Caroline," is the most revealing. It stresses achievement
in the form of a list of middle-class blacks who had been the first of their race
on the school board, on the board of supervisors, and in other public offices.
Many were still alive, and some still held the offices that earned them their
places on the list. Last named was Mildred Loving, "who along with her hus-
band Richard, helped strike down laws prohibiting interracial marriage in the
United States." Taylor had "no problem" with the Lovings' inclusion at the end
of a list of black officeholders. It reframed the lower-class couple's persecution
at the hands of Caroline County officials, one that required the intervention
of the nation's highest court, as one of many positive achievements of Caro-
line's black middle class.[21]

This solution, argued Lydell Fortune, dilutes "this strong message [about
the role of blacks in Caroline] by turning it into a monument that really
commemorates nothing," a monument that "no one in the county really

wants." The NAACP, with Fortune as its attorney, sued the county to prevent the erection of the multicultural monument. The plaintiffs complained that their project was effectively being censored. Yet it would stand in the shadow of a Confederate monument whose text reflected the views of early-twentieth-century white supremacists and of a new veterans' memorial clock and a mural depicting the Union occupation of the town, none of which was subjected to the micromanagement that the black history monument had endured. The county seemed to be enforcing a double standard that violated the plaintiffs' Fourteenth Amendment rights to equal protection under the law. Their suit was dismissed in June 2003, and the debate effectively ended. A year later, the multicultural monument (it has no official name) was dedicated before a hundred people on the courthouse lawn. Having won all of his points, Taylor was magnanimous: "Anytime you embark on new territory you're going to have differences of opinion. That's OK. People's don't always have to agree."[22]

As historian W. Fitzhugh Brundage noted in his discussion of the Bowling Green monument, the controversy could not be explained using neat racial categories, although race was an ever-present catalyst. Like the organizers of many black history monuments, Caroline's Tourism Advisory Committee and its supporters saw their monument as a record of past achievements leading to a present in which the long list of achievers included on the monument could become important figures in the county. The original proposal, to devote a side of the monument to Gabriel's Rebellion and one to the Loving case, was the product of a Tourism Advisory Committee that had ten white and two black members. Stan Beason, a white man, and Linda Thomas, a black woman, were the two most vocal advocates of the initial scheme.[23]

A clearer division marked views of the nature of social change and the roles of various agents in bringing it about. The list of achievers emphasizes the gradual progress of the community building efforts described on the other three sides of the monument. It is a story of achievement within a relatively benign social order. In general, the processes by which Caroline changed from a slave society to a free one are unmentioned and the people who brought about change are deemphasized. The Quakers are recognized for their abolitionist views, but those who challenged the foundations of the socioeconomic order — Gabriel, the Lovings, even black Union soldiers — are treated in a muted manner. Some of the opposition to the inscription was based on this dichotomy — that the Quakers, long gone from the county, were explicitly recognized as agents of change while black self-liberation was slighted.

Overtones of social class transcended racial divisions. Like many monuments, the emphasis on achievement implies that educated people bring about change. In many parts of the South, middle-class blacks struggled during and after the civil rights conflicts of the 1950s and 1960s to maintain or to regain their status as community leaders (see below, chapter 4). It is likely that some middle-class African Americans shared ex-sheriff Garnett Brooks's opinion of the Lovings, who after all brought about the single greatest change in the Caroline County social order. Brooks dismissed the Loving case as inconsequential. "If they'd been outstanding people, I would have thought something about it. . . . But with the caliber of those people, it didn't matter. They were both low-class."[24]

But it was the supervisors who had the last word, and they were politicians concerned above all to manage a political regime that would back development in a growing but relatively poor county. Recall that the monument proposal was originally tied to access to state funds for tourism development. It was meant to be placed on the courthouse lawn as part of a $150,000 renovation plan. Whether or not they were thinking explicitly of their own prospects for reelection, as some locals accused Calvin Taylor of doing, the supervisors realized that substantial consensus was needed to carry out their development plans and that this could be endangered by a divisive fight over the nature of Caroline's racial past. Given a choice of whom to offend, the supervisors chose to anger those who wished to honor "a black man that African-Americans hold in highest esteem" rather than the uncounted, mostly silent constituency of whites still offended by racial integration, interracial marriage, and the idea that slaves were not happy children. At about the time that Caroline's board of supervisors refrained from offending whites, the board of supervisors in adjacent Henrico County dedicated a park to Gabriel. But also at that time the state's transportation board voted unanimously to name two bridges in southwestern Virginia after Confederate soldiers. Although blacks were gaining a say in the monumental landscape, whites often continued to exercise a veto power, either because the legacy of white supremacy—Milton Carey's "instincts that may have unintentional tentacles in our history"—was not yet exorcised or through some vaguer sense of the delicacy, real or imagined, of white sensibilities.[25]

Dissatisfaction with black invisibility in the commemorative landscape, a theme that runs through all of the stories recounted in this book, initiated a decade-long effort to create a memorial to African Americans in Savannah,

Georgia. The driving force behind the monument's creation, Dr. Abigail Jordan, recalled a day in 1991 when two black tourists asked her, "Of all these monuments in Savannah, why can't we find one, just one monument recognizing African-Americans?" As a black Savannahan, Jordan was ashamed not to have noticed the absence. An inquiry to the city's Park and Tree Commission revealed that there were forty-six monuments and historic memorials in the city, but none referred to African Americans.[26]

Jordan's anecdote appeared in nearly every journalistic account of the monument building process and became the origin myth and explanation of Savannah's African American Monument. It was a protest against invisibility. Many citizens' comments in newspapers and in public hearings picked up the rationale, with commenters noting that they were "shocked" by blacks' absence from Savannah's commemorative landscape. Although there was widespread agreement in Savannah that there ought to be at least one monument to African Americans, exactly *how* they should be represented monumentally was not systematically considered. Instead, a solution emerged almost by default, as Jordan and her supporters, the city government, and other interested parties tussled. Should the monument celebrate the progress of contemporary African Americans generally? Of contemporary African Americans in Savannah? Of specific people? Particular achievements, or progress in general? Was it a monument commemorating the horrors of enslavement or their transcendence? No one involved in the decade-long struggle ever articulated a clear vision of the purpose of the monument and its relation to the visual imagery that emerged over more than ten years of contention. Instead, conflicting interpretations were attached to the final monument in ways that almost derailed it. Jordan and her African American Monument Association (AAMA) envisioned the monument purely as a gesture of social justice and historical reckoning, while the council, like the Caroline supervisors, thought in terms of political consensus and the monument's potential impact on the city's tourist economy. In addition, personal animosities shaped the process in important ways and could be read in both personal accounts and official documents. Rivalries and ambitions, personality conflicts, intentional and unintentional misunderstandings, and even resentments and enmities that carried over from Savannah State University, the historically black local university where Jordan and many of the city's political leaders worked at one time or another, shaped the creation of Savannah's African American Monument. These divisions discouraged compromise over procedural matters that might have been resolved easily had each side not been suspicious of the other.[27]

Jordan noted in her autobiography that her encounter with the black tourists, which happened as she was sitting on the waterfront, led her to contemplate the old paving of the quay, where kidnapped Africans, perhaps even her own ancestors, had been brought into Savannah. She wanted to place her monument there, preferably on a spot that she believed enslaved Africans had crossed. She went "looking for a location . . . to place a small memorial acknowledging the presence of African-Americans." In 1991 she proposed to fix an inscribed Plexiglas plaque atop a steel standard. The city demurred, objecting among other things that Plexiglas was an inappropriate material for outdoor display. In response, architect Eric Meyerhoff sketched a revised design with a marble plaque supported on a marble or granite base. Then-city manager Arthur Mendonsa told Jordan that her marker belonged on a wall in a black church, a black cemetery, or a housing project rather than on the waterfront. He also told her that her preferred site on the Savannah waterfront was owned by the adjacent Hyatt Regency Hotel, which the manager of the hotel denied. Mendonsa's explanation of the city's rules for memorialization left Jordan "perplexed . . . and no doubt that was his intention." It may be that the city manager was confused about the site's ownership and thought the form or the proposed contents of the plaque better suited to private display than public memorialization, but in any event Jordan chose to see both statements as deliberate insults growing out of a conflict she had had with the city manager on an earlier occasion.[28]

Jordan then attempted a kind of guerrilla memorialization. She purchased a small classical column of the sort customarily used to display potted plants and had a marble plaque engraved to place on top of it. Then she installed it on the waterfront in the dead of night. The city immediately removed it.[29]

This initial improvised monument already exemplified the confusion of goals and forms that characterized the entire decade-long process. Although Jordan wanted her plaque to be placed where she believed slaves had landed, the plaque had nothing to do with the slavery era. At the top is the name Consortium of Doctors (COD), an organization for black women holders of doctorates from accredited universities. Under it is the legend "Societas Docta (Dr. Abbie Jordan, Founder)" and the COD logo. A "Scroll of Perseverance/1992" includes the names of Eartha Kitt, Addie Byers, Dr. Debbye Turner, Dr. Harriett Bias-Insignares, and the Honorable Robbie Robinson. Byers was a Savannahan who responded to a governor's threat to fire any teacher who joined the NAACP by taking out a life membership. Bias-Insignares is a Savannah-born

poet, while Savannah city councilman Robinson was killed by a package bomb in 1989. But the others had no connections to Savannah other than Jordan's admiration for them. Turner was the first black Miss America and a COD member. Singer Eartha Kitt, who had been honored at the first COD banquet, was included in recognition of her defiance of President Lyndon B. Johnson during the Vietnam War years.[30]

Two issues stalled the project at the beginning. The first was the approval process to which the "living memorial" should be subjected. The city council directed Jordan to obtain the approval of the city's Historic Sites and Monuments Commission (HSMC). In 1991, though, the commission was moribund. When it was revived, the HSMC enacted new criteria for memorialization that required those honored on public grounds to have a specific connection to Savannah and to have been dead for twenty-five years. Jordan insisted that since her proposal had initially been offered when the HSMC was dormant and before it created its new criteria, her plaque should be exempt. The city disagreed. Her supporters' frustration was exacerbated by the presence of living whites in the memorial landscape. The HSMC pronounced those monuments irrelevant, since they had been erected before the new rules were written. At one meeting, a member of the HSMC asked monument spokesman Leonard Smalls if he could live with the rule that honorees be dead for twenty-five years.

> Rev. Smalls said No. He said Mr. Rousakis was not dead and had the plaza [in which the monument was to be erected] named for him.
> Members of the Commission stated that was a plaza.
> Rev. Smalls said this was a Civil Rights Monument and many of their heros [sic] are still alive.[31]

The city and the HSMC believed that they were applying objective standards even-handedly, whereas Jordan "thought the criteria was a form of racism." "Criteria have nothing to do with race or ethnic group. The criteria were set up for guidelines," HSMC member Pete Liakakis told the AAMA, which had been founded in 1996 to formalize the campaign. The Reverend Smalls argued that "people affect you whether they come to your city or not. The idea that you cannot build a monument to anyone other than people who came here and affected this particular community did not make a lot of sense to him. What about building a statue to George Washington, Abraham Lincoln, etc." Liakakis responded that "the guidelines were taken from the Federal Government." The subtext, which Smalls clearly perceived but which neither side articulated explicitly, was that figures such as Washington and Lincoln

were important to everyone, but the African American past was significant only for black people and thus subject to more stringent rules of local relevance. This assumption was reinforced by the AAMA's insistence that it was *their* monument. Ivan Cohen, an AAMA stalwart, told the HSMC that "people should not be able to superimpose somebody's name on someone else's monument. He said there was no African American input when they put names on other monuments here."[32]

The second, more lingering dispute concerned the names to be inscribed on the monument. Jordan modified her list somewhat, retaining Byers, omitting Robinson and Bias-Insignares, and adding Benjamin Clark, a local civil rights activist whose early death she attributed to mistreatment during the movement years, as well as Captain Sam Stevens, reputedly the first black man to own a tourist boat in Savannah. She also retained non-Savannahans Turner and Kitt and added another outsider, Mae Jamison, a COD honoree as the first black woman astronaut. Both the HSMC and the city council objected vehemently to this list. Jordan countered at times with subterfuge, claiming that the "outsiders" may have been connected to Savannah through their enslaved ancestors but that she lacked the resources to do the necessary research. At other times Jordan and her supporters argued that the list of names was an issue of black self-determination. Smalls told the HSMC that he was "bothered by the idea that White people would have to approve the names they select. He said it was a loss of self determination. . . . He said it would be tasteful, but that they wanted the right to put the list together." Later in the meeting, he repeated the point, telling the HSMC that the monument "was not only intended to depict the African American community of Savannah, but that families [who] entered the port and dispersed throughout the nation would be depicted. He said the monument was to the descendants of every slave brought into the country. It would be a national monument."[33]

The conflict continued almost until the time that the memorial was dedicated. Jordan rejected a last-minute attempt by the city manager and interested members of the African American community not connected with the AAMA to resolve the impasse by offering to include her list of names on the walls enclosing the plaza where the monument stood. Since they would not be inscribed on the monument itself, the city could be satisfied that its rules had been followed while Jordan would have her names. In the end, faced with the prospect that the monument would be rejected altogether, Jordan agreed that no names would be included, under the face-saving pretext that they

would be chosen in the future and engraved then. The city council refused to accept her concession, treating it as a petition to change the monument as approved. They denied the change, sending the issue back to the HSMC. This was a serious setback for the monument but not a cancellation, as was reported at the time.[34]

It is difficult to untangle struggles over the nature and purpose of the monument from personal rivalries and from cascading resentments engendered during the long planning process. Jordan was quick to label anyone who opposed her on any detail of the monument an enemy. Her list of enemies included Mendonsa, HSMC chair Lisa White, Mayor Floyd Adams, City Councilman David Jones, and Otis Johnson, a political activist and Savannah State administrator who later served as mayor. When an HSMC member asked why Eartha Kitt was included but W. W. Law, Savannah's most prominent civil rights leader, was not, "Dr. Jordan said they did not want to tell why—it was their secret."[35]

The city's response to Jordan's challenges varied from the rude to the childishly insulting to outright attempts to seize the project from her. Meetings about the monument were held either without her knowing of them or on too short notice for her to respond. In 1996, after wrangling with her for five years over her preferred site, they gave it to the Hyatt Regency to build restrooms on, provoking demonstrations and the formal organization of the AAMA. When Jordan spoke to city council, some aldermen pointedly read newspapers during her presentations.[36]

In response to Jordan's sweeping pronouncement that none of the public memorials in Savannah honored African Americans, the city produced a somewhat trivial counterlist of several that did. While Jordan was clearly thinking of *statues* or sculptures, the city's list encompassed every obscure plaque or inscription that mentioned any black person. They included a plaque commemorating Prince Hall Masons, "erected 1994, vandalized and removed a short time later"; a marker at the First Bryan Baptist Church honoring early African American pastor Andrew Bryan, one in Green Square honoring the Second African Baptist Church; a proposed public art project in the Yamacraw Village housing project celebrating blacks and Native Americans; two churches; and Savannah State College, the first publicly supported black state college in Georgia. It also listed references to black people on two monuments and a sundial.[37]

Most infuriating to Jordan was Mayor Floyd Adams's attempts to take control of the monument project from her and the AAMA. In 1997, he formed

a task force to "evaluate" Jordan's proposal. "The committee has the option to accept or reject her proposal and come back with some alternative," in essence substituting its plan for hers, Adams told a reporter. After a disastrous workshop in January 2000, he made a more concerted effort to commandeer the project, telling reporters that it "may be time to start afresh" and floating the idea of appointing a new committee and holding a national competition for a new design.[38]

The *Savannah Morning News* promoted the idea of starting over with a "consensus-building" process, and Adams tried to put together a coalition, asking the local chapter of 100 Black Men to direct the project in conjunction with the Savannah Area Chamber of Commerce and the Panhellenic Council of black fraternal organizations. Again, nothing seems to have come of this effort. On January 11, 2001, the Reverend Thurmond Tillman, pastor of the city's oldest and most prestigious black church, appeared before the council in a conciliatory mood. In fact, Tillman had negotiated privately with the mayor and council for approval of the monument without the names and without an inscription by Maya Angelou (see below). The council agreed, and after ten years, the city formally approved the African American Monument. Although important details remained to be settled, the AAMA could go forward with its fund-raising for a monument that would finally be built, and the city could begin preparing the site.[39]

During the protracted battle over the names, the form of the monument underwent a dramatic and significant transformation, leading to an even more bitter, and more public, struggle that drew in laypeople as well as members of the AAMA and the city government. Floyd Adams dismissed architect Eric Meyerhoff's redesign of Jordan's original proposal as "a box with a lot of doctors' names on it," and Jordan began to rethink the monument altogether. No longer would a simple plaque be adequate—a sculpture was needed. Dorothy Spradley, a white sculptor who taught at a local art college, volunteered her services and developed a series of designs in consultation with AAMA members.[40]

All of the sketch proposals focused on a black family, presented in various poses. In one, two adults and two children dance in a circle holding hands. Another seats the group, with the woman holding the youngest child. Two drawings depict the group sheltered by an enormous pair of hands with their fingers pointed upward, similar to the chained and unchained hands engraved on the base of the final monument. In the design that was chosen, a family of four stood inside a circle of broken chains dropped at their feet (fig. 18).[41]

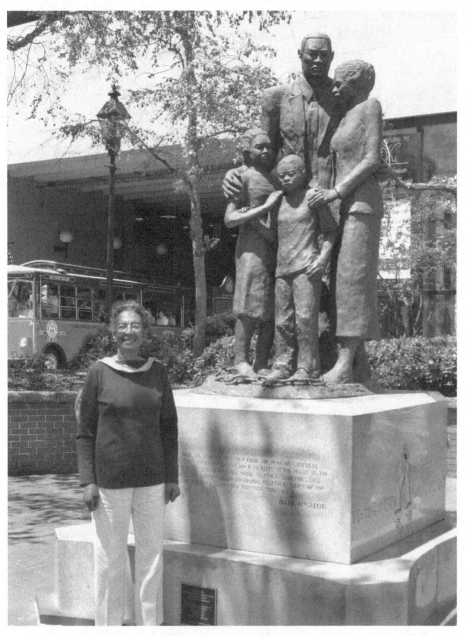

Fig. 18. Abigail Jordan at the African American Monument (Dorothy Spradley, 2002), Savannah, Georgia. Photo: Dell Upton.

The broken chains link the African American Monument to two hundred years of the representation of slavery in Anglo-American art. Antislavery organizations invariably depict slaves as barely clothed, chained creatures, as in the renowned "Am I Not a Man and a Brother" image, created by English abolitionists and widely reproduced in the United States before the Civil War, or in Hiram Powers's statue *Greek Slave* (1847). Building on this iconography, post–Civil War artists often portrayed the moment of emancipation, with newly freed people still wearing or having just shed their newly broken chains. Thomas Ball's Freedmen's Memorial Monument to Abraham Lincoln (1876) is the best known of these, but John Quincy Adams Ward, Henry Kirke Browne, Clark Mills, Harriet Hosmer, and Randolph Rogers all designed or made emancipation monuments. Edmonia Lewis created one that depicted a newly freed slave couple. At Tuskegee Institute in the early twentieth century, Charles Keck sculpted a parallel moment of intellectual emancipation, with Booker T. Washington removing the veil of ignorance from a freed black man (fig. 19). In every case, the newly freed men and women, like their enslaved cousins in pre–Civil War art, are barely clothed, while emancipators, when depicted, are fully clothed in contemporary dress.[42]

Although it belongs to this visual tradition, Savannah's monument depicts the family of a man and woman with their son and daughter in modern dress. The four have their arms on each other's shoulders and look solemnly into a space not shared by the viewer. On the ground plane, encircling their feet, are the broken chains. The result is an ambiguous image open to conflicting interpretations. Is this a monument to the accomplishments of Savannah's black population or to their emancipation from slavery? City officials demanded the former. As the city manager summarized it, "There seems to be a clear consensus that the ultimate purpose of the monument is to acknowledge the achievements of African-Americans and especially African-American families in the cultural, spiritual, economic, and educational life of the Savannah community." The AAMA constantly assured officials that this was their intent and that part of the purpose of depicting the family in modern clothes was to emphasize the present. "What we were trying to get across is that this family had faith, pride and hope, but not a lot of joy at this point," sculptor Dorothy Spradley told a reporter. The monument would be "a positive statement of the triumph of the family in the face of these difficulties" and would inspire the youth of Savannah to greater achievements.[43]

As public debate over the monument played out, Jordan and her followers increasingly treated the monument as a reminder of the city's slave past,

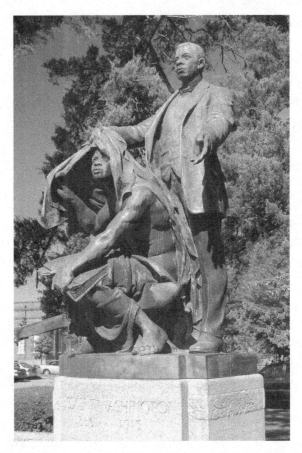

Fig. 19. Booker T. Washington Memorial (Charles Keck, 1922), Tuskegee University, Tuskegee, Alabama. Photo: Dell Upton.

and the city and the public came to see it that way as well. The monument faces east, supporters emphasized, toward Africa, "from which [the family] came." On the north and south sides of the base are stylized waves with a pair of chained hands protruding above the water in each. On one side, the hands are outstretched in supplication, perhaps recalling the moment when some captives were thrown into the ocean as they died or slave traders judged their value too little to bother keeping them alive. On the other, the hands are clasped in prayer, with the shackles opened by emancipation (fig. 20). At one point, the AAMA considered including images of the Savannah skyline and slave ships and a map of Africa along with the shackled hands.[44]

Still, it might have been possible to see the statue as an innocuous image of deliverance if the AAMA had not chosen to quote Maya Angelou on the base. It proposed a passage that read: "We were stolen, sold and bought together

from the African continent. We got on the slave
ships together. We lay back to belly in the holds
of the slave ships in each others' excrement
and urine together. Sometimes died together
and our lifeless bodies thrown overboard to-
gether." The text was like a letter bomb, and
it immediately escalated the conflict to new lev-
els. It provoked disparate reactions among var-
ied audiences, all concerning the best way to
represent slavery in the modern commemora-
tive landscape.[45]

Genteel white correspondents—"well-
meaning and civilized people," in the self-
characterization of one writer—and some
blacks believed that the African American
Monument should emphasize the positive as-
pects of Savannah's history and ignore the neg-
ative ones. One wrote a long treatise, complete
with footnotes, to show that the Middle Pas-

Fig. 20. African American Monument.
Detail of unshackled praying hands.
Photo: Dell Upton.

sage could not have been as bad as the Angelou quotation suggested. Anoth-
er wrote, "Recognizing slavery as part of Savannah history is one thing, but
dwelling on it in the present and exposing it graphically in a public tourist
area is another. . . . One should not dwell on the harshness and cruelty of past
history." This correspondent found the project "quite tasteless"; the subject
line of her e-mail read "Tacky Monument Decision."[46]

Emma Adler, one of Savannah's pioneering white historic preservation-
ists, was deeply disturbed by the monument. She believed that it suggested
that Savannah had not changed, and she complained to Florence Williams,
the author of a travel article about Savannah: "You portrayed a stereotype of
the old south which was prevalent in other regions of our country 30/40 years
ago among those who knew little of the South." The problem was that Wil-
liams "talked with a fringe group promoting Abigail Jordan's project" when
she was in Savannah "and took this point of view, rather than a mainstream
approach." Adler had given Williams "positive material," but instead, "You took
one remark (which I don't remember making) out of context and made me
sound like an innocent and uncaring fool." In a cover letter to Mayor Adams,
Adler made it clear that in providing such positive material to Williams, she
meant to counteract Jordan's campaign without mentioning her, "because I

didn't want negative quotes from me in the article." The offending article characterized Savannah as "a bastion of Anglo-Southern traditionalism, a place where the same families have lived for generations, attending the same soirees, recirculating the same antiques." The writer quoted Adler as saying, "'I want us to have a monument that's dignified. . . . We are a port, and slaves did come,' she sighs, 'but I just don't think of us as brutal.'"[47]

As the monument approached realization, Adler sent Adams her "thoughts on the Proposed African American Monument." Acknowledging the brutality of slavery, Adler nevertheless suggested that Savannah was different. Georgia founder James Oglethorpe had outlawed slavery, although it had ultimately come to Savannah as the city was drawn into the Southern agrarian economy. She then reviewed the career of the Reverend Andrew Bryan, a black Baptist minister in early-nineteenth-century Savannah who was respected by both black and white people, noted Savannah's establishment of a school for black children in 1876, and cited Martin Luther King's observation that Savannah had the South's best race relations. To Adler, Savannah was a place that had always welcomed and nurtured black achievement. "In view of the fact that Savannah's record in race relations is outstanding," she argued, it would be better even at that late date to substitute a statue of Bryan, to be placed in Franklin Square near his Second African Baptist Church, for Jordan's monument.[48]

Not only whites but many middle-class African Americans in Savannah and elsewhere were disturbed by the monument's evocation of slavery. "Our history in the New World (North America) does not begin or end with slavery," Harold L. Hillery wrote to the Savannah newspaper. "This proposed monstrosity communicates misery, servitude and human bondage. Surely our ancestors do not want to be remembered as a conquered people." Hillery wanted a monument that was "positive" and "spiritually uplifting," such as one to Savannah's civil rights leaders. Other correspondents agreed that the message should be positive. Whereas whites thought the references to excrement and urine to be in "bad taste," black correspondents saw them, with the chains, even broken chains, as signs of black abjection. "I will not contribute one narrow dime . . . until those dreadful shackles and chains are removed from the design," Hillery wrote. "The proposed poem (?) has no hope, nor love, nor faith," another correspondent objected. "Please, ka-ka, do-do, pee-pee, need not apply. Solicit: Blood, sweat, tears, or remorse; but especially faith, hope, & love." Some dissenters looked backward, to "our 'Glory Days'—in Africa," but most looked forward, to the achievements of contemporary African

Americans. Many of these communications were in the form of e-mails that identified the senders as employees of universities, the armed forces, or various governmental entities. Among the dissenters were several black members of the Savannah City Council. Alderman David Jones told a reporter, "We're moving forward. I want my children to know about [slavery] but I don't want them to live in yesterday." Mayor Adams asserted, "We don't need to keep hanging on to the fact that years ago our ancestors came to America in chains. . . . I don't even watch slave movies like 'Roots.' I don't even like watching movies about the civil-rights movement. I want to move forward." "As far as I'm concerned," he said on another occasion," if it's not positive, I'd rather see no inscription."[49]

During the debate over the Angelou inscription, outsiders to the process, most self-identified as African Americans, volunteered a folder's worth of alternate inscriptions, all intended to accentuate the positive and eliminate the negative from the monument. James Gardner offered his poem "Freedman," which declared, "I am free now come what may / in life as it will be." James Moore suggested, "We were bought / We also served / We did pay dearly / and / Now We are Free!" Another mentioned slavery but emphasized "America's" sacrifices in battle to "break our chains of bondage." This alternate text made the same kind of claim to inclusion in the public landscape that the statue did: "Today this strange land is proud to claim us as her own. Today we are proud to claim ourselves Americans." Another sent two poems, "Free Me, America" and "I'm Proud to Be Black," for consideration. Iris Formey Dawson submitted her poem "We Stand Firm," apparently at Mayor Adams's invitation.[50]

An African American op-ed columnist summarized the demands of black dissenters for a positive image. "When we listen to veterans of wars," Pearl Duncan wrote, "we hear tales not about how the war-enemy or the oppressors hurt the vets, but how the veterans fought back and survived. . . . The monument to the veterans of slavery should be one similar to the monuments of other wars. It should be a monument whose image and inscription represent strength and heroism, for American slavery was a war. . . . To do that, we first have to uncover the heroic acts of the African Americans who fought against slavery," she argued.[51]

The Angelou passage had its supporters outside the AAMA. Angela R. Kelly wrote to the mayor and council, "We as a people should not be afraid to portray the true history of our ancestors and what they had to go through." She thought that the monument would remind viewers of "how far we have come, but also how far we must travel." Another correspondent reinforced

the point. "It is my feeling, that the monument to slavery, as painful as it may be for some, would be the first of many steps that we as Afrikans need to take throughout the Diaspora, towards healing ourselves, and becoming more productive members of our respective societies." A white Californian who claimed roots among Alabama racists believed that "it requires strong language to jolt our sensibilities to the horrors of the slave trade and serves to remind us of the inhumanity we mortals all too often display in our relations with one another, even today."[52]

To city officials, black and white, even those who were sympathetic to the monument or acknowledged the accuracy of the Angelou text, public reactions to the quotation raised fears of "divisiveness" that would disrupt Savannah's political life and alienate voters and tourists. The placement of the monument on the tourist waterfront was an issue from the beginning. City Manager Mendonsa's suggestion that the marker belonged in a "black" setting was echoed by the Historic Sites and Monuments Commission early in its deliberations. Members phrased the issue in terms of black comfort with the setting. Would the monument's supporters, they asked, be comfortable seeing revelers on Saint Patrick's Day drinking green beer on the statue? They also thought that "public artwork along River Street should be limited to themes of a maritime nature." Although the slave trade certainly falls under that rubric, it was clearly not what the commission members had in mind. They proposed a Martin Luther King Jr. Civil Rights Park, to be built along Martin Luther King Jr. Boulevard, as a more fitting site. This was the former West Broad Street, the traditional, now largely demolished, black main street, which lay safely away from the tourist city. City historic preservation officer Mary Elizabeth Reiter tried to convince the AAMA that "it might be appropriate to broaden the concept to an African American Heritage park and locate the monument there, thus creating a positive inspiration along a street with so many African American ties." This proposal assumed, as so often in the discussion of African American monuments, that the only audience for an African American monument would be local black people.[53]

Mayor Adams had preferred Green Square or Franklin Square—two "black" squares—for the monument, but told the HSMC that he was persuaded by the AAMA's arguments that River Street was the appropriate site. Yet he remained adamant about the quotation, which he believed was "potentially divisive, too graphic and too harsh to be written on a public monument." Resorting to the kind of self-canceling left-right pairing common in American political discourse, Adams compared the statement to the public display of the Confeder-

ate battle flag. He also worried that tourists would be offended by the unflinching Angelou text.[54]

As soon as the quotation came into play, city officials began to try to discredit it. The HSMC tried unsuccessfully to substitute Angelou's poem "Still I Rise" or an excerpt from escaped slave John Brown's memoir. Failing that, they accepted the quotation, although Reiter and Don Gardner, the park and tree director, expressed their opposition in a memo to the city manager. Noting that members of the AAMA had objected to white people's deciding the matter, the two city employees declared that the quotation did not accord with "the stated spirit of the monument, it is not uplifting and does not describe the triumph of the African American or the African American family." Instead, it "serves to keep open old wounds." They also questioned whether these words should be placed "on a bronze plaque right behind City Hall, on our most visited tourist site." In subsequent meetings, the HSMC tried to draw a *cordon sanitaire* around the offending quotation, placing it firmly in the past. They would do this by prefacing it with the statement, "For those who have forgotten or others who never knew, Maya Angelou summarizes Slavery," and following it with the note, "That was yesteryear. Today we are a family united, free, moving forward in expectation of a brighter tomorrow."[55]

Even as these changes were proposed, the HSMC and the city council tried to scuttle the quotation altogether. It could not be found in any of Angelou's writings, they said. Jordan did not help the situation by claiming (as she continued to do in her summary publication) that it was derived from Angelou's poem "On the Pulse of Morning," read at President Bill Clinton's first inauguration. South Carolina state senator Kay Patterson sent Mayor Adams a photocopy of a page from Angelou's *Even the Stars Look Lonesome* (1999), which contained part of the quotation, but that book had been published after the passage was put forward in Savannah. It appears that Angelou used variations of the text on several occasions and that Jordan may have encountered it in an *Ebony* article. In any event, Angelou had not given her permission to use the quotation. When she finally did so, she added a final, "hopeful" line to the passage: "Today, we are standing up together with faith and even some joy." The critics were still not placated. Adams wrote to City Manager Michael Brown, "Regardless of the permission, I still oppose the poem being placed on the monument. Do not construe this permission as giving Dr. Jordan the right to place it on the monument." Emma Adler told Adams that the alteration was not "adequate compensation" for the rest of the

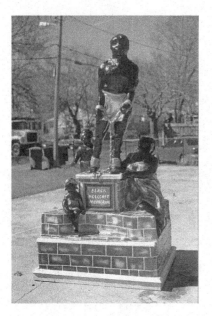

quotation, adding that Savannah was not a principal slave port, that slavery has been practiced in many times and places by many people, and that an African American journalist was reported to have expressed gratitude that "his ancestor survived his voyage on the slave ship so that his descendants could be Americans." Nevertheless, the city council approved the revised text, and the monument was built with it. On July 26, 2002, eleven years after the project was conceived, the African American Monument was dedicated.[56]

Fig. 21. Black Holocaust Memorial (James Kimble, 2002), Savannah, Georgia, in 2003. Photo: Dell Upton.

A remarkable response to the African American Monument was James Kimble's Black Holocaust Memorial (2002), created shortly after the bronze memorial was installed (fig. 21). Kimble placed it on a vacant building foundation at East Broad and Anderson Streets in a poor black neighborhood of Savannah. The monument, three or four feet tall, is made of papier-mâché and colored with house paint. It depicts a black man, woman, and two children on a stepped platform meant to evoke an auction block. In the best antislavery tradition, the family is scantily clad. The man is bound by golden chains. This, Kimble told me in 2003, is what life was really like for African Americans in contemporary Savannah. (In recent years, Kimble has described the work as a more truthful representation of enslavement in Savannah, made "so they [children] could really see how they were brought over here.") In late February 2003, the Black Holocaust Memorial was extensively damaged. Kimble believed that the police had done it, while a neighborhood activist attributed the damage to "four guys" who "jumped out of a 4x4 pick-up with baseball bats." The police claimed that the monument had been poorly made and that it had melted in a rainstorm. Kimble quickly reconstructed the work and added a wooden canopy, painted the red, yellow, and green of black nationalism, with the title "Black Holocaust Memorial" prominently displayed (fig. 22). To the left of the statue, a papier-mâché panther guards the figures.[57]

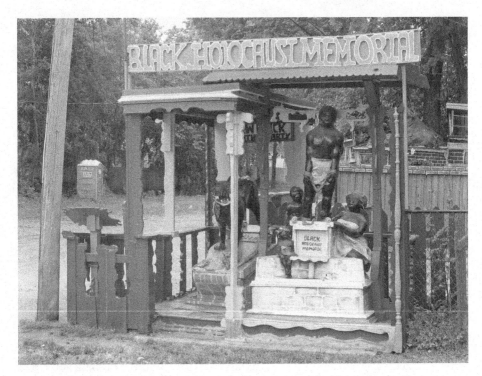

Fig. 22. Black Holocaust Memorial in 2006 after reconstruction and addition of protective shelter. Photo: Dell Upton.

Kimble's sculpture might have gone unnoticed had he not been a member of the New Black Panther Party (NBPP), a small, black nationalist sect headed by Savannah's Yusuf Shabazz, who resigned from the AAMA over its use of a white sculptor to create the African American Monument. Kimble described the NBPP as "a black military," but the group's antiwhite and anti-Semitic rhetoric upset many people. The Black Holocaust Memorial is divisive in exactly the way Mayor Adams feared, rejecting the notion that racial differences have been or can be transcended in post–civil rights Savannah. The poor black community in which it is based contradicts that rosy official view, and Kimble and his colleagues are "focusing on . . . trying to get these young kids to get themselves together." Kimble's memorial is one among many papier-mâché sculptures he has made, "kid-like things" that he places around the neighborhood for the benefit of local children. While the Black Holocaust Memorial was meant as a response to the African American Monument, it is not one that would ever be countenanced on public land, nor is it really aimed at those outside the neighborhood. It is a despairing rejection of the

goals of presence, uplift, and progress that the official bronze monument embodies.[58]

If Kimble thought the African American Monument too timid, white supremacist critics predictably found it overstated. Interestingly, they did not often deny the evils of slavery or even the existence of racism but, like their more temperate neighbors, felt that it was a matter that had been laid to rest. Neo-Confederate Dow Harris carried a sign at the unveiling that declared, "We refuse to sit upon your stool of everlasting repentance." The increased recognition of black history and the accompanying discrediting of neo-Confederate symbols and myths were doubly painful for these people. "It is bad enough that we have a Turn-Coat Governor that did away with our state flag because it was what the blacks wanted," John J. Thomas wrote to the mayor. "I am sick and tired of the blacks wanting everything to stand for only them when many, many White Men died in the Civil War to end slavery and yet today they use it to promote and continue their racist activities. The fact [is] that Racism in this country is 85% Black Fueled! . . . Blacks are getting away with everything including murder in our country and no one seems to care or give it a second thought." Another professed to think a statue honoring blacks a good idea, "and I would like to send A LARGE CHECK to FULLY FUND your project. . . . However, as I read further about how the statue was to be erected—where white tourists would be largely viewing it . . . and when I read the emphasis would be on using such words as excrement and urine, I had second thoughts. It is clear to me now that the goal of all this is not to honor people but to SLAM WHITEY."[59]

From a decade's distance, it is evident that the conflict in Savannah was not about the way the monument represented slavery. The statue is innocuous, its narrative understated. The broken chain at the family's feet and the manacled hands on the base are the only visual hints that the monument is intended to be a comment on slavery. The image is ambiguous enough that some city officials worried about its potential misinterpretation. Mayor Adams raised the example of Charles Keck's monument to Booker T. Washington (see fig. 19): "It appears that he is lifting up the man from slavery, but some people think he is pushing him down. [I want] this [Savannah] monument to have a clear message that this community has evolved and come together and [has] gone above slavery." An African American blogger found the monument "neither provocative nor pretentious," but thought that in dressing the family in modern clothes the sculptor "was more intent on indulging her personal creative sensibilities than communicating a point of any particular historical significance." He preferred that the passage of time be indicated by

clothing the parents in "the rags of slaves" while depicting the children in modern dress as signs of the progress that had occurred since emancipation. Even the Angelou quotation, graphic as it was, spoke of the Middle Passage, rather than the experience of enslavement in North America.[60]

Rather than the monument's *depicting* slavery, then, it injected the peculiar institution into the contemporary landscape as a way of speaking about white-black power relations in Savannah. In this case, it was not simply that African Americans became present but that they became present with a specific history of relationships to nonblack Savannahans. It implied that whites were in some ways still indebted to blacks and that the current position of African Americans remained tinged by the experience of enslavement. Whites and blacks sensed that the monument was not about the past or the present so much as the future, although few were able to say so directly. Reiter, the city's historic preservation officer, came closest to doing so in writing to City Manager Brown that "it is my sense that the monument theme is not to commemorate the contributions of African Americans to local cultural, economic etc. affairs but that it is a Civil Rights Monument. It is no longer, in my opinion, a civic monument, but a political statement." That is, the African American Monument implied a judgment about interracial relations rather than celebrating a nonspecific and impersonal "progress" or "healing." It lacked the positive spin that the HSMC, the city council, the mayor, and many white and black correspondents wanted. It was not uplifting, a requirement that even the AAMA acknowledged. As one disgruntled neo-Confederate said at the unveiling, "Monuments are supposed to inspire. This one brings down." As often as she demanded that the monument tell the hard truths about slavery, Jordan insisted that "Savannah should be happy to have this kind of display that now shows we are a united family."[61]

The impulse to present a positive message had several roots. One was the widespread American notion of public space. Early in the history of the United States, public space was formulated as neutral and universal, representing no particular point of view but somehow expressing universal public values. Monuments standing in public space had to speak, at least putatively, for everyone. The idea that there exists a single public good or set of values to which every person of good will should subscribe is deeply rooted in Anglo-American politics of the seventeenth and eighteenth centuries despite nearly 250 years of political practice that contradicts it. Consensus forms around the positive and the forward-looking, not the negative and backward-looking—around accomplishments, not conflict.[62]

Both those middle-class black people who supported the monument and those who opposed it viewed it through lenses deeply rooted in the experience of the 150 years after Emancipation. On the one hand, there was an energetic effort to form African American institutions, to stabilize families, to create businesses that proceeded relatively rapidly until the return to power of white supremacists undermined and sometimes destroyed these institutions through legal condemnation and officially sanctioned terrorism. These institution-building projects were born of, and helped reproduce, an ethos of uplift, of raising oneself to become mentally and spiritually free and, among the black middle-classes especially, of a responsibility to uplift "the race" through example and assistance. Uplift often served as a substitute for political power in the era of white supremacy, and it remains ingrained in contemporary black political and religious discourse. When Savannahans as different as Abigail Jordan and James Kimble spoke of their responsibility to teach or nurture the next generation, they were speaking the language of uplift. The many writers who offered alternate inscriptions for the African American Monument offer a glimpse into the contours of uplift in black popular culture. All wrote of individual and racial transcendence of adversity. "We are The Dead [of the Middle Passage], our souls sing freely / Beyond the Beloved earth and troubled sea— / Give back to us the Honor of our Lives / By becoming the best that you can be." Another proclaimed that "Slavery was a drawback— / But not our only way ... [sic] / Like Marcus Garvey and Maya Angelou say ... / 'up you mighty race,' We'll rise to greatness / Again—One Day!"[63]

The impulse to uplift coupled, as the sociologist E. Franklin Frazier observed in his scathing *Black Bourgeoisie,* with a desire for the recognition of accomplishment that sometimes conflated minor accomplishments with earthshaking ones. Like the list of officeholders on the Bowling Green monument, the list of names that Abigail Jordan pressed so hard to have included mixed the significant with the ephemeral. For black opponents of the monument, and especially of the Angelou text, to focus on slavery was both to generate painful recognition of continued limitations on African American accomplishment and to distract viewers from the record of achievement. The desire for achievement also created a tension among the black middle class in their relations with poorer African Americans. Eager to assert achievement and claim respectability, they often ignored the economic and social marginalization of poorer people. Hence the African American Monument seemed much too positive to James Kimble, who responded by crafting the Black Holocaust Memorial.[64]

These broad issues were molded in Savannah by *personal* histories. Jordan's shifting of emphasis from black achievement to the experience of enslavement over the course of the eleven years that it took her monument to be realized were certainly grounded in her personal narrative. She told me and many other interviewers of her own memories of persecution by whites — of her mother's being pushed down the courthouse stairs in retaliation for trying to vote, of the threatening behavior of white students at the University of Georgia, where she earned her doctorate. No doubt her struggles with Savannah's political leaders added to a feeling of persecution. Many of them, in turn, developed a personal dislike for her that led them to place as many roadblocks in her way as they could, insisting that every "i" be dotted and every "t" crossed while professing to favor the monument itself. Moreover, as public officials, they were unwilling to provoke large segments of the electorate who might retaliate at the polls. The practicalities of electoral politics reinforced the fictions of American public space established in the early nineteenth century.

Slavery may not have been the best metaphor for black political claims about contemporary power relations in Savannah. Like the neo-Confederates, many whites and some blacks saw slavery as a distant event that had no connection to the present. A better choice might have been to focus on the experience of Reconstruction, when blacks made great strides in creating a civil society that were later rolled back. But the power relations of slavery were so stark that they provided a kind of blunt weapon for use in Savannah's racial contest.

CHAPTER 3 { **A STERN-FACED, TWENTY-EIGHT-FOOT-TALL BLACK MAN**

The presence of the original is the prerequisite to the concept of authenticity.

— WALTER BENJAMIN, "THE WORK OF ART IN THE AGE OF MECHANICAL REPRODUCTION," 1936

On a corner of Kelly Ingram Park in Birmingham a bronze statue of the Reverend Martin Luther King Jr. gazes pensively across at the Sixteenth Street Baptist Church (fig. 23). In dress, scale, and demeanor, the bronze King could stand unnoticed in a crowd. He wears a business suit. The large Bible he carries in his left hand hints at his religious calling. His body is at rest. The relaxed quality of his body language and his placid facial expression make King appear to be an observer rather than an actor in the violence and chaos that reigned around the real King in Birmingham in the spring of 1963.

The Birmingham King statue is neither the best nor the worst of many similar Kings scattered throughout the United States. It reveals the sculptor's competence but no aesthetic or symbolic ambition. Nevertheless, this unremarkable monument has been the object of two noteworthy responses. The first occurred during the creation and dedication processes. White conservatives on the Birmingham City Council saw the statue's creation as a bid for political hegemony by then-mayor Richard Arrington Jr., the first African American to hold the post. Yet they felt that they could not criticize it directly. As Republican councilmember John Katapodis put it, "When you speak any word against a Martin Luther King Jr. statue you're labeled a racist." Instead, opponents resorted to indirection, criticizing the sculptor for his work on the Bear Bryant monument at Birmingham's Legion Field, as well as questioning the choice of fabricator, the cost, and ultimately the likeness of the finished statue to King. Based on the model, Katapodis claimed the work was "a lifelike portrayal—of somebody" that looked more like Mayor Arrington than the Reverend King.[1]

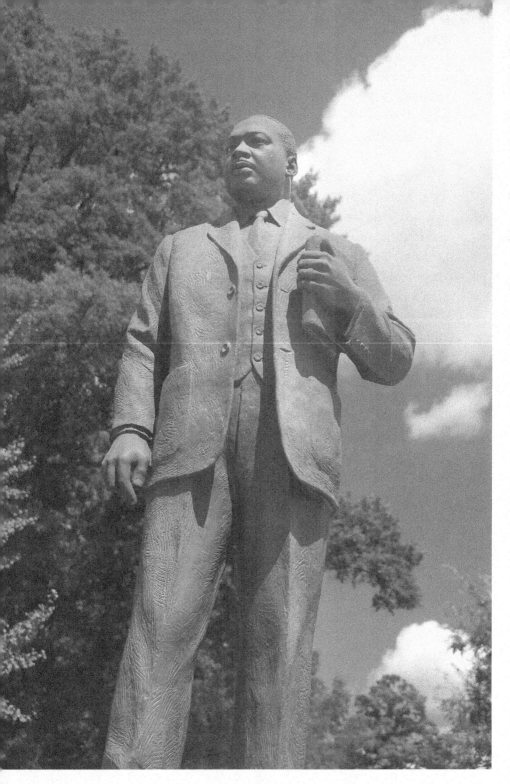

Fig. 23. *Martin Luther King, Jr.* (Carlo Roppa, 1986), Birmingham, Alabama.
Photo: Dell Upton.

The second remarkable response occurred many years after the statue's dedication and would have gone unrecorded had I not been there. One summer day in 2010, two middle-aged black women came to the statue to scatter their mother's ashes in the flower bed around it. All the while, they spoke to her in low tones about her life and her aspirations. They were giving their mother over to the care of the saint.

Great leader monuments have lost ground in the South as understanding and interpretations of the civil rights movement have evolved over the past forty years. For the most part, these figures are relatively bland and have generated little excitement or opposition. Statues that celebrate the Reverend Martin Luther King Jr., the most ubiquitous of the genre, are the exception. They continue to be erected, and in a striking number of instances they have been the foci of bitter struggles over their representation of the man. The most common criticism: "It doesn't look like him," as Katapodis claimed of Birmingham's King. An explanation for both the popularity and the contentiousness of King monuments lies in the roles they, alone of all other civil rights and black history monuments, are assigned. King's image is expected to be an agent of social "integration," to stand for some panracial form of the "Beloved Community" that he often preached. This is a role particularly favored by whites and by politicians of all stripes, who want to see the years since King's assassination as a time of progress and as a basis for creating a political order free of the racial divisions of the past. But many African Americans view King as a champion and intercessor, as suggested by the actions of the black women who scattered their mother's ashes around his image. The inexact fit between the fusionist political understanding and the racially based understanding of King has generated conflict over several King statues. Which King will be celebrated in the public landscape? The discussion is typically framed as debate of over the monuments' physical and spiritual likeness to their original.[2]

On November 27, 1962, the Reverend Martin Luther King Jr. spoke at Booker T. Washington High School, Rocky Mount, North Carolina's segregated institution for African Americans. There he delivered what locals like to think of as the first, or at least an early, version of the "I Have a Dream" speech that roused the March on Washington the next August. This speech provided a pretext for Rocky Mount officials, seeking to mend the political and racial divisions that marked the city in 1997, to discuss honoring King with a park and a monument. In 2002, a statue was commissioned from Illinois sculptor

Erik Blome and installed in the newly created Martin Luther King Jr. Park, a few blocks from the site of the 1962 speech. The seven-foot bronze figure stands on a pedestal atop a low rise in the otherwise flat and open park (fig. 24). At the foot of the hillock, a spiraling flagstone walkway, interrupted by nine black granite tablets engraved with excerpts of King's speeches at the March on Washington and in Memphis, threads through a circular concrete-paved plaza surrounded by trees and furnished with three black granite benches. The stone portion of the walkway is laid in varied patterns "to represent people of different creeds, colors and nationalities." A fountain formed of a rough, black stone with a keyhole-shaped trough anchors the center of the spiral. In the keyhole's basin is a polished, black marble sphere engraved with a map of the continents, washed with water. King stands on his pedestal above the plaza, dressed in a suit, legs slightly spread and arms folded, looking serenely off to his left. In his right hand, almost hidden by his left elbow, he holds a pen.[3]

The crease and texturing of King's trousers are interrupted a few inches above the cuffs where the figure was sawn off to remove it from its base, then reattached a few years later (fig. 25). That indentation is the only trace

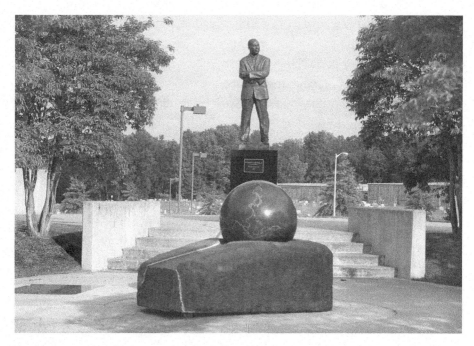

Fig. 24. *Martin Luther King, Jr.* (Erik Blome, 2002), Rocky Mount, North Carolina.
Photo: Dell Upton.

Fig. 25. *Martin Luther King, Jr.* Detail showing weld where figure was reattached to its feet. Photo: Dell Upton.

of a bitter struggle that erupted soon after the statue was installed, when the local newspaper reported that some residents were "asking who is that man on the podium? No matter how much some people squint, the larger-than-life bronze sculpture doesn't resemble King. The nose looks about right, but the eyes and the brow look like someone else entirely." The newspaper sided with the monument's critics: "The city paid [sculptor Erik Blome] $55,800 to make a sculpture of King, not something of King's spirit which happens to look nothing like him.... The MLK Park is ... not meant to cause confusion, division and strife. And it shouldn't need a plaque to tell us who the statue is supposed to be."[4]

African American community leaders, some of whom had known King personally, demanded that the monument be altered or removed. "We don't need no compromising. That statue has got to go," argued the Reverend Dr. Elbert Lee, pastor of North End Missionary Baptist Church. The local chapter of the NAACP concluded that "the statue does not look like Dr. King and does not depict the dignity and honor accorded to his bearing.... The individuals involved in the selection process did not inform the city council or public that the likeness did not look like Dr. King." At a mass meeting, one audience member said that "she was blind, [but] she could touch the sculpture and still tell it wasn't King," although she didn't explain how she was able to do so when the head of the statue was more than ten feet above the walk. Lillie Solide, of Voices for Effective Change, told reporters that "it's important that the statue look like King so that children who visit the park will know how he looked. 'Nobody can identify that statue,' she said. 'In order to honor him, it should look like him.'" Henry V. Davis added another dimension. Not only should the statue look like King, but "the whole memorial, including the statue, should clearly invoke [sic] King's image. Davis said he didn't like the pose because it looks like the person was arrogant." That is, it misrepresented King's character as well as his appearance.[5]

The uproar caught city officials by surprise, since a fourteen-inch-tall maquette of the statue had been exhibited publicly at the city' arts center and illustrated in the *Rocky Mount Telegram* without provoking objections. "As an individual, what we're looking at is a sculpture," one official said, "There's no way it would look exactly like the individual"—a sentiment echoed by one

city councilman, who observed that "bronze statues are rarely exact." A councilwoman thought it better than Raleigh's statue of King, while others urged dissidents to focus on the park's message of unity rather than on the monument's perceived shortcomings (see fig. 3). The dispute became an issue in the next city council election, with candidates offering their opinions about the quality of the monument and its appropriate fate.[6]

As the dispute accelerated, the city formed a steering committee consisting of council members, the city manager, and the Reverend Lee. It was soon enlarged to eleven members as the thorniness of the problem became apparent. Having delayed the dedication of the park and the monument, the city was then asked not to hold a celebration of the fortieth anniversary of Dr. King's Lincoln Memorial speech there, on the grounds that it was "insensitive" to those who disliked the statue.[7]

Sculptor Erik Blome's active and occasionally intemperate interventions fanned the flames. Noting that he had earlier create sculptural portraits of Rosa Parks, Thurgood Marshall, George Washington Carver, Duke Ellington, Michael Jordan's father, and even King himself without having been accused of faulty depiction, Blome argued that the statue *did* resemble King. He repeatedly identified himself as an artist, and he challenged local citizens to make their own statue if they liked. "Artwork is not a body cast of a human being . . . It's a person's interpretation. I put my heart and soul into that sculpture." The city review committee responded, "We don't want an interpretation."[8]

As the review committee deliberated, Blome offered to create four reliefs for the base of the statue, a $30,000 value in his own estimation, at no charge. They would "complement the sculpture that is there with more images of King." He declined to rework the head but proposed to make a second statue for a second full fee.[9]

The statue committee, as it was popularly known, quickly concluded that the existing statue must go. At first they thought that Blome should be given the opportunity to "save face" by meeting with the committee to arrive at a solution. After conferring with Blome, the committee asked the city to rehire him to create another sculpture, with the four proposed reliefs added gratis. The lone dissenter, Kimberle Evans, doubted that Blome understood what the city wanted: "an exact likeness of King's facial expression." Rocky Mount offered the sculptor a $54,000 contract for a new figure that would represent King in a "photo-realistic" manner and would include the four reliefs, to be based on photographs mutually acceptable to Blome and to the city. A few days later, however, the statue committee voted to rescind its endorsement

of Blome after hearing from Kenneth Washington of Roanoke Rapids, North Carolina, who told them he could obtain a better figure from the Guangzhou Academy of Fine Arts for $20,000 less than Blome's fee. "I believe I could provide a more accurate image of King at a much more affordable cost for Rocky Mount," he said. Washington also offered to pay the costs of shipping himself, and he guaranteed that the city would not have to pay anything if the statue was not satisfactory. One skeptical committee member told Washington, "Your proposal sounds like (something a) used car salesman would deliver."[10]

Before the committee could draft a call for proposals for a replacement monument, its chair and senior African American member, the Reverend Lee, resigned, complaining that the committee had lost its focus. Lee was particularly frustrated that the members were "bogged down in irrelevant debates" about whether the sculptor should be American. Committee member Penn Stallard had worried aloud about the outsourcing of jobs to China, whereas Lee thought that if the quality were good, the origin didn't matter: "A lot of products people purchase in the United States are made in China, Lee said." Stallard responded that she didn't think that "the community wants a 'Wal-Mart' statue for King."[11]

After receiving proposals from a variety of sculptors for projects ranging from statues to busts, at prices ranging from $35,000 to $200,000, the committee selected Jeffrey Hanson Varilla and his Koh-Varilla Studio, creators of King statues at the University of Texas and in Roanoke, Virginia. The committee was encouraged by the Austin statue's "close likeness to King." It was also intrigued by proposals from sculptors Stephen Smith and Ivan Schwartz, and attempted to negotiate prices with all three. Varilla's $140,000 fee, reduced from $173,000, was sobering.[12]

Rocky Mount searched for funding ideas, including selling Blome's statue to help pay Koh-Varilla's fee. At the same time, they tried to negotiate a price similar to Blome's, which the sculptors thought would "damage their negotiating power for commissions on other pieces." They suggested conserving materials by changing King's garb from clerical robes to a business suit, but eventually the price was too steep. Stephen Whyte, a California sculptor, offered to take the original statue and credit $55,000 toward his $140,000 fee for a new monument of his design. He also proposed to do his work in public view via the Internet to forestall objections to the likeness and to have the finished monument ready for the following January's Martin Luther King Jr. holiday. Whyte intended to use the same pose as Blome's statue. His willingness to work quickly and to allow public input convinced the city council to

place its hopes in Whyte. However, Whyte's work met nearly as much public opposition as Blome's had. Among city residents polled by the city staff, 153 did not like the statue, 54 did like it, and 31 more preferred to retain Blome's. By this time, Blome's King had been sawed off at the ankles and moved to a warehouse.[13]

After three revisions and Whyte's multiple delays in meeting deadlines, his contract was canceled by a vote of four to two. The city council voted at the same time not to restore the original statue to its base, in light of the vociferous opposition to it. One councilman proposed using the pedestal for an eternal flame or other alternative to a figural sculpture, which another endorsed: "Since getting a statue that looks like King has proved to be such a subjective nightmare, he said, he has simply lost faith in the city's ability to do it." Correspondents to the local newspaper weighed in with a variety of alternate proposals, ranging from "something … that symbolizes American freedom" to an engraved list of "black Americans who have made a difference in our lives today" or a statue of Rosa Parks.[14]

The Rocky Mount controversy attracted widespread attention, including two articles in the *New York Times*. National reporters ruefully described the "grumbling" and "wrangling" among Rocky Mount blacks, whom they accused of lacking the spirit of unity in which the statue was offered. They sided with Blome, depicting him in his own terms as the victim of provincial philistinism at best and of racism at worst. Many local commentators, black and white, also believed that the statue's opponents had missed the point. "Dr. King's image and what he stood for means more than a lot of controversy over a statue," said a woman who had known King personally.[15]

Critics faulted varied aspects of the work. Some viewers claimed that they could not tell "who that man in the park was." One thought that the figure looked "like a black slave," while another declared that "he looked like a white main painted black." Others were more specific. "The lips, the eyes, the moustache, the cheeks. It doesn't favor him." To Blome such remarks, as well as the demand for a "literal" rendition of King's appearance, betrayed an abysmal ignorance of art. He told a British reporter, "I don't think the people of Rocky Mount have any public art. They have a different mentality to, say, what you might find in a city where they are used to art."[16]

Certainly much of the debate treated the image of King as fixed. Few critics noted that viewpoint — whether one viewed an image from below or at eye level, whether one saw the work in strong or weak light — would affect one's perception of a statue as much as of a living human being. Even less attention

was given to the ways we perceive living faces—that they are masses of tiny muscles that are constantly in motion. Our sense of the way a person "looks" is a remembered synthesis of the countless temporary faces that a living person displays. A person looks least like him- or herself, or like our memory of him or her, when the face is completely at rest—asleep or dead. A statue's face is static, and only a few sculptors have ever succeeded in making bronze or marble resemble living flesh. Thus, a portrait of any sort, but particularly a statue that lacks naturalistic coloration, can only approximate the appearance of a living human being, much less a particular one.

Some Rocky Mount citizens, including critics of Blome's work, did acknowledge the contingency of facial recognition. City Councilman Lamont Wiggins acknowledged that "how you perceive a person, especially a person such as Dr. King, depends on at what point in time and at what era in his life and in what medium you actually met him—if you met him as a minister in a church, if you met him as an activist on the street, or if he was sitting in a restaurant at your dinner table." The debate over likeness, however, was a way of discussing the nature of portraiture and the purpose and reception of public monuments. Is it possible for statues to be exact likenesses of their subjects—to be "photorealistic," as some demanded? Should they be? The question of likeness is at once fascinating and vexing for scholars of portraiture. Popular culture treats "photorealism" as a real possibility. In his decision in the matter of *Barnes v. Ingalls,* Alabama judge R. W. Walker wrote in 1863 that

> a most important requisite of a good portrait is, that it shall be a correct likeness of the original and although only "experts" may be competent to decide whether it is well executed in other respects, the question whether a portrait is *like* the person for whom it was intended is one which requires no special skill in, or knowledge of the art of painting to determine. The immediate family of the person represented, or his intimate friends, are, indeed, as a general rule, the best judges as to whether the artist has succeeded in achieving a faithful likeness. To eyes sharpened by constant and intimate association with the original, defects will be visible, and points of resemblance will appear, which would escape the observation of the practiced critic.... The fact of *likeness,* or resemblance, is one open to the observation of the senses, and no peculiar skill is requisite to testify to it.

By definition, however, a portrait differs from its subject—it is *not* the subject, so it can only be *like* its subject. The question arises how much perceptible difference is allowable while still considering a portrait a "true" likeness? For those who were dissatisfied with Blome's work, the answer was none. "I know an artist is probably going to say this is an interpretation of Dr. King.

That's not what we're looking for," Rocky Mount resident Allen Mitchell told a reporter.[17]

Mitchell's comment touches on a central aspect of portrayal: a portrait presents both a likeness, meaning a visual resemblance, and a characterization, meaning a representation of the subject's intangible personality or significance. Sometimes the characterization can be thought to carry the burden of likeness: a portrait of a ruler "looks like" the ruler if it depicts the trappings of power in a recognizable and orthodox way. Whether one has ever seen the person or not, there is no doubt that the figure in the painting is a good characterization. Sculptors have tried to characterize King, who had no formal paraphernalia of office, through his pose and incidental accoutrements. He is sometimes dressed in clerical robes (Raleigh, Austin), or he is posed in ways that suggest that he is speaking (Charlotte and Fayetteville, North Carolina; Roanoke, Virginia), which was the context in which most Americans saw the living King, whether in person, in still photographs, or on television.

Characterization of this sort is important to critics of King monuments. It was a secondary issue in Rocky Mount and a major one, as we shall see, at the national memorial in Washington, DC. In popular discourse, though, characterization requires close likeness. The more an image "looks like" King, the more it conveys his importance and his message. To my knowledge, this claim has never been made for portrait statues of other widely known civil rights figures such as Medgar Evers, Andrew Young, Rosa Parks, or Coretta Scott King, or of locally familiar activists such as A. P. Tureaud of New Orleans or the Little Rock Nine (see fig. 6).

King holds a special place in the popular imagination despite the efforts of both historians and of former participants to demonstrate that the civil rights movement of the 1950s and 1960s was much broader and more varied than what he did and said. To many blacks and some whites, King was the closest thing to a saint that a Protestant Christian can imagine, and indeed his image can be found in many African American churches, where it is sometimes given equal prominence with images of Jesus. Like traditional Christian saints, King is often described as both a charismatic leader and as an intercessor or defender, as one man told a Birmingham reporter when the King monument there was unveiled. S. J. Stephens, who was seventy-seven in 1986, recalled abuse he had suffered from the police as he passed through Kelly Ingram Park. "But Dr. King, here, he's helped change all that. . . . Now when I walk through here, I know that I'm going to be treated like a human

being," he told a reporter. "Mr. King helped us get rid of that old 'Boy, do this' and 'Boy, do that' stuff. Now when white people talk to me . . . they call me Mister Stephens. . . . That's nice."[18]

For many people, then, a King statue is a kind of religious icon, and icons have historically derived their power from their authenticity. This sense of the spiritual power of an image has survived from the ancient world into the present. An authentic image allows a viewer to experience a god's or a saint's gaze and power. Art historian Hans Belting observed that icons of modern-day saints often take the form of photographs, which are popularly thought to be inherently truthful.[19]

Many of those who criticized the Rocky Mount statue's likeness to King thought that it lacked the power to convey King's message and his greatness to those who had not known him personally. "It's important to capture his likeness, because it reminds people what he said and who he was," according to City Councilman Reuben Blackwell. He explained that future generations would no longer have had direct experience of King. "When we're four generations away, will people still remember who he was and what he looked like?" he asked. "It's not as difficult to find statues that look like other important Americans, such as George Washington and Abraham Lincoln," he added. A poor likeness "hurts the children," said another critic.[20]

The obvious response to Blackwell's argument, and one that was voiced in Rocky Mount, is that there are so many photographs of the Reverend King that it is difficult to imagine that any child of a future American generation would *not* know what he looked like. "If you want to see exactly what he looked like, put a picture of him up on the pedestal," wrote a correspondent to the local newspaper. For those who saw the King statue as an icon, though, a statue's three-dimensionality was important for both likeness and characterization. The experience of common space, of the statue's and the viewer's occupying the same existential realm, facilitates the sense of power and of shared identity. It encourages the viewer to confront the statue as another person rather than as an image. To show King, say, among a group of figures depicting a familiar incident of his life would be to place him in a different space into which the viewer peered, as into a television screen or onto a dramatic stage. But to view a bronze King by himself is to step out of the naturalistic world and to interact ritually with a man who still possesses a saint's power. As art historian Jaś Elsner observed of ancient Roman worship, "The viewer enters the god's world and likewise the deity intrudes directly into the viewer's world in a highly ritualized context."[21]

For a significant portion of its audience, then, a statue of King depicts not biography but character. This is evident in the secondary debate over the statue's pose: arms crossed, (nearly invisible) pen in hand, legs slightly apart, staring directly ahead. Some viewers saw this as "arrogant" (fig. 26). Blome explained that this stance was taken from Bob Fitch's classic photograph of King (fig. 27). A pensive King is viewed from the side, standing behind a desk, arms crossed, and pen in hand, with a photograph of Mahatma Gandhi framed by the intersection of his body and the desk's surface. King's head is turned a little to his left, as though considering some person or object out of the frame. This was a carefully staged image. Fitch posed King near a desk that was better-lit than his own and moved the Gandhi photograph from King's office to include it in the shot. The significant difference is that in the photograph King is not facing the camera. The Gandhi image in the background softened any impression of confrontation, and significantly, King's legs are not shown. This may account for the differences between the ways Blome, who knew the photograph, and Rocky Mount critics viewed the statue, but to some extent it was beside the main point, which was that it did not matter that King had been photographed in this pose. What mattered to critics was that this stance did not correctly characterize Dr. King as they understood him.[22]

For some opponents of Blome's statue, the sculptor's race was an issue. According to vocal critic Kimberle Evans, "I think a black person can relate to what we wanted. . . . When Erik Blome said [in an op-ed piece in the *Rocky Mount Telegram*] he wanted to do a quieter side of Martin, he wasn't relating to me." When he was interviewed about the controversy by the *New York Times*, prolific Denver sculptor Ed Dwight gave the racial issue an essentialist spin. " 'White people don't look at us the way we look at ourselves. . . . I compete with many white artists all over the country, and they bring their maquettes in and they don't look anything like the subject.' . . . Mr. Dwight, who has crafted more than 400 pieces of Dr. King, added, 'It's a cultural thing, a very, very spiritual thing.' " Remarks like these led many whites, including the sculptor, to portray the monument's detractors as racists.[23]

Local commenters were more nuanced. They spoke in terms not of a reified racial spirit or way of seeing, as Dwight did, but of common experiences of the travails of segregation and the civil rights movement. Even bitter critics of the statue such as the Reverend Lee were willing to give Blome another chance. When they turned to other sculptors they recommended, in succession, two other nonblack candidates. Most critics realized that to choose a black sculptor did not guarantee a better outcome, since the matter was one

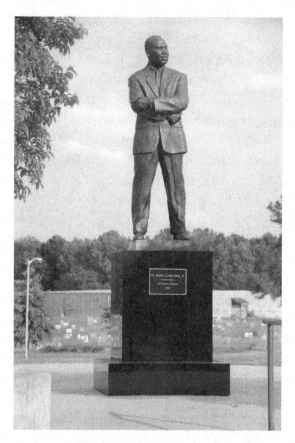

Fig. 26. *Martin Luther King, Jr.* Photo: Dell Upton.

of individual skill and understanding rather than of racial identity. African American council member Angela R. Bryant, who was sympathetic to the criticism of Blome's statue, told a reporter that "there are some people who would prefer a black artist and would seem more confident that a black artist would connect with the impression of the likeness. . . . But the experience throughout the country has been that that isn't a guarantee." She may have been thinking of Charlotte, North Carolina's King statue, created by renowned African American sculptor Selma Burke. When it was unveiled in 1980, this monument was treated to a barrage of criticism over its likeness to King that was similar to, but shorter-lived than, that in Rocky Mount. With perverse pride, a local blogger still reminds his audience annually that Charlotte can boast "the World's Worst Martin Luther King Statue."[24]

Five years after the Rocky Mount statue was removed, nine of the ten members of the city's Martin Luther King, Jr. Commission began to press for

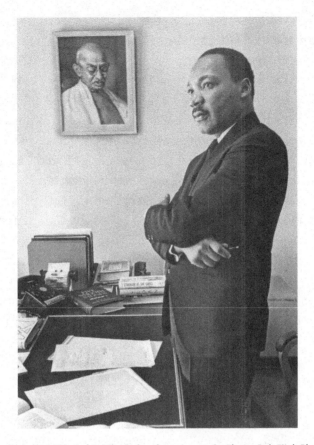

Fig. 27. Martin Luther King in his Atlanta headquarters, 1965. Photo: Bob Fitch Photographic Archive, © Department of Special Collections, Stanford University.

its return to its base, in part to alleviate the "barren appearance" of Martin Luther King, Jr. Park. After a year's discussion, the city council voted five to two to reinstall the work. Councilman Lamont Wiggins, who voted to restore the statue, said the city had "made a good-faith effort to get another statue or memorial to King but that didn't pan out." In May 2007, Blome's statue was restored to its pedestal, and the park was finally dedicated that August. The controversy was almost, but not quite, over. As recently as October 2011 the Reverend Elbert Lee, original head of the statue committee and an early opponent of Blome's work, "commended the City Council for its efforts to erect a statue honoring the memory of Dr. Martin Luther King, Jr. in Martin Luther King, Jr. Park and for the beautiful park, but stated that the statue does not look like Martin Luther King, Jr. He stated he is willing to contribute funds and solicit additional funds to replace the statue with a statue with a better likeness."[25]

The Rocky Mount debate was at its core a struggle over the meaning and audience of the statue. If it was an icon, a sign and bearer of the Reverend King's power as a liberator of African Americans, then a black sculptor might be more likely than a white one to understand the power that black people saw in King, just as an icon is more likely to be thought authentic if its maker shares the viewer's faith in the saint. If it was intended instead to reconcile whites and blacks, to take the first steps toward the creation of the vaunted color-blind society, then the sculptor's race was insignificant. "This is a statue of Martin Luther King. Wasn't King about transcending race?" Blome asked. He pointed out, irrelevantly, that he had kept the Fitch photograph on his studio wall for many years, that he and his wife had adopted an African child, and that he was working on a project to encourage the adoption of Ethiopian orphans in the United States. To put it more directly, to whom did King belong? Increasingly it seemed that he belonged to whites, who claimed the final say in his representations. As one high school student explained to an interviewer, "Dr. Martin Luther King Jr. belongs to the world, but Malcolm X belongs to us."[26]

Custody of Martin Luther King Jr. and the right to define him were contested on a much grander scale during the twenty-eight years between the conception and dedication of the Martin Luther King, Jr. Memorial in Washington, DC. Despite the differences in national visibility of the two monuments, many of the same issues of likeness and characterization, of the purpose of monuments, of the relation between a sculptor's identity and his work, even of the "outsourcing" of American monuments to China roiled Washington as they did Rocky Mount.

Although few people openly challenged King's worthiness of national commemoration, the form and message of the memorial were bitterly debated up to and after the dedication. This argument transpired in two relatively discrete registers, each taking a somewhat different direction. One register was defined by the formal process of initiating, designing, and, most important, revising and approving the memorial's form, a process in which the African American fraternity Alpha Phi Alpha, which initiated and managed the construction of the monument through its Martin Luther King Jr. National Memorial Project Foundation, assisted by professional designers and managers, negotiated with Congress, the National Park Service, and various regulatory agencies, notably the National Commission on Fine Arts (NCFA, now the US Commission on Fine Arts). Discussions in this register were focused on ques-

tions of the *nature* of King's importance to American society and how best to convey this in the memorial. They were particularly concerned with the pose and facial expression of the statue and with the choice of texts to be inscribed on the boundary wall. The second register, as dense as and more broadly ranging than the first, was elaborated mostly on the Internet, on blogs and websites aimed at African Americans, at artists, and at political interest groups of various stripes. The comments readers added to those sites were as important as the original posts. The discussants in these forums, too, were concerned to define King's importance but not necessarily to a monolithically conceived American society, and they were also concerned with the ways this significance might be conveyed. In part this point was made for many of these commentators by the very fact of the monument's being constructed on the National Mall and by details of its siting there. The visual representation of the Reverend King was even more central to the public discussions than to the official one, but in addition to questions of pose and mien, popular discussion focused on likeness and on the symbolic implications of the identity of the sculptor, a Chinese national; on the process by which he was chosen; and even on the size of the statue. The participants in the first register almost never responded to or even acknowledged the second one, although the two did sometimes intersect in the mainstream press, which heavily mediated and occasionally distorted both discussions in ways that redirected them.

The completed Martin Luther King, Jr. Memorial occupies a triangular site at the edge of the National Mall's Tidal Basin, separated from it by the footpath that runs along the shore of the basin (fig. 28). Much of the site of the memorial is occupied by two large, planted berms that support a curving granite boundary wall and that help to fulfill the requirement of the National Capital Planning Commission that at least two-thirds of the site be "softscape." At the center of the boundary wall are two large mounds of granite, collectively known as the Mountain of Despair, which are meant to represent a single stone with its center ripped out. By passing between these mounds along a path that forms the main entrance, the visitor enters a crescent-shaped plaza and sees the rear of the Stone of Hope, whose sides are treated to indicate that the Stone of Hope is the missing portion of the Mountain of Despair. Together, the mountain and the stone allude to a favored metaphor of King's, "Out of the mountain of despair, a stone of hope," a phrase that is carved on one side of the Stone of Hope.[27]

As visitors move around the Stone of Hope, a colossal statue of King is revealed on the side facing the Tidal Basin (fig. 29). He stands with his legs

I WAS A DRUM MAJOR FOR JUSTICE
PEACE AND RIGHTEOUSNESS

Fig. 28. Martin Luther King, Jr. Memorial (ROMA Design Group and Lei Yixin, 1998–2011),
Washington, DC. Photo: Dell Upton.

Fig. 29. Martin Luther King, Jr. Memorial. King figure. Photo: Dell Upton.

slightly apart, arms crossed, scroll in his left hand, looking across the Tidal Basin with a slightly bemused expression on his face. At that point, a visitor might look back and note that the granite boundary walls to either side of the Mountain of Despair are covered with brief quotations from King's writings and speeches, and that the mountain itself is set off from these texts by recessed cascades of water that spill over textured stones, recalling another familiar metaphor of King's, which he derived from the Bible: "Until justice rolls down like water and righteousness like a mighty stream" (fig. 30).[28]

Low retaining walls and planters are scattered through the plaza, holding trees that will soften the glare of the summer sun on the hard stone surfaces when they mature. Most of the plaza's open space extends to the sides and rear of the Stone of Hope, meaning that most people attending a ceremony at the memorial would not have a clear view of King's image. The site plan thus severely constricts the space available for mass gatherings of the sort for

Fig. 30. Martin Luther King, Jr. Memorial. "Mountain of Despair," enclosing wall, and waterfalls. Photo: Dell Upton.

which King was renowned. Nevertheless, one of the jurors in the original competition observed that the scheme "creates a space that 20 people could be in, or as many as 300 — which seems appropriate for the King Memorial." The memorial is meant for individual contemplation rather than for mass political mobilization. The goal, according to Ed Jackson Jr., the executive architect of the project, was to move people through quickly rather than to encourage them to linger. In this respect, the monument follows a pattern, common since the 1990s, of placing monuments and other installations in public spaces in a manner that reduces their utility for mass protest. One thinks of the alterations to City Hall Park in New York and the siting of the National World War II Memorial in Washington as prime examples. The location of the World War II Memorial squarely on the axis between the Lincoln Memorial and the Washington Monument was bitterly contested as an impediment to democratic mass gatherings such as the 1963 March on Washington, where King delivered the renowned "I Have a Dream" speech that is celebrated at the King Memorial.[29]

There are other ways in which the memorial resonates with a variety of contemporary monuments. It has become something of cliché to create a landscape memorial, as the ROMA Design Group, winners of the design

competition for the memorial, labeled their scheme. By this they meant a memorial that is open to the air and comprises a mixture of text, sculpture, and open space. This is in contrast not only to freestanding sculptural monuments but also to familiar older structures such as the Lincoln Memorial and the Jefferson Memorial, both of which the focus on a colossal figure of the honoree, surrounded by quotations that are prominent but subordinate to the figure itself, all enclosed in a classical temple.[30]

Modern landscape memorials often follow the formula seen at the King Memorial: a freestanding sculptural element shares an open plaza broken by plantings and often featuring a water element. The space is defined by a curving wall covered with texts. The awkwardly titled Japanese American Memorial to Patriotism during World War II (Davis Buckley, 1992–2000), which sits a short distance from the King Memorial, is typical. As with the King Memorial, the Japanese American Memorial is replete with symbolism that must be interpreted by a park ranger or an explanatory brochure. The fountain, for example, contains five boulders representing "the five generations of Japanese Americans who were living in 1988." The enclosing wall records the names of the concentration camps in which people of Japanese ancestry were imprisoned during World War II, the numbers of people imprisoned at each, and the names of the Nisei members of the American military who died during the conflict. It also incorporates quotations from "prominent citizens" that emphasize "the universal messages of justice, equality, and liberty under the law."[31]

In many respects, the Japanese American monument can be thought of as a template for the King Memorial. The two share the use of plantings, water, walls of quotations, and focal sculptures. They also share an emphasis on a "universal" message. But there is an important difference: inscribed prominently on the lip of the pool at the Japanese American site are the words "here we admit a wrong," taken from President Ronald Reagan's remarks of August 10, 1988, when he signed a bill authorizing a token monetary restitution to those who were confined in the camps—hence the significance of the five generations alive in 1988 commemorated by the stones on the pool. The central element, a fourteen-foot-tall bronze sculpture by Nina Amaku that depicts a pair of cranes entrapped in barbed wire, evoking the concentration camps, – reinforces the message. In Japanese culture, cranes symbolize good fortune, longevity, and, significantly, fidelity. The monument commemorates and apologizes for a specific historic event while pointing to the lessons it might teach future generations.[32]

No such ambivalence clouds the King Memorial, which effectively lifts the honoree from the time and place in which he worked. This has the effect of suppressing the specific meanings of his words, reducing them to aphorisms. That was the price of a location on the Mall, a site that was ardently desired by Alpha Phi Alpha, the King family, and many ordinary African American citizens who commented on the monument at various stages of its development. "I am proud to see a large monument of an African American Man that fought for peace and justice for everyone," Claudia Brown Ukutegbe responded to an online commentary disparaging the design. A black attendee at the opening of the monument in August 2011 observed that the very fact that King's was the first memorial on the National Mall to honor an African American was "why it's got to be there." "He definitely earned it," said another black man who attended the August opening.[33]

What did King do to earn the honor of a memorial on the National Mall? As observers of all stripes noted, the King Memorial is the first on the Mall to honor an individual African American and only the second to honor a private citizen. The other major monuments honor United States presidents and veterans of various military campaigns. To put it another way, they honor those who served the state, as opposed to serving American citizens or humankind generally. Presumably King was the exception to this rule, but as the design negotiations stretched on for over a decade, he was gradually excised from history; removed from his adversarial role toward the state, its agents, and many of its citizens; and recast as a tutelary deity for the populace at large, a fount of generic and unthreatening aphorisms about "hope, democracy, and love."[34]

This wasn't necessarily what the fraternity or the designers initially had in mind. The official story is that in 1984 a retired army major, George H. Sealey Jr., described to friends his desire to see a memorial to a black American built on the Mall. After some discussion, the group decided that King was the proper honoree and Sealey took the idea to Alpha Phi Alpha, his own and King's fraternity. King had a special meaning for Alpha Phi Alpha. The fraternity prided itself on its longevity, claiming to be the oldest predominantly black Greek-letter fraternity and the most elite among them. King was perhaps the best known of a long list of fraternity members that included Thurgood Marshall, W. E. B. Du Bois, Jesse Owens, and many of the civil rights leaders of the 1950s and 1960s. Fraternal connections traditionally follow African American men and women much more closely throughout their lives than among nonblacks. The King Memorial served, and was widely recognized, not always gladly, as

Alpha Phi Alpha's claim to continuing preeminence in black life by virtue of its self-assigned mission as an agent of racial uplift. One member said at the groundbreaking that "Martin Luther King, as an Alpha, set the mold. . . . He is the first African American here on the Mall, just as we were the first African American Greeks. We will continue to follow in his footsteps." Although the official dedication of the memorial was postponed in the face of an impending hurricane, the fraternity went ahead with a private ceremony the Friday evening before the public one was to have been held, with members sporting the fraternity's colors on black suits or gold blazers and black-and-gold-striped bowties and waving black-and-gold flags.[35]

King was an obvious choice. He was certainly the most celebrated leader of the 1950s and 1960s black liberation movement, and his reputation was on the upswing in the 1980s. Reagan reluctantly signed the act making King's birthday a national holiday in 1983. David Garrow's admiring biography of King won the Pulitzer Prize in biography in 1987, and Taylor Branch published the first volume of his trilogy *America in the King Years*, which won the Pulitzer Prize in history one year after Garrow's win. This is not to say that King did not always have admirers or that his importance was not evident before the 1980s but that during that decade his value to all (read white) Americans was acknowledged, among other ways, by the erection of monuments in public spaces, often financed by public funds.[36]

The nature and significance of King's presence on the Mall was viewed differently by insiders and outsiders to the design process. Denver sculptor Ed Dwight, who figured briefly in the Rocky Mount controversy and even more extensively in that surrounding Washington's King Memorial, was hired to design a memorial to black soldiers who fought in the American Revolution that was also destined for the Mall. It was never built, but Dwight described it, together with the King and Lincoln Memorials, as "three legs of a stool" depicting African American history through the centuries. Instead, the King Memorial stands at the midpoint of the base of a larger, flattened triangle whose corners are defined by the Washington Monument, the Lincoln Memorial, and the Jefferson Memorial. Just below the base line between the King and Jefferson Memorials is Franklin Delano Roosevelt's. According to executive architect Jackson, the memorials defined a "path of heroes" along the Tidal Basin.[37]

Jackson told an interviewer from an African American news site that he "had envisioned from the very start, King, . . . although he was not a president, that his contribution to what America stood for and what America should be

about was equal to their contributions to the creation of America, who we are and what we stand for. So it was our obligation to make certain that the end product of how we represented his message would be just as powerful as the first lines that you read when you walk into the Lincoln Memorial." The price of "universalizing" the King Memorial was to excise it from American racial history.[38]

The origin of the King Memorial, then, lay in a desire for a black presence in the monumental Valhalla of the Mall, a common impetus for African American monuments in many cities and a desire echoed by many lay observers of the creation of the King Memorial. Alpha Phi Alpha lobbied Congress for several years. Finally, in 1996, President Bill Clinton signed an act authorizing a monument to Dr. King to be built in the District of Columbia. The foundation to carry on the work, organized by the fraternity in 1998, was approved by unanimous resolutions of the House of Representatives and the Senate. Almost immediately the foundation announced a design competition that drew nearly nine hundred entrants. The victors, ROMA Design Group of San Francisco, teamed with the firm of Devrouax and Purnell to design the final product. Eventually both withdrew and were replaced by the historic African American architectural firm McKissack and McKissack, who refined the design in consultation with the Turner Construction Company. At every stage, the process was overseen and sometimes redirected by governmental entities, including the National Park Service, which had responsibility for the Mall and would ultimately take custody of the monument; the National Capital Planning Commission; and, most important, the National Commission on Fine Arts. The finished work closely resembled the competition design, but with a number of relatively small changes. Most of these were based on incidental practical and aesthetic considerations, but some, as we will see, critically affected, and in some cases redefined, the work's message.[39]

Historical consciousness, uplift, and the quest for wider African American visibility were evident in the winning design for the King Memorial. The boundary wall was to be punctuated by twenty-four niches that would honor other figures from the civil rights movement of the 1950s and 1960s such as Rosa Parks and Fannie Lou Hamer, thus locating King as one actor, albeit the most significant one, in a specific historical moment. It would have recognized that history as one in which men and women from a variety of backgrounds participated. For example, King was a product of the black clerical elite and held a doctorate. Parks had a high school education, worked her way into the urban middle class, and was trained in sophisticated political ideas

by labor unions and the NAACP. Hamer, a poor resident of a rundown hamlet in the Mississippi Delta, dropped out of school after the sixth grade. All three participated in the movement in different ways, through varied routes, and with differing mixtures of motives and skills.[40]

When the design was presented to the National Commission on Fine Arts in 2002, the commissioners demanded that the niches be removed. The architects responded by reducing the number to fifteen before the commission saw the design again in October 2005, but the pantheon was doomed. Ed Jackson Jr. informed the commission that "the sponsoring foundation has clarified the memorial's focus to include Dr. King's broader impact on issues of universal importance, extending beyond the civil rights movement within the United States." He described the monument's themes as "justice, democracy, and hope," which had been included in the competition brief, "as well as the additional theme of love for mankind," and assured his audience that the texts inscribed on the monuments "would be chosen to emphasize these themes." By March 2006 the niches had been excised altogether, and with them King's connection to other figures of the historical civil rights movement.[41]

Dehistoricized, King's words, spoken and written as political acts in the heat of a bitter struggle, became his "teachings." The planners' focus turned to the selection of excerpts to inscribe on the memorial. The initial efforts combined often-elided quotations from disparate writings into synthetic texts that both the National Park Service and the National Commission on Fine Arts challenged. Architect Jackson responded that the omitted passages "were references to specific locations—Vietnam and Montgomery, Alabama. The foundation's intention was to make the inscriptions universal and avoid making references to specific cities and countries." James Chaffers, a member of the panel appointed to select the texts, described a difficult process, "with the eventual consensus that the emphasis should be on how Dr. King's values could influence our daily lives and character, rather than emphasizing his own times; the result would be a 'living memorial' that would inspire generations."[42]

The texts were not finally approved until the fall of 2010, when the commission and the foundation clashed again over the issue of the quotations' authenticity. Jackson assured the commissioners that the quotations had by then been "fully researched" for accuracy. Commissioner Witold Rybczinski challenged the use of "bibliographic" citations that might "detract from the intended uplifting effect of the quotations." This was not customary for quo-

tations carved on buildings and monuments, he said, and "the bibliographic information has a bureaucratic character that is not uplifting." National Park Service representative Peter May responded that "the members of the public take a close interest in the accuracy of quotations on existing memorials," but Rybczinski held his ground against this "bureaucratic tendency."[43]

The most significant change involved the inscriptions on the Stone of Hope. As imagined by ROMA, the sides were to be inscribed with two passages from King's "I Have a Dream" speech, delivered at the Lincoln Memorial on August 28, 1963. One was the mountain of despair–stone of hope passage that provided the visual theme for the King Memorial. The other was a lesser-known passage sometimes known as the "Promissory Note," in which King explicitly described the nation's ongoing failure to extend to African Americans the benefits guaranteed in the Constitution and the Declaration of Independence. "When the architects of our republic wrote the magnificent words of the Constitution and the Declaration of Independence," King declared, "they were signing a promissory note to which every American was to fall heir. This note was a promise that all men, yes black men as well as white men, would be granted the unalienable rights of life, liberty, and the pursuit of happiness." Black Americans had come to Washington to collect on that note. But, he said, "it is obvious today America has defaulted on the promissory note in so far as her citizens of color are concerned.... America has given the Negro people a bad check." To include this text (or the first sentence of it) on the memorial would be to imply the kind of apology inscribed in Reagan's words on the Japanese American Memorial and it would imply a still-outstanding debt, particularly since the ROMA designers envisioned that King's hand would grasp a pen, as in the original photograph, that would point toward the promissory note. As the design of the memorial was vetted and altered, these words disappeared and the pen was replaced by a scroll. No outstanding debt to African Americans would be acknowledged.[44]

The promissory note was replaced by a short phrase in which King declares, "I was a drum major for justice, peace and righteousness." These words embodied the abstract, nonspecific qualities that the planners believed rendered King's words "universal," but they also represented a misquotation, or at best an elision, of King's words. The full quotation is derived from "The Drum Major Instinct," a 1968 sermon that decries attention seeking, "the desire to be important, to surpass others, to achieve distinction" effortlessly. King concludes by speculating about what might be said of him at his funeral: "If you want to say that I was a drum major, say that I was a drum

major for justice; say that I was a drum major for peace; I was a drum major for righteousness. And all of the other shallow things will not matter. I won't have any money to leave behind. I won't have the fine and luxurious things of life to leave behind. But I just want to leave a committed life behind."[45]

Critics immediately attacked the abbreviated text, vindicating Peter May's observation that the public indeed scrutinized monument inscriptions. A *Washington Post* editorial writer pointed out the truncation, and the writer Maya Angelou, who had served on the committee that chose the quotation, declared that the result made King look like an "arrogant twit." Ed Jackson proposed to add words to the beginning and end of the inscription to "contextualize" it, but National Park Service officials determined to remove the inscription and to replace it with the full quotation. Jackson and his employers at the foundation dug in their heels, arguing that the decision had been made without consultation and that the Stone of Hope had been designed to accommodate the quotation as it appeared. Both sculptor Lei Yixin and inscription carver Nick Benson "felt that the inscription should be 'very brief and succinct,'" Jackson said. Moreover, to excise the quotation and replace it would create a visible color difference that would belie the fiction that the Stone of Hope was a monolith pulled from the Mountain of Despair. The controversy should have been no surprise. When the truncated quotation was first presented to the National Commission on Fine Arts in 2007, Rybczinski "explicitly urged that the full quotation from Dr. King about being called a 'drum major' be used; Mr [Earl] Powell [the commission chair] and Ms. [Pamela] Nelson [the vice chair] concurred that the full original quote is stronger than the excerpt. Dr. Jackson agreed to make this change," but he never did.[46]

As the planners and the regulators were debating the choice of King's words, they were also negotiating the details of the King statue. ROMA's winning competition entry envisioned a figure of King emerging from, or perhaps merging into, the Stone of Hope. The image survived the entire decade's vicissitudes of planning and construction, but the details of that image proved vexatious, as the parties struggled with everything from the degree to which King's body should merge with the Stone of Hope to his facial expression.[47]

King's pose was based on the same Bob Fitch photograph that Blome had used for the Rocky Mount statue (see fig. 27). In 2007, the foundation introduced Chinese sculptor Lei Yixin as sculptor of record. He would be responsible for transforming the historic photograph into the three-dimensional Stone of Hope. As Lei's interpretation took shape, commission members began to question the nuances of the pose and of the figure's integration with

the stone. In the version presented in April 2008, said Earl Powell, "the original concept of the figure emerging from the stone has now shifted to a more centralized and static figure," with the figure protruding more from the stone and posed less dynamically. Commissioner Diana Balmori, a landscape architect, added that the figure "appears to be applied onto the stone, whereas the original concept had a more integral relationship." Powell, Balmori, and Commissioner John Belle praised "the off-center dynamic stance of the original concept" as superior to the version presented by Lei and Jackson. Commissioner Michael McKinnell "emphasized the symbolic importance of Dr. King's image 'being merged with the natural force of the stone'—an important metaphor for the memorial—rather than depicting him through the 'colossal monumentalization' that has acquired a negative connotation. He added that 'the degree to which the metaphor of the stone and the man become one is absolutely imperative here.'" Powell condescendingly directed Lei to "the sculptures of Michalengelo [sic] and Rodin as successful examples of a figure emerging from stone."[48]

The extended discussion of the Stone of Hope marks the National Commission on Fine Arts's deepest intervention into how the King Memorial would characterize its subject. As art historian Michele Bogart has shown, agencies such as the commission, appointed to oversee the embellishment of their home cities, mix aesthetic, historical, and political considerations in uneasy and often unacknowledged measures. They are typically appointed from the artistic and social elite of their locales, and they view their own aesthetic preferences as the most appropriate vehicles for creating a popular consensus around communal, social, and political values. At the time the critical issues of the King Memorial's design were considered, the National Commission on Fine Arts was chaired by the director of the National Gallery of Art, with a Texas artist and contributor to then-president George W. Bush's campaign as vice chair. The other members were nationally known artists, architects, and landscape architects. The critiques of Lei's design for the Stone of Hope drifted from the formally aesthetic to issues of the proper characterization of the subject. In doing so, the discussion inevitably became political.[49]

The debate began as the commission considered the figure's integration with the Stone of Hope. Chair Earl Powell "questioned whether the rigid pose is the best way to express Dr. King's personality." John Belle added that "the current proposal has a more confrontational stance which is not appropriate." As in the choice of quotations, which was largely the work of a committee appointed by the foundation, the commission sought to soften King's image,

to treat him as a gentle shepherd rather than as a radical critic of American society and government, an analyst of economic as well as political injustice and, in the last years of his life, a trenchant critic of American militarism. As King delivered it, the "I Have a Dream" speech celebrated at the King Memorial combined the optimistic passages inscribed there with an unblinking denunciation of the desperate condition of blacks in 1960s America. His arguments could well be considered "confrontational," yet neither the commission nor the foundation was comfortable with them. Commission secretary Thomas Luebke told a reporter, "I don't know that most people would say, 'Dr. King, he was really a confrontational guy.'" King's nephew Isaac Newton Farris responded, "They're saying it looks too confrontational. . . . I'm saying, what do you think he was doing?"[50]

Rather than seeing Lei's "confrontational" King as a kind of native prophet, the commissioners chose to liken it to "colossal human sculptures [that] are rarely created in modern times. [McKinnell] said that recent imagery of such sculptures includes television broadcasts of these statues being pulled down in other countries, a comparison that would be harmful to the success of this memorial." In his formal letter conveying the commissioners' conclusions to Joe Lawler, the National Park Service's regional director, Luebke wrote, "The Commission members [believed that the Lei design] featured a stiffly frontal image, static in pose, confrontational in character—and appearing as if it had been affixed to the surface of the Stone of Hope." Moreover, they "found that the colossal scale and Social Realist style of the proposed statue recalls a genre of political sculpture that has recently been pulled down in other countries. They said that the proposed treatment of the sculpture—as the most iconic and central element of the memorial to Dr. King—would be unfortunate and inappropriate as an expression of his legacy." The commission believed that the problems it identified could be addressed formally by pushing the figure deeper into the stone, "with increasing detail and emphasis on the upper part of the figure."[51]

At the next commission meeting, architect Jackson read a formal response to the commission's criticism. The foundation had rejected two earlier artists' proposals, he said, because they "depicted Dr. King embedded deeply in the Stone of Hope, which the Foundation concluded would conflict with the intended metaphorical emergence of hope and freedom." He also claimed that, contrary to the commissioners' recollections, all earlier versions of the Stone of Hope had centered the statue. Jackson cited Fitch's photograph as justification for the statue's pose, although "the sculpture was not intended

to represent a single historic photograph but to convey Dr. King's spirit." He added the King family was happy with the stone in its current incarnation but acknowledged that the foundation and the family continued to discuss whether the statue's face ought to have "more of a smile ... as opposed to a concerned look."[52]

The last point refers to the "softening of Dr. King" that foundation director Harry Johnson had promised soon after the April meeting. Lei produced three alternative versions of King's head as possible ways to "soften" his expression. The primary differences lay in the relative prominence of the furrowed ridges between his eyebrows and the varied narrowing of his eyes. In the end, the King family, granted the decision-making prerogative, chose the original.[53]

Popular discussion of the King Memorial, generally characterized by dissatisfaction with both the process and the result, began in earnest with the appointment of Lei Yixin in early 2007. Lei was chosen, the foundation said, "because of his talent, [his] vast expertise working with granite, and his experience with sculptures on a grand scale. Master Lei is considered both a national treasure of China as well as a first-class sculptor." Ed Jackson particularly emphasized Lei's reputation as a carver of human faces.[54]

The choice of a nonblack sculptor generated heated discussion, much of it accelerated by attacks mounted by disgruntled sculptor Ed Dwight. The foundation had initially hired Dwight to produce a small version of the Stone of Hope to give to donors. Dwight was named sculptor of record, and he expected to produce the full-scale sculpture. He participated in the selection of Lei, he said, on the understanding that the Chinese sculptor would be his assistant. According to a foundation spokesperson, the change was "a business decision. . . . We're trying to raise money to build a memorial to Dr. King."[55]

Dwight's supporters argued that an American should carve the statue. No other nation, they claimed, would allow a monument to a national hero to be made by a foreigner. Some were adamant that it should be an *African* American, that "KingIsOurs," as an Internet crusade organized by Atlanta artist Gilbert Young put it. The argument was made on several grounds. Some, Dwight foremost among them, made essentialist claims about an inherently African American ability to "see" other blacks. Taking a position similar to that with which he had weighed in on the Rocky Mount controversy, Dwight told a reporter that Lei "doesn't know how black people walk, how they stand, how their shoulders slope." Others offered a more nuanced and experiential version of that argument, claiming that only an African American who had

been through the same experiences as King could understand and represent the true meaning of his struggle.[56]

Lei's partisans relied on the same arguments about "universality" that the foundation and the commission had voiced. King's "legacy belongs to all mankind, regardless of color, creed or geography," the *Atlanta Journal-Constitution* editorialized in response to Gilbert Young's crusade. Those who stressed the reverend's blackness were "demagogues falsely claiming him as their exclusive property." After all, the paper said, hadn't King declared that people should be judged purely on their own merits — "the content of their character — without considering race, nationality or creed"? "Either we're a colorblind society or we're not. Imagine the outcry if a sculpture for the National Mall was limited to white artists only." To make any other argument was reverse racism, a self-appointed online ethics maven scolded.[57]

There was a nonessentialist historical argument for the choice of an African American sculptor that a few observers raised and that was much closer to King's point of view than the abstraction of color-blindness. It is that color-blindness is an ideal that has not yet been achieved. As long as African Americans are demonstrably hindered by persistent structural and historical conditions that prevent their being judged on individual merit, then ostensible color-blindness merely perpetuates existing inequalities. Just before King's speech at the Lincoln Memorial, James Baldwin wrote that "as long as we in the West place on color the value that we do, we make it impossible for the great unwashed to consolidate themselves according to any other principle. Color is not a human or a personal reality; it is a political reality. But this is a distinction so extremely hard to make that the West has not been able to make it yet." This view was very close to King's, who, as Michael Eric Dyson has noted, wanted "a color-blind society, but only as oppression and racism were destroyed. . . . When color suggested neither privilege or punishment, human beings could enjoy the fruits of our common life." If that were the case, then color-blindness could apply in this instance only if true civic, social, and economic equality had been obtained. Thus, a *Washington Post* blogger reasoned, whereas it is absurd to claim that members of any particular group can be depicted only by others of the same group, the symbolic nature of a monument is such that every detail, including the identity of the maker, is important to interested parties. "In a country [where blacks are] still struggling to achieve parity with the majority," she wrote, "it just seems viscerally wrong that somebody from within that community was not chosen to do this work."[58]

For Lei's opponents, conspiracy was the only possible explanation for his selection. It was self-evident that there were Americans, especially black Americans, who were competent to do the job. They seized on the absence of a competition for the statue. Since the King memorial was being created by a private foundation, albeit in consultation with and financially assisted by the federal government, it was free to make whatever choices it liked with respect to the selection process. There was no requirement for a competition or for open bidding, which made matters worse in the eyes of critics. They did not trust the motives of Alpha Phi Alpha or its King Memorial Foundation, which some depicted as eager to sell out black interests for its members' own advancement. Lei was "hand-picked by a group of brothers who had fought for more than ten years to have Dr. King honored on the mall." Why would they do this if there were not some ignominious reasons for doing so? Ed Dwight made the widely repeated charge that Lei was chosen in return for a promised gift of $25 million from the Chinese government and a good price on the stone from which the memorial would be made, an accusation that both the foundation and China vehemently denied. Detractors found corruption in every aspect of the foundation's work. "Public and private donors are not aware [of] the extent to which MLK Memorial Project members are using funds to travel to Italy and China to inspect stones," prolific foundation critic Gloria D. Gibson charged. According to Gibson and others, a play by Clayborne Carson, editor of the Papers of Martin Luther King, Jr. and a member of the foundation board, was being produced in China in exchange for the choice of Lei. Accusations of this sort then washed back over the original competition for the memorial's design, which had received little scrutiny during the previous seven years. Now it appeared that that competition, too, had been corrupt. Carson, the head of the King Research Institute, had served as an adviser to the ROMA Design Group, the team that won the competition. "No other entrant was favored with his input," wrote Lea Winfrey Young, wife of KingIsOurs's Gilbert Young. In retrospect, it seemed that the original competition had also been rigged, a suspicion that appeared to Winfrey Young to be confirmed when [KingIsOurs] "made that bit of info public, [and] Roma quietly bowed out (didn't read about that did ya.) They were replaced by a black, female run firm from DC. Things have to 'look' right, RIGHT?"[59]

In the summer of 2007, unexpected allies shifted the attacks on Lei to another key. Prominent Chinese American anti-Communist Anna Lau lent her voice to the opposition. The American granite industry also weighed in,

disappointed that its products would not be more extensively used in the King Memorial. (Although the main elements were crafted of Chinese granite, American stone was used for some subsidiary details, which critics dismissed as "the leftovers.") Clint Button, a sculptor and the self-identified spokesman for American granite producers, allied with the Youngs' King-IsOurs campaign to protest the hiring of Lei and the use of foreign granite. Button was careful to note that his family had been granite cutters in Barre, Vermont, since the late nineteenth century, thus evoking the familiar narrative of the decline of American craft and industry in the face of foreign competition. Now the emphasis on African American identity was dropped in favor of a nationalist appeal. "We should not forget that when many of us say … King is ours, we typically mean that he is … American," Gibson wrote. The Youngs agreed: "When we say King Is Ours, we don't mean he belongs only to black people. We mean he belongs to US." The foundation, its opponents said, had "outsourced" the project to China, exacerbating America's economic decline and putting it at a disadvantage on the global stage. Americans couldn't compete for the project because the Chinese version would be "quarried/produced under virtual slave labor conditions." Far-right commentators, while not explicitly allying themselves with KingIsOurs, publicized its campaign. The Young-Button effort has never elicited a response from the foundation, nor has it been terminated by the completion of the monument. The Youngs, Button, and their supporters demanded after the dedication ceremony that the King Memorial be destroyed and replaced with another one made in the United States.[60]

The fight over the sculptor has, not surprisingly, affected the reception of the work. In this instance, Thomas Luebke's widely reported characterization of Lei's design as "Social Realist" proved decisive. Several common but questionable assumptions crystallized around it. The deepest of these was grounded in the Romantic notion that a work of art is not merely a physical artifact but a revelation of the artist's deepest personal attributes. If this is so, the artist's ethnic identity, life history, and political allegiances are all germane to understanding his or her work, and indeed the artist cannot escape revealing them. A second was to conflate "China," "Communism," and artistic style into one entity. The term "Social Realism" as Luebke used it was not coextensive with Socialist Realism but referred to an aesthetic of the 1920s and 1930s widely practiced in nations of varying political orientations, including the United States. Socialist Realism is a subset of Social Realism. The terms are similar enough, though, to reanimate Cold War stereotypes of Communism

and Socialist Realism. That Lei was from China meant that his art was automatically Socialist Realist. A campaign of Red-baiting of the foundation and of Lei followed that was uncomfortably similar to the kind of Red-baiting directed at the civil rights movement in the 1960s and that one still hears from the far right today. Others on the right assumed that the Chinese government's interest in the project served its project to "merg[e] the legacies of Mao and MLK.... Are the Chinese attempting to raise their murderous leader to the same level of respect as MLK?"[61]

Lei was depicted as a quintessentially Communist artist. His creation of statues of Mao Zedong defined him as the embodiment of the Chinese political system of *fifty years earlier*. "Lei Yixin is well known throughout China for fabricating statue(s) of the murderous Communist dictator Mao Tse Tung. This means he is a supporter of the ideology of the People[']s Republic of China, and a member of the manipulative, artistic arm of the socialist government whose job is to glorify the teachings of Mao and control anyone and everyone who would try to be like Dr. King," wrote a columnist for a self-identified politically progressive website. A conservative African American blogger agreed: "Let us remember that if Dr. King was living in China during his lifetime, he would have been arrested because China did not have Civil Rights for their people." But King was not living there, and of course he was arrested here many times, since America "did not have Civil Rights" for many of its own people either. Moreover, Lei's own history is more complex than the caricature acknowledges and makes it difficult to categorize him neatly as an apologist for the Chinese government, past or present. He has made statues of Mao, but as the child of scholars, he was also one of the educated youth exiled to the countryside during the Cultural Revolution of the 1960s and 1970s. Lei has family in the United States who fled the 1949 Chinese Revolution and who served as his guides and interpreters during his visits to Washington to work on the King Memorial. To characterize him by one group of his works is to miss the eclecticism of most public sculptors. Although some specialize in certain subjects, such as Dwight's focus on African American history, most, including many who have made civil rights memorials, lack that luxury. Sculptors of King have also made images of sports, political, business, and military figures, as well as of private clients. It is unlikely that they shared all of their subjects' political sensibilities.[62]

Lei's responses to his critics gave them ammunition. Sometimes he described the task before him as technically "not very difficult" and emphasized that his studio was lined with photographs of King from every possible angle,

which was all he needed to produce better work than any of his competitors could. As if to demonstrate the simplicity of the task, he produced a working maquette in four weeks. To be a sculptor of this sort was simply to be a skillful translator of images from one medium to another. At other times Lei seemed to accept, or to feel he had to preempt, the Romantic conception of the artist. When he was announced as sculptor of record, he claimed to have first read King's Lincoln Memorial speech when he was ten years old and to have watched "hours" of videos of King speaking in preparation for undertaking the King Memorial commission. He was inspired in his work by his subject's "passion in pursuing a dream and his faith in mankind."[63]

Lei's King came almost inevitably to be perceived as "just another semidivine communist hero ... a variant on Andy Warhol's giant portraits of Mao," as a participant in a web-based sculptural discussion group declared. Others professed to see "a certain Oriental cast to the features." These sentiments echoed widely not only in the blogosphere but among mainstream journalists such as the *Washington Post's* Marc Fisher, who charged that Lei's King has the "arrogant stance of a dictator, clad in a boxy suit, with an impassive, unapproachable mien, looking more like an Eastern Bloc Politburo member than an inspirational, transformational preacher who won a war armed with nothing but truth and words." Art critic Blake Gopnik made similar accusations. Curiously, the only critic who disagreed with the charge of arrogance and authoritarianism was Ed Dwight, who thought the figure "shrinking [and] shriveled."[64]

Throughout the planning and creation of the King Memorial, the central battle was over the characterization of King, not the likeness. Although wags claimed that the statue looked more like Eddie Murphy, Jesse Jackson, or "Hans Solo frozen in carbonite," few people other than Ed Dwight seriously questioned the statue's resemblance to its subject as they had at Rocky Mount. Dwight claimed that "the head is too small in relation to the body and sits too far back, the forehead lacks King's distinctive slope, the brow is too prominent, the eyes are too deep-set, the posture is too stiff, and the body is too thick. Also the clothing is uncharacteristically bulky, the eyes are cast down, and the look of King gracefully emerging from the rock has been replaced by a mostly separate form merely 'plastered' onto the stone." He told another interviewer that Lei "has him with this big bulky coat on and with his legs far apart. King never looked like that in his life, man. This man was a suave, silk-suit-wearing dude."[65]

Most disputed the nature of King's character and the clarity of its representation in the memorial. Was he a mild-mannered saint or a stern prophet?

A dispenser of comfort or of rebuke? Whites overwhelmingly preferred the former. They wanted to see him as "universal," as a healer, someone who appealed to their better instincts and made them see the error of their ways. They wanted a "Safe Negro," in Michael Eric Dyson's formulation. The implications were first, that those dark days are behind us, and second, that it was white agency rather than black that was important. Their consciences pricked, whites lifted blacks to equality, with the objects of their newfound sympathy playing only a passive role in the process. As political scientist Adolph Reed pointed out, such a viewpoint "implies that the black experience exists only insofar as it intersects white American concerns and responds to white initiatives." Reed went on to cite Ralph Ellison's observation that white society tends to view blacks "'simply as the creation of white men.'" Having made slaves and serfs of blacks, whites now made them citizens, coaxed along by the gentle and conciliatory tones of Martin Luther King Jr. This theme underlay the planning of the memorial at least since congressional authorization in 1997. Maryland representative Constance A. Morella, a cosponsor of the legislation in the House of Representatives, spoke of the "spirit of brotherhood and cooperation" that King promoted. "Dr. King challenged us to envision a world in which social justice and peace will prevail among all people." Since African Americans presumably didn't need help envisioning such a world, the antecedent of "us" seems clear. A *Philadelphia Daily News* editorial emphasized that "Dr. King is a hero of epochal greatness for all America, not just for one race or cause. His was a message to free, to heal, to inspire all people." To put it another way, we know better than you how King should be portrayed.[66]

The dismissal of black concerns through appeals to universalism also colored the debate over the choice of Lei Yixin and reactions to the completed monument. "Lei was chosen after an international search because of his renowned virtuosity for hewing large, lifelike statues from unforgiving granite. In other words, the content of Lei's artistic character mattered more than the color of his skin or country of origin," the *Atlanta Journal-Constitution* intoned. *Washington Post* critic Blake Gopnik argued that a great King monument "would distill out the essence of his message." Even here, white centrality in the story often crept in. One white correspondent, responding to an article about architect Ed Jackson Jr., attacked the "outsourcing" of the work, arguing that "White AMERICANS are seldom given credit for helping the Black people of the USA, but they sure as heck have done more than the Chinese toward MLK's dream."[67]

Lay commentators and established critics, including some who were sympathetic to the King Memorial, noted a glaring omission in the texts and images: the absence of references to race generally, and specifically to African Americans, who, after all, were the objects of King's efforts. *New York Times* reviewer Edward Rothstein was at a loss to explain why the memorial never referred to the civil rights struggle, preferring instead to attempt "a kind of ethereal universality." Boyce Watkins, an African American blogger, passed on an unattributed but widely believed report that "during a meeting with the heads of the committee to build the memorial . . . race and racial inequality had been deliberately excluded from all of the quotes on the MLK Memorial. According to the witness who sent me this message, the individual [foundation CEO Harry Johnson] who made the decision to leave out Dr. King's quotes on race and racial inequality felt that for his children, race isn't a factor and that he wanted the memorial to go beyond race."[68]

At the same time, many of these same commentators revealed an uneasiness toward, or even an outright rejection of, the idea that King, universal though his message might be, was the equal of his neighbors on the National Mall. This uneasiness was most evident in the ubiquitous comments about the size of King's statue compared to those of Jefferson and Lincoln that bracketed it. It is as though statue size were an absolute indicator of relative importance. After attesting that King "is one of the few undoubtedly, undilutedly great figures of the 20th century," Gopnik asked what the scale of the statue meant "other than that he counts as a really big guy in American history?" The question is fair enough, but then Gopnik felt compelled to remind his readers that the statue is bigger than Abraham Lincoln's, which is meaningless unless one thinks the disparity improper. Rothstein, too, noted the size difference without drawing out its implications explicitly. Right-wingers were less coy. "This statue—taller than both the Jefferson and Lincoln memorials—is slated to stand between them and it must be stopped. Just like the Ground Zero mosque," one wrote. All focused on the absolute size of the statues rather than their scale within their settings. None acknowledged that if we think of the three memorials in their entirety, rather than focusing exclusively on the figural sculptures, both the Jefferson and the Lincoln Memorials are much taller than the King Memorial, whose total height was strictly limited by the National Capital Planning Commission when the memorial was first approved. The Jefferson and Lincoln Memorials are visible from a distance; King's must be sought out.[69]

The black audience's response was mixed but largely favorable to the "confrontational" King. Columnist Courtland Milloy told of a black friend who

agreed that King looked confrontational, but "I love that King is looking defiant. . . . Hands crossed. . . . King looks more forceful than [President] Obama. With so many of our rights (and money) being taken away we need some cold 'Stone Leaders' to stop the assault." Milloy's own view was more cynical. He thought that King's stern mien would appeal to America's militaristic culture as well as to the black middle class, "which places a premium on order and discipline." Syndicated columnist Eugene Robinson put the matter very directly: "Given a choice between a Martin Luther King whose saintly martyrdom redeemed the soul of white America and a defiant Martin Luther King who changed the nation through the force of his indomitable will, I'll take the latter."[70]

The King Memorial that emerged from this contentious process is a curious hybrid of the anodyne and the confrontational, although the nature of the confrontation remains unnamed. Those who dislike the memorial see only the former. This memorial is "about Caucasians and their worldview." It tells "their story instead of our story . . . despite our hand in the creation of the memorial." The foundation is to blame: the King Memorial presents a spectacle of "these so-called Black people Kissing these white people's ASS for the Love of Money and selling Their Afro-American people back into slavery in modern times."[71]

It is noteworthy that the foundation was responsible for both the anodyne and the confrontational aspects of the King Memorial. The foundation's committee made the selection of quotations to emphasize the "universal" by playing down race, nation, and the politics of the 1960s. But the foundation also chose the confrontational pose. Lei told a reporter that "there was much internal debate at the foundation about how King should look. Some thought the statue should reflect King as an ambassador of peace. Some wanted to present his urbane, intellectual side. Still others wanted to make him into a towering heroic figure." The last prevailed. James Chaffers and Jon Lockard, two artists who were part of the foundation's decision-making process, reported that the foundation "wanted the statue to show King as a warrior for peace, not a placid pacifist." It appears that the foundation sought to follow Alpha Phi Alpha's mission of uplift and black visibility but was wary of the predictable bridling of the National Commission on Fine Arts at such a presentation.[72]

The process gave us a King Memorial that is neither good nor bad. Like most King memorials, it reduces the man to a few clichéd metaphors—the stone of hope, the waters of righteousness—and then visualizes these in a lit-

eral way, failing to acknowledge that visual and literary metaphors work differently and are not interchangeable. Formally and conceptually the King Memorial is a middle-of-the-road version of the contemporary American formula for large-scale public memorials. Like most of its peers, historical rough edges are smoothed off so that no one can be offended, as commenters were quick to note. Its shying away from what Michael Eric Dyson calls frankly "our blood-stained racial history" is as predictable and as consistent with most civil rights and African American history memorials as it is disappointing. The civil rights movement arose to confront this central fact of American history, one that has shaped not only black but all of American history since its beginning. Yet even in a monument to the movement's central figure, it is a truth that cannot be named. One need not fall into the trap that has captured many contemporary memorials, in which creators try to override fluidity of visual metaphor through texts and images that fix the interpretation available to the viewer, but a more historically complete presentation that allowed King to remain in his historical context and to appear as a changing human figure with many facets would have made for a richer memorial.[73]

The King monuments at Rocky Mount and Washington offer, at differing scales and degrees of complexity, a glimpse of the ghost of white supremacy that haunts the Southern memorial landscape. In both cities, African Americans and whites struggled over the issue of memorial portraiture as likeness and characterization, as a way of working out the meanings of Martin Luther King Jr. and, by extension, of the movement in which he was a central actor. The result in both cases was muddled, but in both instances whites continued to insist on the superiority—the breadth, the objectivity, the inclusiveness—of their own viewpoint and to disparage black views as narrow, self-involved, and myopic. Only in Birmingham was the tyranny of white sensitivities challenged, if not entirely overcome.

CHAPTER 4 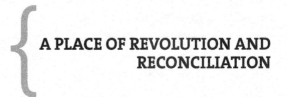 **A PLACE OF REVOLUTION AND RECONCILIATION**

It became sacred ground for us.

—THE REVEREND ABRAHAM WOODS JR., 1985

Among the many monuments in Birmingham's Kelly Ingram Park, one catches the eye (fig. 31). A German shepherd dog, its teeth bared, lunges at a young African American boy. A stern-looking police officer, his eyes hidden behind aviator glasses, pulls the dog's leash in one hand and grasps the boy's sweater in the other. To most viewers, the reference is immediately evident: the statue is based on Bill Hudson's famous photograph of Walter Gadsden and Officer Dick Middleton and his dog Leo, taken on May 3, 1963 (fig. 32). But Ronald Scott McDowell's *Dogs* (1995–96; also known as the Foot Soldier Monument) departs significantly from its model. The cop in the monument is slimmer, more static and resolute in his pose, more clearly an aggressor than in Hudson's photograph. The photographic policeman appears to be pulling the youth toward him; the sculptural one appears to be preventing the boy from falling away from the dog's grasp. The boy in the statue is younger than the one in the photograph. He is off-balance and falling, unable to resist the dog and its handler, his hands dropping back to brace his fall. In the photograph, Gadsden grabs Middleton's arm with his left hand and lifts his left leg to fend off the dog's attack, as his father had taught him to do. Most important, Gadsden was an observer rather than a participant in the demonstrations, whereas the monumental representation of the incident is dedicated to the "foot soldiers . . . warriors of a great cause" who were active demonstrators.[1]

Dogs erases the ambiguities of the photograph, noted by several recent observers, that allow one to read it as an image not of black victimization but of black resistance (the hand and the knee) or of white struggles to control black disorder. Like many contemporary monuments, it forgoes the ambiguity of metaphor in favor of a clear narrative and an unmistakable message.

The difference is one, not simply of artists' points of view, but of thirty years of construction of the meaning of the events in Kelly Ingram Park and their significance for Birmingham's present. The statue conveys part of the political message underlying the park's transformation in the years 1990 to 1993. That redesign crystallized a civic myth articulated by Mayor David J. Vann and adapted by his successor, Richard Arrington Jr., whose administration shifted the accent to black agency and at the same time emphasized white transgressions more openly.[2]

Kelly Ingram Park today is a kind of sculpture garden, a complex space that houses a disparate group of eleven monuments. The park retains the diagonal walks and central circle that organized it almost since its beginning. It focuses on a circular pool of water divided into four quadrants, with a bandstand to its east (downtown) side. A larger circular path, "Freedom Walk," serves as a setting for three blue-steel monuments by artist James Drake — *Children's March*, *Police Dog Attack*, and *Firehosing of Demonstrators*. Just north of the southeast walk McDowell's *Dogs* stands on a high pedestal. Near the northwest corner, the statue of Martin Luther King Jr. faces the Sixteenth Street Baptist Church, a site that was important to veterans of the 1963 demonstrations, according to one of the planners (see fig. 23). Diagonally opposite the King statue, a low, limestone sculpture by Raymond Kaskey depicting three ministers kneeling in prayer stands in an open circle of granite bollards. Four bollards are broken to represent the four children murdered in the bombing of the Sixteenth Street Baptist Church, which is visible behind the monument. At the southwest corner, four stelae honoring pre-1960s leaders of black Birmingham flank the entry, facing the Gaston Building. Diagonally opposite them, on the northeast corner, is a monument to Osmond Kelly Ingram, namesake of the park, which was moved from its original site at the center of the park. A low wall of rough-faced ashlar stones, with indented quadrants at each corner, encircles the park. The inscription "Place of Revolution and Reconciliation" marks each park entrance.[3]

In 1963, Kelly Ingram Park was a very different place from that I have just described. Return to Bill Hudson's renowned photograph of Walter Gadsden and the police dog (see fig. 32). The central action in the photograph takes place at the intersection of Sixteenth Street North and Sixth Avenue North. There are people all around. Some watch the dog attack, while others look out of the frame to the left, perhaps at similar actions happening elsewhere in the scene. The Coca Cola–branded Jockey Boy Restaurant sign presides over the tableau. The sign is visible in many other photographs such as this one, taken

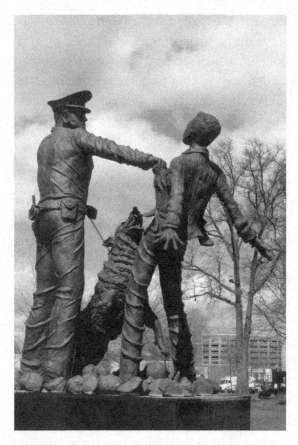

Fig. 31. *Dogs* (The Foot Soldier Monument) (Ronald Scott McDowell, 1995–96), Kelly Ingram Park, Birmingham, Alabama. Photo: Dell Upton.

near the corner of Sixteenth Street North and Sixth Avenue North in 1963. In one, Bob Adelman captured two girls and a boy, arms outspread, standing in Kelly Ingram Park holding hands. They appear to be dancing as they brace themselves against the blasts of high-pressure water hoses. In a third, four men, including Julian Bond and John Lewis, stare wearily out of the frame toward the bombed remains of Sixteenth Street Baptist Church (fig. 33).

On closer examination, one can see that the Jockey Boy sign that looms so incongruously over the action in these photographs projects from the corner of an ordinary late-nineteenth-century commercial building that serves as a common stage set framing all of the photographs. The sign identifies a specific place within which the racial struggle is played out, giving disparate acts a spatial concreteness that seems to knit them into a single narrative. Ordinary landscapes such as this one, relics of the New South city of the early

Fig. 32. Police dog attacking Walter Gadsden, Birmingham, Alabama, May 1963.
Photo: © Bill Hudson/Corbis.

twentieth century, were the stages of the civil rights struggle. As a side effect of the destruction of the New South racial order, the New South townscape exemplified by the Jockey Boy Restaurant was eventually, although not inevitably, dismantled. Even those who came to see Kelly Ingram Park and its environs as "sacred ground," as it is now commonly called, had no use for its particulars. The historic setting was replaced by a commemorative landscape that re-presented the struggle in a contextless space.

Kelly Ingram Park's role in Birmingham's racial struggles was almost accidental. From the inception of Birmingham's system of racial apartheid, African Americans resisted, their resistance becoming more overt and more resolute as the twentieth century wore on. As the struggle heated up in the 1950s, civil rights organizing took place in many small, mostly working-class black churches that were scattered throughout Birmingham's industrial periphery and that formed the backbone of the Alabama Christian Movement for Human Rights (ACMHR), organized in 1956 by the Reverend Fred L. Shuttlesworth with the Reverend Abraham Woods, Jr., the Reverend Nelson Smith, and several other young clergy. Civil rights actions were also scattered

Fig. 33. Jimmy Hicks, Julian Bond, John Lewis, and Jeremiah X view the bombed remains of the Sixteenth Street Baptist Church, Birmingham, Alabama, September 12, 1963. Photo: © Danny Lyon/Magnum.

throughout the city, at the city's bus stops, in its buses and train stations and schoolyards, and often in its city hall and courtrooms. But Kelly Ingram Park happened to be located between the African American churches that were the sally ports of most of the 1963 marches and the city hall, county courthouse, and white business district that were the destinations of most of the demonstrations.[4]

Still, Kelly Ingram Park's notoriety was not entirely accidental. Even before it became sacred ground, it was a fraught space in the tense racial landscape of Birmingham. As West or West End Park, the 3.75-acre square was one of three public spaces deeded by the Elyton Land Company to the fledgling City of Birmingham in 1883, with the stipulation that they be "ornamented, kept and used as public parks." Before the city's borders were expanded in 1910, West Park was surrounded by the houses of prosperous whites. The neighborhood began to diversify as the well-off migrated to neighborhoods around the fringes of the enlarged city. By 1936, African Americans formed 70 percent of the neighborhood's population. As blacks began to move to this section of Birmingham, a black business district grew in the right angle defined by the white-dominated commercial districts along First and Second Avenues North and Twentieth Street North.[5]

Despite the neighborhood's racial transformation, West Park remained a white preserve. In 1903 black Birminghamians were legally forbidden to use any of the city's parks, except when working as servants to whites or passing through. Eventually a few parks were designated for African Americans in other parts of the city, but the white grip on West Park tightened. On November 12, 1918, a day after the armistice that ended World War I, it was renamed in honor of Osmond Kelly Ingram, a white sailor from nearby Oneonta who was the first American seaman killed in the war. Fourteen years later, the city's Armistice Day celebration culminated at West Park, the endpoint of "one of the greatest parades Birmingham has ever witnessed." Josephus Daniels, the wartime secretary of the navy, publisher of the *Raleigh News and Observer*, and an

outspoken white supremacist, presided at the dedication of a monument to Ingram donated by a fraternal order, the Knights of the Maccabees [sic].[6]

The park's status as a white preserve was vigorously reasserted in the early 1960s. In response to a 1957 lawsuit initiated by Shuttlesworth that sought the integration of Birmingham's parks and recreational facilities, US District Judge Hobart H. Grooms ordered in October 1961 that the parks be integrated by January 15, 1962. Police Commissioner Eugene "Bull" Connor and Mayor Art Hanes took measures to close them instead, threatening to sell them if necessary. Shortly after the judge's ruling, Connor ordered the parks and recreation board to suspend all capital projects in the parks and to cancel all contracts for construction that had not yet begun. The *Birmingham News* attempted to rally public opposition to the closings on the grounds that it would adversely affect the city's ability to attract new businesses and jobs, while members of the park and recreation board resisted the move on the grounds that children would be harmed. The city commission reduced the city's park budget to the minimum required by state law, prepared to sell the zoo's animals, and posted No Trespassing signs on park structures throughout the city, although the park and recreation board refused to post them on the grounds themselves. Eventually a compromise allowed the zoo, the botanical garden, Legion Field stadium, and Woodrow Wilson Park, adjacent to the city hall and county courthouse, to remain open, but Kelly Ingram Park, along with other ordinary park facilities, was officially closed.[7]

Kelly Ingram Park's whiteness was occasionally challenged before the 1960s. According to A. G. Gaston, who reigned as Birmingham's wealthiest and most powerful African American businessman for seven decades before his death in 1996, the establishment of his funeral home in a former mansion at the southwest corner of the park emboldened some blacks to use the park recreationally. Yet it was risky to do so. W. C. Patton recalled that in the 1920s when he walked through the park on his way home from Sixteenth Street Baptist Church, he "was always afraid of being attacked by somebody."[8]

In truth, the park was increasingly a no-man's land. Surrounded by a black neighborhood but formally restricted to white use, it lost its potential active African American constituency as its black residents began to abandon the neighborhood. As whites left the city of Birmingham for the suburbs, blacks who could afford to do so moved into formerly white-dominated districts, so that the black neighborhoods close to the city center in 1950 were occupied predominantly by unemployed and underemployed industrial workers hard-hit by the loss of reliable jobs in the declining steel and coal

industries. A 1950 Sanborn map shows the area around Kelly Ingram Park as a mixed commercial and residential neighborhood with significant vacancies beginning to open in the landscape. Around the edges of the park, Gaston built a new motel, a radio station, a modernist building for his Booker T. Washington Insurance Company and his business school, and a funeral home. By 1965, despite Gaston's heavy investment in new construction, the Sanborn map shows a landscape even more pockmarked by vacant lots, some caused by the riots that followed the May 1963 bombing of Gaston's motel. The park itself "was dirty. Paper littered its patchy grass," according to a *Birmingham News* account of the demonstrations of May 1963.[9]

Thus when Kelly Ingram Park was finally opened to African Americans, few people were living nearby. The park became "a repository of various bits of civic bric-a-brac, a place where decent blacks seldom went and whites were almost never seen," according to one reporter. It was taken over by "derelicts," recalled one of the planners of a 1990–92 redesign. Then the park began to accumulate symbolic importance as a repository of monuments arguing conflicting interpretations of black Birmingham's recent past. Initially it embodied the struggle over black leadership in the 1960s and beyond. Eventually it was redesigned as a didactic landscape by the city's transformed urban government.[10]

The *Southern Courier,* a Montgomery-based civil rights paper, observed in 1966 that "you could fill a small convention hall with all the 'Negro leaders' in Birmingham. There are political leaders, social leaders, economic leaders, religious leaders, and civil rights leaders—all leading in different directions." This struggle for legitimacy among black Birmingham's would-be leaders occasioned the earliest memorialization in Kelly Ingram Park. In 1979, the year that the city elected its first black mayor, two pink marble stelae were erected in the park on A. G. Gaston's initiative (fig. 34). The markers were erected at the southeast corner of the park facing Gaston's striking modernist headquarters, which had been celebrated at its opening in 1960 as a model of black achievement. The new markers honored two prominent members of the early-twentieth-century black middle class, Pauline Bray Fletcher and Carrie L. Tuggle. Fletcher was the first black registered nurse in Alabama. As president of Birmingham's black YWCA, she organized a campaign after World War I to construct a new building for the organization a block north of Kelly Ingram Park. In 1926, Fletcher became director of a summer camp for black children that she had founded with the aid of the some of the city's

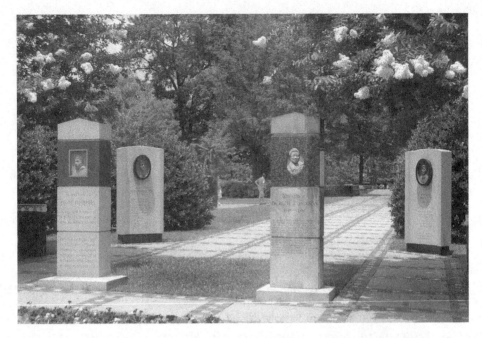

Fig. 34. Monuments (left to right) to Pauline Bray Fletcher (1979), Julius Ellsberry (Ronald Scott McDowell, 1998), Carrie L. Tuggle (1979), and Ruth L. Jackson (McDowell, 1998), Kelly Ingram Park. Photo: Dell Upton.

most prominent African American businessmen and professionals. Tuggle opened a school for poor black children in 1903 that limped along until her death in 1924. She was closely allied with Booker T. Washington, who visited the school several times. Washington's philosophy of black self-reliance and political reticence deeply impressed one student—Gaston—who named several of his enterprises after the conservative black leader.[11]

The choice of honorees was pointed. Fletcher and Tuggle were black achievers who had done much to uplift the lower classes. Just as important, Tuggle's school had been founded as the result of the joint efforts of black fraternities and charitable white businessmen. In Gaston's words, the school was "supported by good people throughout the city, both white and colored." The message could not be lost on those familiar with the civil rights struggles of the 1950s and 1960s, when Gaston and other black "moderates" sought to negotiate the amelioration of Birmingham's racial order with their counterparts among the white elite. The earliest efforts collapsed after the *Brown v. Board of Education* Supreme Court decision and the subsequent hardening of white supremacist politics in Birmingham, marked by the return to power of Eugene "Bull" Connor as police commissioner.[12]

The slack was taken up by the Reverend Fred L. Shuttlesworth. Under his leadership, the ACMHR mounted an aggressive and multipronged attack on segregation, working simultaneously for the integration of schools, transportation, parks, the police force, and governmental employment. For the first several years of its existence, the ACMHR employed a carefully calculated strategy that used limited direct-action interventions to set up court challenges. Black moderates saw Shuttlesworth as an upstart, insufficiently respectful of his more established elders, and as a danger to the glacial progress they envisioned. They resented both Shuttlesworth's notoriety and his successes in his more aggressive efforts.[13]

The tensions between black moderates and black activists in Birmingham, their joint goal of eliminating segregation, and the visibility of national developments in the early 1960s complicated Birmingham's famous demonstrations of 1963 in ways that shaped the future memorial landscape. Black moderates believed that they had an opening for negotiated change. In 1962, white moderates had persuaded voters to change the form of government from the three-person city commission, dominated by Connor, to a mayor-council system that they believed would curtail the power of white supremacists. Shuttlesworth and his followers, frustrated by the slow pace of court-ordered change and intrigued by the successes of direct action elsewhere, had meanwhile begun to plan a series of major demonstrations that ultimately became known as Project C, for Confrontation. In doing so, they called in the Southern Christian Leadership Conference, a group to which Shuttlesworth and other local ministers belonged and that was famously associated with Martin Luther King Jr.[14]

In the heat of the Project C demonstrations, lines between the two camps were crossed and recrossed. At the urge of the moderates, the ACMHR and the SCLC had agreed to suspend the Project C actions until after the referendum on city government, but the white and black moderates wanted them to wait longer "to give us a chance to prove what we could do through the political processes." Instead the demonstrations were launched during a period when the city had two governments. Connor and the other city commissioners refused to leave office, arguing that they were entitled to serve out their terms, while the new mayor and council claimed immediate authority. During this period, two competing mayors occupied city hall, but Connor controlled the police and fire departments, with the result visible to the world in the notorious photographs and films of the demonstrations of April and May 1963. The black moderates were opposed to the use of children in the marches, but as

the city's response became increasingly violent, they were drawn into the conflict. Gaston quietly provided bail money for some of the demonstrators of 1963, and his motel was the headquarters of the campaign. At a critical point in Project C and its aftermath, the ACMHR and the SCLC formed a central committee to help guide the action; this committee included Gaston, Miles College president Lucius Pitts, attorney Arthur D. Shores, John and Addine Drew, and other moderates.[15]

In many respects, King had closer ties to moderates such as John Drew, a prominent black businessman who had been a Morehouse College classmate of Martin Luther King Sr., and Gaston, of whose bank King served as a director, than he did to the lower-class radicals. During much of his stay in Birmingham, King lodged with the Drews, and many decisive meetings were held at their house, including those that ultimately ended Project C. By that time, Shuttlesworth and many of his ACMHR colleagues believed that they had been pushed aside by an SCLC eager to promote its own agenda. They felt particularly betrayed by King, whom they felt had brought negotiations with Birmingham's whites to a precipitous close for his own benefit, rather than considering the needs of the local movement.[16]

Despite the black moderates' attempts to cooperate with whites, the two groups differed on one major point. Many white moderates wanted simply to put a more paternalistic face on segregation, to make it more palatable to blacks by fixing some of the worst abuses. African American moderates agreed with their more radical black rivals that segregation was inherently evil and must end. This difference was made subtly clear by the 1998 addition to the array at the corner of Kelly Ingram Park of a stele in memory of Julius Ellsberry (see fig. 34). Recall that Osmond Kelly Ingram, a white man, was the first sailor killed in World War I. Julius Ellsberry died at Pearl Harbor on December 7, 1941, the first black Alabaman to be killed in World War II and among first Americans to die. In 1942 a group of black citizens began to press the city to name the new Colored Memorial Park in the Titusville neighborhood after Ellsberry as it had named West Park for Ingram. Emory O. Jackson argued the case forcefully to Mayor W. Cooper Green, who returned a series of rude and increasingly angry responses. Green told Jackson that the city had made its decision and that his opinion was not wanted. "You have 'popped' off about it and you have done more harm to the negro park cause here than anything that has happened, in my mind, in the last ten years," he wrote. Because "there would be other colored heroes . . . to name it after one would not be right," although of course there were other whites who had died

in World War I, as the city commission knew, since Kelly Ingram Park was re-named after the war had ended. A park in North Birmingham was finally named after Ellsberry in 1979. However, the erection of a monument to Ells-berry in Kelly Ingram Park itself showed that the insult to black sacrifices had not been forgotten. Here again the project was dominated by moderates, with Ruth Jackson and A. G. Gaston at the head and prominent moderates such as Gaston's wife, Minnie; Drew; Mitchell; dentist and NAACP leader John Nixon; the Reverend Erskine Faush, pastor of the Metropolitan A.M.E. Church; Bishop Jasper Roby, leader of the small, Birmingham-based denomi-nation Apostolic Overcoming Heaven Church of God; and retired principal and former city council member Bessie S. Estell among the principal organiz-ers and contributors. Even former mayor George Siebels Jr., by no means a friend of the 1960s racial changes, was listed among the contributors to the Ellsberry monument.[17]

So the Fletcher and Tuggle monuments, along with the later Jackson and Ellsberry memorials that were set next to them, celebrate the moderate pro-gram of cooperation with whites under the guidance of established black leaders. If the message was unclear, one had only to look at the committee who created the monuments. They are named on the backs of both stones. Gaston himself was the chair of the Fletcher-Tuggle Memorial Committee. Most of the other members of the committee were business or political allies of his, including Ruth J. Jackson, a prominent cosmetologist and owner of the Birmingham Beauty College; Dr. J. King Chandler III, president of the African Methodist Episcopal Church's Daniel Payne College; Dr. Ossie Ware Mitchell, who had been assistant director of Gaston's Booker T. Washington Business College and in the 1970s became the first black member of the board of edu-cation; and Philander L. Butler, an attorney who was also a close associate of Gaston's. Gaston and Butler, along with other moderates such as John Drew, Pitts, Shores, Emory O. Jackson, and Shuttlesworth's longtime rival, the Rever-end James L. Ware, had been among the founders of the Inter-Citizens Com-mittee and later of the local chapter of the Urban League. The name of Oscar W. Adams Jr., Tuggle's grandson, the first black justice of the Alabama Su-preme Court, a Republican and a moderate, was recorded in smaller print at the bottom of the Tuggle monument's text.[18]

Yet because of the complexities of 1960s alliances, a scattering of activ-ists could be found among the creators of the "moderate" monuments. Eva Lou Billingsley Russell, owner of the Fraternal Café, which catered to activists (or "foot soldiers," as they are called in Birmingham), served on both the

Fletcher-Tuggle committee and the executive committee of the Ellsberry monument. Similarly, the Ruth Jackson Memorial Committee was chaired by Beatrice Johnson, a voting rights activist and the wife of Shuttlesworth's long-time bodyguard Colonel Stone Johnson, a central figure of the activist camp. It also included Hattie Felder, another stalwart of the local NAACP and the AC-MHR and a member of Shuttlesworth's Bethel Baptist Church. This crossover served to emphasize that there was fundamental agreement among the moderates and the radicals in the black community about their goals even as they differed over the best means of achieving them and entitlement to leadership roles.[19]

The activists' opportunity to make their case came a few years after the Fletcher and Tuggle monuments were installed. In the mid-1970s, Kelly Ingram Park was drawn into a growing national movement to honor Martin Luther King Jr. The first suggestion in Birmingham, raised in the early 1970s, was to establish a King Day in his honor. This provoked familiar white objections that King "had Connections With the Communist[s]. Was Supported by all those unamerican sects." Then the focus shifted to Kelly Ingram Park, with a proposal to rename the park after him. "How dare any white person wanting the Kelly Ingram Park named after a Darn Black man. . . . I beg of you Please don't turn the Park over to the name of Dr. Martin Luther King[.] show the White Southerners where you stand," wrote a man who identified himself as a Mormon deacon and a "true Southerner." After David J. Vann, a major white player in the settlement of 1963, was elected mayor in 1975, a community center was designated to be named after King. This prompted a protest from 1960s moderate John Drew, who told Vann that the naming was "inadequate tribute to the memory of a man who gave so much, including his life to the world." Vann responded in an equally aggrieved tone. He was "disturbed" that Drew did not think the gesture adequate. Vann reminded Drew that he had proclaimed a Martin Luther King Jr. Day in Birmingham shortly after taking office, and he noted that Coretta Scott King and Martin Luther King Sr. were satisfied with the honor and would attend the dedication. He assured Drew that more recognition would be forthcoming.[20]

In the mid-1980s, the campaign to honor King in Birmingham came to fruition with the monument in Kelly Ingram Park (see fig. 23). The park's formal transformation into an African American shrine had advanced in the early 1980s when it was nominated to the National Register of Historic Places. Echoing an earlier phrase of ex-mayor David Vann, the Reverend Abraham Woods

Jr., the local head of the SCLC, explained in 1985, "We usually gathered [in Kelly Ingram Park] before we would go out to the various parts of the city. It became sacred ground for us."[21]

Woods made this remark during the campaign to erect a statue of King. If the Tuggle-Fletcher-Ellsberry-Jackson memorials represented the claims of the moderates, then the King statue was primarily the work of those who had been part of the great demonstrations of April and May 1963. It was intended as a monument not only to King but to the SCLC and, to a lesser extent, to the ACHMR. To emphasize the Project C connection, the statue faced the Sixteenth Street Baptist Church. Again, a look at the organizers of the project offers insight into the statue's subtexts. Woods initiated the fund-raising, secured permission from the Birmingham Parks and Recreation Board for the use of the site in 1984, and headed the statue committee. Dr. Herschell Hamilton (known as the "battle surgeon" or "dog-bite doctor" for his services during the 1963 demonstrations) and Dr. Joseph E. Lowery, a Methodist pastor in the city in the 1960s and in 1986 the national head of the SCLC, were the committee heads. The members included barber James Armstrong, another of Shuttlesworth's principal aides, one of the first parents to enroll his children in newly integrated Birmingham schools, and the carrier of the American flag in the renowned photographs of the Selma-Montgomery march of 1965; the Reverend Edward Gardner, second in command in the ACMHR during its most active years; Colonel Stone Johnson; and the Reverend William J. Battle, a local chair of the NAACP and one-time interim pastor of Shuttlesworth's former church. The committee also included Judy Hand and Scott Douglas III, at the time former and current staffers respectively of the Southern Organizing Committee for Economic and Social Justice, which had been founded by the renowned white civil rights activist Anne Braden as the successor to the antiracist Southern Conference Educational Fund.[22]

Considered solely in the context of 1960s rivalries and resentments, the choice to honor King would be puzzling. However, in the two decades between Project C and the erection of the monument, King's martyrdom had transformed him from an often inconsistent and vacillating leader into a culture hero. The Project C leaders, who had felt betrayed by King in 1963, used his new prestige to elevate him as the central figure of the Birmingham freedom movement. A fund-raising letter on behalf of the Martin Luther King, Jr. Statue and Birthday Celebration Committee, signed by the Reverend Woods and Mayor Richard Arrington Jr., described King as "a man whose dream liberated Birmingham from itself . . . [and] brought redemption to us

all." Similarly, King's new national prestige took the edge off his association with direct action of the 1960s in the minds of many moderate whites and blacks. In most respects the black moderates and the black middle class generally benefited more from the struggles of the 1960s and emerged with more power than the rank and file of the ACMHR, who had carried the burden through the most difficult times, and certainly than the mass of lower-class blacks in Birmingham. Thus King became an important symbol both to former radicals and to former moderates, who were represented on the statue committee by Gaston and John Drew and his wife, Addine, a voter registration activist and a member of the Inter-Citizens Committee.[23]

It is fitting that the King who appears in the Birmingham statue is circumspect to the point of inscrutability. Unlike the more active images found in many monuments to the leader, this one betrays no hint of emotion or action. It is a statue on which all sides in the Birmingham struggle could project their own interpretations, whether one saw him as a conciliator or as a protector. Reflecting on the dedication ceremony of January 20, 1986, the first national Martin Luther King Day holiday, held before a crowd of ten thousand, the white press summed the statue as a benchmark of Birmingham's progress since 1963, of a "better today," a measure of how far the city had come from the days of Bull Connor. This tale of racial progress is comforting to white and many nonwhite Americans, who retell it at every civil rights anniversary. The *Post-Herald* in 1968 and the *News* in 1974 both featured articles contrasting the scenes in Kelly Ingram Park in 1963 with those in later years. Their titles — "From Rioting to Recreation in 5 Years" and "Can Conditions Have Changed So Much since 1963?" were among the earliest formulations of this "how far we've come" theme. In doing so, they repeated a contemporary cliché of civil rights commemoration, but they also located King in that cliché's specific Birmingham context, its civic myth formulated by Mayor David J. Vann.[24]

Vann had been an organizer of the 1962 referendum that replaced the city commission with a mayor-council government. Genuinely committed to social justice, he was nevertheless a prime voice for the moderate claims that negotiation was preferable to direct action, and he played a central role in forging the agreement that ended Project C. In the 1970s, dissatisfied with the failure of the city to respond in more than token ways to the 1963 agreements, Vann entered city politics, running for city council and then winning the office of mayor from George Siebels Jr. in 1975. During this time, Vann seems to have undergone a conversion experience that led him to identify

more strongly than ever with the transformations of the 1960s and their as-yet-unfulfilled promise. He began to compare the sites of the demonstrations he had opposed to Valley Forge and Yorktown, eventually extending the metaphor to call them "sacred ground." And he crafted a myth of the New Birmingham.[25]

Cities use origin myths to explain themselves to themselves, myths that are then enshrined in civic rituals. Vann articulated Birmingham's in a lengthy 1978 speech and reiterated it many times afterward. The 1961 Freedom Rider riot was the crux of the story: it "helped to start the movement to change the form of government in Birmingham." In testimony given before the US Senate Intelligence Committee just after he was elected mayor, Vann accused Bull Connor of orchestrating the beating of Freedom Riders by members of the Ku Klux Klan at the Birmingham Trailways bus station on May 14, 1961. "Eugene Connor was in full command of the police department that day. . . . Eugene Connor was in personal control and directed the actions of the police on that day." In his various summary accounts of the Birmingham's racial transformation, he singled out Connor as the salient figure who distinguished Birmingham's racial order from that of other, equally racist Southern cities.[26]

In Vann's telling, the redemption of Birmingham was the product of the good white people who threw off Connor's yoke and transformed the city's racial caste system. As it happened, a delegation of Birmingham businessmen was in Tokyo at an international meeting of Rotarians on the day of the riot. The notorious images of the Freedom Rider beatings were reprinted in the Japanese newspapers, and these upstanding Birminghamians "quickly recognized that no city could survive this type of publicity for long without serious repercussions." In short, white civic leaders framed the issue at the time as a public relations disaster.[27]

Vann's tale was an early version of a widely heard claim in the contemporary South that whites were as much the victims of the Connors of the 1960s as blacks were. Looking back after nearly thirty years on the events of 1963, the owners of several of Birmingham's downtown businesses of that era invoked this excuse. Richard Pizitz, who was a negotiator for the white moderates and whose Pizitz Department Store was one of the principal targets of the demonstrations, told a reporter, "It's hard to explain to kids that this was a community where you grew up with it. It was around for 100 years. It was a custom in this community and in the South." He and two other businessmen prominent in the era:

said the Ku Klux Klan, Bull Connor, the White Citizens Council and others threatened and even harmed the business elite if they tried to seek change, so they didn't.

"You do what the community does," [Coca-Cola Bottling Company chairman and 1963 chamber of commerce president Crawford T.] Johnson said.

"It was fear," [Head, Inc. owner James] Head [Sr.] said. "Fear is a horrible thing."

Pizitz blamed the city's problems on the local newspapers, especially the rigidly segregationist *Birmingham News,* comparing Birmingham's history to Atlanta's, where desegregation proceeded more smoothly under the leadership of "an enlightened newspaper."[28]

Even though they had succeeded in changing the form of government, Vann said, these moderates realized that they must negotiate change outside even the new governmental structure, since city boards and agencies were staffed by entrenched appointees who would not leave office for some time after any restructuring. Thus black and white moderates "had to work out our entire negotiations within a formula of commitment that could be made and carried out in the private sector, because the situation we were dealing with was one that made any other resolution impossible."[29]

Vann thus framed the events of 1963 as an act of noblesse oblige. Despite his reverence for the demonstrations of 1963, which were black-led and predominantly African American in composition, he downplayed the agency of the "foot soldiers" who risked their safety in the marches and depicted the transformation of Birmingham as a gift from black and especially white leaders to the city's black population and to African Americans generally, who "come to Birmingham to see the place where things happened that had such a deep impact on their lives," and indeed to all Americans: "not just black people, but all people are more free." Kelly Ingram Park and its surroundings were nothing less than "a national shrine."[30]

During much of Vann's term, many African American citizens of Birmingham saw him as their ally, and he worked hard to earn that trust. Then he made a serious misstep. In the summer of 1979, Birmingham police, responding to a report of a robbery at a convenience store, shot and killed a young black woman named Bonita Carter who had nothing to do with the crime but who had the misfortune to be at the scene when the police arrived. Vann's response to the shooting was less decisive than many African Americans wanted, and his refusal to fire the officer involved was a particularly sore point. As a result, councilman Richard Arrington Jr., an ally of Vann's who made his reputation

on the council as an opponent of police brutality, defeated Vann in November to become the city's first black mayor.[31]

Arrington narrowly won a run-off election against Vann, but from then until his final campaign in 1999 he won reelection convincingly, though in each case with a shrinking proportion of the white vote. In 1987, the year after the dedication of the King monument and three years before the redesign of Kelly Ingram Park, he won his largest majority—64 percent of the total vote—but that broke down to 98 percent of the black vote and 10 percent of the white vote.[32]

This disparity shaped Arrington's administration decisively. Soon after his election, Arrington proceeded, as most American big-city mayors do, to build a governing regime based on growth and economic development, particularly on downtown revitalization. He courted the city's business leaders, and in the early years of his administration a few major downtown projects were constructed, notably AmSouth Harbert Plaza, a joint venture of Alabama's largest bank and its largest construction company. There was also a federal building and a couple of other downtown projects. But during his first term Arrington had relatively little success in winning the cooperation of the white business elite. Despite his efforts to get them to take him seriously, he said, they saw Arrington as a radical enemy, not an ally. John Harbert, chair of Harbert Construction, one of the developers of the AmSouth Harbert Plaza building, graciously said at the cornerstone laying that he had participated out of civic duty but that he didn't expect the project to be profitable and he would not build anything else in Birmingham. He preferred to focus on Huntsville, Harbert told a reporter.[33]

Arrington faced two handicaps in his efforts to build a regime. The first was that he was the first African American to take charge of Birmingham's city government. Even worse, he came neither from the business world nor from the legal profession. This was not unique to him. In black-run cities throughout the South, including, as we have seen, Savannah, African American politicians and their allies most often are drawn from the worlds of religion and academe. They are the successors of the old black middle-class intermediaries with the white world during the segregation era. Arrington is a good example. He received his doctorate in zoology from the University of Oklahoma and was an administrator at Miles College and later for the Alabama Center for Higher Education, a consortium of African American colleges. His aides and appointees during his long term of office moved in and out of

positions at Miles, Birmingham Southern College, and the University of Alabama at Birmingham.[34]

Lacking effective access to the white power structure, Arrington built his regime in other ways. In the 1980s he invested city monies in outsider-initiated development projects, including an arena football team and an amusement park, both of which failed, and a horse track, the Birmingham Turf Club, that was more successful. Annexation turned out to be a more effective tactic. During his first decade in office, Arrington aggressively annexed land around the edges of the city. He took advantage of a 1908 state law that allowed a city to defer property taxes for several years to encourage industrial and commercial development. Arrington was careful to annex land that was developable but underpopulated, thus acquiring for the city a future tax base without also acquiring voters who might object to annexation or taxation. In addition, since new voters would come from the urban fringes, they would most likely be whites who would oppose the black-run administration. By careful selection of new lands, Arrington's administration was able to increase the city's area by 63 percent between 1980 and 1989 at a time when the total population of Birmingham dropped 15 percent. The annexed lands added only 639 people to the city's population.[35]

In addition to joint ventures and annexation, Arrington assiduously worked to build solid cadres of loyal black voters, acting through the Jefferson County Citizens' Coalition, referred to by his opponents as Arrington's "machine." His criticism of the Bonita Carter shooting won him wide support among lower-class African Americans, who bore the brunt of police brutality. At the same time, he won middle-class black loyalty through his dramatic increase in city employment for African Americans and in his enforcement of affirmative action policies in the police and fire departments, which had managed to resist employing more than a few black people for fifteen years after the 1963 "Points for Progress" agreement that ended Project C and whose nonimplementation had distressed Mayor Vann. In addition, Arrington sought to focus cultural and economic development in African American neighborhoods and for the benefit of black businesses, which further solidified his support among the black middle classes.[36]

Civil rights history and Kelly Ingram Park played central roles in both the cultural and the economic agendas of the Arrington administration. David Vann had proposed the construction of a civil rights museum in Birmingham. To his mind, the idea had several advantages. It would acknowledge the black presence in Birmingham in a way that had not yet been done. In addition, it

would give visible form to the civic myth, showing off and solidifying Birmingham's transformation, and thus improving its dismal image in the eyes of the outside world. The museum would also stake a claim to Birmingham's centrality in the civil rights story in the face of similar claims by Memphis and by Atlanta, Birmingham's traditional rival and object of envy, by its intended status as "the most definitive museum and research facility on the racial aspects of Civil Rights and racial discrimination in America, if not the world." This idea became entwined with the Vann administration's efforts to revitalize downtown and the adjacent historically black business district along Fourth and Fifth Avenues North, adjacent to the southern edge of Kelly Ingram Park. This area had lost its traditional constituency with the fall of segregation, which made the white downtown more receptive to black consumers. When planning consultants proposed in 1978 that a civil rights museum be constructed as a magnet for development in the area, the Fourth Avenue Merchants Association seized on the proposed museum as a panacea for their economic difficulties and assumed that it was a fait accompli.[37]

Arrington adopted Vann's civic myth as his own, emphasizing King's and African Americans' agency but not denying that of the white moderates. At the same time, Arrington adopted Vann's museum proposal, along with his efforts to energize the black business district. A quasi-governmental agency called Urban Impact was formed to oversee the process and to connect with existing business- and property-owners. The businesspeople of the neighborhood, however, were disappointed in their hopes that revitalization would result in the resurrection of their traditional, small-scale, black-oriented trade. City planner Michael Dobbins told them that it was impossible to "turn the clock back" to make the district what it had been earlier. In fact, the area attracted little new commercial investment, since there was no market for it.[38]

Nevertheless, Arrington came to see Kelly Ingram Park and its environs as opportunities for black participation in the city's economic development and as symbols of the new Birmingham as keys to his political success. The King statue offered the first chance to realize his goals, and Arrington staffers and allies were placed on the statue committee to direct its deliberations. At the time of dedication, administration insiders saw the monument as a potential foundation for rituals of civic incorporation. An unsigned draft discussing the dedication ceremony, probably written by an Arrington staffer, argued,

> We are designing activities which must be worthy of ritualization—as the observances which cultivate and consolidate as they celebrate—the greatest

triumph and redemption achieved to date—the transformation of Birmingham from ... [sic] to ... [sic]. The annual civic ritual which unites the entire population, or that is which the entire population participates in projecting as a unitary image to those who use the three day week end to make a PILGRIMAGE TO OBSERVE MARTIN LUTHER KING'S BIRTHDAY IN BIRMINGHAM.[39]

At this point, Arrington took up the civil rights museum. Twice, in 1986 and 1988, he tried to fund the project through bond issues that were meant to support several municipal cultural institutions. In both cases, the issue failed. White voters turned out in droves to vote against it, while Arrington's working-class black base was not particularly interested in the project, so they didn't vote at all. Arrington began "quietly ... exploring ways in which the City might provide funding for the proposed Civil Rights Institute other than through an approved general obligation bonds issue." He initially considered using Downtown Redevelopment Authority bonds issued to a nonprofit foundation. Arrington ended up financing the project by selling the city-owned Social Security Building for $7.2 million and by pooling funds left over from other projects that had come in under cost.[40]

The mayor persisted in his plans for the museum because it was important to the city's middle-class African Americans. Despite the ambivalence of many members of the black middle class toward the events of 1963 when they happened, they took up the civil rights museum (eventually named the Birmingham Civil Rights Institute) to assert their continuing political legitimacy. Arrington's commitment to the BCRI and to the subsequent remodeling of Kelly Ingram Park was personal as well as political, and he kept a tight rein on both, personally deciding many details of the projects, down to naming the park, providing its entrance mottoes, and eventually donating *Dogs* and writing its inscription.[41]

Despite its relatively small budget of about $15 million, the BCRI was a high-profile project that prominently featured African Americans. The architectural commission for the building was given to the African American–owned architectural firm Bond Ryder James of New York. The management of the project, along with that of the Birmingham Turf Club and other public works, was awarded to Diversified Project Management, a black-owned firm from Atlanta.[42]

Once the Birmingham Civil Rights Institute was under way, the planners turned to Kelly Ingram Park. Renovation of the park was originally slated as part of the redevelopment of the neighborhood. The designation "Civil Rights District" and the brick pattern, reminiscent of kente cloth, in the walks that

surround the park, front the institute building, and are scattered throughout the neighborhood, serve as reminders of the park's development agenda. As the BCRI took shape, Arrington and landscape architect Edah Grover discussed turning Kelly Ingram Park into a fully developed memorial and an extension of the institute, whose 1990 mission statement promised to "provide the proper outdoor public setting for the Institute" and to "establish interpretive and artwork settings for the events of the Movement." Picking up on the un-realized civic ambitions for the King statue, the park's planners envisioned it as a setting for a variety of festivals broadly related to the institute's themes.[43]

The nature of the park was in some ways predetermined by the exhibi-tion program created for the institute in 1987. As formulated by the consul-tants, American History Workshop, the central theme of the museum would be "Walking to Freedom," since "Walking, purposeful walking, was a basic element of the activist strategy of the civil rights movement. Simple walking, natural to people of all ages and levels of experience and knowledge, became a statement of the people's presence and their self-initiated progress toward freedom and equality." Thus visitors' movement through the spaces of the museum was imagined as a kind of civil rights march. The museum building would have a "Wall of Segregation" rising full height through its center. "The Processional," a group of about twenty full-sized human figures modeled in bronze or plaster, would stand atop the wall in a position that could be seen from outside the building, further emphasizing the walking metaphor. The planners wanted to extend exhibits into the neighborhood around the new museum, particularly into Kelly Ingram Park. They proposed a monument to the child marchers of 1963, "perhaps a bronze sculpture of a young person being hit by the force of a water hose, displayed right up against a tree in Kelly-Ingram Park." They also suggested a second, more abstract monument placed at the opposite corner from the King statue to "become the focal-point for a 'ritual of honor,' a daily ceremony of respectful marchers who walk from the Institute around the Park to the sculptures and back, in honor of the courageous black children of Birmingham."[44]

Although this program was written before the building was designed and much of it was abandoned, traces remain in the finished museum. "The Procession" survived as a group of plaster figures in the final gallery. They face a large window looking onto the Sixteenth Street Baptist Church. As the exhibits were refined, the metaphor of walking or marching remained the unifying thread of the institute, whose major publication is entitled *March to Justice*. Yet while marches were a key element of Project C, they were less

important in the history of Birmingham's civil rights movement as a whole. Until 1963, boycotts and limited provocations, such as the use of a handful of people to test the integration of busses, waiting rooms, and lunch counters, aimed at generating court cases that would require the integration of schools, parks, public transportation, and commercial facilities, were the preferred mode of protest in Birmingham. Thus the choice implicitly focused Birmingham's monumental program on the Kelly Ingram Park area and on April and May 1963.[45]

The landscape design commission was given to Edah Grover's firm Grover and Associates (GHH). Their brief was to rework Kelly Ingram Park "to provide a setting for the Public Arts Program [the sculpture] and to program events" in the park. Because the BCRI and the park were at least as important to redevelopment as to education, the commission also included an entry plaza for the museum building, landscaping around the museum in general, a parking lot for use by the institute and adjacent churches, and street improvements within the boundaries of the Civil Rights District.[46]

The metaphor of walking or marching was central to the park's design. In its initial research report, GHH imagined the project as an exterior "Freedom Walk" that would incorporate a "daily ritual processional route" of the sort proposed by the American History Workshop and "on-site interpretive strategies for the routes of the Civil Rights marches and demonstrations." This route would wrap around Kelly Ingram Park, moving past a "gallery" — presumably a series of interpretive signs or markers — while the center of the park would be left open as a space for individual contemplation.[47]

The memorial terrain was conceived expansively by the landscape architects. In addition to the processional around the park, others would be extended "into the urban fabric of the City along Fifth and Sixth Avenues" to draw the city center into the story. At one point, the report suggested that "these marches and demonstrations [should be] memorialized on our streets *throughout Birmingham*," suggesting that the designers were thinking of the geographically extensive history of the Birmingham civil rights struggle. Over the course of development a design that extended deep into the urban landscape was increasingly drawn back within the bounds of the park proper.[48]

GHH presented three design strategies to Mayor Arrington in April 1990, each incorporating a different approach to the issues of what can and cannot be said. The first and most adventurous sought to offer "a realistic portrayal of the events of the period in an environment visually similar to the neighborhood in 1963," although the architects realized that "much of the urban

fabric" of 1963 was gone. One is immediately struck by the irony of such a proposal in light of the destruction of the original neighborhood. As recently as 1982 the city had sanctioned the demolition of the Aqua Lounge, a building that had stood at the southwest corner of the park, at Seventeenth Street North and Fifth Avenue North during the 1963 demonstrations, on the grounds that it was not essential to the goals of the civil rights district and the integrity of Kelly Ingram Park as a historic site listed on the National Register of Historic Places. Other demolition took place even as the park was being planned. The city did not consider the historic landscape important even though, as we will see, it insisted on literalism in the representation of events.[49]

Another scheme scattered the memorials through the urban landscape, setting aside Kelly Ingram Park physically as a quiet center. All landscaping was to be kept inside the sidewalk line, so that the sidewalks—"Freedom Walk"—would be part of the representation of the old cityscape. New construction would emulate the shreds of surviving urban fabric, to instill in visitors "a sense of the environment within which these events actually happened." Panels of sidewalk "cast with the imprints of marching feet, firemen and police footprints, dog prints, and evidence of water hose sprays" would be scattered throughout the Civil Rights District at the precise sites of canonical events. A series of commemorative sculptures that replicated notorious images "'frozen' in time (much like the figures found in Pompeii)" would also be placed at the sites where they happened. Some might even bracket or intrude on roadways, adding to the trope of realism and participation. For instance, a depiction of the police-dog attack recorded in Bill Hudson's photograph would balance the victim on the curb as the dog pushed him off (see fig. 32). Another might place figures of firemen with hoses at the corner of Fifth Avenue North and Sixteenth Street, with their fallen targets across the street.[50]

The desire for realism and viewer involvement (the latter a common theme of late-twentieth-century public art, as art historian Miwon Kwon has observed) at first pushed the commemorative program out into the street, which may have contradicted the redevelopment agenda of the city. As a redevelopment scheme, Kelly Ingram Park and the BCRI were to draw visitors into the Civil Rights and Fourth Avenue Districts but not to interfere with the process of modernization and economic revitalization.[51]

The most abstract proposal focused on the intersection of Sixth Avenue North and Sixteenth Street North, where Kelly Ingram Park, the Sixteenth

Street Baptist Church, and the new BCRI faced one another. Stone pavers planted with trees would be set into the sidewalks to represent the marchers, while the monuments themselves would be abstracted from canonical images. For example, figures of demonstrators might face off against a sculptural policeman and dog without physically interacting, leaving the visitor to imagine the coming confrontation. The firehosing monument would use realistic representations of people and the hoses, but the ground plane would be tilted, with the victims raised in the air above the firemen in a manner meant to represent the figures ascending to heaven found in many medieval and Renaissance paintings. Oddly, for a site known as "sacred ground" and in the context of a civil rights history and a commemorative pattern permeated with religious imagery, this was the only time an explicitly religious metaphor was proposed for Birmingham's monuments.[52]

The third scenario was the basis for the final design for the park. This retained the idea of realistic figures based on "the images recorded by news media in 1963" but would not place them at the sites where they were recorded. In this case, the landscape of the Kelly Ingram Park would draw the sidewalks in, with the "sculptures and memorials . . . placed in carefully designed settings where visitors can contemplate the events in a calm environment," thus defining the park as the commemorative space and leaving the broader cityscape unencumbered. In an echo of the American History Workshop's plan for a line of marching figures atop a Wall of Segregation in the BCRI, this scheme also incorporated figures of children demonstrating. These would be placed atop a stone wall at the eastern (downtown) side of the park to act as a signpost to draw people into the park and the Civil Rights District.[53]

At this point in the development process, Kelly Ingram Park was conceived solely as a monument to 1963. GHH proposed dividing the park into quadrants, with each celebrating the events most closely associated with it spatially. The northwest quadrant would focus on the Sixteenth Street Baptist Church, the southwest quarter on the events that occurred at the Gaston Motel, the northeast on marches launched toward City Hall, and the southeast on sit-ins and other actions in the commercial downtown. The park would be "renamed to reflect [its] importance" to the civil rights movement. No mention was made of the Kelly Ingram monument or of the Fletcher and Tuggle memorials.[54]

The "Public Art Project," the process that chose specific artists and sculptural works to furnish GHH's general plan for Kelly Ingram Park, was directed by a

committee that included representatives of the landscape architects, mayoral appointees, and members of the BCRI board of directors, guided by a New Orleans–based "public art consultant," Grover E. Mouton III. Even before the panel began its work, the events and personalities to be represented had been selected by Mayor Arrington and Odessa Woolfolk, the chair of the Civil Rights Museum Task Force and later of the BCRI board of directors. The monuments would depict the children's marches, the firehosing of the demonstrators, the police dog attacks, the moment on Palm Sunday 1963 when three ministers dropped to their knees to pray as the police halted their progress toward downtown, the September 15, 1963, bombing of the Sixteenth Street Baptist Church, and the "Rev. Fred Shuttlesworth's Leadership." A central "Fountain or Water Feature" was included in the brief to act as "the centerpiece of the Plan and . . . the major focus that will serve to unify the many components of the Institute and the District."[55]

Their choices were products of the Arrington administration's effort to realize the civic myth in tangible form, but they also reflected Arrington's inability to form a conventional urban regime built around the city's white business elite. Arrington and his staff worked to consolidate support among the city's growing African American majority, which freed them from some of the limitations of what can be said by monuments in American public places because a potential source of objection to the park's message — resentful white voters — posed no significant threat to the administration's electoral chances. At the same time, the planners were confronted with the problem of what can and can't be said within the Euro-American formal language of monuments, and the deliberations over the choice of sculptors and the form of the memorials in Kelly Ingram Park have left the most varied and extensive record to date of the consideration of those issues.

Despite a competition program that specified that the artist or artists chosen should be black, should be well versed in the history of the civil rights movement, and should have experience with the kinds of public interactions and negotiations inherent to contemporary public art projects, the initial list of twenty-four candidates Mouton presented to the selection committee was composed of a majority of well-known white artists, including Jonathan Borofsky, Joel Shapiro, Jenny Holzer, and Raymond Kaskey, most of whom were familiar for outdoor works that were not usually of a commemorative or memorial nature. Only four artists were African American, and only five had undertaken projects related to African American history, culture, or experience. These were the four black artists and Clyde Connell, a white woman from

Louisiana whose social and political work with black churches in the 1950s and 1960s had led her to create works exploring bondage and social rejection.[56]

Overall, the list of artists was an odd one, in that most of the artists whose work was figurally based—an important criterion in the committee's eyes—created figures that were distorted or caricatured, some in a Pop Art manner, others in a more abstracted form. British sculptor Raymond Mason's work, for example, was described by the *New York Times* as "teeming street scenes and narrative tableaux [that] evoked an animated world of ordinary people caught up in the drama of daily life," a fitting approach, perhaps, to represent the events in Birmingham. But his figures, some monochrome and somber, others polychromed and cartoonish, remind one of the work of Red Grooms. (The *New York Times* said Robert Crumb.) John Rhoden's most renowned works, such as *Nesaika* (1976), fused sculptural forms that owed much to Isamu Noguchi with references to African traditional sculpture. His figural works showed many of the same characteristics. A few artists such as Lin Emery created formalist, metaphorical works in a recognizably modernist mode. In the 1980s, Keith Sonnier was creating abstract sculptures using neon and fluorescent lighting. Marvin Whiting of the Birmingham Public Library and the BCRI board of directors promoted Jenny Holzer, whose work is based on the inscription of texts in a variety of media, to create inscriptions for the granite benches and on the base of the Shuttlesworth monument. These would be taken from oral histories and other material in the library's archives. Yet Holzer's *Truisms*, the work for which she is best known, involve the ironic or slyly subversive transformation of familiar sayings.

All of the sculptors on the list were established artists who did worthy if not always cutting-edge work. Many worked in forms more closely associated with the 1950s to the 1970s. Nevertheless, it would be easy to imagine any of them as sculptors of Kelly Ingram Park's monuments. Expressionist human figures similar to those found in the work of such artists considered by the Public Art Project as Rhoden, Robert Schoen, or William King could be found in war and Holocaust memorials of the post–World War II era and, closer to Birmingham, in Memphis's Martyrs' Memorial (1971), which commemorated those who gave their lives to nurse their neighbors during the yellow fever epidemic of 1878. Magdalena Abakanowicz's *Katarsis* (1985), in Pistoia, Italy, comprises an array of thirty-three bronze figures resembling standing, headless figures. A work such as this, which evokes Auguste Rodin's *Burghers of Calais*, might have been a powerful realization of the metaphor of marching that shaped the BCRI and Kelly Ingram Park, but there is also something stark

about the work, which suggests dismemberment, that could have given a strong overtone of victimization to the work. Abstract works representing higher or ineffable values were also popular in the postwar era and were given renewed life in the years following the construction of Maya Lin's Vietnam Veterans Memorial. Even the irony of works such as Holzer's might have worked if, say, one juxtaposed the words of city leaders who supported and opposed segregation or quoted some of the dire predictions segregationists made about life after integration.[57]

Art historians often ask whether the civil rights memorial are "good art" and why there are no civil rights "countermonuments," a concept that has captured their imaginations through the work of Holocaust memorial scholar James Young. My point in suggesting possibilities in the work of artists considered by the Public Arts Project but not (with the exception of Rhoden) hired is not that any of the alternate possibilities would have been better art or necessarily good at all, although many of them might have suited the tastes of high-art partisans more closely. Instead, I introduce these possibilities as roads not taken to help illuminate the choices that *were* made. Neither humorous nor despairing representations of the movement nor ironic transformations of its words were likely to be viewed favorably by a committee that, as the discussion showed, sought sobriety, realism, and optimism in the works it commissioned. The traditional middle-class African American quest for uplift, together with a broader national sense that public monuments should "inspire," as the protestor at the unveiling of Savannah's African American Monument argued, motivated the planners of the park's artworks, even as they were charged with commemorating incidents that in themselves were not very uplifting. In this respect, their thinking was consonant with that of the committees that planned other monuments that I have discussed. They want monuments that celebrated achievement in a positive way and whose message was explicit rather than cloaked in metaphor—"the artist's interpretation" that the people of Rocky Mount, North Carolina, spurned—that might leave them open to divergent readings. In a sense, the civil rights memorials are countermemorials to the view of black Americans embodied in the white supremacist monuments that stand all around them.[58]

Popular expectations that monuments be positive and conciliatory surfaced in the discussion of Houston Conwill's work. John Wetenhall, the representative from the Birmingham Museum of Art, "noted that artist Houston Conwill's work is usually confrontational and documents a point in history that reflects upon the past. [He] recommended that the artist be instructed to

look to the future for reconciliation of struggles encountered in the past. This central design [Conwill was being considered for the water element] should depict the healing and unifying process which resulted from events documented by other memorials throughout the Park and District." Tommie Mitchell, the representative of the adjacent African American neighborhood Fountain Heights pointedly responded "that the artist should also be aware that, although some progress has been made during the Civil Rights Movement, there is still more work to be done." Even within its own self-imposed criteria, some of the Public Arts Project committee's choices were puzzling. For example, they passed over Tina Allen, a prominent and prolific African American sculptor of portrait statues and busts in a traditional mode. After the initial discussion, Houston Conwill had been selected to do the water element, Jenny Holzer to create the memorial to the victims of the Sixteenth Street Baptist Church bombing, and John Rhoden to sculpt Fred Shuttlesworth.[59]

At its next meeting the committee tackled the major event-based sculptures, debating whether they ought to be given coherence by being assigned to a single artist or whether separate artists should be chosen to make each monument visually distinctive. Mouton urged the selection of a single artist to lend the group consistency, to save money on fees, and to facilitate administration of the project. By this time, several of the artists under consideration had been dropped, and two others, Sidney Simon and William King, were added. Audrey Flack and Sam Gilliam, who were then married, were presented as a team. According to Mouton, "Ms. Flack is a sculptor who does pop characterization and Mr. Gilliam is an artist whose work is basically abstract." Committee member Carl Bradford, a local sculptor and former Tuskegee Airman, objected that "such a diverse team . . . would render an abstract interpretation of real events that occurred during the Civil Rights Movement." He similarly objected to Borofsky, whom Mouton recommended to do *Three Ministers Kneeling*, worried "about the artists' [sic] inability to portray realism in his work." Michael Dobbins objected to Raymond Mason, worried by "the facial expressions portrayed in the artist's work and noted that the perceived facial expressions of the Children's March should be one of hope."[60]

Ultimately the committee commissioned Raymond Kaskey to do the kneeling ministers. Artist James Drake would represent the police dog attack, the children's march, and the firehosing of demonstrators. Drake was presented to the committee as someone who was easy to work with and able to respect established schedules. Kaskey was put forward as a classical sculptor with significant public works to his credit. The Sixteenth Street Baptist

Church bombing monument was never realized; one person recalled that it may have been for lack of money. A modest disk on a pedestal was installed in 2008, and a black granite marker at the site where the bomb was laid was added on the anniversary of the crime in 2011.[61]

Former Birmingham city planner Michael Dobbins viewed Kaskey's *Three Ministers Kneeling*, the first of the new works to be installed, as the most important (fig. 35). The three life-size, kneeling ministers, clad in their clerical robes, are partially contained within the six-foot-high block of Alabama limestone from which they were carved. The two flanking figures bow their heads in prayer while the central figure raises his eyes to heaven. Like all the monuments installed in 1992–93, *Three Ministers Kneeling* encourages direct interaction. It sits on the ground, and one can walk up to the men and inspect them closely, looking down on them in their humility. The pose and the drapery are reminiscent of classical statuary, but the incident depicted is documented in a historical photograph that reveals the three men to have been the Reverends Nelson Smith, John T. Porter, and A. D. King, the brother of Martin Luther King Jr. Kaskey originally portrayed the three in the sculpture, but in July 1992, a few months before the formal dedication, Fred Shuttlesworth, Abraham Woods Jr., and other ministers more intensely involved in the events of

Fig. 35. *Three Ministers Kneeling* (Raymond Kaskey, 1992), Kelly Ingram Park. Photo: Dell Upton.

1963 began to object on the grounds that the three men had not been important to the movement. One form of historical truth—the fact of these three clergymen's being depicted in the contemporary photograph—clashed with another—their perceived inadequate zeal for the cause. At the last minute, Kaskey changed the three faces to those of anonymous young models.[62]

If one approaches Kelly Ingram Park from the direction of the Birmingham Civil Rights Institute or the church, it is possible to miss the modest-sized *Three Ministers Kneeling*. That is not true of Drake's three large, blue-steel sculptures, each of which straddles the walk that encircles the open space. The three are linked by their materials, by the large rectilinear slabs that organize them, and by the participatory response that their positioning demands.

In today's Kelly Ingram Park, the contemplative space that was to have occupied the entire park is confined to the reflecting pools at the center, while the Freedom Walk through the entire city is now the park's circular walkway, also called Freedom Walk, along which Drake's three monuments are sited. *Children's March* is formed of two steel walls with steps protruding at one end (fig. 36). The wall on the inside of the walk is set with steps at the bottom, which become a plinth supporting two still figures, a boy and a girl, their hands clasped before them, who stand in an arched opening like a doorway.

Fig. 36. *Children's March* (James Drake, 1992), Kelly Ingram Park. Photo: Dell Upton.

They look across the walk at the other wall, which is set with the steps at the top, protruding as a kind of overbearing cornice. A rectangular opening in the wall is barred like a jail. "I Ain't Afraid of Your Jail" is written on the children's steps. "Segregation is a Sin" is inscribed upside-down on the protruding step-cornice of the barred wall.

The monument's effect is based on its placidity. It is not the march that is represented but its consequences. In our sentimental view of children, children and jails seem antithetical, as the separation implies. Their very lack of reaction to the jailhouse seems more courageous than any show of resistance to it. By walking between the walls, we are confronted with that dichotomy, and we are also invited to choose. We can walk around behind the children's side and take their perspective, joining them in their courage. Or we can walk around the other side and take the perspective of the jailers, seeing the children through the bars. In both cases, the inscriptions are most easily visible from these positions behind the walls.

As we move clockwise along the walk, we arrive at *Firehosing of Demonstrators* (fig. 37). In this case, the wall straddles the path. We pass through an

Fig. 37. *Firehosing of Demonstrators* (James Drake, 1992), Kelly Ingram Park. Sixteenth Street Baptist Church visible in background. Photo: Dell Upton.

opening and are confronted with a water cannon pointed at us, its force reputedly powerful enough to remove the bark from trees. The danger seems more ominous than the threat of jail, and as we glance to our left, we see another boy and girl, one on his knees, the other with her face turned to the wall, drenched by the water (fig. 38). Here the calm of the boy and girl in the previous monument is simply not possible. The poses of these children replicate those in historic photographs and in that respect are the only instance in Drake's three works that have the literal quality demanded by the Public Art Project.

Fig. 38. *Firehosing of Demonstrators.* Detail of figures. Photo: Dell Upton.

Finally we pass the band pavilion at the east side of the park, and as we approach our starting point, we encounter the third and certainly the most unnerving of the three Drake works. *Police Dog Attack* features no human figures (fig. 39). Instead, two tall blue walls parallel to the path anchor leashes that barely restrain three ferocious German shepherd dogs, their fangs bared, that lunge toward anyone who dares pass them. They are located so that at least one is at the head level of almost any adult who might walk through. *Police Dog Attack* resembles several of Drake's works from the 1980s, many of which play in various ways on the clash of form, imagery, and materials—glass knives, golden machine guns, benches with machine guns used as brackets—that make familiar objects and beings seem more sinister than they do already. His outdoor work *Praetorian Guard* (1985) features two machine guns mounted on pedestals, flanking a pedestal supporting a mutilated body. It makes the similarly deployed water cannon of *Firehosing of Demonstrators* seem more threatening to know of this precedent, but it also makes the firehosing sculpture seem somewhat toned down with respect to Drake's other work. *Police Dog Attack* refers most specifically to earlier Drake works, such as *Triptych* (1985), where three-dimensional elements are attached to each of three separate walls. The central one has a standing figure turned to the wall, as in *Firehosing* but without the specificity of personality and dress. At the right two skeletal-looking busts are attached near the top. The left panel, *Guardian of the Rose,* features two Cerberus-like dogs heads flanking a single rose, all

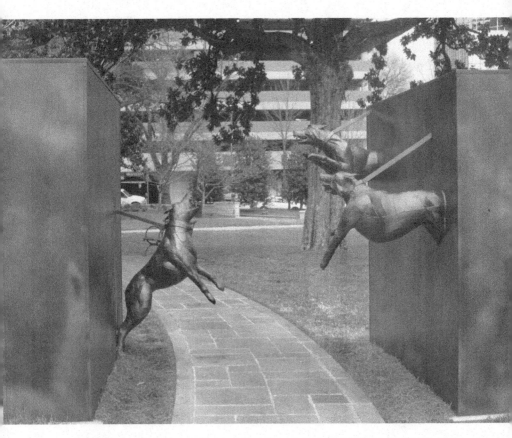

Fig. 39. *Police Dog Attack* (James Drake, 1993), Kelly Ingram Park. Photo: Dell Upton.

Fig. 40. *Police Dog Attack*. Detail. Photo: Dell Upton.

made in blue steel. The material robs the rose of its beauty, while the dogs' heads are rendered more chilling by their lack of eyes and by the welded seams that make them seem like devilish masks. These dogs, now with complete bodies, reappear in *Police Dog Attack* (fig. 40). They strike one as diabolical cyborgs, worse than real dogs.[63]

Individually Drake's monuments are disparate in the degree to which they are faithful to historic images of the events in Kelly Ingram Park, but they are arranged in such a way that our experience becomes more intense as we move around Freedom Walk clockwise. From detached assessment of which side to endorse in *Children's March*, to sharing the hoses' blast in *Firehosing*, we discover when we arrive at *Police Dog Attack* that we are the focus of the dogs' attention. There are no steel children here to distract them. Those fangs are aimed at us; they are present realities as much as historical representations. Yet Mayor Arrington believed that they were insufficiently intense in their emotional effect.

When the park was dedicated in 1992, only *Children's March* and *Firehosing of Demonstrators* had been installed. *Police Dog Attack* was absent. The newspapers reported that Drake had missed the deadline for the installation, while Drake denied having been told of a deadline. It was rumored that the police, who were then engaged in a lawsuit with Arrington, were furious that the leashes that restrained the dogs are clearly labeled Birmingham Police, and that they tried to have the monument suppressed on that account. Mayor Arrington told me that the opposite was the case—he wanted the sculpture to show more explicitly that particular human beings controlled the dogs. After struggling unsuccessfully to persuade Drake to change the monument, he

commissioned McDowell's *Dogs* to make his point (see fig. 31). *Dogs*, whose lengthy inscription honors the ordinary "foot soldiers" of the Birmingham movement, also responds to a demand by former foot soldiers for more voice in the Civil Rights Institute, whose planners had ignored them, and for payment for oral history interviews they gave to institute researchers.[64]

Based on a well-known photograph, *Dogs* is the most literal of the monuments introduced to the park in the 1990s, and it is the most problematic. In increasing the distance of age and power between the boy and the policeman, it becomes a monument that stresses victimization in a way that is not at all uplifting. But it also evokes uncomfortably the tradition of what might be called "action" monuments, war memorials such as the Civil War monuments with which many Southerners grew up, the Iwo Jima Monument in Washington, DC, or the Korean War Memorial in Nashville, Tennessee (see fig. 8). In action monuments, the figures are engaged in struggle, but the honorees are the heroes and the actual or implied victors of the struggle. Here the hero is clearly the loser. The limitations of the Western monumental tradition, which is best suited for celebrating heroic individuals and heroic actions, are apparent. McDowell told reporters that he "wanted faith in the rightness of the cause to exude from the boy's faith and posture. He wanted fear borne [sic] of knowing the wrongness of his position to emanate from the officer. The little black boy is giving himself willingly to the cause." At least in this form, these are things that cannot be said in this visual language. The uplifting message is obscure.[65]

The monument is more legible within the total ensemble of Kelly Ingram Park. In siting the new monuments and in moving older ones the planners created a subtly crafted narrative that is built upon, but surpasses, GHH's suggestion that the park be quartered, with each quarter devoted to a particular subtheme. The 1992 redesign reconfigures the old tension of moderates versus the activists to create a picture of new political order of Birmingham through the adroit spatial distribution of the old and the new monuments. Let me offer a reading.[66]

The monuments along Freedom Walk evoke the abuse of official power under the segregationist regime. The firehoses, the jailed schoolchildren, and the police dogs were all the work of the police and fire departments, controlled by Bull Connor. The police and fire departments, not coincidentally, were continuing centers of resistance to Birmingham's political transformation, and at the time of the dedication the two departments were embroiled in a decade-long lawsuit against the city over Arrington's affirmative action policies.[67]

The Drake pieces can also be read as allusions to current white abuses of power. For years, the local US attorney, Frank Donaldson, had tried unsuccessfully to indict Arrington for something—anything. Donaldson threw in the towel a few days before the dedication, and a few days after Bill Clinton's election to the presidency. Some of Arrington's supporters believed that the BCRI was the source of the mayor's travails. "Some powerful folks didn't want to see that come about," according to one city councilman. The pastor of Sixteenth Street Baptist Church believed that the investigation would not have been dropped if George H. W. Bush had been reelected. Fred Shuttlesworth's speech at the 1992 dedication explicitly connected the events of 1963 to Arrington's ordeal.[68]

We begin to understand why Arrington and his aides insisted on monuments that are so visually literal and that refer so directly to iconic incidents. They chose didacticism over metaphor, as most contemporary monument builders do, even though as a group the monuments vary in the literalness of their interpretations. Nevertheless, Arrington sought to engender in visitors a visceral experience of the white abuse of power as an ongoing, or potentially renewed, phenomenon. The Freedom Walk monuments evoke what it meant, and in many cases still means, to be black in Birmingham.

If we turn to the monuments around the periphery, we see a complementary message. Middle-class black people, their achievements on a par with those of whites, form a protective circle around the younger and poorer, if more actively engaged, victims along the Freedom Walk. So we can read the redesigned Kelly Ingram Park as a tableau of governing, of being in charge, of establishing political personas for Birmingham's mayor and his constituents, and signaling, even more than the King statue itself, of the permanency of the new Birmingham.

And where is Fred Shuttlesworth in all of this? Across the street under the overhang of the BCRI (fig. 41). Birmingham native John Rhoden departed from his customary style to depict Shuttlesworth in a conventional and not very distinguished manner. The minister looks toward the park as though he is about to say something but isn't sure anyone is listening. Although Shuttlesworth was accorded great deference during and after the construction of the institute and Kelly Ingram Park, and although his statue was the first of the Public Arts Project monuments to be installed and dedicated, the pose and the monument's siting speak eloquently of his role in the 1960s and of his uncertain position in the civic myth.

In many ways the redesigned Kelly Ingram Park can be interpreted as the triumph of the moderates, who take a conciliatory but firm stand toward

Fig. 41. *The Reverend Fred Shuttlesworth* (John Rhoden, 1992), Birmingham, Alabama.
Photo: Dell Upton.

whites. It is telling that the oldest monument, to the white sailor Kelly In-
gram, was not removed, nor was the name of the park changed, as the archi-
tects suggested. Instead, Ingram's memorial was moved to the northeast
corner, and that to Julius Ellsberry, his black counterpart, was installed in a
complementary position in the southwest corner among the other black
achievers, facing the Gaston empire headquarters. The whole ensemble was
then wrapped in an enclosing wall inscribed with a phrase coined by Mayor
Arrington — "A Place of Revolution and Reconciliation."

Collectively, the monuments in Kelly Ingram Park mark the outer limits
of what can be said in the context of contemporary Southern urban politics.
The park advances revitalization goals, a common goal of all Southern urban
regimes, but it also celebrates black empowerment while warning of its pre-
cariousness. Because Arrington had such a comfortable electoral majority,

the monuments are much more confrontational than those in other cities. As a group they contradict the claim, articulated by David Vann and by white moderates and progressives elsewhere in the South, that the depredations of the segregation era were the actions of a few thugs such as Bull Connor or his allies in the Ku Klux Klan. They do not exonerate those people or excuse their sins, yet they make it clear that the villains acted with the indulgence of a social and political power structure that allowed them to do its dirty work. And yet, as Arrington stressed, he still needed to reach accommodation with the white economic elite and to serve the needs of the black religious and cultural elite. So the emphasis on black self-help and the contrast between heroic leaders and the victimized foot soldiers at Kelly Ingram Park aids both causes as a "Place of Reconciliation *after* Revolution": reconciliation on African American terms.

At the same time, the monuments employ the same visual language and metaphorical structures that other civil rights monuments do, many of them inherited from and posed in opposition to, the Confederate monuments that form their ubiquitous context. For the most part, this language speaks of great leaders and epic battles. Neither of these themes really addresses the peculiarities of the civil rights movement, however frequently its participants and memorializers resort to military metaphors.

The story of Kelly Ingram Park in all its rich detail, then, opens out some of the complexity that is obscured when we evoke heritage or collective memory. A monument or an elaborately organized site such as Kelly Ingram Park represents not a memory but an interpretation or interpretations of specific events, offered in the context of contemporary ideological and political struggles. Birmingham's turbulent midcentury history provided a medium within which to articulate a strategy for governing the postindustrial city. Nevertheless, the skillfully organized ensemble barely holds together the varying agendas and still-remembered conflicts of the participants of the 1960s and their politically successful descendants. It overlooks most of the history of the Birmingham freedom struggles that took place in other parts of the city and that occurred over the decades from the 1930s to the 1990s. By historical accident, it stands near the portions of the city most frequented by whites, but it is marginal enough to be ignored by those who do not wish to "bring all that up again," as writers of letters to the editor frequently complain. Although monuments and memorials seek to activate or legitimize memory, they are limited by the resolutely individual nature of memory and the consequent unpredictability of the responses monuments can invoke.

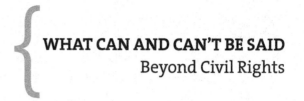

WHAT CAN AND CAN'T BE SAID

Beyond Civil Rights

The memorial ain't big enough.... It should be monstrous.

—ED DWIGHT, 2000

For aficionados of public monuments, the South Carolina State House Grounds are a treat. They are home to many more monuments than most state capitols can boast. These range from a memorial commemorating a South Carolina Revolutionary War general to a recent one honoring law enforcement officers. Among the predictable portrait statues of soldiers and politicians are several surprises. One is a delightful life-sized, polychromed, cast-iron palmetto tree, installed in the 1850s to pay tribute to the Palmetto Regiment, a South Carolina unit that fought in the Mexican-American War. Another honors Governor Robert E. McNair for overseeing the master planning of the capitol complex that accommodated the vast growth that characterized South Carolina's state government, like other states', in the 1960s and 1970s. A third, more somber surprise celebrates Dr. J. Marion Sims as the founder of "the science of gynecology," who did so in part using medical experiments on enslaved women.[1]

Most of the State House Grounds' monuments, however, celebrate the defining era of the state's white political consciousness, that period between Secession and World War II that witnessed the consolidation of white supremacy. The State House itself, begun in the 1850s but not finished until 1903, is the largest of these monuments, the sun around which the others revolve. Its lengthy and costly construction process, said a local newspaper, was "intimately associated with many tragic incidents in the State's history," meaning the Civil War and Reconstruction.[2] A nine-foot-tall marble plaque prominently displayed on the second floor is inscribed with the Ordinance of Secession by which South Carolina declared its intention to leave the Union, along with the names of the ordinance's signers.[3]

Outside, markers record South Carolina whites' sense of their victimization during the Civil War. One identifies the site of the second capitol, burned by Union troops in February 1865. Bronze stars in the west and southwest walls of the capitol mark places that Union cannonballs struck it. On the north steps, an 1858 bronze casting of Jean-Antoine Houdon's 1788 statue of George Washington is missing an inch or two of the president's cane. A plaque on the statue's base notes that during the Union occupation, "soldiers brickbatted this statue and broke off the lower part of the walking cane."

Other monuments chronicle the development of the myth of the Lost Cause, Reconstruction, and "redemption." An elaborate memorial on the north, depicting an angel crowning a woman with a laurel wreath, allegorizes Confederate women's loyalty to the cause. Markers celebrate highways named after Jefferson Davis and Robert E. Lee. The names of state office buildings honor John C. Calhoun, who articulated the nullification theory upon which secession was based and who was notable for his contempt for democratic government generally, and Wade Hampton, a Confederate general who was later elected governor to "redeem" South Carolina from Reconstruction. Statues celebrate Benjamin "Pitchfork Ben" Tillman, an early-twentieth-century governor and senator whose race-baiting was extreme even for its time, and James F. Byrnes, "the most distinguished South Carolinian of his time," an ardent New Dealer who had been a United States representative, a senator, secretary of state, (briefly) a Supreme Court justice, and governor of South Carolina, in which position he was an outspoken critic of *Brown v. Board of Education*. Byrnes's monument was erected in 1972, shortly after his death. Most recently, Dixiecrat Strom Thurmond was added to the white supremacist pantheon.

Chief among the freestanding monuments is the South Carolina Confederate Memorial, which stands at the north side of the grounds on axis with the city's major commercial street. A single soldier crowns a tapered shaft whose base carries a lengthy inscription describing South Carolina's Confederates as "men whom power could not corrupt, whom death could not terrify, whom defeat could not dishonor, and let their virtues plead for just judgment of the cause in which they perished.... The state taught them how to live and how to die" (fig. 42). On another side, the monument declares that they "have glorified a fallen cause, by the simple manhood of their lives." Here, as early as 1879, a full-blown version of the Lost Cause mythology discussed in chapter 1 is proclaimed. At the opposite side of the grounds stands an equestrian statue of Wade Hampton, who looks north toward the Confederate monument (see fig. 10).[4]

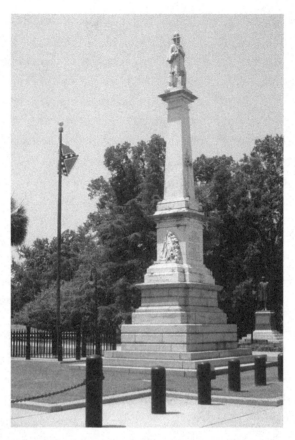

Fig. 42. South Carolina [Confederate] Monument (Muldoon, Walton, and Cobb, architects; Nicoli Sculpture Studios, sculptor, 1873–75), South Carolina State House Grounds, Columbia. Figure destroyed by lightning and replaced, 1884. Photo: Dell Upton.

After nearly a century of contemplating the Confederate soldier on his column, Hampton's gaze was interrupted by a new memorial, visually and thematically different from any of the others, that celebrates South Carolina's African American history from the arrival of the first African captives to the present. It is unlike the others in that it does not honor politicians, soldiers, or other servants of the state. Nor does it commemorate any single person, event, or era. And of course it sits uncomfortably among the monuments to white supremacy. Yet the African American History Monument is, in its way, integral to the entire group and emblematic of the problem faced by all builders of civil rights and black history monuments in the South, for it must cohabit with, and respond to, the still-treasured relics of white supremacy.

The monument owes its creation in part to a bitter struggle over the Confederate battle flag, which then flew from the State House dome. Although

the entire landscape of the capitol and its grounds is a celebration of the Confederacy and its aftermath, the battle flag has acquired a peculiar position in recent years. Predictably, neo-Confederates describe it as a symbol of "heritage" that has nothing to do with racism or slavery. As the historian Thomas J. Brown has argued, much of the genteel social meaning of the Lost Cause, a creation of the Southern elite, has fallen away. Instead, as in commemoration of the civil rights movement, the emphasis has moved to the foot soldier, an ostensibly apolitical figure who sought simply to do his duty and to defend his home. One opponent of the African American History Monument (who was nevertheless appointed to the monument's planning committee) said that "if they want to build one to veterans or black soldiers who contributed to the history of the state, that's fine. That's what the other monuments on the State House grounds are to, people who fought in wars." In some ways, as Brown notes, this view has become an expression of largely working-class white male resentment of Southern white elites, but it is deeply imbued with race, for the elite are believed to have deserted their white neighbors while favoring African Americans. Opponents of display of the battle flag foreground its renewed currency in the 1950s and 1960s through its use by racists as a rallying symbol. It was first displayed in the state house of representatives' chamber in 1938 to celebrate the defeat of federal antilynching legislation, in the state senate's chamber in 1956 during a session devoted to thwarting federally ordered racial integration, and atop the dome in 1962 during a dispute between representatives of national and Southern bodies established to commemorate the Civil War Centennial.[5]

South Carolina was the last state to fly the Confederate battle flag over its capitol, although Georgia, Alabama, and Mississippi continue to incorporate it into their state flags and to display it on state property. Futile efforts to remove the flag began in 1972 and continued through the remainder of the twentieth century. In the late 1990s, business progressives in South Carolina began to reconsider the battle flag at about the same time they began to come to terms with the civil rights movement. One banker complained that "because of this flag issue, the more sophisticated businesses don't view us in the light that would encourage them to expand in South Carolina." After years of proposals and counterproposals, the legislature agreed to move the flag from the capitol dome to the Confederate monument. It was finally struck on July 1, 2000.[6]

Few except legislators were happy. African Americans and their supporters still objected to the official display of the battle flag on the State House

Grounds, while neo-Confederates believed that their values had been deni-grated at the same time that those of African Americans were honored. The NAACP called for an economic boycott of the state, one that remains in effect. Its most painful result for many South Carolinians is that the National Colle-giate Athletic Association, recognizing that a large proportion of college ath-letes are African American, has honored the boycott by refusing to allow NCAA tournaments to be played in South Carolina. As a result, the sports col-umnist for the Columbia newspaper, the *State,* has become one of the most vociferous opponents of the flag's display on public property.[7]

As part of a dual-heritage strategy to solve the problem, the South Caro-lina Senate passed a Heritage Act in 1994 that would have moved the battle flag to the Confederate monument and constructed an African American his-tory monument. The bill failed in the house. Another attempt two years later failed when the house again refused to consider the plan. One gets a sense of the nature of the opposition from the actions of Republican representative Jake Knotts, who held up the bill until the senate agreed to pass bills favoring higher speed limits, a shorter legislative session, and easier access to con-cealed weapons permits. Eventually the bill for the monument was passed when senate leaders connected it to an economic development proposal fa-vored by the governor. Before the monument was dedicated, South Carolina became the last state to recognize the Martin Luther King Day holiday, but at the same time made Confederate Memorial Day a state holiday.[8]

Among the strongest supporters of the flag in the state legislature was Senator Glenn McConnell, a Charleston Republican, a Civil War reenactor, and the owner of a gallery selling "Confederate-based art and memorabilia." He also helped engineer the passage of the African American history monument bill and was appointed chair of a state commission comprising five black members and four whites, all but one legislators, that supervised the memo-rial's creation.[9]

At the beginning, the African American History Monument Commission (AAHMC) had "only the vaguest notion of what the privately funded monu-ment should say." However, the commissioners' initial comments centered around familiar themes of uplift, achievement, and optimism. Senator Darrell Jackson, the other major Senate sponsor of the monument, told a reporter that he wanted a "generic" monument that would "accentuate the positive aspects of the black story in South Carolina and serve as an inspiration for visiting chil-dren." "We don't need to deal in horrors, we need to deal in honor," he said. Jack-son also emphasized that the monument needed to depict a war without

enemies." "What the monument should do is talk about black endurance in the face of oppression, not about who was doing the oppressing.... 'I want to highlight the strengths of African-American people in enduring, as opposed to talking about the other side,' he said. 'I don't want to villainize anyone.'" Columbia attorney John Rainey, who took charge of the fund-raising, added, "We're one people. We're all South Carolinians with a common heritage and yet a diverse heritage." The acknowledgment of conflicts, even those that created the conditions and shaped the events depicted on the monument, was out of bounds. It would undermine the strict parallelism of the dual-heritage strategy, in which black history and white history move adjacent to each other without intersecting in uncomfortable ways. Thus McConnell, like the participants in the debate over the multicultural monument at Bowling Green, Virginia, framed the African American History Monument as one of three equivalent freedom struggles: "First there was the struggle for liberty from the British, then the struggle for states' rights and finally the struggle for civil rights."[10]

Not everyone agreed with the avoidance of conflict. Cleveland Sellers, a former civil rights activist and a student survivor of the 1968 Orangeburg Massacre at South Carolina State University, in which state police fired into a group of demonstrating students, killing three and injuring twenty-six, told the same reporter, "We shouldn't put up something that is just lovely, smiling faces." He favored recognition of the Orangeburg Massacre as well as of figures such as Denmark Vesey, a freedman executed for organizing a slave uprising in Charleston, or Robert Smalls, an enslaved man who seized a Confederate ship in Charleston harbor and used it to ferry himself and his family to freedom and later served as a legislator during Reconstruction.[11]

None of these proposals affected the final form of the monument because the AAHMC was resolutely determined not to offend. To avoid the problem, the commissioners decided that no identifiable person would be depicted on the monument. They also decreed that "a modern abstract sculpture is out of the question," since the general assembly was unlikely to approve one. After choosing a site at the east end of the State House from among the possible locations for the monument, the commission met with the members of the official Citizens Advisory Committee. One Citizens Advisory Committee member wanted the designers to use "a round shape instead of something flat. The round shape would symbolize the drum in African-American heritage that was used for communication (signals, escape, and entertainment) when the African-Americans came to this country." She then described something very close to the final monument: it should constitute a series of vignettes

starting with slavery, not necessarily people in chains, but something to symbolize that part—either some kind of escape, someone with a lantern, an underground railroad scene, or something symbolic (some kind of chain design), moving on to reconstruction with the scene of a town and a church (which was most important in the community) then to Civil Rights with people protesting—and finally, to something more modern with a group of African-Americans sitting at a round table in discussion (in summary, touching on each part of history and telling the story).

Another member of the committee "liked the idea of the drum and church" but wanted South Carolinians such as Ronald McNair, an astronaut killed in a space shuttle disaster, and the Reverend Jesse Jackson to be depicted on the monument.[12]

Elizabeth Alston, a former member of both the State Archives and History Commission and the South Carolina African-American Heritage Council, pointedly raised an issue that had come up during the discussions over the King Memorial in Washington and the African American Monument in Savannah when she asked "if this would be the first and last monument. There are thousands of monuments to other people. 'Are we African-Americans limited to one?'" The question was important not only for its implications for black visibility in the public realm but as a practical matter. Was it necessary to try to encompass all of the state's black history in a single monument, or would there be other opportunities? If there was a response to Alston's question, it wasn't included in the minutes. At the Charleston hearings, however, William Hamilton, a white Civil War reenactor offered a kind of unintended response to Alston. He wanted "one figure—an adult cast of metal mounted on stone, who can be singled out to visiting school children as a hero." He argued, "If you want to tell a story with one monument it ends up garbled, something only an art history major could understand."[13]

In early 1997, AAHMC members traveled around the state to hold a series of hearings, one in each of South Carolina's six congressional districts, to seek public suggestions about the content of the monument. In preparation, Vice-Chair Gilda Cobb-Hunter asked the press's help in impressing on the public that these hearings were about the monument, not the Confederate flag, which she said was a separate and settled issue. The citizen comments varied but were in many ways predictable, reflecting an inclination to uplift and often advocating the use of an idealized African imagery. The Charleston hearings seem to have become a forum for black and white Civil War reenactors, at least as they were reported in the local newspaper. A black Civil War reenactor wanted the state to erect a memorial to the mythic blacks who

fought for the Confederacy. Another black reenactor who portrayed a member of the Massachusetts Fifty-Fourth, the famous black regiment that fought at Fort Wagner in Charleston Harbor, and who also happened to be Charleston's chief of police, argued against tearing down Confederate monuments, instead urging the construction of "additional monuments on public land to aid in telling the story of the war from all sides." Thus, despite Cobb-Hunter's strictures against raising the Confederate flag issue, the discussion edged inevitably and necessarily toward the question of how one reconciled recognition of the state's black history with simultaneous celebration of its proslavery actions.[14]

At Orangeburg, the speakers advocated both historical and symbolic or allegorical strategies. County Councilman John Rickenbacker wanted to recognize Reconstruction era figures such as Alonzo J. Ramsey, the state's first black lieutenant governor, and Joseph Rainey, who was the first African American to serve in the United States House of Representatives. Rickenbacker's neighbors argued for representative figures. One envisioned a monument that included a teenage boy, a young girl, a male worker, a World War II veteran, a female doctor, and (shades of *2001: A Space Odyssey*) "a male in astronaut's suit standing in a circle with one raised hand supporting a new baby." Another preferred "a monument (starting) with a man who has broken his chains and spiraling upward to farmer and on to astronaut. . . . Each accomplishment should have some type of emblem to represent its area. If you single out individuals, someone will be missed." The latter suggestions were rooted, on the one hand, in twentieth-century social art that attempted to depict the varied human types who compose a particular community and, on the other, in notions of social evolution and advancement that are widespread in American society but that were reinforced here by the African American tradition of uplift through self-help.[15]

The comments collected at the hearings were submitted to the historians on the Citizens Advisory Committee, who discussed them "in light of their historical expertise and training." Then the historians met with the artists on the committee and the two groups produced a prospectus for the monument. The historians emphasized that the monument should reflect "change and continuity." Specifically it should acknowledge the Middle Passage and slavery, "the moment of freedom," Reconstruction ("the first civil rights movement and a noble experiment in bi-racial government and social reform"), the modern civil rights movement, and the ongoing freedom struggle. It should stress "resistance to injustice and the struggle for freedom and

power," as well as the survival of black cultural traditions, with particular attention given to the role of the church. All of this should be visualized in a way that "present[ed] a reflection of history and a sense of timelessness." The monument should be "multi-faceted," and it should be shaped to accommodate its site, a circular flower garden. The committee also emphasized that the monument's design should be "harmonious" with others already on the State House Grounds.[16]

The design criteria ruled out a single figure as in a common soldier memorial. They ruled out abstraction, since there were no abstract memorials on the grounds. They ruled out the kind of representative group or progress memorials that some speakers at the hearings envisioned, and they played down the emphasis on the Civil War that emerged in the Charleston hearings. They pushed the monument toward a historical treatment that comprised a series of vignettes representing the historical eras and episodes listed. The finished design fits the specific requirements of the prospectus quite closely, although the criteria left room for great variation among possible realizations of the criteria.

A competition attracted forty-six entries from which the commissioners selected fifteen sculptors or collaborative groups for consideration. That list included names familiar from earlier chapters of this book, including Erik Blome, the Rocky Mount sculptor; Houston Conwill, who was a contender at Birmingham; and the eventual winner, Ed Dwight. Commissioners voted for as many candidates as they liked; Dwight was the only one to receive votes from all nine. Three finalists—the team of Houston Conwill, Joseph DePace, and Estella Conwill Majozo; the team of Antonio Tobias Mendez and James Urban; and Ed Dwight—were interviewed. Collectively, the finalists covered most of the themes enunciated in the hearings. One relied on a romanticized conception of African culture, one presented its message metaphorically through representative figures and cultural allusions, and the third employed historical imagery.[17]

The Houston Conwill group's "Carolina Shout" featured "a circular granite ceremonial dance ring sandblasted with a cosmogram tracing the struggle for freedom and justice from Africa to South Carolina." Conwill described the cosmogram as "a Kongo-Yoruba rooted African-American crossroads symbol found in Black Atlantic folk art," but while that figure served to structure the monument spatially, the visual elements of the design included words, symbols, and images rendered in a contemporary, rather than a romantic-ethnographic, style.

Around the edges of the cosmogram four granite benches would be connected by seven-foot columns bearing sixteen paired photographs of black leaders, etched in glass and backlit.[18]

Mendez and Urban began with an image derived from African American folk culture, the sweetgrass baskets produced along the Carolina and Georgia coast, which have demonstrable origins in West Africa. The baskets are made by coiling bunches of grasses around a central point, creating a continuous spiral from base to rim. The Mendez-Urban design would have used groups of figures representing the black experience from slavery to the present spiraling out from a central point engraved with a familiar image of Africans packed into a slaver's ship. The figures would show "how [cultural practices] came from Africa and are 'still alive in South Carolina' today, which explained the baskets" in the model. Each figure represented a different stage in the historical chronicle demanded by the sponsors. There would also be a series of inscriptions including a summary text that would give the monument "a spiritual content and reflect the spiritual life of the African-American in South Carolina." Other inscriptions would list up to two hundred notable black South Carolinians. Nevertheless, the works would be "a monument to all African-Americans from South Carolina and it will not recognize one individual over another." Senator Darrell Jackson worried about the names "since he is aware of the 'psychology of calling names.... It's ... whose name is left off.'"[19]

In response to the requirement of contextual harmony, Dwight described his design as "Victorian architecture." A central "tower of progress" would be flanked by panels representing aspects of South Carolina's and the nation's black history. "I go from 1619," Dwight told the commission, "and stop with the marches in Washington." Within those parameters, "we have the option of putting anything in here that we want." There would also be "two small podiums" on either side of the entrance that could be inscribed with names. Commissioner Jesse Washington praised the design but wondered whether everyone, black and white, would be able to understand the visual imagery. Would there be "a legend or explanations"? Yes, said Dwight, there would be an audio tape or a "handout." When asked about future additions, Dwight simply said that there could be additions. In response to a question about the representation of people other than public officials, he promised that "the different panels ... would include different groups—legislators, men, women and children doing regular things—heroes and sheroes."[20]

The Selection Recommendation Committee reported that it was "split down the middle" between Mendez-Urban and Dwight. In the end, the AAHMC chose Dwight's entry on the basis, according to Chair McConnell, of its height, which gave it presence, and because "it carries some Victorian incorporation," which fit well with the State House Grounds. He stressed "the importance that the monument not be so strong politically," by which he explained that he did not want too many political figures included. Jackson stressed that the committee accepted the "concept of the Victorian style without the details."[21]

Both Dwight's vague answers to particular questions and the commissioners' reservations reflect the nonspecificity of Dwight's proposal, which responded to the design prospectus with a generic account of the African American struggle, rendered in the requisite mood of triumph and uplift. There was little in it that addressed South Carolina's history specifically. It was built around a "central core icon," a monolith that would symbolize "the accumulation of, and culmination of the history and the struggle for civil rights." The floor of the monument would focus on "three granite engraved Middle Crossing icons" leading to the central monolith. The right side of the core monolith would support a granite plaque recounting "the slavery struggle" from 1619 through the Civil War and would feature "heroic participants," such as Crispus Attucks, Frederick Douglass, Sojourner Truth, and Harriett Tubman, "in collage at the large end of the bas relief." That is, Dwight already imagined the relief as a pair of trapezoidal panels like that used on the final work and in his Underground Railroad Memorial (1993) at Battle Creek, Michigan, and as one that would be divided into discrete panels or vignettes. It would have a sloping profile oriented north toward Gervais Street. The left side of the memorial would continue the story of the black struggle from Reconstruction through the civil rights movement and would feature Martin Luther King Jr., "Medgar Evers, Malcolm X, etc." At the center would be a figure of Denmark Vesey. There would also be space "to honor local Civil Rights heroes from South Carolina" by etching photographic portraits into the granite. The "core element" would include "supporting iconography and lesser elements addressing other aspects of the struggle," culminating in "racial progress affected [sic] through Law and Justice; and finally the Spirit of Triumph, through unfettered possibilities in the pursuit of security and happiness in America." The final "Spirit of Triumph Panel" was "intended to be inspirational and a tribute to what we have achieved and what as a Black Community we can be inspired to do." It also contained many of the didactic elements that characterize other contemporary

monuments. The panel devoted to slavery "would be supported with textual data regarding the institution of slavery ... engraved into the granite."[22]

In the three years between Dwight's selection and the installation of the African American History Monument in 2001, the meaning and content of the monument were intensely, sometimes bitterly, contested among the members of the commission. The proposal to include Vesey was immediately dismissed on the principle of including no one identifiable, but some committee members and public observers objected to the exclusion. A Charlestonian, presumably a constituent of McConnell's, wrote to the legislature that Vesey's planned insurrection was "the most profound accomplishment of any single Black American from slavery to the present, bar none." He denounced the proposed monument as a "sham ... due to the ideology of the members." The legislature was unlikely to permit the monument to honor any true African American freedom fighter, as their position on Vesey and "your voting record" demonstrated. Senator McConnell responded that the AAHMC had been divided about whom to honor. Because there could be no consensus, it was decided to avoid the issue altogether. This would avoid a public debate "that would not create unity for the monument but rather disunity." Rather than being a plot to deny black freedom fighters their recognition, he said, "It was a simple case of trying to design a monument based on a consensus which could pass the General Assembly and the State House Committee and the community at large without debate or division over what should be in it." McConnell added that in the absence of historical images of Vesey, he could not be depicted "with undeniable accuracy."[23]

Nevertheless, the wall between the dual heritages was continually threatened and sometimes breached. As monument building got under way, black members of the legislature renewed efforts to remove the Confederate battle flag from the State House dome and the NAACP reiterated its calls for a boycott of the state. At one point, Senator Darrell Jackson called on McConnell to resign on the grounds that the AAHMC chair's defense of the flag and his criticism of the NAACP "tainted" fund-raising efforts. McConnell replied that "his defense of the flag is based not on race but on reverence for heritage" and refused to resign unless he received a no-confidence vote from the commission as a whole. Jackson's position offended Vice-Chair Gilda Cobb-Hunter, an African American woman who reiterated her position that the monument and the flag were separate issues. "I think a part of political maturity suggests that in this body and in this arena, you have to learn to work with people whether they agree

with you or not." A scheduled AAHMC meeting was called off to allow tempers to cool. Later, members accused one another of trying to sabotage the project. A black legislator from Charleston, Senator Robert Ford, demanded at the last moment that his name be added to the list of commission members inscribed on the monument, and he succeeded despite widespread opposition. Cobb-Hunter boycotted the dedication ceremony in protest.[24]

The flag issue continued to inflect perceptions of the African American History Monument as the dedication day neared. In the spring of 2000 most white Democrats and a majority of white Republicans reached a compromise to move the flag. Although all but one black senator supported the move, only three of twenty-six black members of the house did. To offset the rebel flag some African Americans, led by Ford and another state senator and endorsed by McConnell, advocated flying of the black, green, and yellow Black Liberation flag at the African American History Monument. The suggestion annoyed Cobb-Hunter, who dismissed the idea on the grounds that "the [liberation] flag represents the civil rights era but the monument covers three centuries." She added that "people who are raising that as an issue have no clue as to what is on the flag."[25]

While they were wrangling with one another and with the public, the commission interacted with Dwight in a way that was sometimes equally tense but that created a monument whose imagery was much more vivid and more specific than that Dwight had proposed. In this case a committee produced a better result than the artist alone might have. The monument that was unveiled on March 29, 2001, centered on a twenty-three-foot obelisk set to the rear (west) of the circular footprint, just in front of the gap between two curving, twenty-five-foot walls that slope away from the obelisk (fig. 43). According to the sculptor, who was unable to resist the essentializing reference, this shape represents "an African village built in the round."[26]

In finished form the combination of the walls and obelisk is strikingly similar in size, shape, and materials to the South Carolina Vietnam Veterans Memorial (1986), which stands a few blocks away (fig. 44). John Rainey and Bud Ferillo, fund-raisers for that project, also raised money for the African American History Monument. Columbia's Vietnam memorial in turn is a kind of inversion of Maya Lin's Vietnam Veterans Memorial (1982) in Washington: its sloping, name-covered walls rise from the earth rather than burrowing into it, and it is made of light gray rather than black granite. When Ferillo said that the African American History Monument would "be to the Capitol grounds what the Vietnam monument is to Washington," he said more than he knew.[27]

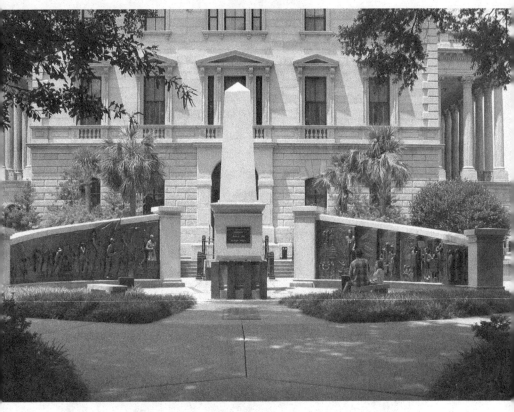

Fig. 43. African American History Monument (Ed Dwight, 1998–2001), South Carolina State House Grounds, Columbia. Photo: Dell Upton.

The main opening at the east is preceded by a reproduction of part of the plan of a slave ship packed with 482 captives (fig. 45). This was derived from *Description of a Slave Ship* (1789), an image created by British abolitionists that was widely distributed by English and American abolitionists. It depicts an actual Liverpool slave ship, the *Brooks*, but the plan is a hypothetical

Fig. 44. South Carolina Vietnam Veterans Memorial (1986), Memorial Park, Columbia. Photo: Dell Upton.

representation of the maximum number of people who could legally be packed into the space under the provisions of proposed regulations bitterly opposed by slave traders. In fact, at the time the image was published, the real *Brooks* had made voyages carrying as many as 740 captives. As Marcus Wood has shown, the publishers wished to depict the passengers as

Fig. 45. African American History Monument. Slave ship plan. Photo: Dell Upton.

victims stripped of their culture and their individuality as a way of arousing feelings against the slave trade. But the image has been republished and adapted for more than two hundred years since its initial appearance and accepted as a record of a particular ship on a particular voyage. The plan has been imprinted in contemporary consciousness as the quintessential representation of the slave trade, and its use in the African American History Monument is one among many. Here, however, its use oddly contradicts the emphasis on "honors" rather than "horrors" and on black agency.[28]

Dwight intended to sandblast the plan into the granite pavers, but then decided that the recesses would collect dirt and leaves. Instead he cast the figures in bronze and embedded them in terrazzo. The experience of entering by walking over the ground-level plan was meant as an emotionally affecting introduction to the monument, similar to the effect intended by the original print. Soon after the work was dedicated, though, it became clear that it could not withstand the tread of so many feet. No action was taken for several years because of fear of the liability that might be incurred by installing an appropriate but unobtrusive protective enclosure. Eventually, shuffling feet forced the installation of a low metal enclosure resembling a ship's rail.[29]

Between the slave ship and the obelisk, a black granite plaque raised on a pedestal displays a map of Africa and the Americas, with the regions highlighted from which most enslaved Africans who came to South Carolina were taken. For each, there is a corresponding chunk of indigenous stone presented like a talisman: "Rubbing a stone from 'home' can take one back in spirit," as one journalist put it.[30]

The most important elements of the monument are the two bands of bronze reliefs attached to the curving walls (fig. 46). They are subdivided into panels that collectively recount a historical narrative that begins at the outer end of the left panel and concludes at the outer end of the right panel. Each panel steps back slightly from the one before it (on the left) or the one after it (on the right), while the images are rendered in low relief that becomes progressively higher as one approaches the climax of each series. The first vignette on the left depicts a slave auction, which Dwight originally said would depict a scene in 1619 when slaves were first brought to British America. In the finished work the image of people standing on an auction block was a "reproduction of an 1852 newspaper ad" meant to stand for the slave trade over the 190 years from South Carolina's founding to the Civil War. Thus this scene is chronologically out of place and visually separated from the narrative flow. It is also the only panel without a visual link to its successor.[31]

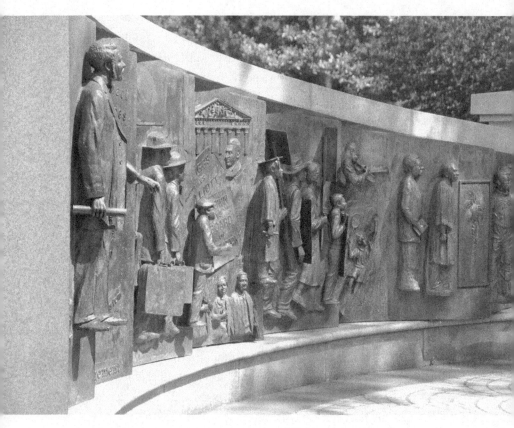

Fig. 46. African American History Monument. Right (north) wing. Photo: Dell Upton.

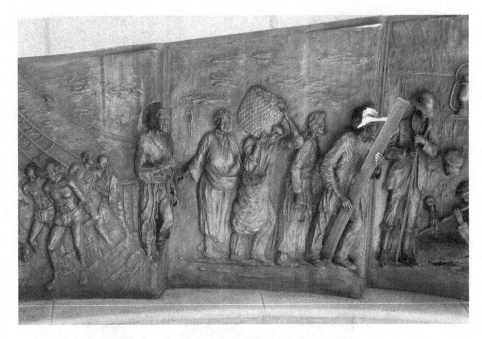

Fig. 47. African American History Monument. "Slave Labor." Photo: Dell Upton.

The second panel depicts the Middle Passage again, with captive Africans on a ship bound for North America. One is chained and about to be flogged by a member of the ship's crew. Then we see a procession of enslaved people at work (fig. 47). A woman scatters seeds, a man carries a coiled sweetgrass basket on his shoulders, another woman carries a basket, perhaps to market, and finally a man carries a plank, perhaps to a building site. Although these workers seem stoic, in the next scene, into which the man with the plank peers, a group of men gather under the light of a lantern, studying some sort of paper. This image, entitled "Resistance," is ambiguous. The men could be planning a rebellion, but since that might unsettle white viewers, we are told that they are planning to escape. On the right side of this panel, a man carrying a hoe looks into the next panel, officially called "The War Between the States" (the Lost Cause term for the Civil War and an indication of the influence of neo-Confederates on the monument) (fig. 48). This vignette depicts the South Carolina Volunteers, the first all-black unit from the state to fight for the Union. At the head of the procession a black soldier carries the "authentic" flag of the unit, a version of the American flag with "God Gives Liberty" embroidered on the stripes. Behind him, a white officer turns to rally the troops, whose posture and disposition in space recall Augustus Saint-Gaudens's renowned

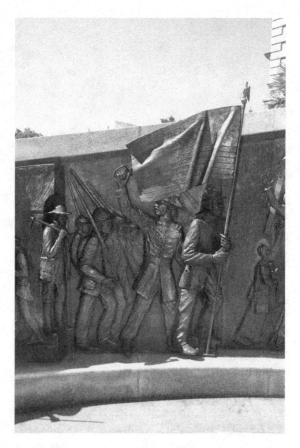

Fig. 48. African American History Monument. "War Between the States."
Photo: Dell Upton.

Shaw Memorial (1883–97) in Boston. This is the visual climax of the left series. The characters are the most energetic and are rendered in the highest relief, and the action breaks the picture frame, for the flag projects not only above the borders of the bronze panel but above the wall to which it is affixed.

The narrative concludes on this wall with an image of jubilant freedpeople arrayed under an eagle-borne banner labeled "Emancipation" (fig. 49). Some throw up their arms in joy; others lift their clasped hands in prayerful thanks or kneel in private prayer. The narrative is carried across the gap to the right-hand panel by the gaze of a still, thoughtful-looking woman who gazes away from the celebrators toward the future as depicted on the right. Her costume resembles contemporary images of Sojourner Truth and Harriet Tubman, and she reminds one of the importance of women in the freedom

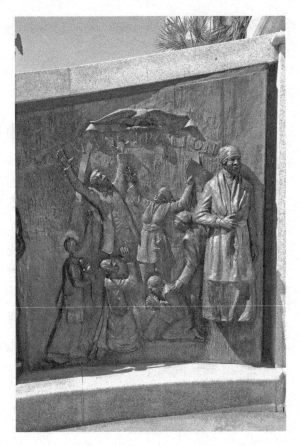

Fig. 49. African American History Monument. "Emancipation." Photo: Dell Upton.

struggle and of their publicly expressed understanding that emancipation was not its final act.[32]

The narrative picks up on the right with "Reconstruction" (fig. 50). Like most panels on this wing, "Reconstruction" offers an array of small images rather than the single, all-encompassing action that characterized the panels on the left. In the upper left corner, black men line up to vote. In the lower left, one sees "Land Grants to Ex-Slaves." Significantly, the grants are conveyed here by African Americans to African Americans. At the lower right, a black man stands behind a desk such as that found in the State House. He is, according to the official brochure, "a proud, effective African American legislator arguing for the passage of Civil Rights laws in the South Carolina legislature in 1868." This claim stands in explicit rebuttal to the Southern mythology of Reconstruction as a time when ignorant blacks were given political rights they could

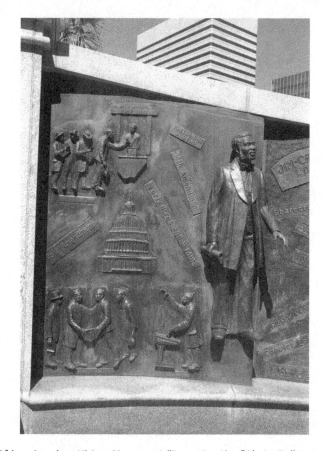

Fig. 50. African American History Monument. "Reconstruction." Photo: Dell Upton.

not understand so that they could be manipulated by corrupt Northern "carpetbaggers." Viewers who know D. W. Griffith's scurrilous film *Birth of a Nation* (1915) will also recognize the contrast to the filmed scenes of black legislators in the South Carolina State House drinking and carousing, their unshod feet resting on the type of desk behind which the man on the monument stands. At the center of the panel, the dome of the United States Capitol is surrounded by labels that read "14th Amendment," "15th Amendment," "Forty Acres and a Mule," and "Freedmen's Bureau," suggesting that there was no visual language adequate to convey these important but intangible ideas. Equally striking is the absence of activities such as union organizing or institution building that are both difficult to depict as a moment of action in the standard language of monuments and fall outside the standard narrative of the struggle for freedom and civil (read citizenship) rights that the African American History Monument depicts.[33]

This limitation carries over to the next panel, "Southern States Reaction to Federal Law," which conveys the era that the historian Rayford Logan labeled "the Nadir": the long decades of repression, terrorism, peonage, and denial of basic rights to African Americans after the end of Reconstruction (fig. 51). Here there are no images at all, only the words "Jim-Crow Law," "Black Codes," "Sharecropping," "Segregation," "Lynching," "Plessy vs. Ferguson," "Convict Labor System," and "Abridgement." These, too, are complex ideas, but in this case, according to Dwight, "his effort to tell the whole truth was muted when it came to depicting the era when segregation was legalized and the Ku Klux Klan flourished." He had intended "hooded Klansmen burning crosses and the bodies of blacks hanging from trees," but he was asked to tone the panel down to avoid controversy. So he made an all-text panel.[34]

In reaction to the depredations of the Jim Crow era, blacks left the South in great numbers. This migration is the subject of the next panel, which shows a family of four—man, woman, older girl, and younger boy—suitcases in hand, lined up to board a bus or a train to the North. Their poses recall those of the enslaved workers opposite, but now, rather than doing someone else's bidding, they are acting to free themselves from the restrictions imposed on them in the South (see fig. 47).

At this point the narrative reaches the civil rights era. Again, a series of related images rather than a single action organizes the panel. Schoolchildren with their books share the pictorial space with the portico of the Supreme Court building in Washington, a silhouette of Thurgood Marshall, and two scrolls reading "Briggs vs. Elliott" and "Brown vs. Board of Education." *Briggs v. Elliott* was a school integration lawsuit initiated in Clarendon County, South Carolina, in the late 1940s. When it reached the United States Supreme Court, it was folded into the cluster of suits that became known as *Brown v. Board of Education.* A young man in cap and gown, carrying his diploma, looks into the following panel, which features four demonstrators carrying picket signs that read "Freedom Now" "Freedom & Equality," and "We Deserve Equal Rights." Their postures recall those of the slave workers and the migrants to the North, and even those of the marching soldiers, thus giving the visual sense of a continual march from prerevolutionary South Carolina to the present.

The narrative concludes with a double "Panel of Progress." Officially, the panel "illustrates African Americans' amazing progress and triumph over adversity in South Carolina." In truth, many of the figures are readily identifiable. Four figures, whom I read as Modjeska Monteith Simkins, a venerated Columbia civil rights activist; Judge Ernest Finney, the first black chief justice

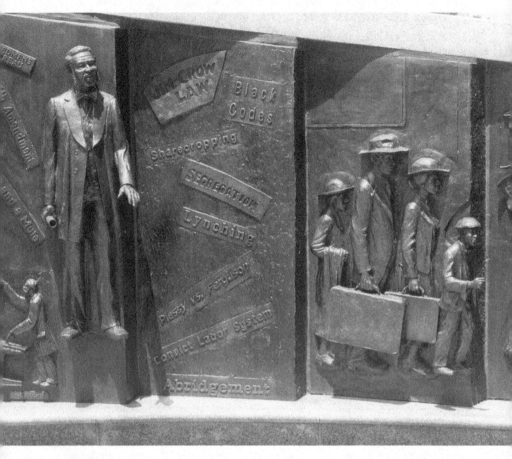

Fig. 51. African American History Monument. "Southern States React to Federal Law" and "Exodus North." Photo: Dell Upton.

of the state Supreme Court; astronaut Ronald McNair; and Jesse Jackson, flank a panel bearing South Carolina's iconic palmetto. Around them, smaller figures show a trumpeter who is identifiable as Dizzy Gillespie by his inflated cheeks and the upward tilt of the bell of his horn, tennis player Althea Gibson, a boxer (perhaps Joe Louis), a basketball player, and generic icons representing science, technology, medicine, and agricultural labor.

The African American History Monument vividly epitomizes the parameters of what can and cannot be said. The bronze panels are visually compelling. Figures that project from one panel into the next smooth many of the changes in level. For the most part, these are static figures, rendered almost in the round, that face diagonally outward in the manner of the *statues colonnes* of the Gothic cathedral at Chartres (see figs. 46, 50). The device effectively connects separate vignettes into a continuous visual flow. Yet the flow is not entirely smooth. Most notably, it is interrupted by the static and fragmented panels devoted to Reconstruction and the Jim Crow era. In part this is owing to the difficulties of illustrating abstract concepts such as constitutional amendments, but it is also a direct result of the decision to present the black struggle in a vacuum. These panels remind one of the absence of visualized conflict in most of the work. Even the Civil War panel depicts soldiers marching rather than fighting. The only explicit depiction of black-white conflict appears in the Middle Passage panel, where a white sailor prepares to beat a black captive. The sailor can be dismissed as a non-Carolinian, in keeping with the Southern myth that slavery was foisted on the region by outsiders. Thus conflict among South Carolinians is deflected. The choice to avoid depicting recognizable historic figures serves the same goal. The rule was used to exclude Denmark Vesey, and slave resistance generally is depicted as escape rather than rebellion. Vesey is absent, yet most of the figures in the final panel are readily recognizable as well-known contemporary South Carolinians. Journalists regularly name them, but when the AAHMC was asked about those portraits in 2005, four years after the dedication ceremony, they responded that "commission members consider any likeness on the monument to be interpretive, and they do not take an official position on the identities of anyone depicted here."[35]

The other break in movement is in the final panel, the "Panel of Progress" (originally "Triumph"), which is also somewhat disjointed. The four central figures face forward and are surrounded by a constellation of smaller figures and symbols. For formal reasons, moreover, they are placed at the narrow end of the right panel. It is as though the constant movement toward black

liberation implied by the procession, reinforced by the congruent poses of the slave laborers, migrants, and civil rights demonstrators, had come to an end. The struggle has been completed, visually at least, although all parties involved in creating the monument professed not to believe that.

Limiting as was political censorship, or at least squeamishness, the power of the African American History Monument was deflected as much by a cacophony of messages. The bronze panels, the strongest part of the monument, borrowed their visual strategy from the war memorial tradition. This is not surprising, since the monument stands in a physical and conceptual landscape of war memorials. The mounted Confederate general Wade Hampton looks across the lawn at the African American History Monument, perhaps to his discomfiture as Dwight noted, but also in a way that demands response from the newer monument. The march of progress on the African American monument reminds one not only of Saint-Gaudens's Shaw Memorial but of the bronze Confederate soldiers marching around the collar of the Confederate memorial in Montgomery or the terra-cotta Union soldiers who encircle the Pension Building in Washington (see fig. 13). When Americans think of struggle and sacrifice, they seem unable to think in any other than military terms.

Equally unsurprising is the emphasis on positive thinking and uplift. It seems obligatory for monument builders to stress that they have "the children" in mind. Fund-raiser John Rainey spoke of his hopes for what the Columbia monument would mean to "future generations." Journalists dutifully report children's reactions to new memorials. "It's cool," one eight-year-old summed up the African American History Monument. Uplift means that struggle can only be shown as endless, conflict-free progress.[36]

The historical narrative of the Columbia monument is overlaid with elements of romantic cultural essentialism expressed as an idealized and unitary conception of Africans and African Americans. This is a phenomenon that is not unique to black popular culture; it is common among emerging nations and ethnic groups in the industrializing world. Most newly industrialized nations, for example, experience an architectural era in which idealized forms from their preindustrial past are set forth conveying the "real" character of the people. The Colonial Revival in America, which began at about the time of the Centennial celebration of 1876 and which remains strong in American culture, is a pertinent example. Pre-Revolutionary Anglo-American architectural garb cloaks everything from tract houses to churches to banks and courthouses, creating a kind of imaginary and unified ancestral

homeland. As a group, these buildings suggest that the culture's finest characteristics and most important values antedate industry and immigration. Moreover, the early proponents of the Colonial Revival saw it as an extension of the Renaissance in Europe, which they viewed as the high point of human civilization.[37]

Ancestral homelands in the United States are not restricted to dominant groups such as the Anglo-Americans of the late-nineteenth-century United States. Many minorities and newcomers have also used idealized architectures of their homes to establish cultural legitimacy in a new land. Italians built Baroque churches. Chinese merchants operated from ersatz pagodas. Black Americans had to confront a much more systematic and virulent campaign to exclude them than other groups, as well to refute the assumption that the Middle Passage and slavery eradicated any cultural memories that they might possess, so the process of cultural essentialization was similar but not identical to that among other Americans. Since the late nineteenth century, African Americans have wrestled with the nature and relevance of their relationship to Africa. Like those white Americans who saw in their ancestors' colonial buildings glimpses of the Renaissance, African American thinkers wanted to find in their own practices a reflection of ancestral glories. The poet Langston Hughes worked a steamer to West Africa in 1923, partly to find his roots. When he told the locals that American blacks had the same problems they did, they laughed and told him that he was a white man. Eventually Hughes decided that there was no significant connection between the old world and his own. Others as diverse as the African Methodist Episcopal bishop Henry McNeal Turner, the conservative black nationalist Marcus Garvey, black practitioners of various forms of Islam, and contemporary Afrocentric scholars have all worked on the same problem, coming to varied conclusions. Some have argued that Africa was once the home of great kingdoms and civilizations to which African Americans are heirs. Although they are now weakened, these great cultures will rise again. Others see Africa, and particularly Egypt, as the root of many aspects of Western culture traditionally credited to Europe. In black popular culture, the idea that Egypt was a "black" civilization and perhaps the real source of European culture leads to the widespread use of obelisks such as that at the Columbia monument as a sign of the claim (fig. 52).[38]

Both Dwight's evocation of a circular African village and his use of an obelisk and of stones from Africa partake of these essentialized notions of a pan-African culture. Not all Africans, even in the areas from which Africans

Fig. 52. Obelisk, Shot Caller Records, Savannah, Georgia. Photo: Dell Upton.

were brought to South Carolina, lived in circular houses or villages. But in contrast to the dominant use of rectilinear forms in the Euro-American landscape, the circle acts as a marker of nonwhiteness. As for the obelisk, it is not clear that Dwight meant to use it in explicit assertion of Afrocentric claims but he accepted the general popular belief that it is an "African" form. The African stones add little to the power of the narrative, since they tell us little about the geology or cultural landscape of the four African regions, nor do they add to the message of the monument as a whole, but they are credited with giving the African origins of black South Carolinians a palpability that a map or a phrase cannot.

In short, the African American History Monument uses two different, possibly incompatible, strategies to achieve its purpose. One is a historical narrative rooted in the specifics of the black experience in South Carolina. The silences and censored passages of the narrative remove it from its historical context, however, into the realm of dual heritages, balanced against, but not directly acknowledging, the Confederate memorial to the north and Wade Hampton and Strom Thurmond to the south. The AAHMC insisted that the flag and the monument, the celebration of the Confederacy and the celebration of black history, were *separate* issues, but the public was not willing to accept that fiction. The second strategy is the romanticized pan-Africanism that creates another type of separation, one that locates all that is fundamental to the African American experience in preslavery Africa and in those aspects of African culture that survived in South Carolina. Perhaps the dual strategy allows black viewers to approach the historical narrative with a visceral sense of their fundamental unity. This was suggested by some descriptions of the ideal experience of the monument: moved by contact with "Africa" in the form of the stones and by a sense of the horrors endured, as depicted in the plan of the slave ship, one would be prepared to empathize with the images in the bronze panels. It is equally likely that the dual strategies represent an effort to meet the monument program's dual demands that the monument express both continuity and change, tradition and history.

It is also possible to argue that the two strategies undercut each other. If this is true, it is because the African American History Monument follows a pattern set by many contemporary monuments of all sorts: it tries to say too much. Dwight told one reporter that "the memorial ain't big enough.... It should be monstrous." The desire to encompass everything is also a desire to control viewers' understanding of the events depicted. Distrusting visual metaphors or narratives, monument designers and their clients attempt to say everything, to overdetermine their messages through heavy-handed imagery, long inscriptions, and explanatory pamphlets, turning them into tendentious museum exhibits. As at the Columbia monument, this often results in lessening the impact of an otherwise eloquent work. It is a trap into which even the best monuments fall. The African American History Monument is certainly one of those.[39]

There is no such thing as Negro History or Jewish History or Chinese History in the sense of isolated contributions. The relations and interrelations of races, the close communication of peoples, and the widespread diffusion of ideas have made it necessary for one group so to depend upon the other and so to profit by the achievements of the other that it is difficult to have any particular history ear-marked.

— CARTER G. WOODSON, *THE STORY OF THE NEGRO RETOLD,* 1928

In recent years, memorials to the broader sweep of African American history, of which South Carolina's African American History Monument is the most elaborate, have become increasingly common and may eventually overshadow the civil rights monuments. For the moment these works offer a fresh chance to rethink memorial strategies, yet they, too, are limited by the same problems of visual language and political circumscription. Even more than the civil rights memorials, they are constrained by the myth of dual heritage, of separate black and white histories. A few recent exceptions suggest what might be said.

Perhaps the most unexpected is also to be found at South Carolina's state capitol. It is a monument to Strom Thurmond, the former governor, senator, Dixiecrat presidential candidate, and staunch segregationist until it was no longer politically expedient to be one. In 1998, as plans for the African American History Monument were getting under way, planning also began for a monument to Thurmond, then approaching his hundredth birthday. The chair of the planning committee was also a member of the African American History Monument Commission, while the Thurmond committee also included African American senator Kay Patterson, a longtime advocate of civil rights in the South Carolina legislature, and Senator Jake Knotts, who had attempted to derail the African American History Monument in the pursuit of various right-wing goals. Knotts said the monument would "recognize the great statesman that [Thurmond] is."[1]

The statue itself, a full-length portrait figure, is unremarkable and undistinguished. Thurmond stands between the state house and the Confederate Women's Monument, striding south. It is the inscription that is notable. In keeping with nearly all contemporary monuments, which are publicly sanctioned but privately funded, the pedestal lists the names of the members of the official Strom Thurmond Monument Commission as well as those of the corporations that underwrote the project. It records the long succession of public offices that Thurmond held during his life. It also takes note of Thurmond's private life, and at the bottom of the west panel he is described as the father of four children, who are named.

Thurmond died shortly after the monument was dedicated, and not long after his death it was revealed that he had a fifth child, Essie Mae Washington-Williams. She was in fact his first, conceived by Thurmond in 1925 with an African American maid who worked for his family. The revelation should not have been surprising in the light of Southern history, particularly that of the early twentieth century. What was more startling was the reaction of Thurmond's other children, who quickly accepted Washington-Williams's claim.[2]

Even more notable was the Thurmond family's request that the state legislature add Washington-Williams's name to the Thurmond monument. In July 2004, a little over a year after Thurmond's death, the inscription was changed (fig. 53). The line "FATHER OF FOUR CHILDREN" was altered by crudely filling the word FOUR and replacing it with FIVE. Essie Mae's name was added as a line under the names of the other four children, a placement that she did not fail to note, although she said she was glad to be there at all.[3]

The crude alteration, still visible a decade later, and even the placement of Washington-Williams's name below those of the white children, are highly appropriate and, perhaps, intentional. In a much less qualified manner than the official memorials to African American history do, the altered Thurmond monument acknowledges the unity of Southern history. It does so not by suppressing issues of conflict or domination, as the African American History Monument a few yards away does, but in a matter-of-fact manner. This is not to say that the Thurmond inscription solves the problem, answers all the questions, or lays the issue to rest. Among other things, it is silent on the nature of the relationship that produced Essie Mae, on the reasons she would have to be added after the fact, and on the tensions between Thurmond's racist politics and his personal relationships. Yet it does open the door for

Fig. 53. *Strom Thurmond* (William Behrends, 1999), South Carolina State House Grounds, Columbia. Detail of inscription. Photo: Dell Upton.

thinking of Southern history in a more holistic way. Two other recent monuments do better.[4]

Salisbury, North Carolina's Freedman's Cemetery lies on the downhill corner of a block that divides predominantly black and predominantly white neighborhoods in the city. Old English (formerly Oak Grove) Cemetery is adjacent to it on the uphill side. It holds the graves of many of the town's white worthies, including Revolutionary soldiers, Confederate officers, politicians, and merchants. As was common in the South, African Americans were buried in a separate section of the cemetery. In 1842, William Gay left money in his will to build a wooden fence to separate whites' graves from blacks'. Thirteen years later that fence was replaced by the granite wall that still separates the two. The white section became a carefully tended object of veneration even as the black section was left to decay. People continued to be buried in Freedman's Cemetery, even as bits and pieces were nibbled away over the years for development projects and street improvements. The last markers—most probably made of wood or of unshaped, unlettered rocks—had disappeared by 1940, and the cemetery was largely forgotten.[5]

In 1998, Waterworks Visual Arts Center, a local arts organization, initiated a public art project to mark the site and to protect it from further violation. The core of the project comprises nine stones that were removed from the nineteenth-century wall segregating Freedman's Cemetery from Old English

Cemetery, the blocks scattered across the grass on the Freedman's side as though the wall had been forcefully burst open. Artist Jerome Meadows and art historian David Driskell were selected for the project, but they withdrew in 2003. They proposed to make a 20-foot breach in the wall and to remove a single 160-foot course of capping stones, which would have been incorporated into a memorial. The demolition appears to have been a source of contention, along with unspecified elements that the local historic preservation commissioner viewed as "conveying a false sense of history in the future, and [losing] a portion of the story that the wall tells."[6]

The final Oak Grove Freedman's Cemetery Memorial (2006) was designed by artist Maggie Smith and the Raleigh landscape-architecture firm of Reynolds and Jewell (fig. 54). It was presented to the local historical preservation commission for approval with the assurance that the opening in the wall would be much smaller — 10 feet wide in the initial scheme — without the lowering of the wall by removal of the additional, 160-foot capping course. Opponents continued to describe the opening of the wall as a "violation." Clyde Overcash argued that "a cemetery is sacred ground and should be respected" and that any alteration of the grounds or the markers was a crime. In an echo of the controversy surrounding New Orleans's white supremacy

Fig. 54. Oak Grove Freedman's Cemetery Memorial (Maggie Smith with Reynolds and Jewell, Landscape Architects, 2006), Salisbury, North Carolina. View of wall breech. Photo: Dell Upton.

monument, some white Salisburians objected to removing even 10 feet of the wall as a violation of historic preservation ordinances. Proponents of the project argued that state laws protecting cemeteries had been violated even more grievously when special legislation permitted the city to widen West Liberty Street, removing some Freedman's Cemetery graves in the process.[7]

As usual, there was more to the design than the simple opening. An inscription listed those among the nearly 150 people buried in the Freedman's Cemetery whose names were known, appropriately rescuing them from anonymity. The plot was surrounded by a low granite retaining wall along North Church Street and a granite-veneered concrete retaining wall along West Liberty Street that was built in 1983 when the street was widened (fig. 55). These walls were engraved with uplifting quotations by prominent figures from African American history, although the choices were a little less pusillanimous than in most such monuments. Last, the intersection of North Church and West Liberty Streets was repaved using a "West African textile motif." A "local historian" objected to the paving pattern on the grounds that it was "out of context" with the period of the cemetery. A memorial committee member responded that because the area around the cemetery was once all-black, the textile pattern was "very much in order because it would attest to what used to be there."[8]

Although it was somewhat obscured by the requisite elements of uplift and by African American cultural essentialism, the opening of the wall at Oak Grove Freedman's Cemetery Memorial was a powerful gesture that suggested the reconnection of white and black histories into a single account. Opposition to the breach, expressed in terms of "violation," suggests the discomfort occasioned by the prospect. One former member of the memorial committee appeared before the historic preservation commission to ask that its approval be withheld. He believed that although the project was meant to "unify the people of Salisbury," it was "bringing animosity" instead, and that the commission "should not approve something that not everyone is in favor of."[9] The city's ambivalence is eloquently revealed by the current state of the memorial. In August 2013, the scattered stones were pushed back against the wall from which they had been removed and the grass was unkempt, while that in Old English Cemetery was neatly trimmed. The visual effect of the memorial has been reduced to one of casual neglect similar to that from which the project was intended to rescue Freedman's Cemetery.

Despite a clumsy title that reflects the overloaded agendas of many contemporary memorials, *Our Peace—Follow the Drinking Gourd; Memorial to the*

Fig. 55. Oak Grove Freedman's Cemetery Memorial before it was allowed to deteriorate.
Photo: Dell Upton.

Enslaved, near Nashville, Tennessee, pushes even farther beyond dual heritage than the Oak Grove Freedman's Memorial, although that was not the intention of any of its creators. Near the Hermitage, which was Andrew Jackson's plantation and is now a museum dedicated to him, developers began in 2000 to grade a tract known to contain a Native American burial site, exposing several graves. Work was halted by legal injunction, and 360 ancient burials, representing ten thousand years of occupation, were revealed. After relocation of the Native remains and the expansion of the site in 2006, 63 more burials of people ranging from one to forty-five years of age, arrayed in family groups, were discovered. These were the graves of enslaved people held on property owned by nephews of Rachel Donelson, Jackson's wife.[10]

The Ladies' Hermitage Association agreed to rebury the remains at the nineteenth-century church on the museum's property, where members of the Donelson family had also been reinterred. The remains of the enslaved people were placed in a single grave, but each person was buried in a separate container. The association also decided to form a committee "consisting of the descendants of the enslaved individuals and leaders of the African-American community to determine the proper way to memorialize these individuals." According to those involved in the process, that consultation never occurred. Instead, under the auspices of the Arts Commission of Nashville, the Hermitage undertook a competition to create an appropriate memorial for the site.[11]

Aaron Lee Benson won the commission with a proposal that envisioned a hundred-foot circle of thirty Adirondack crab apple trees and an inner ring, about eighty feet across, made of thirty large Tennessee boulders. A low stone wall would cover the bodies, which had already been buried before the competition was held (fig. 56). The trees and stones together would represent the sixty-odd people interred there. Benson imagined the trees as living entities that bridged the centuries between the lives of the enslaved people buried within the circle and the present and that would "represent giving of life to individuals once marginalized." The stones would ensure that the message would not be lost: "Thousands of years after we are gone these stones will still speak clearly what you have decided was worthy of saying." A Tennessee fieldstone wall covering the grave "dissects the piece as representational of how slavery and the civil war fought to abolish it dissects the history of America." There would also be a smaller stone circle tangential to the main one containing a single weeping willow tree meant to symbolize regret at the wrongs of slavery. "On a contemporary level and speaking to future citizens

Fig. 56. *Our Peace—Follow the Drinking Gourd; Memorial to the Enslaved* (Aaron Lee Benson, 2009), Hermitage Church, Nashville, Tennessee. Dry-laid wall covering burials. Photo: Dell Upton.

it is symbolic of our commitment to reconciliation and restoration of all human and civil rights." Responding to the original program, Benson described his work as a space of contemplation.[12]

While the design was being refined, newly appointed Hermitage CEO Howard J. Kittell demanded the removal of the circle of trees on the grounds that it would block the view of the church. As Benson drove home afterward, he relates, he spotted the North Star and thought that it would be interesting to make stars part of the design. He remembered stories of how escaped slaves used the Little Dipper as a navigational device and learned of the song "Follow the Drinking Gourd," which referred to that practice. Within twenty-four hours, the sculptor had devised a new scheme where seven trees would be planted inside the stone circle in the form of the Dipper, with the tree in the smaller circle representing the North Star.[13]

As the design was developed, the memorial's tone changed. The original proposal spoke of the profound sins of slavery, which resulted in national division, the Civil War, and the violation of human rights. An undated PowerPoint presentation that the artist made before Hermitage authorities included the line, "We are here to make, once and for all, a declarative statement, WE WERE

WRONG!" By the time *Our Peace* was dedicated, Benson's artist's statement, while retaining the interpretation of the wall over the graves as a reference to the divisions of the Civil War and slavery, declared that the work "was not conceived nor will it be built to make a civil, political, cultural or religious statement on slavery." Instead, the message now emphasized the standard theme of uplift: *Our Peace* would be "a singular declaration of our greater hopes, of a renewing of our faith in one another."[14]

At the same time, glimpses of dual-heritage mythology entered into official dicta and into the reception of the memorial. Hermitage vice president Marsha Mullin told a reporter, "We decided to make it a memorial to all the people who had ever been enslaved, not just these particular individuals." When the monument was dedicated, it was embedded in an ahistorical, generically African American ceremony that included drummers, reenactors from the Thirteenth United States Colored Troops Living History Association, choirs, and an exhibition of quilts. Annual remembrances are held during Black History Month.[15]

Nevertheless, *Our Peace* escapes the bonds of dual heritage through its powerful formal qualities. Benson's circle of large, crudely shaped stones closely resembles a Neolithic stone circle (fig. 57). The low, dry-laid stone wall that covers the grave is off-center and only partly crosses the circle from east to west, creating a tension that denies a clichéd closure or false balance. The durability and crude form of the circle of stones when compared to the fragility and ultimate ephemerality of the living trees also encodes a religious message for the sculptor, a preacher's son with a "strong Christian faith." In an interview, Benson stressed his sense of the sacredness of the grave and of the site generally. He sought to treat the site with the dignity that he had experienced at the most "sincere" of the many funerals he had attended with his father, and to acknowledge the equality of life and death among all people. Although the trees he originally proposed to encircle the stones might have conveyed the relation between life and eternity more effectively, the power of the visual images obscures the generic reference to the lore of slavery embodied in the drinking gourd. At this early stage in the trees' growth, their configuration is readily overlooked by those who do not read the text on an adjacent sign.[16]

The power of *Our Peace* arises from a sense of human dignity that transcends the essentialist narratives of dual heritage. At the same time, it also achieves a historical complexity that similarly evades the dual-heritage monuments. *Our Peace* shares the churchyard with a small number of Donelson

Fig. 57. *Our Peace*. Photo: Dell Upton.

family burials that were moved from the family's private holdings and with a cemetery for residents of a Confederate old soldiers' home that once stood nearby (figs. 58, 59). The three plots lie slightly apart from one another, but *Our Peace* weaves them together by virtue its visual qualities. The people buried under the stone wall are interred individually, but in a common grave and under a common, uninscribed marker. The Confederates are also buried in a circle, but each lies under an individual marker. The stones are identical, in the spirit of the common soldier memorials, and they face a central monument celebrating the Confederate cause. The Donelsons, elite, slaveholding white Southerners, are buried in rows under highly individualized, even idiosyncratic, markers that suggest distinct selves whose personhood was not subsumed by a greater authority, whether it be the Southern Rebellion or the Peculiar Institution. The reverberating differentials of race, status, personal identity, and social role are affecting without the need for written interpretation or the overlay of myth. The relations among the three burial sites visualize the complexities of Southern history as a single, tangled story. In this way *Our Peace* evades the trap of dual heritage.

What Can and Can't Be Said began as a study of civil rights memorials, stimulated by the admiration I had for the people and transformations of the mid-

Fig. 58. Donelson family graves, Hermitage Church, Nashville, Tennessee. Photo: Dell Upton.

Fig. 59. Confederate Home graves, Hermitage Church, Nashville, Tennessee.
Photo: Dell Upton.

twentieth century. That was too simple a motivation. While it is unreason-
able to claim that there is no connection between the civil rights *movement*
and the civil rights *monuments,* that connection is complex and sometimes
elusive. The complexity of the freedom struggle revealed by recent scholars
is rarely reflected in the memorials. They tend to focus on the familiar figures
and iconic events that make up the canonical popular history of the move-
ment that has congealed over the past half century. They rarely challenge us
to reimagine the movement in new ways. At the same time, memories of the
civil rights era give the memorials a living power. As their builders strive to
assert a black presence in Southern society and the Southern landscape, the
movement reminds us that it is possible for a determined grassroots effort to
overcome major inequities, even while others remain to be confronted. In
that sense, monument building is an integral part of a new, less dramatic
phase of a movement that was so powerful at midcentury.

As I studied the monuments, I also came to see them as memorials to a
second Civil War. In addition to trivial coincidences, such as the culmination
of both in the sixties of their respective centuries, both the Civil War and civil
rights activism constituted fundamental conflicts over the role of race in
American society, both resulting in major but incomplete transformations of

politics and society. From a purely sculptural point of view, the heyday of both Civil War monument building and civil rights monument building came about fifty years after the most dramatic events, as veterans of the conflicts aged and began to seek recognition. Furthermore, as we have seen, the countless Confederate memorials throughout the South serve as the inescapable context of and challenge to the newer generation of monuments that address the black American presence. It is not possible to ignore the older monuments in imagining and siting the newer ones. While the juxtaposition of both groups may appear to support the dual-heritage mythology, it seems to me that it in fact exposes the insupportable tension that underlies that fiction. The Confederate memorials and the late-nineteenth-century memorials to white supremacist politicians, many of whom were themselves veterans of the Confederate military, stand as rejections of the promise of full citizenship that the Civil War held out to its citizens of African descent. The movement from civil rights memorials to African American history monuments and, finally, to memorials such as those in Salisbury and at the Hermitage imply a renewed promise: that the remnant of white supremacy that still pollutes American politics will eventually be scrapped, along with its monuments. This can never happen, however, as long as all parties cling to the illusions of dual heritage and to the desire for uplift, without acknowledging the long, bloody history of race in the United States before and after emancipation.

APPENDIX
Caroline County, Virginia,
Multicultural Monument
Inscriptions

[1]

Caroline Religious Society of Friends
Established 1739

Known as Quakers, the Caroline Friends were pioneers in the County's frontier wilderness who were distinguished in the development of social and economic ideals significant to the county, state and nation.

Early social inventions such as economic development, banking, insurance and fixed prices for commodities were among those established within the County by the Caroline Friends. Their practices in social justice and human rights including the right of religious freedom, women's voting rights and condemnation of slaveholding, were among exemplary ideals they embraced.

In their meetinghouse at Golansville on May 9, 1767, the Caroline Friends, together with the Cedar Creek Friends Meeting of Hanover, undertook the first organized movement in the Virginia Colony to abolish slavery, forever marking their place in American history.

[2]

The first African-American slaves were brought to Caroline County around 1700. Few records were kept of their existence, except for their status and value as property and the occasional brush with the law. Many slaves of Caroline County were executed for their participation in slave uprisings or rebellions, while others were rewarded by their slave master for their loyalty and betrayal of their slave brothers and sisters.

Slave labor cleared the vast wilderness Caroline once was and built huge tobacco plantations and palatial mansions. Tobacco was the main crop of the County at that time. There were, however, only three small trading centers in Caroline, two of which were located on the Rappahannock River. Slave labor was used in the road-building program to unite the three districts and furnish the planters with an overland road to the Rappahannock.

Caroline County was home to a few free African-Americans who prospered quite well. Some were granted their freedom, while others were born free. Most free men were skilled craftsmen, such as blacksmiths, coachbuilders, etc.

Slaves participated in the Civil War in support of the Union Army. At the end of the war, Caroline County supported growth and prosperity. People of color became landowners, entrepreneurs and government officials.

Dedicated to the history, culture and heritage of the African-American citizens of Caroline County. African-American citizens of Caroline overcame slavery and other forms of prejudice to make many significant contributions to the County, the Commonwealth of Virginia and the United States of America. Pioneers in the fields of government, education, civil rights and religion include:

- Lorenzo Boxley and Luther Morris—First African-American Members of the Board of Supervisors
- Christine Tillman—First Female African-American Member of the Board of Supervisors
- Harvey Latney, Jr.—First African-American Commonwealth's Attorney
- Luther Morris—First African-American Clerk of the Circuit Court
- Chester Sizer—First African-American Member of the School Board
- Stanley Jones—First African-American Superintendent of Schools
- Reverend R. W. Young, Reverend A. P. Young and the Caroline Baptist Sunday School Union who founded and built Union High School (which now serves as the Caroline County Community Services Center)
- Reverend L. L. Davis—First Principal of Caroline Training School (former Union High School)
- James Shelby Guss—First African-American Director of Instruction for the Virginia Education Association and First African-American to serve on the Board of Directors for the Rappahannock Electric Cooperative
- Ed Ragland—First African-American State Director for the Farmer's Home Administration
- Mildred Loving, who along with her husband Richard, helped strike down laws prohibiting interracial marriage in the United States

[4]

The Peopling of Caroline County

When English settlers arrived at Jamestown, Virginia in 1607, the area that later became Caroline County was occupied by seven tribes of Native Americans—the Pamunkeys, Mattaponys, Youngtamunds, Secobees, Nantangtacunds, Mannohcos and the Dogues.

The first European to explore the area now called Caroline County was Captain John Smith, within a year after he landed at Jamestown. The earliest merchants were English, but by the mid 18th century, the Scottish arrived and were joined by French merchants at the end of the century.

Jews arrived during colonial times and by the time Caroline became a county, the Irish had established businesses in the County. Germans operated businesses in the County in the latter part of the 19th century and persons of Italian descent were among the first settlers in the Port Royal area, even before the establishment of the County.

After 1685, Huguenots left France, fled to England and later settled in Caroline County. The 20th century ushered in many changes in the population of the County. In 1908, a number of Slovaks arrived from Pennsylvania and New Jersey and settled on depleted land in the upper part of Caroline. Following the world

wars of the 20th century, Caroline saw settlers from many nations and every continent.

History has brought together the people of Caroline County from many diverse cultures, and in ways as different as the people who comprise our community. What we once saw dimly as differences, we now see clearly as diversity. Mutual understanding derived from unique experiences is the strength of Caroline.

ABBREVIATIONS

AAHMC	African American History Monument Commission (Columbia, SC)
AAMA	African American Monument Association (Savannah, GA)
ADAH	Alabama Division of Archives and History
AJC	*Atlanta Journal-Constitution*
BAH	*Birmingham Age-Herald*
BN	*Birmingham News*
BPH	*Birmingham Post-Herald*
BPL	Birmingham Public Library
CS	*The State* (Columbia, SC)
FLS	*Free Lance-Star* (Fredericksburg, VA)
JCL	*Clarion-Ledger* (Jackson, MS)
MA	*Montgomery Advertiser*
NAACP	National Association for the Advancement of Colored People
ND	*Neshoba Democrat* (Philadelphia, MS)
NOPL	New Orleans Public Library
NYT	*New York Times*
RMT	*Rocky Mount Telegram*
RNO	*Raleigh News and Observer*
RTD	*Richmond Times-Dispatch*
SCLC	Southern Christian Leadership Conference
SCV	Sons of Confederate Veterans
SMN	*Savannah Morning News*
STJ	*Selma Times-Journal*
TP	*Times-Picayune* (New Orleans)
UDC	United Daughters of the Confederacy
WP	*Washington Post*

NOTES

INTRODUCTION

1. Tim Weiner, "Congressman and His Colleagues Re-Enact March," *NYT,* Mar. 8, 1999.
2. Shaila Dewan, "Push to Resolve Fading Killings of Rights Era," *NYT,* Feb. 3, 2007. Eventually the FBI decided that only twelve cases were viable (Jerry Mitchell, "FBI Narrows Viable Cases to a Dozen," June 16, 2010, *Journey to Justice* [blog], http://www.clarionledger.com/blog/journeytojustice/). For a pessimistic view of these efforts, see Hank Klibanoff, "Civil Rights Cold Cases Are Growing Colder by the Day," *AJC,* Aug. 13, 2010. For discussion of the self-congratulatory tone of news reports of these convictions, see Renee C. Romano, "Narratives of Redemption: The Birmingham Church Bombing Trials and the Construction of Civil Rights Memory," in *The Civil Rights Movement in American Memory,* ed. Renee C. Romano and Leigh Raiford (Athens: University of Georgia Press, 2006), 96–133.
3. Patsy R. Brumfield, "Closing Arguments: Each Side Presses for Jury Decision," *Northeast Mississippi Daily Journal,* June 20, 2005.
4. For a synthetic overview of the movement and its historiography, see Jacquelyn Dowd Hall, "The Long Civil Rights Movement and the Political Uses of the Past," *Journal of American History* 91 (2005): 1233–63. "Whiggish" is a historian's adjective derived from Herbert Butterfield's classic *The Whig Interpretation of History* (New York: W. W. Norton, 1931, 1965), which criticized historians who treated the past as a tale of progress leading inevitably and directly to an enlightened present.
5. In fact, all but the most complex civil rights monuments have been fabricated and often designed by gravestone makers.
6. Sergiusz Michalski, *Public Monuments: Art in Political Bondage, 1870–1997* (London: Reaktion Books, 1998), 28–30, 49; June Hargrove, *The Statues of Paris: An Open-Air Pantheon; The History of Statues to Great Men* (New York: Vendome Press, 1989).
7. Charles W. Eagles, "Toward New Histories of the Civil Rights Era," *Journal of Southern History* 66 (2000): 826. For examples of the newer approach to the movement, see Aldon D. Morris, *The Origins of the Civil Rights Movement: Black Communities Organizing for Change* (New York: Free Press, 1984); John Dittmer, *Local People: The Struggle for Civil Rights in Mississippi* (Champaign-Urbana: University of Illinois Press, 1994); Youth of the Rural Organizing and Cultural Center, *Minds Stayed on Freedom: The Civil Rights Struggle in the Rural South; An Oral History* (Boulder, CO: Westview Press, 1991); and Charles M. Payne, *I've Got the Light of Freedom: The Organizing Tradition and the Mississippi Freedom Struggle* (Berkeley: University of California Press, 1995).
8. Eagles, "Toward New Histories," 816, 839; Margaret Talev, "Barbour Recalls Civil Rights Era Fondly, but Classmate's Memories Differ," *Commercial Appeal* (Memphis), Sept. 13, 2010.

9. On civil rights outside the South, see Thomas J. Sugrue, *Sweet Land of Liberty: The Forgotten Struggle for Civil Rights in the North* (New York: Random House, 2008).

10. Alliniece T. Andino, "King Holiday Raises Hopes for an Ax Handle Memorial," *Florida Times-Union* (Jacksonville), Jan. 15, 2001. Freeman was speaking in the context of a proposal to erect a monument commemorating 1960s "Ax Handle Saturday," when demonstrators in Jacksonville's Hemming Plaza were assaulted by men armed with ax handles and baseball bats.

11. The description of Birmingham as "the most thoroughly segregated city in America" is found Martin Luther King Jr.'s 1963 *Letter from Birmingham Jail* (Martin Luther King Jr., *The Autobiography of Martin Luther King, Jr.*, ed. Clayborne Carson [New York: Intellectual Properties Management and Warner Books, 1998], 189).

12. Erika Doss, *Memorial Mania: Public Feeling in America* (Chicago: University of Chicago Press, 2010), 19, 34. I have discussed the compulsion to verbosity in monumental inscriptions in "Why Do Contemporary Monuments Talk So Much?" in *Commemoration in America: Essays on Monuments, Memorialization, and Memory*, ed. David Gobel and Daves Rossell (Charlottesville: University of Virginia Press, 2013), 11–35.

13. The phrase "historical logic of whiteness" is Manning Marable's (*Living Black History: How Reimagining the African-American Past Can Remake America's Racial Future* [New York: Basic Books, 2006], 20). As one example among many of the workings of dual heritage, see Jill Nolin, "Walk into History: Group Working on Trail that Tells the Tale of the Capital City," *MA*, Oct. 16, 2011: "Instead of seeing Montgomery as a dichotomy and the histories as opposing in nature, members of the Montgomery Downtown Business Association and historians are asking people to take a walk and consider what these movements [the Confederacy and civil rights] actually have in common."

14. Stephen L. Elkin, *City and Regime in the American Republic* (Chicago: University of Chicago Press, 1987), 5, 6, 34, 36–37, 47; Harvey Molotch, "The City as a Growth Machine: Toward a Political Economy of Place," *American Journal of Sociology* 82 (1980): 309–32; Gerry Stoker, "Regime Theory and Urban Politics," in *Theories of Urban Politics*, ed. David Judge, Gerry Stoker, and Harold Wolman (London: Sage, 1995), 54–71. The classic regime-theory study of an American city is Clarence N. Stone, *Regime Politics: Governing Atlanta, 1946–1988* (Lawrence: University Press of Kansas, 1989).

15. Paul Gaston, *The New South Creed: A Study in Southern Mythmaking* (New York: Vintage, 1970, 1973), 4–6, 214; Kirk Savage, *Standing Soldiers, Kneeling Slaves: Race, War, and Monument in Nineteenth-Century America* (Princeton, NJ: Princeton University Press, 1997), 178–79.

16. Askew quoted in Owen J. Dwyer, "Location, Politics, and the Production of Civil Rights Memorial Landscapes," *Urban Geography* 23, no. 1 (2002): 44–45; Marty Ellis and Wendi L. Lewis, *Montgomery, at the Forefront of a New Century* (N.p.: Community Communications, 1996), excerpted at www.waka.com/montgomery/montgomery.htm, viewed Nov. 3, 1998 (no longer online); Hall, "Long Civil Rights Movement," 1243.

17. Michael B. Katz, *In the Shadow of the Poorhouse: A Social History of Welfare in America* (New York: Basic Books, 1986), 16–19, 22–25; Essie Mae Washington-Williams and William Stadiem, *Dear Senator: A Memoir by the Daughter of Strom Thurmond* (New York: Regan Books, 2005), 169–70; J. L. Chestnut Jr. and Julia Cass, *Black in Selma: The Uncommon Life of J. L. Chestnut, Jr.* (New York: Farrar, Straus and Giroux, 1990), 126–27, 174, 176–78, 265, 270–71; Manning Marable, *Black History: How Reimagining the African-American Past Can Remake America's Racial Future* (New York: Basic Books, 2006), 25;

Hall, "Long Civil Rights Movement," 1243. For an example of a white supremacist's profession of close personal relationships between whites and blacks, see William Alexander Percy, *Lanterns on the Levee: Recollections of a Planter's Son* (Baton Rouge: Louisiana State University Press, 1941, 1973), 26–27, 275, 285–309. Malcolm Gladwell has perceptively analyzed the role of Southern personalism in *To Kill a Mockingbird*: "The Courthouse Ring: Atticus Finch and the Limits of Southern liberalism," *New Yorker*, Aug. 10, 2009.

18. "Killen Freed on Bail," *ND*, Aug. 17, 2005; "Killen Ordered Back to Prison," *ND*, Sept. 9, 2005; Shaila Dewan, "Man Convicted in '64 Case and Out on Bail Is Rejailed," *NYT*, Sept. 10, 2005; Jerry Mitchell, "Killen Ordered Back to Prison," *JCL*, Sept. 10, 2005.

19. Michele H. Bogart, *The Politics of Urban Beauty: New York and Its Art Commission* (Chicago: University of Chicago Press, 2006), 263.

20. Marable, *Living Black History*, 14; Pero Gaglo Dagbovie, *African American History Reconsidered* (Urbana: University of Illinois Press, 2010), 15, 34, 40.

21. Kevin K. Gaines, *Uplifting the Race: Black Leadership, Politics, and Culture in the Twentieth Century* (Chapel Hill: University of North Carolina Press, 1996), xv, 1–2; Clarence E. Walker, *Deromanticizing Black History: Critical Essays and Reappraisals* (Knoxville: University of Tennessee Press, 1991), xvi, xviii; Eagles, "Toward New Histories," 839; Lee Bandy, "South Carolina Panel Approves African-American History Monument," *CS*, Dec. 15, 1998.

22. On the informal memorials that invariably accompany notable crimes and disasters, see Doss, *Memorial Mania*, 61–116.

23. Hall, "Long Civil Rights Movement"; Marable, *Living Black History*, 20, 47.

24. David Hollinger, "Historians and the Discourse of Intellectuals" (1979), quoted in Adolph L. Reed Jr., *W. E. B. Du Bois and American Political Thought: Fabianism and the Color Line* (New York: Oxford University Press, 1997), 12.

25. Upton, "Why Do Contemporary Monuments," 26–31.

CHAPTER 1. DUAL HERITAGE

1. Jenn Rowell, "Cleanup Begins on Vandalized Statues," *MA*, Nov. 15, 2007; Desiree Hunter, "Alabama Capitol's Confederate Monument Vandalized," *Decatur Daily*, Nov. 15, 2007.

2. Rowell, "Cleanup Begins."

3. Rowell, "Cleanup Begins"; Leonard Wilson, letter to the editor, *STJ*, Nov. 21, 2007; Heidi Beirich, "The Struggle for the Sons of Confederate Veterans: A Return to White Supremacy in the Early Twenty-First Century?" in *Neo-Confederacy: A Critical Introduction*, ed. Euan Hague, Heidi Beirich, and Edward H. Sebesta (Austin: University of Texas Press, 2008), 305n18; Kenneth Mullinax, "Cleaning Up the Damage: Restorer Brings Expert Touch to Confederate Monument," *MA*, Nov. 17, 2007; Mullinax, "Vandalism Stirs Talk of Hate," *MA*, Nov. 16, 2007; Ellen Williams, Leroy, letter to the editor, *MA*, Nov. 19, 2007.

4. Kenneth Mullinax, "Three Teens Charged," *MA*, Dec. 15, 2007; Desiree Hunter, "Trial Date Set in Statue Vandalism," *MA*, Feb. 8, 2008; Hunter, "Attorney: Teen to Admit Defacing Monument," *MA*, Apr. 8, 2008.

5. Comments by bubbalib and bhmhater appended to Ginny MacDonald, "3 Juveniles Charged with Defacing Confederate Monument in Montgomery, Alabama," Dec. 3, 2007, http://blog.al.com/spotnews/2007/12/3_juveniles_charged_with_defac.html; Hunter, "Attorney."

6. "Ladies Memorial Association," typescript, n.d., Ladies Memorial Association folder SG 6966.30, ADAH; David W. Blight, *Race and Reunion: The Civil War in American Memory* (Cambridge, MA: Harvard University Press, 2001), 65–71; W. Fitzhugh Brundage, *The Southern Past: A Clash of Race and Memory* (Cambridge, MA: Harvard University Press, 2005), 12–54; Catherine W. Bishir, "'A Strong Force of Ladies': Women, Politics and Confederate Memorial Associations in Nineteenth-Century Raleigh," in *Monuments to the Lost Cause: Women, Art, and the Landscapes of Southern Memory,* ed. Cynthia Mills and Pamela H. Simpson (Knoxville: University of Tennessee Press, 2003), 3–11; William Blair, *Cities of the Dead: Contesting the Memory of the Civil War in the South, 1865–1914* (Chapel Hill: University of North Carolina Press, 2004), 62–63, 77–78, 80–83; Gaines M. Foster, *Ghosts of the Confederacy: Defeat, the Lost Cause, and the Emergence of the New South* (New York: Oxford University Press, 1987), 50–51.

7. Blair, *Cities of the Dead,* 34–42.

8. Caroline E. Janney, *Burying the Dead but Not the Past: Ladies' Memorial Associations and the Lost Cause* (Chapel Hill: University of North Carolina Press, 2008), 133, 138–42; Mrs. I[na]. M[aria]. Porter Ockenden, ed., *The Confederate Monument on Capitol Hill, Montgomery, Alabama, 1861–1900* ([Montgomery, AL]: Ladies' Memorial Association, [1900]), 4; Foster, *Ghosts,* 50–51; [Belle Allen Ross], "The Confederate Monument," typescript, n.d. [ca. 1945], Confederate Monuments folder S.G. 6950.11, ADAH; Peter A. Brannon, "Through the Years: The Confederate Monument on Capitol Hill," *MA,* Aug. 10, 1947, Confederate Monuments folder S.G. 6950.11, ADAH. On fundraising difficulties, see Bishir, "'Strong Force of Ladies,'" 14–16; and Kirk Savage, *Standing Soldiers, Kneeling Slaves: Race, War, and Monument in Nineteenth-Century America* (Princeton, NJ: Princeton University Press, 1997), 136–39. For an extensive history of the monument, much derived from Ockenden but also including conservation data, see The Confederate Memorial Monument, Montgomery Alabama, www.monumentpreservation.com, viewed Sept. 25, 2011 (no longer online).

9. Ockenden, *Confederate Monument,* 3; "Montgomery. The Monument. History of the Movement that Resulted in Its Erection," *MA,* Dec. 8, 1898, typescript in Confederate Monuments file, ADAH, container SG6950.20; Brannon, "Through the Years"; Foster, *Ghosts,* 36.

10. Blair, *Cities of the Dead,* 77–97, 108; Janney, *Burying the Dead,* 40; Savage, *Standing Soldiers,* 162–208.

11. Ockenden, *Confederate Monument,* 18–19, 22–42; Leon F. Litwack, *Trouble in Mind: Black Southerners in the Age of Jim Crow* (New York: Knopf, 1998), 193–95.

12. Janney, *Burying the Dead,* 172; Henry Woodfin Grady, *The New South and Other Addresses* (New York: Gordon Press, 1904, 1972), 51, 54. Grady's words were written in 1887.

13. W. E. B. Du Bois, *Black Reconstruction in America, 1860–1880* (New York: Free Press, 1935, 1998), 110.

14. "Moving of Monument to Dexter and Decatur Is Endorsed by Blan," *MA,* Mar. 2, 1947; [Ross], "Confederate Memorial"; Katharine Keller Tyson, "Move the Confederate Monument? Yes and No Vehemently Expressed," *Alabama Journal,* Apr. 6, 1966, Confederate Monuments folder, ADAH.

15. Blight, *Race and Reunion,* 168, 259–60; Litwack, *Been in the Storm So Long,* 193–95; John M. Coski, *The Confederate Battle Flag: America's Most Embattled Emblem* (Cambridge, MA: Harvard University Press, 2005), 21, 194; Charlie Graham, Prattville, letter to the editor, *MA,* Apr. 10, 2008. On claims about black participation in the Confederate

military, see James W. Loewen and Edward H. Sebesta, eds., *The Confederate and Neo-Confederate Reader: The "Great Truth" about the "Lost Cause"* (Jackson: University Press of Mississippi, 2010), 19–20, 372–74.

16. Graham letter; Katherine Stuart, Mobile, letter to the editor, *MA*, Nov. 19, 2007.

17. Thomas J. Brown, "The Confederate Battle Flag and the Desertion of the Lost Cause Tradition," in *Remixing the Civil War: Meditations on the Sesquicentennial*, ed. Thomas J. Brown (Baltimore: Johns Hopkins University Press, 2011), 37–72; Wilson letter; Connie Mori, letter to the editor, *MA*, Nov. 19, 2007.

18. Jeffrey Gettleman, "To Mayor, It's Selma's Statue of Limitations," *Los Angeles Times*, Oct. 22, 2000; Jonathan McElvey, "Monument of Nathan Bedford Forrest Draws Protests," *STJ*, Oct. 8, 2000.

19. www.confederate-rose.org, viewed Oct. 7, 2011; these words are no longer included on the website. For a different interpretation of the Forrest Monument controversy, see Owen J. Dwyer, "Symbolic Accretion and Commemoration," *Social and Cultural Geography* 5 (2004): 419–35.

20. David Firestone, "The 2000 Campaign: The South; Making History at the Polls, Selma Elects and Black Mayor," *NYT*, Sept. 13, 2000; "After 36 Years in Office, Selma Mayor Voted Out," Sept. 12, 2000, http://cgi.cnn.com/2000/ALLPOLITICS/stories/09/12/smitherman.loss/index.html; Gettleman, "To Mayor."

21. Douglas Martin, "Joseph Smitherman, Mayor in Selma Strife, Dies at 75," *NYT*, Sept. 13, 2005; J. Mills Thornton III, *Dividing Lines: Municipal Politics and the Struggle for Civil Rights in Montgomery, Birmingham, and Selma* (Tuscaloosa: University of Alabama Press, 2002), 392–93, 428–34, 478. My account of Selma politics up to the 1990s is based heavily on Thornton's exhaustive study.

22. Thornton, *Dividing Lines*, 499, 531–39; Chestnut, *Black in Selma*, 260–71, 290–91; Firestone, "2000 Campaign"; Ronald Smothers, "25 Years Later, Racial Tensions Revive in Selma," *NYT*, Feb. 11, 1990; Alvin Benn, "Selma Votes for Residents to Pick School Board," *MA*, Apr. 29, 2009.

23. J. L. Chestnut Jr. and Julia Cass, *Black in Selma: The Uncommon Life of J. L. Chestnut, Jr.* (New York: Farrar, Straus and Giroux, 1990), 408–9.

24. Chestnut and Cass, *Black in Selma*, 62–64.

25. Chestnut and Cass, *Black in Selma*, 265.

26. Chestnut and Cass, *Black in Selma*, 249–53, 257 (quotation); "Faya Ora Rose Touré Biography — Selected Works," biography.jrank.org/pages/2993/Tour-Faya-Ora-Rose.html; Thornton, *Dividing Lines*, 538–39, 548; Tammy Leytham, "Evans Apologizes to Citizens," *STJ*, Feb. 15, 2006.

27. Thornton, *Dividing Lines*, 542–53; Chestnut, *Black in Selma*, 402–7; Smothers, "25 Years Later." Touré offered her analysis of the conflict in Rose Sanders and Wythe Holt, "Still Separate and Unequal: Public Education More Than Forty Years after Brown," *In Motion Magazine*, Oct. 20, 1997, www.inmotionmagazine.com/forty.html.

28. Chestnut and Cass, *Black in Selma*, 363; Thornton, *Dividing Lines*, 559; David Firestone, "Old Southern Strategy Faces Test in Selma Vote," *NYT*, Sept. 10, 2000; Penny L. Pool, "Joe Goes; Perkins Finally Unseats Smitherman," *STJ*, Sept. 13, 2000; "After 36 Years in Office."

29. Josh Bergeron, "Selma City Council Member to Retire; Supports Election," *STJ*, May 31, 2014; Tucker, "Selma, AL City Council President Pro Tem"; "Henry Sanders et al. v. Joe T. Smitherman and Cecil Williamson, decided June 30, 2000," http://caselaw.findlaw.com/al-supreme-court/1473981.html; Nate Brown, letter to the editor, *STJ*, Jan. 24,

2007; Cecil Williamson, letter to the editor, *STJ,* Aug. 16, 2006; Williamson, letter to the editor, *STJ,* June 24, 2006; Williamson, letter to the editor, *STJ,* June 22, 2006.

30. Pat Godwin, presentation to Society of Architectural Historians' *Civil Rights and African-American Urban Landscapes in the Twentieth-Century South* tour, Old Live Oak Cemetery, Selma, AL, Oct. 10, 2009; Johnson, letter to the editor, Nov. 16, 2007.

31. Chestnut and Cass, *Black in Selma,* 363; Thornton, *Dividing Lines,* 559; Firestone, "Old Southern"; Penny L. Pool, "Joe Goes; Perkins Finally Unseats Smitherman," *STJ,* Sept. 13, 2000; "After 36 Years in Office."

32. Dusty Brown, quoted in Julia Cass, letter to the editor, *STJ,* Aug. 10, 2004.

33. Thornton, *Dividing Lines,* 535–36; McElvey, "Monument."

34. Arlethea W. Pressley, "Council Addresses Forrest Monument," *STJ,* Oct. 10, 2000; Selma City Council, "Resolution—Nathan Bedford Forrest," reproduced on *The Lt. General Nathan Bedford Forrest Monument* [hereafter *NBFM*] website of the Friends of Forrest, Inc., viewed Apr. 19, 2006, www.forrestmonument.org (website discontinued); Pressley, "Mayor Wanted to Know about Forrest Monument," *STJ,* Oct. 13–14, 2000; "Confederate Groups Could Demonstrate Leadership," editorial, *STJ,* Oct. 12, 2000. On Fort Pillow, see Foster, *Ghosts,* 25; Blight, *Race and Reunion,* 142.

35. Jared Felkins, "Heated Battle Began at Riverside [sic] Park," *STJ,* Feb. 27, 2001; Thornton, *Dividing Lines,* 494–96; Amy Bach, "Selma Is Still Selma," *Nation,* Sept. 7, 2000; Gettleman, "To Mayor"; Steve Lopez, "Ghosts of the South," Apr. 23, 2001, edition.cnn.com/ALLPOLITICS/time/2001/04/30/ghost.html; "Forrest Statue Attacked in Protest," *Daily Beacon* (University of Tennessee), Jan. 17, 2001.

36. Arlethea W. Pressley, "Perkins Says Statue of Forrest Will Be Moved," *STJ,* Oct. 15, 2000.

37. Jonathan McElvey, "'Friends of Forrest' Not Ready to Move Statue," *STJ,* Oct. 15, 2000; Cecil Williamson and Pat Godwin, FoF Monument Committee, to Mayor James Perkins Jr., Oct. 20, 2000, *NBFM.*

38. Arlethea W. Pressley, "City Doesn't Budge; Monument Will Go," *STJ,* Oct. 24, 2000; Pressley, "Still No Vote on Statue," *STJ,* Feb. 13, 2001; Felkins, "Heated Battle."

39. Arlethea W. Pressley, "Parade Takes Radical Turn; Monument Protests Heat Up," *STJ,* Jan. 16, 2001; Bob Johnson, "Racial Strife Tears Once More at the Fabric of Historic Selma; Incidents Include Attempt to Topple Klansman Statue," AP report, Jan. 21, 2001, www.mindfully.org/Reform/James-Perkins-Selma-AL.htm.

40. Pressley, "Still No Vote"; Felkins, "Heated Battle"; Arlethea Pressley, "Forrest Finds New Home," *STJ,* Feb. 27, 2001; Alan Riquelmy, "Squabble over Statue a Complicated Tale," *STJ,* May 29, 2003; Riquelmy, "Forrest Appeal Denied," *STJ,* Apr. 16, 2004.

41. Faya Ora Rose Touré, interview with author, Selma, AL, June 18, 2009; Pressley, "Parade Takes Radical Turn."

42. Coski, *Confederate Battle Flag,* 85; Eric Foner, *Reconstruction, 1863–1877: America's Unfinished Revolution* (New York: Harper and Row, 1988), 342; FoF, "Our Position"; Gary W. Hearon, letter to the editor, *STJ,* Oct. 10, 2000.

43. Godwin presentation; Joseph Ralph, letter to the editor, *STJ,* Feb. 28, 2001; Franklin Sharon, letter to the editor, *STJ,* Oct. 17, 2000. On monuments as historic facts, see Dwyer, "Symbolic Accretion," 422–23.

44. Godwin presentation; Pressley, "Forrest Finds New Home"; "In Alabama, a 'Wizardess' Disputes Her Title," *Southern Poverty Law Center Intelligence Report,* no. 118 (Summer 2005).

45. Ed Ballam, "Forrest Monument's Removal in Selma May Lead to Court," *The Civil War News* (blog), www.civilwarnews.com/archive/articles/forrest_monument.htm;

Riquelmy, "Confederate General's Statue"; Yow to Nunn, Nov. 17, 2000, "Friends of Forrest vs. City," viewed Apr. 19, 2006, *NBFM*; Constance A. Foster, letter to the editor, *STJ*, Oct. 24, 2000. Yow, who presented himself as a neutral civil liberties lawyer, was a member of the radical rightist wing of the SCV (Beirich, "Struggle for the Sons of Confederate Veterans," 294).

46. "Frequently Asked Questions about the LS," *League of the South* [hereafter *LS*], dixienet. org/rights/2013/faq_frequently_asked_questions.php; J. Michael Hill, "What Would It Take to Get You to Fight?," July 30, 2011, *LS*, dixienet.org/rights/what_would_it_take_ to_get_you_to_fight.php; Godwin presentation.

47. Godwin presentation; Michael Hill, "League of the South Core Beliefs Statement," *LS*, dixienet.org/rights/2013/core_beliefs_statement.php; "Frequently Asked Questions," *LS*.

48. Hill, "League of the South Core Beliefs Statement"; "Frequently Asked Questions," *LS*; Peter Applebome, "Could the Old South Be Resurrected?; Cherished Ideas of the Confederacy (Not Slavery) Find New Backers," *NYT*, Mar. 7, 1998; Douglas Martin, "Grady McWhiney Dies; Historian of South Was 77," *NYT*, Apr. 30, 2006; Cecil Williamson, interview with *STJ* editor, n.d., viewed Oct. 7, 2011, https//:www.youtube.com/ watch?v=fKi22kx-EpM; Connie Tucker, "Selma, AL City Council President Pro Tem Cecil Williamson Accused of Being White Supremacist and Secessionist," Sept. 16, 2010, http://greenecountydemocrat.com/?p=405. Although Williamson claims to have left the league in 2001, he has appeared at league-sponsored events since then and told a radio interviewer in 2007 that he supported its mission (Denise Johnson, letter to the editor, *STJ*, Aug. 7, 2007).

49. "League of the South," *SPLC Intelligence Files*, www.splcenter.org/get-informed/ intelligence-files/groups/league-of-the-south.Kershaw, an attorney who defended King assassin James Earl Ray, was also a sculptor who had created a twenty-seven-foot-high equestrian statue of Forrest, set on private property near an interstate highway (Douglas Martin, "Jack Kershaw, 96; Challenged Conviction of King Assassin," *NYT*, Sept. 26, 2010).

50. www.lragsdale.com/skeer.html, viewed Oct. 7, 2011 (no longer on website); "Nathan B. Forrest & King Philip Billboard in Selma," *Southern Independence Party*, April 2004, viewed Apr. 19, 2006, www.siptn.org (website discontinued). The billboards remained in place until at least 2006, when I saw them. They were gone by 2009.

51. Pressley, "City Doesn't Budge"; Charles E. Yow, "The Lt. Gen. Nathan Bedford Forrest Monument," Feb. 10, 2001, *Students and Teachers against Racism* (blog), www.racism-againstindians.org /Tribute/Southern/SouthernBedfordForrest.htm; "Group Clashes over Symbols of Confederacy," *NYT*, July 24, 2005; Beirich, "Struggle for the Sons of Confederate Veterans," 280–308.

52. Godwin presentation; Pressley, "Perkins Says Statue of Forrest Will Be Moved"; Pressley, "Forrest Finds New Home."

53. "Confederate Groups Could Demonstrate Leadership," editorial, *STJ*, Oct. 12, 2000.

54. Arlethea Pressley, "Woman Says 'Move Statue,'" *STJ*, Feb. 18, 2001.

55. Arlethea Pressley, "Selmians Speak Out on Monument Move," *STJ*, Feb. 28, 2001; Ross Slack, letter to the editor, *STJ*, Oct. 24, 2000; Pressley, "Woman Says 'Move Statue'"; Coski, *Confederate Battle Flag*, 85; Foner, *Reconstruction*, 342; Tim Bounds, "Remembering Nathan Bedford Forrest: White Supremacy and the Memphis Monument," www. africanafrican.com/folder11/world%20history4/harlem%20renaissance/Remembering_Forrest.pdf. On the issue of Civil War versus civil rights memorials, see, e.g., "Our

Position," *NBFM:* "The City of Selma has allowed the placement of monuments to civil rights figures, such as Martin Luther King and Rev. James Reeb, on city property without council approval. To remove the Forrest Monument without removing the others would be a clear act of racial discrimination." The Voting Rights Museum is a private museum located in a privately owned building, and the King memorial stands on land owned by the Brown Memorial AME Church. The Reeb memorial, which once stood at the Old Depot Museum, now stands on a vacant lot at the site where he was assaulted.

56. Tim Reeves, "Monument Now Headless," *STJ,* Mar. 13, 2012; Reeves, "Forrest Monument an Ongoing Battle," *STJ,* Sept. 5, 2012; Reeves, "Construction of Expanded Forrest Monument Halted," *STJ,* Aug. 23, 2012; Josh Bergeron, "Ruling Says City Council Violated Due Process Rights," *STJ,* Oct. 31, 2013; Bergeron, "One Final Step Remains for Council in KTK Mining Lawsuit," *STJ,* Dec. 10, 2013. Since the bust has not been recovered and no one has claimed responsibility for the abduction or accused anyone else of having stolen it, it is likely that it was taken by apolitical bronze thieves.

57. Lawrence N. Powell, "A Concrete Symbol: Lacking a Glorious Confederate Heritage, Wealthy Whites in New Orleans Rewrote History to Suit Their Political Needs," *Southern Exposure* 18, no. 1 (1990): 40–43.

58. Foner, *Reconstruction,* 262–63, 550–52; "The White League," in Walter L. Fleming, *Documentary History of Reconstruction: Political, Military, Social, Religious, Educational and Industrial, 1865 to the Present Time,* vol. 2 (Cleveland: Arthur H. Clark, 1907), 359; Stuart Omer Landry, *The Battle of Liberty Place: The Overthrow of Carpetbag Rule in New Orleans, September 14, 1874* (Gretna, LA: Firebird Press, 1955, 2000), 179.

59. Landry, *Battle,* 193; Lawrence N. Powell, "Reinventing Tradition: Liberty Place, Historical Memory, and Silk-Stocking Vigilantism in New Orleans Politics," *Slavery and Abolition* 20, no. 1 (1999): 127–41; Powell, "Concrete Symbol," 41; Sanford Levinson, *Written in Stone: Public Monuments in Changing Societies* (Durham, NC: Duke University Press, 1998), 47.

60. Powell, "Reinventing Tradition," 129–30, 133; "Ceremonies Held at Monument to Patriots of City; Rout of Carpetbag Rule in 1874 Celebrated by Citizens," *TP,* Sept. 15, 1932; James N. Duffy to Councilman Frank Friedler, June 18, 1976, Liberty Monument folder, Councilman Frank Friedler Papers [hereafter FP], 1974–1980, box 2, NOPL; "Added Words Ordered Off Monument," *TP,* Jan. 17, 1981; James Gill, *Lords of Misrule: Mardi Gras and the Politics of Race in New Orleans* (Oxford: University of Mississippi Press, 1997), 260. On varying attitudes toward African American political and economic advancement among Reconstruction era white conservatives, see C. Vann Woodward, *The Strange Career of Jim Crow,* 2nd rev. ed. (New York: Oxford University Press, 1966), 44–65. Lawrence Powell thinks that the 1932 inscriptions reflected the city's elites' battle with Huey Long, who attempted to draw African Americans into his political coalition (Powell, "Reinventing Tradition," 140–43).

61. "Ceremonies Held."

62. "An Ordinance Providing for a Board of Commissioners for Liberty Place," Ordinance no. 13681, Apr. 12, 1933; Ordinance no. 13820, Sept. 28, 1932, Commission Council Series City Council, both in City Council Ordinances AB 311, 1925–50, microfilm roll 1242, NOPL.

63. "States' Righters Goal Is Explained; Fight to Avert Despotism, Declares Dixon," *TP,* Sept. 16, 1949.

64. "To Restore the Monument of Liberty Place to Its Original Intent," photocopy, n.s., n.d., Liberty Monument folder, FP; "White League," 359; Landry, *Battle*, 15–37; Norman A. Woods, letter to the editor, *TP*, Feb. 19, 1974; William E. Theodore, letter to the editor, *TP*, Feb. 19, 1974. The belief that African Americans sought an all-black state like revolutionary Haiti's was expounded at length in the White League platform. On Louisiana's repeated attempts to circumvent federal desegregation rulings, see Liva Baker, *The Second Battle of New Orleans: The Hundred-Year Struggle to Integrate the Schools* (New York: HarperCollins, 1996), 225–28, 268–71, 380–87.

65. Theodore letter; Joe Hunter, New Orleans, letter to the editor, *TP*, Feb. 19, 1974; Duffy to Friedler, June 18, 1976; "Monument Removal a Mistake," *TP*, Jan. 16, 1981. Landrieu's plaque was placed in June 1974 but dated February 1974, as though the city had responded immediately to black concerns. The local Youth Council of the NAACP, which had picketed the monument in February, called the mayor on this attempted deception (Mayor's Advisory Committee on Human Relations, Recommendations on the Liberty Place Monument, July 1, 1993 [hereafter Recommendations 1993], n.p., photocopied report, NOPL item no. AAHC 150 1993Lm).

66. FP; "Liberty Monument: Then, Now," editorial, *TP*, Feb. 15, 1974.

67. Joe Massa, "Morial in Dutch with Blacks and Whites," *TP*, Jan. 17, 1981; Brendan McCarthy, "Infamous Algiers 7 Police Brutality Case of 1980 Has Parallels to Today," Nov. 7, 2010, www.nola.com/crime/index.ssf/2010/11/algiers_7_police_brutality_cas.html.

68. Jeannette Hardy and Joe Massa, "Canal Monument Bowing to Protests," *TP*, Jan. 15, 1981; Iris Kelso, "That Obelisk: Who Cares?" *TP*, Feb. 5, 1981; "Liberty Monument Resolution," editorial, *TP*, Jan. 21, 1981; Lucius Coke, letter to the editor, *TP*, Jan. 26, 1981; Steven M. Krantz, letter to the editor, *TP*, Feb. 1, 1981; Richard R. Rothermel, letter to the editor, *TP*, Jan. 31, 1981.

69. Betty Wisdom, letter to the editor, *TP*, Feb. 5, 1981; J. W. Frankenbush, letter to the editor, *TP*, Feb. 14, 1981.

70. Hardy and Massa, "Canal Monument Bowing"; Wisdom letter.

71. John Pope, "Morial Lauds One Statue, Disowns Another," *TP*, Jan. 16, 1981.

72. "Monument Removal a Mistake," editorial, *TP*, Jan. 16, 1981; Felix L. Paul, PhD, letter to the editor, *TP*, Feb. 14, 1981; Robin W. Winks, "A Place for the Liberty Monument," *TP*, Aug. 17, 1992, cited in Levinson, *Written in Stone*, 63–66 (I have been unable to locate this article in online archives of the *TP*); Thomas P. Cooke, letter to the editor, *TP*, Jan. 23, 1981.

73. M. D. Smith, letter to the editor, *TP*, Jan. 26, 1981; Valward Marcelin, letter to the editor, *TP*, Jan. 26, 1981; Rev. Horace Dyer, letter to the editor, *TP*, Jan. 26, 1981.

74. Lovell Beaulieu, "Two Protests Collide at Monument," *TP*, Jan. 5, 1981; Pope, "Morial Lauds One Monument."

75. This issue is discussed in Sanford Levinson, "Silencing the Past: Public Monuments and the Tutelary State," *Report from the Institute for Philosophy and Public Policy* 16, nos. 3–4 (1996), www.puaf.umd.edu/PPP/levinson.htm.

76. "Added Words Ordered Off Monument," *TP*, Jan. 17, 1981; Clancy duBos, "Can't Move the Statue, Council Tells Morial," *TP*, Feb. 13, 1981. The ordinance forbidding the removal of monuments passed by a vote of four to three, with three white and one black councilmember in favor, and two black and one white councilmember opposed (duBos, "Can't Move"). On similar attempts elsewhere in the South to thwart attempts to remove unpopular monuments, see Ed Anderson, "Bill Would Preserve Monuments—N.O. Memorial Inspires Lawmaker," *TP*, Apr. 2, 1997.

77. "Monument Fuss Epilogue," editorial, *TP*, Feb. 14, 1981; "Added Words Ordered Off"; James Gill, "Ancient Injustices and Modern-Day Sensibilities," *TP*, Mar. 14, 1993.

78. Kelso, "That Obelisk"; Bruce Eggler, "Statue Removal on Canal Street at a Standstill," *TP*, Oct. 14, 1989; Eggler, "City Gets Green Light to Move Monument," *TP*, Nov. 11, 1989; Adm. Arthur H. de la Houssaye, Board of Commissioners of Liberty Place, to Mayor Victor H. Schiro, Jan. 12, 1967, Liberty Monument—1967 folder, Victor Hugo Schiro Collection AA512, 1957–1970 Subject File, carton S67-12, NOPL; Eggler, "Disputed Monument in Warehouse," *TP*, Nov. 16, 1989. In response to a 1993 questionnaire on the monument, Tassin stated that he did not believe that the monument honored or praised an ideology "in conflict with the requirements of equal protection for all citizens," that it supported white supremacy, that it praised "violent actions taken wrongfully against citizens of the City to promote ethnic, religious, or racial supremacy of any group over another," or that it would constitute a continuing expense for maintenance and security (Recommendations 1993, n.p.).

79. Recommendations 1993, n.p.; Bruce Eggler, "White Monument Held in Limbo by City," *TP*, Apr. 10, 1991; Eggler, "U.S.: Re-Erect White Monument—Federal Officials Back Plaintiff," *TP*, Apr. 1, 1992; Eggler and Coleman Warner, "City's Deadline for Monument Is Missed Again," *TP*, Jan. 20, 1993; Eggler, "Liberty Statue Is Replaced," *TP*, Feb. 11, 1993; Christina Cheakalos, "Debate Ranges in New Orleans over Monument—Obelisk Called Racist Symbol," *Atlanta Journal*, Dec. 15, 1992.

80. Coleman Warner, "Column Ripped from Monument," *TP*, Mar. 2, 1993; Scott Lindsly, Slidell, letter to the editor, *TP*, Feb. 20, 1993. The favored comparison among neo-Confederates is to the erection of a monument to Adolf Hitler in Tel Aviv.

81. Garry Boulard, "New Orleans Battles over a Monument," *Christian Science Monitor*, Apr. 19, 1993.

82. Warner, "Column Ripped from Monument"; Michael Perlstein, "5 Arrested at Monument Ceremony—Legislator Leads Protest," *TP*, Mar. 8, 1993; Lisa Frazier, "Celebrating Old Divisions," *TP*, Mar. 12, 1993.

83. Kevin Bell, "Council Takes Step against Monument," *TP*, Apr. 16, 1993; Dawn Ruth, "City Sets Hearings on Monument," *TP*, May 21, 1993. The opponent who voted for the measure said that she did so because the city needed such an ordinance against nuisances and the majority had rejected her proposal to defer acting until the wording of the act could be refined (Bell, "Council Takes Step").

84. Recommendations 1993, n.p.; Susan Finch, "Duke Condemns 'Nazi-Like' Moves over Monument," *TP*, June 16, 1993.

85. Recommendations 1993, n. p.

86. Recommendations 1993, n. p.; Susan Finch, "Liberty: Store Monument, Panel Says," *TP*, July 1, 1993.

87. Susan Finch, "Liberty Meetings Begin," *TP*, June 9, 1993; Avery C. Alexander, "Why No Scene at Monument," *TP*, Oct. 8, 1993; Bill Voelker, "Monument: Court Fight Delayed as Judge Quits Case," *TP*, Dec. 4, 1993; Gill, *Lords of Misrule*, 274–75; Bill Voelker, "Monument Future Uncertain," *TP*, Mar. 12, 1994.

88. Bell, "Council Takes Steps."

89. "S.C.'s New African-American Monument Sits among Confederate Reminders," Mar. 23, 2001, *Arizona Daily Wildcat Online*, http://wc.arizona.edu/papers/94/121/01_93_m.html; Anne Marie Harmison, letter to the editor, *TP*, Feb. 25, 1993.

1. Community Profile, Caroline County, Virginia, www.visitcaroline.com/commprofile22409.pdf; US Census Bureau, Caroline County, Virginia, QuickFacts, at quickfacts.census.gov.

2. Betty Hayden Snider and Ruth Finch, "Present Confronts Past; Monument Plan Food for Thought," *FLS,* Oct. 20, 2000; Snider, "Caroline Group Seeks Black History Tribute," *FLS,* Oct. 13, 2000; Finch, "Caroline Tourism Group Disbanded," *FLS,* Feb. 15, 2001.

3. Snider, "Caroline Group Seeks."

4. Snider, "Caroline Group Seeks"; Betty Hayden Snider, "Planned Monument Stirs Talk; Caroline Mulling Black History Nod," *FLS,* Oct. 18, 2000; Dionne Walker, "Pioneer of Interracial Marriage Looks Back," *USA Today,* June 10, 2007; "Mildred Loving," *Economist,* May 15, 2008; David Margolick, "A Mixed Marriage's 25th Anniversary of Legality," *NYT,* June 12, 1992; Phyl Newbeck, *Virginia Hasn't Always Been for Lovers: Interracial Marriage Bans and the Case of Richard and Mildred Loving* (Carbondale: Southern Illinois University Press, 2004), 219; Ruth Finch, "Caroline to Add Quakers, Indians to Monument," *FLS,* Sept. 29, 2001. On Brooks's racial views, see Newbeck, *Virginia Hasn't Always,* 11.

5. Chris L. Jenkins, "County's Past Is Divisive in Present; Va. Board Balks at Plan to Commemorate Slave," *WP,* Dec. 4, 2000. For an account of Gabriel's Rebellion, see Douglas R. Egerton, *Gabriel's Rebellion: The Virginia Slave Conspiracies of 1800 and 1802* (Chapel Hill: University of North Carolina Press, 1993).

6. Thomas Jefferson, quoted in *To Make Our World Anew: A History of African Americans,* ed. Robin D. G. Kelley and Earl Lewis (New York: Oxford University Press, 2000), 168; Ruth Finch, "Caroline Rejects Slave-Uprising Text," *FLS,* Nov. 17, 2000.

7. Marvin Williams, letter to the editor, *FLS,* Nov. 29, 2000; Bert Nichols, "Gabriel Paid the Ultimate Price to Be Free: Remember His Army," op-ed, *FLS,* Dec. 1, 2000; Stan Beason, "Caroline Memorial Isn't an Anti-Confederate Plot, but a Broadening of History," *FLS,* Dec. 12, 2000.

8. Calvin B. Taylor, "Remember Gabriel's Rebellion? Indeed. But Don't Memorialize It," op-ed, *FLS,* Dec. 1, 2000.

9. Finch, "Caroline Rejects"; Milton G. Carey, "Supervisors, Rethink Your Decision on a Monument for Gabriel," op-ed, *FLS,* Dec. 7, 2000; Larry Evans, letter to the editor, *FLS,* Nov. 27, 2000.

10. "Remember a Rebel; Gabriel Wasn't Exactly a Hero, but He Is Part of Caroline County History Nonetheless," editorial, *FLS,* Oct. 22, 2002.

11. Taylor, "Remember Gabriel's Rebellion?"; "Remember a Rebel"; Carey, "Supervisors."

12. Egerton, *Gabriel's Rebellion,* 30, 38, 41, 49, 102, 109.

13. The recent interpretation is Michael L. Nicholls, *Whispers of Rebellion: Narrating Gabriel's Conspiracy* (Charlottesville: University of Virginia Press, 2012).

14. Jenkins, "County's Past"; Taylor, "Remember Gabriel's Rebellion?" The white supervisors were notably close-mouthed throughout the controversy, allowing Taylor to represent their faction. Among their few reported comments were Acors's protest (in reply to demands that the antis be turned out of office at the next election) that "I am not a racist.... 'I would hope that people will look at what I've done over time and not at one issue that has been blown out of proportion'" and his statement at another point that he agreed with Taylor about the example the monument would set for children. He also couldn't understand "why we need separate monuments when we are one people" (Ruth Finch,

"Caroline Board Unmoved by Slave Memorial Appeals," *FLS*, Nov. 29, 2000; Jenkins, "County's Past"; Snider, "Planned Monument Stirs Talk"). To the best of my knowledge, Robert Farmer made no public statements at all. It is worth noting that Farmer was the magistrate who signed the arrest warrants for the Lovings in 1958. The warrants are illustrated in Newbeck, *Virginia Hasn't*. On Farmer, see Corey Byers, "A Lifetime of Service: Robert Farmer, Longtime Caroline County Supervisor, Leaves His Mark on Community," Feb. 23, 2008, Fredericksburg.com (no longer online).

15. Taylor, "Remember Gabriel's Rebellion?"

16. Taylor, "Remember Gabriel's Rebellion?" Another dimension of the conflict, unrecoverable through published accounts, may have been resistance to the racially liberal views of recently settled white outsiders such as Beason.

17. Jenkins, "County's Past"; Kiran Krishnamurthy, "Caroline Debate Heats Up—Monument Battle Opens Eyes, Some Say," *RTD*, Mar. 10, 2003; Ruth Finch, "Caroline to Add Quakers, Indians to Monument," *FLS*, Sept. 29, 2001. The supervisors paid for a roadside historical marker in the county (but not in Bowling Green, the county seat) and permitted Gabriel's Rebellion to be mentioned in the county's 2001 tourism guide. "Putting it in a tourism guide and putting it on a monument are two different things," according to Taylor (Ruth Finch, "Slaves' Rebellion Gets Nod; Caroline Pitches Event to tourists," *FLS*, June 14, 2001).

18. Ruth Finch, "Caroline Board to Revisit Issue of Courthouse Monument," *FLS*, Mar. 28, 2002; Finch, "Caroline Panel Debates Wording for Courthouse Memorial," *FLS*, May 21, 2002; Krishnamurthy, "Caroline Debate."

19. Caroline County Board of Supervisors, Supervisors' Orders No. 14, Apr. 23, May 14, 2002; Finch, "Caroline Panel Debates."

20. Ruth Finch, "Compromise Plan Unveiled for Courthouse Memorial; Caroline Considers Less Controversial Text for Monument," *FLS*, Aug. 15, 2002.

21. Ruth Finch, "Chairman's Views Shift on Caroline Monument," *FLS*, May 30, 2002.

22. Lydell Fortune, letter to the editor, *FLS*, Apr. 10, 2002; Ruth Finch, "NAACP Sues to Block Caroline Monument; Civil Rights Group Objects to Board's Marker Decision," *FLS*, Nov. 28, 2002; Finch, "Caroline Seeks Dismissal," *FLS*, Dec. 18, 2002; Kristen Davis, "Caroline Finally Gets Monument; To Some, the Event Was Personal," *FLS*, July 4, 2004.

23. W. Fitzhugh Brundage, *The Southern Past: A Clash of Race and Memory* (Cambridge, MA: Harvard University Press, 2005), 271; Beason, "Caroline Memorial Isn't an Anti-Confederate Plot."

24. Margolick, "Mixed Marriage's 25th Anniversary."

25. Finch, "Caroline Rejects Slave-Uprising Text"; Marvin Williams, letter to the editor, FLS, Nov. 29, 2000; Michael Paul Williams, "Double Standards Monumental," *RTD*, June 23, 2003; Carey, "Supervisors, Rethink."

26. Abigail Hester Williams Jordan, *To Honor Our Forebears: Trials and Tribulations of Building an African American Monument in Savannah, Georgia, 1991–2002* (Savannah: self-published, n.d. [ca. 2010]), 5–6. The details of the monument's origin myth have evolved in Jordan's telling over the years, but the core, recounted here, has remained constant. My references to Jordan's version of the story are derived primarily from a lengthy interview with her on April 29, 2006 (cited hereafter as Jordan interview), which was conducted at her house, at the monument, and at an NAACP breakfast, and from *To Honor Our Forebears*, her self-published summary of the struggle. The book contains an exhaustive archive of the journalistic coverage of the struggle, haphazardly arranged but unsparing of

the compiler. Jordan included editorials, cartoons, and letters to the editor that harshly criticized her own conduct. All other primary sources can be found in the chronological series of folders entitled City Manager's Administrative Subject Files; Monuments—African American, and Mayor's Papers, 0110-001-35; African American Monument, both City of Savannah Research Library and Municipal Archives, City Hall, Savannah, GA.

27. Rev. Billy Hester, Asbury Memorial United Methodist Church, to Abigail Jordan, May 7, 1997.

28. Jordan, *To Honor Our Forebears*, 5–6; Jordan interview; Official Proceedings of Savannah City Council [hereafter OPSCC], Jan. 7, 1993, City of Savannah Research Library and Municipal Archives, City Hall, Savannah, GA, 9; Jordan, *To Honor Our Forebears*, 7; John W. Russell, General Manager, Hyatt Regency Hotel, to Abigail Jordan, Sept. 15, 1992, reproduced in *To Honor Our Forebears*, n.p.

29. Jordan keeps this column and plaque at her home.

30. Ray Jenkins, "The Kind of Man Who Sends Bombs by Mail," *Baltimore Sun*, Dec. 16, 1994.

31. Minutes, HSMC [Historic Sites and Monuments Commission] and Technical Advisory Committee, June 30, 1998.

32. Minutes, HSMC, July 17, 1998.

33. [HSMC], Proposed African-American Monument, draft, ca. 1998; Minutes, HSMC and Technical Advisory Committee, June 30, 1998; Minutes, HSMC, July 17, 1998. For one statement of the rationale for the particular names chosen see African American [Monument] Association, memo to Savannah City Council, n.d. [ca. April 1999].

34. OPSCC, Feb. 25, 1999, p. 26, Apr. 8, 1999, p. 2, Feb. 10, 2000, p. 15; Minutes, HSMC, Mar. 18, 1999; [Michael Brown and staff], Proposed African-American Monument, Report to the Mayor and Aldermen, Apr. 8, 1999; Abigail Jordan to Brown, Feb. 8, 2000; Kate Wiltrout, "African-American Monument Plan Crumbles; Telfair Advances," *SMN*, Feb. 11, 2000.

35. Jordan, *To Honor Our Forebears*, 13–14, 16; Jordan interview; Minutes, HSMC, July 17, 1998. Jordan told me that Law did not support the monument and said nothing publicly for or against it. Law did many good things but "didn't want competition" (Jordan interview). He died on the day of the monument's dedication.

36. Jordan, *To Honor Our Forebears*, 9–11, 13; Ivan Cohen, letter to the editor, *SMN*, Feb. 5, 2000.

37. Henry Moore, Assistant City Manager/Public Development, to City Manager Michael Brown, Oct. 16, 1995.

38. Richard Fogaley, "Memorial a Monumental Undertaking," *SMN*, Nov. 18, 1997; Wiltrout, "City Council Workshop Grows Heated." Adams's 1997 committee vanished without a trace. It is uncertain whether it is this incident or Adams's 2000 attempt to create a new committee that Jordan refers to when she describes Adams and Otis Johnson's attending an AAMA meeting to announce that the city would take over the AAMA (Jordan, *To Honor Our Forebears*, 13).

39. "Editorial: Fresh Start for Old Idea," *SMN*, Feb. 12, 2000; Kate Wiltrout, "Mayor Moving on Monument," *SMN*, May 19, 2000; "Savannah Mayor Pushes for African-American Monument," May 20, 2000, *OnlineAthens*, onlineathens.com /stories/052000/new_0520000010.shtml; OPSCC, Jan. 11, 2001. On Tillman's role, see Kate Wiltrout, "City to Build Monument Foundation," *SMN*, May 17, 2002.

40. Lynn Hamilton, "City Finally Approves African-American Monument," *Connect Savannah*, Feb. 2–8, 2001, 5. Jordan says that she stayed out of the design process (*To Honor Our Forebears*, 11–12).

41. The alternate designs are illustrated in Jordan, *To Honor Our Forebears.*

42. Kirk Savage, *Standing Soldiers, Kneeling Slaves: Race, War, and Monument in Nineteenth-Century America* (Princeton, NJ: Princeton University Press, 1997), 89–90, 114–19; Kirsten Pai Buick, *Child of the Fire: Mary Edmonia Lewis and the Problem of Art History's Black and Indian Subject* (Durham, NC: Duke University Press, 2010), 52–64.

43. Michael B. Brown to Mayor and Aldermen, Nov. 18, 1999; Jingle Davis, "'A Long Time Coming': Family of Color Gets Spot in Savannah," *AJC,* July 26, 2002.

44. Amy Goodpaster Strebe, "African-American Monument Gets OK," *Savannah Georgia Guardian,* July 10–16, 1998.

45. For a discussion that treats the memory of slavery as the fundamental cause of the controversy, see Derek H. Alderman, "Surrogation and the Politics of Remembering Slavery in Savannah, Georgia," *Journal of Historical Geography* 26 (2010): 90–101. I argue that slavery, like the civil rights movement, is a means of contesting contemporary urban racial politics, so its role in the Savannah memorial is more complex than Alderman believes. For contemporary Americans' relationship with slavery generally, see the essays in James Oliver Horton and Lois E. Horton, eds., *Slavery and Public History: The Tough Stuff of American Memory* (Chapel Hill: University of North Carolina Press, 2006).

46. Christiane S. Peck-de Néré, Tampa, FL, to Mayor Floyd Adams, Feb. 12, 2001; William Frederick Johnson, Washington, DC, to Adams, Apr. 15, 2008; Patricia Epsimos, Boston, e-mail to Adams, Feb. 12, 2001.

47. Emma M. Adler, Savannah, to Florence Williams, Helena, MT, Nov. 17, 1999; Adler to Mayor Floyd Adams, Nov. 18, 1999; Florence Williams, "Behind Savannah's Sweet Historic Charm, There's a Secret Aching to Be Told," *Travel Holiday,* ca. 1999, 131–32, photocopies in Savannah Mayor's Papers 0110-001-35, African-American Monument folder.

48. Emma Adler to [Floyd Adams], 2000, cover letter for "Thoughts on the Proposed African American Monument," 2000. Another correspondent made a similar suggestion "to my friend W. W. Law" that Franklin Square, adjacent to the venerable First African Baptist Church, would be a better location. The church could sponsor ceremonies there periodically, as "markers, statues, etc." would be added to honor "outstanding Afro-Americans. . . . It would be the only square devoted to Good Black History!" (Nick J. Mamalakis to Adams, n.d. [rec. Feb. 14, 2000]).

49. Harold L. Hillery, letter to the editor, *SMN,* July 9, 1998; Peck-de Néré to Adams; James Franklin Gardner to Adams, Feb. 25, 2001; Chris Acemandese Hall, Elmont, NY, to Adams, Mar. 2, 2001; Dan Chapman, "Savannah Struggles over Inscription on Monument Depicting Slaves," *AJC,* Feb. 23, 2001; Hugo Kugiya, "How Graphic a Monument? City Debates Depiction of Slavery," *Newsday,* Feb. 25, 2001, copy in Mayor's Papers; Bret Bell, "Council Approves African-American Monument," *SMN,* Jan. 12, 2001.

50. Gardner to Adams; James F. Moore, Easton, WA, to Savannah City Council, May 1, 2001; Steven Wade Wilson, St. Charles, IL, to Floyd Adams, Mar. 12, 2001; Rev. James A. Brown to Adams, Dec. 7, 1999. The file of alternate inscriptions is Mayor's Papers 0110-001-88.

51. Pearl Duncan, "Make Monument Symbol of Victory and Heroism," *SMN,* Mar. 28, 2001.

52. Angela R. Kelly to Mayor and Council, Jan. 20, 2000; A. Wokomaokereke, Seattle, to Floyd Adams, Feb. 14, 2001; Charles R. Bishop, Sacramento, CA, to Mayor, Council, and City Manager, July 28, 2002.

53. Russ Bynum, "Savannah Officials Question Quote Proposed for Monument to Slaves," *CS*, Feb. 11, 2001; Minutes, HSMC, Aug. 7, 1997, June 30, 1998; Lisa L. White, Chair, HSMC, to Michael Brown, Aug. 8, 1997.

54. Kugiya, "How Graphic a Monument?"; Chapman, "Savannah Struggles"; Bret Bell, "Council Approves African-American Monument," *SMN*, Jan. 12, 2001; Jingle Davis, "Angelou's Words May Be Just Right," *AJC*, May 16, 2002.

55. Michael B. Brown to Mayor and Aldermen, Nov. 18, 1999; Don Gardner and Mary Elizabeth Reiter to Brown, July 20, 1998; Reiter to Rev. Thurmond Tillman, Nov. 15, 2000. In the private correspondence Reiter emerges as one of the most adamant opponents of the monument. She objected to nearly every aspect of it at one time or another. She even urged another sculptor to approach the city council about substituting his own work for Spradley's (Jerome B. Meadows, MeadowLark Studio, Savannah, to Brown, Jan. 26, 2000).

56. Jordan, *To Honor Our Forebears*, 12; Maya Angelou, *Even the Stars Look Lonesome* (New York: Random House, 1999), 111–12, photocopy with Kay Patterson's card attached; Beth Reiter to Floyd Adams, Feb. 22, 2001; Maya Angelou to Johnnye M. Jones and Abigail Jordan, Jan. 14, 2002; Adams to Michael Brown, Feb. 7, 2002; Emma M. Adler to Adams and City Council, May 22, 2002; OPSCC, May 16, 2002, 15.

57. Conversation with James Kimble, Feb. 23, 2003; Allen Duncan, "Double Dutch Chooses Paper over Rocks," *District*, Mar. 27, 2012, republished at https://thecharismaticmisanthrope.wordpress.com/category/written/nonfiction; Jenel Few, "Rain or Racism: New Black Panthers Claim Vandals Destroyed Monument; Police Believe Weather Caused the Damage," *SMN*, Mar. 4, 2003. Kimble now says that the monument was demolished by a drunken neighbor who was imitating the destruction of Saddam Hussein's statue in Baghdad (Duncan, "Double Dutch").

58. Jenel Few, "New Era, New Panthers," *SMN*, Dec. 18, 2002; Duncan, "Double Dutch."

59. John J. Thomas, e-mail to Mayor Floyd Adams and other Savannah city officials, July 29, 2002; anonymous to Abigail Jordan and Adams, n.d.

60. Minutes, HSMC, June 30, 1998; Aberjhani, "The Bridge and the Monument: A Tale of Two Legacies," 2005, in Nordette Adams, *WritingJunkie.net* (blog), www.writingjunkie.net/bridge-monument.html. The AAMA says that the decision to clothe the family in modern dress was not the sculptor's choice but a collective one taken by the members, who thought that "it represents strength" (Kate Wiltrout, "River Street Ready for Unveiling," *SMN*, July 27, 2002).

61. Reiter to Brown, July 8, 1998; Kate Wiltrout, "A Dream Comes True," *SMN*, July 28, 2002; OPSCC, May 21, 1998, 2.

62. On the origins of this concept of public space, see Dell Upton, *Another City: Urban Life and Urban Spaces in the New American Republic* (New Haven: Yale University Press, 2008), 281–333.

63. M. Deborah Ellett, "Amanda," enclosed in Ellett to Floyd Adams, Feb. 21, 2001; Chris Acemandese Hall, "Return to Greatness," enclosed in Hall to Adams. On the ethos of uplift, see Kevin K. Gaines, *Uplifting the Race: Black Leadership, Politics, and Culture in the Twentieth Century* (Chapel Hill: University of North Carolina Press, 1996), 1–2, 19–21.

64. E. Franklin Frazier, *Black Bourgeoisie* (New York: Free Press, 1957), 179–94; John Michael Vlach, "The Last Great Taboo Subject: Exhibiting Slavery at the Library of Congress," in Horton and Horton, *Slavery and Public History*, 57–65.

CHAPTER 3. A STERN-FACED, TWENTY-EIGHT-FOOT-TALL BLACK MAN

Note: The title phrase is taken from Eugene Robinson, "King as He Was," *WP*, May 20, 2008.

1. Jamie Lucke, "City Allots $15,000 for King Statue," *BPH*, July 3, 1985; Sherrel Wheeler, "Skeptical Council OKs Sum for King Statue," *BN*, July 3, 1985; Siona Carpenter, "Statue's Likeness to King Debated; Answer Jan. 20," *BPH*, Jan. 7, 1986.

2. Victoria J. Gallagher, "Remembering Together: Rhetorical Integration and the Case of the Martin Luther King, Jr. Memorial," *Southern Communication Journal* 60 (1995): 111–12. Gallagher's article examines the King Center in Atlanta, not the new King Memorial in Washington, DC. For a discussion of the treatment of King as an exceptional or unique figure in the civil rights struggle, see Michael Eric Dyson, *I May Not Get There with You: The True Martin Luther King, Jr.* (New York: Simon and Schuster, 2000), 300–302.

3. Joe Miller, "MLK Statue Nearing Completion," *RMT*, Apr. 18, 2003; Lou Rutigliano, "RM Council Sinks 'Teen Night' Bid," *RMT*, July 15, 1997; Jeffrey Gettleman, "Rocky Mount Journal: King Statue, a Unity Symbol, Severely Tests the Dream," *NYT*, Dec. 13, 2003. Like most accomplished African American preachers, and indeed like many politicians, King had a repertoire of images and set pieces that he combined and recombined during his public appearances. These pieces, together with a relatively standardized structure, were mnemonic devices that allowed preachers to preach extemporaneously but fluently. King, of course, was more educated than most folk preachers and could offer a more intellectually sophisticated argument than they (see Bruce A. Rosenberg, *Can These Bones Live? The Art of the American Folk Preacher*, rev. ed. [Urbana: University of Illinois Press, 1988]).

4. "Lifelike? MLK Statue Raises a Fuss," *RMT*, July 8, 2003.

5. Jerry Allegood and Joanna Kakissis, "Statue of Uniter Is Dividing," *RNO*, July 27, 2003; Miller, "MLK Sculpture: 'The Statue Does Not Look Like Dr. King," *RMT*, July 11, 2003.

6. Allegood and Kakissis, "Statue of Uniter"; Jeff Herrin, "In Search of Unity over King," *RMT*, July 21, 2003; Miller, "MLK Sculpture"; Joe Miller, "Council Members Weigh in on Statue," *RMT*, July 12, 2003; Miller, "Bellamy Wants to Focus on Edgecombe Side of City," *RMT*, July 20, 2003; Miller, "Mayor's Race Pits Incumbent vs. Councilman," *RMT*, Sept. 27, 2003.

7. Joe Miller, "Panel to Meet about Statue," *RMT*, July 29, 2003; Miller, "MLK Statue Panel Wants Larger Group," *RMT*, July 31, 2003; Miller, "Council Wants Committee to Solve Statue Issue," *RMT*, Aug. 12, 2003; Miller, "MLK again Dominates Meeting," *RMT*, Aug. 25, 2003.

8. Joe Miller, "Artwork Is Not a Body Cast of a Human Being," *RMT*, July 2, 2003; Erik Blome, "Artist's Statement," *RMT*, July 19, 2003; "Clarification," *RMT*, July 15, 2003; Miller, "MLK Sculpture"; Miller, "Panel to Meet"; Miller, "MLK Statue Panel Wants Larger Group."

9. Joe Miller, "Sculptor Offers Free Solution," *RMT*, Sept. 26, 2003.

10. Joe Miller, "Committee Votes to Have Blome Try Again," *RMT*, Nov. 13, 2003; Miller, "MLK Statue Committee to Meet," *RMT*, Feb. 3, 2004; Miller, "MLK Committee Will Consider Other Artists," *RMT*, Feb. 5, 2004.

11. Dorothy Y. Lewis, "Rev. Lee Quits MLK Statue Committee," *RMT*, Mar. 26, 2004.

12. Joe Miller, "MLK Committee Views Proposals," *RMT*, May 28, 2004; George A. Chidi, "MLK Panel Narrows List of Proposals," *RMT*, June 11, 2004; Chidi, "MLK Panel Chooses Sculptors," *RMT*, Jan. 28, 2005; "Rocky Mount Considers Selling Controversial MLK Statue," Apr. 7, 2005, www.wral.com/news/local/story/116336/.



13. George A. Chidi, "City Looks to Put MLK Statue on Auction Block," *RMT*, Mar. 28, 2005; Chidi, "Council, Sculptors Discuss New MLK Statue Proposal," *RMT*, Apr. 12, 2005; John Ramsey, "City Weighs Options for Another MLK Statue," *RMT*, July 27, 2005; Ramsey, "City Aims to Finalize MLK Statue Contract," *RMT*, Aug. 24, 2005; Michael Barrett, "Public Pans Statue Model," *RMT*, Oct. 11, 2005; Ramsey, "MLK Statue Vote Comes Monday," *RMT*, Oct. 23, 2005.

14. Michael Barrett, "Council Votes No on Statue," *RMT*, Nov. 29, 2005; "N.C. Town Scraps Plans for King Statue," *NYT*, Nov. 29, 2005; "Speak Up: Honor Americans," *RMT*, Dec. 11, 2005; "Speak Up: Put Parks on Pedestal," *RMT*, Apr. 9, 2006. Both the proponents and the opponents of killing the project were evenly divided racially (Barbara Barrett, "Rocky Mount Scraps MLK Statue Goal," *RNO*, Nov. 30, 2005).

15. Gettleman, "Rocky Mount Journal"; "City Ends Quest for King Statue: Community Was Never Able to Agree on Likeness of Leader," *WP*, Dec. 4, 2005; "Town Scraps Plan for King Statue"; [Erik Blome], "Rocky Mount Experience," *Eric Blome: Sculptor,* www.figurativeartstudio.com/id65.htm; Andrew Buncombe, "'Arrogant' Monument to King to Be Pulled Down," *Independent* (London), Apr. 19, 2005; Ellen Sung, "Monument to Change," *RNO*, Feb. 6, 2005; Margaret Lillard, "A Rocky Tribute to Martin Luther King: City Where Rights Leader First Spoke of 'Dream' at Odds over Statues' [sic] Likeness," *WP*, Nov. 27, 2005.

16. Sung, "Monument to Change"; Darryl Fears, "Depiction of King Divides N.C. Town: Complaints about Likeness Spur Review," *WP*, Jan. 19, 2004; Lillard, "Rocky Tribute"; Buncombe, "'Arrogant' Monument."

17. Lillard, "Rocky Tribute"; Walker quoted in Richard Brilliant, *Portraiture* (London: Reaktion Books, 1991, 2008), 25; Sung, "Monument to Change." My discussion of portraiture in this and the following paragraph is derived from Brilliant's book and from Shearer West, *Portraiture* (Oxford: Oxford University Press, 2004). In smaller monuments, which typically consist of laser-cut images on a black marble background, a technique widely used in contemporary gravestone making, designers attempt to escape disputes over likeness by including several photographic views of King's face taken from different angles. See the undated monument at Red Springs, NC, for an example. In full-scale sculptural memorials, artists sometimes include reliefs with alternate views of King on the base (e.g., the King sculptures at the University of Texas [Koh-Varilla, 1999] and Kalamazoo, MI [Lisa Reinertson, 1989]). Blome offered to do this as one solution to the impasse in Rocky Mount.

18. Rick Bragg, "King Monument Stirs Memories of Past, Symbolic of Better Today," *BN*, Feb. 2, 1986.

19. Thomas F. Mathews, *The Clash of Gods: A Reinterpretation of Early Christian Art,* rev. ed. (Princeton, NJ: Princeton University Press, 1999, 2003), 178; Jaś Elsner, *Roman Eyes: Visuality and Subjectivity in Art and Text* (Princeton, NJ: Princeton University Press, 2007), 22–23; Hans Belting, *Likeness and Presence: A History of the Image before the Era of Art* (Chicago: University of Chicago Press, 1994), 11.

20. John Ramsey, "City to Put MLK Statue Back Up," *RMT*, May 15, 2007; Miller, "MLK Sculpture."

21. "Speak Up: Bring Back the MLK Statue," *RMT*, Apr. 10, 2006; Dell Upton, "Architecture and Everyday Life," *New Literary History* 33, no. 4 (2003): 716–18; Elsner, *Roman Eyes,* 24.

22. Deanna Isaacs, "Too Close a Copy or Not Close Enough? The Controversy over a Martin Luther King Monument to Be Made in China Goes beyond Politics and Race," *Chicago*

Reader, Sept. 20, 2007, www.chicagoreader.com; Lillard, "Rocky Mount's King Dream a Nightmare"; Blome, "Artist's Statement"; Sung, "Monument to Change." Thanks to the members of the California Art and Design Multicampus Research Group of the University of California for their observations on the statue and the photograph. One other King monument, that at Hopewell, VA, is based on the Fitch photograph. To the best of my knowledge, it stirred no controversy. It depicts King only from his folded arms up.

23. Darryl Fears, "Depiction of King Divides N.C. City; Complaints about Likeness Spur Review," *WP,* Jan. 19, 2004; Buncombe, "'Arrogant' Monument"; Gettleman, "Rocky Mount Journal." For a far-right interpretation of the controversy as one purely and simply of racist blacks' biting the hands of naive white liberals, see Sam Francis, "Martin Luther King Day: A Preview in Rocky Mount N.C.," VDARE.com, Jan. 4, 2004, http://www.vdare.com/articles/martin-luther-king-day-a-preview-in-rocky-mount-nc.

24. Lillard, "Rocky Tribute"; Fears, "Depiction of King"; John Grooms, "Don't Fret, D.C.—Charlotte's Still Shamed with 'World's Worst Martin Luther King Statue,'" *Creative Loafing Charlotte,* Jan. 16, 2012, http://clclt.com/theclog/archives/2012/01/16/dont-fret-dc-charlotte-still-shamed-with-worlds-worst-martin-luther-king-statue.

25. Michael Barrett, "MLK Panel Says Return First Statue," *RMT,* Mar. 29, 2006; John Ramsey, "City to Put MLK Statue Back Up," *RMT,* May 15, 2007; "Rocky Mount to Bring Back King Statue," *RNO,* May 16, 2007; Ramsey, "Council Upholds Decision on Statue," *RMT,* May 22, 2007; Ramsey, "Martin Luther King Jr. Park Dedicated," *RMT,* Aug. 27, 2007; Rocky Mount City Council, Action Agenda, Oct. 31, 2011, www.rockymountnc.gov/agenda/prnews_item.asp?NewsID=269.

26. Blome, "Artist's Statement"; Gettleman, "Rocky Mount Journal"; Sung, "Monument to Change"; [Blome], "Rocky Mount Experience"; Manning Marable, *Living Black History: How Reimagining the African-American Past Can Remake America's Racial Future* (New York: Basic Books, 2006), 16 (black student explaining the difference between King and Malcolm X).

27. National Capital Planning Commission [hereafter NCPC], Martin Luther King, Jr. Memorial, Tidal Basin, Report to the National Park Service and the Martin Luther King, Jr. National Memorial Project Foundation, Inc., Dec. 2, 1999, NCPC File No. 5907, www.ncpc/gov/actions/pdf/1999/mlk-12-2-99.pdf. At the October 2005 NCFA meeting, one commissioner, the sculptor Elyn Zimmerman, claimed that the Mountain of Despair/Stone of Hope duo was uncomfortably similar to her own *Malabar,* installed at the National Geographic Society in Washington. Although ROMA's Boris Dramov disavowed the similarity, Zimmerman recused herself from further discussions of the King Memorial (NCFA, Minutes, Oct. 20, 2005, available at http://www.cfa.gov/records-research/record-cfa-actions; henceforth referred to in the format NCFA, [date]; Paul Schwartzman and Petula Dvorak, "King Memorial Still a Concern: U.S. Arts Commission, Worried about Views, Will Visit Site in D.C.," *WP,* Oct. 21, 2005; NCFA, Oct. 19, 2006).

28. "But let judgment run down as waters, and righteousness as a mighty stream" (Amos 5:24 [King James Version]).

29. Randolph Hester, quoted in Cathy Cockrell, "Design Selected for King Memorial on National Mall," *Berkeleyan,* Sept. 27, 2000, http://www.berkeley.edu/news/berkeleyan/2000/09/27/kingdsgn.html; Kirk Savage, *Monument Wars: Washington, D.C., the National Mall, and the Transformation of the Memorial Landscape* (Berkeley: University of California Press, 2009), 297, 300, 306. Jackson told the NCFA "that the National Park Service discouraged extensive seating, placing greater emphasis on the

ability to accommodate large numbers of people for visits of shorter duration" (NCFA, Sept. 18, 2008).

30. The "landscape tradition . . . utilizes the contouring of the earth, the shaping of the site and natural elements to convey meaning. . . . The embracing form of the MLK Memorial unifies the site, engages the Tidal Basin, reinforces the cove-like shape of the shoreline, and creates a space that is peaceful and expansive and that, in its form, nurtures inclusivity, shared purpose and a sense of community. In this way, the characteristics of the landscape speak to the characteristics of the man that it was intended to honor" (Bonnie Fisher and Boris Dramov, "ROMA Design Group on Designing the Martin Luther King Jr. Memorial," *Huffington Post*, Oct. 18, 2011, http://www.huffingtonpost.com/bonnie-fisher-and-boris-dramov/roma-design-group-on-desi_b_1018655.html).

31. *Japanese American Memorial to Patriotism during World War II* (National Park Service, 2009), interpretive brochure distributed on site.

32. "Tsuru: The Japanese Crane," *Japanese American National Museum*, viewed Aug. 11, 2014, janmstore.com. According to the *Japanese American Memorial* brochure, the crane sculpture "symbolize[s] the quest to achieve freedom and equality while struggling to free themselves from prejudice, hatred, and hysteria represented by the barbed wire." The full Reagan inscription says, "Here we admit a wrong; here we reaffirm our commitment as a nation to equal justice under the law."

33. Claudia Brown Ukutegbe, comment, Aug. 17, 2011, on Boyce Watkins, "Intentional? MLK Memorial Does Not Mention the Words 'Racism' or 'Black,'" Oct. 16, 2011, http://blacklikemoi.com/2011/10/mlk-memorial-does-not-mention-the-word-black/; Deborah Barfield Berry, "Locals to Make Trek to DC for Martin Luther King Jr. Memorial's dedication," *MA*, Aug. 23, 2011.

34. "Council of Historians Selects Martin Luther King, Jr. Quotations to Be Engraved into Memorial" (press release), Feb. 15, 2007, http://www.marketwired.com/press-release/council-historians-selects-martin-luther-king-quotations-be-engraved-into-memorial-719395.htm. The story of the memorial's conception is repeated, with minor variations, in nearly every publication about the its history and has acquired the status of origin myth.

35. Lawrence Otis Graham, *Our Kind of People: Inside America's Black Upper Class* (New York: HarperPerennial, 1999), 91–92; Tamaiya Baker, "Civil Rights Icon Gets Memorial on the Mall," *District Chronicles*, Nov. 20, 2006, http://www.districtchronicles/ www.districtchronicles.com/news/view.php/426638/Civil-Rights-icon-gets-memorial-on-the-M; Suzanne Gamboa, "King Fraternity Holds Own Dedication of Memorial," *AJC*, Aug. 26, 2011; Michael E. Ruane, "Alpha Phi Alpha Honors Martin Luther King Jr.," *WP*, Aug. 26, 2011; Michael H. Washington and Cheryl L. Nuñez, "Education, Racial Uplift, and the Rise of the Greek Letter Tradition: The African American Quest for Status in the Early Twentieth Century," in *African American Fraternities and Sororities: The Legacy and the Vision*, ed. Tamara L. Brown, Gregory S. Parks, and Clarenda M. Phillips, 2nd ed. (Lexington: University Press of Kentucky, 2012), 141–45, 164, 174.

36. David J. Garrow, *Bearing the Cross: Martin Luther King, Jr., and the Southern Christian Leadership Conference* (New York: William Morrow, 1986); Taylor Branch, *Parting the Waters: American in the King Years, 1954–1963* (New York: Simon and Schuster, 1987).

37. Petula Dvorak, "How Efforts to Get a Statue Honoring Revolution's Black Soldiers Crumbled," *WP*, Aug. 25, 2011; Carol D. Leonnig, "Supporters Struggle with Location of Proposed King Memorial," *Detroit Free Press*, Sept. 13, 1999.

38. Joi-Marie McKenzie, "Chief Architect, Dr. Ed Jackson, Reflects on Martin Luther King Memorial," Aug. 25, 2011, loop21.com (website discontinued); Sabrina Tavernise, "A Dream Fulfilled, Martin Luther King Memorial Opens," *NYT*, Aug. 22, 2011.

39. Theola S. Labbe, "Memorial to King Drives On; Mall Project Raises a Third of Funds," *WP*, Jan. 16, 2005; Butler T. Gray, "Martin Luther King Memorial on National Mall Approved," http://iipdigital.usembassy.gov/st/english/article/2005/05/20050524121619pssnikw ad0.5068628.html#axzz3SJs0MqFY. Most of my chronology is derived from "History and Timeline," *The Memorial Foundation: Builders of the Martin Luther King Jr. Memorial*, http://www.thememorialfoundation.org/content/history-timeline. Construction began in December 2009 and the finished monument was opened to the public in August 2011, but a hurricane caused the formal dedication to be delayed until October 16, 2011.

40. Rosa Parks with Jim Haskins, *Rosa Parks: My Story* (New York: Puffin, 1992), 53–54, 60–64, 72–75; Kay Mills, *This Little Light of Mine: The Life of Fannie Lou Hamer* (New York: Plume, 1994), 12.

41. NCFA, Oct. 20, 2005, Mar. 16, 2006.

42. NCFA, Feb. 15, 2007.

43. NCFA, Sept. 16, 2010. As noted in chapter 1, the truth value of monuments as "history" is indeed an important component of the popular perception of memorials.

44. Martin Luther King Jr., *A Testament of Hope: The Essential Writings and Speeches of Martin Luther King Jr.*, ed. James M. Washington (New York: HarperOne, 1986), 217; "MLK Memorial Evokes Hope and Civil Rights Legacy," *AIArchitect*, Feb. 23, 2004, www.aia. org/aiaarchitect (no longer online); "Martin Luther King Jr. Memorial," *NCPC Quarterly* [hereafter *NCPCQ*], Spring 2001, 2–3. On King's political, racially specific understanding of the Promissory Note, see Dyson, *I May Not Get There*, 12–29.

45. June Dobbs Butts, "The Little-Known Story of MLK's 'Drum Major for Justice,'" *AJC*, Oct. 16, 2011; King, *Testament of Hope*, 267.

46. Rachel Manteuffel, "Martin Luther King a Drum Major? If You Say So," *WP*, Aug. 25, 2011; Gene Weingarten and Michael E. Ruane, "Maya Angelou Says King Memorial Inscription Makes Him Look 'Arrogant,'" *WP*, Aug. 30, 2011; "Park Service to Remove Inscription on MLK Memorial," *JCL*, Feb. 10, 2012; Cynthia Gordy, "King Memorial Flap Continues," *The Root*, Feb. 15, 2012, http://www.theroot.com/articles/politics/2012/02/martin_luther_king_memorial_quote_change_foundation_complains.html; Michael E. Ruane, "Martin Luther King Jr. Memorial Architect Says Controversial Inscription Will Stay," *WP*, Sept. 3, 2011. Neither the Stone of Hope nor the Mountain of Despair is a monolith; both were assembled from many individual pieces of granite. In late 2012, the National Park Service announced that it would remove the offending inscription without replacing it. Lei Yixin erased it in July 2013 (Michael E. Ruane, "Controversial King Memorial Inscription Set to Be erased, Not Replaced," *WP*, Dec. 11, 2012; Erin Banco, "Sculptor Removes Phrase from Memorial to King," *WP*, Aug. 1, 2013).

47. ROMA Design Group, "News."

48. NCFA, Apr. 17, 2008. Belle is a principal in the Beyer Blinder Belle firm of restoration architects, while McKinnell heads the architectural firm that designed the Boston City Hall (1969).

49. Michele H. Bogart, *The Politics of Urban Beauty: New York and Its Art Commission* (Chicago: University of Chicago Press, 2006), 93, 250.

50. NCFA, Apr. 17, 2008; Shaila Dewan, "Larger Than Life, More to Fight Over," *NYT*, May 18, 2008; Dyson, *I May Not Get There*, 17–19, 40, 51–77.

51. NCFA, Apr. 17, 2008; Luebke to Lawler, NCFA, Apr. 25, 2008. The phrase "Social Realist style" appears nowhere in the minutes of the meeting but appear to be Luebke's own improvisation, which he later came to "regret" (Dewan, "Larger Than Life"). It is noteworthy that Commissioner Witold Rybczinski, who grew up in pre-1989 Poland, refrained from totalitarian references, instead treating scale as a contextual issue of visibility and viewers' location (NCFA, Apr. 17, 2008).

52. NCFA, June 19, 2008.

53. Stephen Manning, "Arts Panel Criticizes MLK Statue Design for D.C. Memorial," *WP*, May 9, 2008. The four alternate heads are illustrated in Joanne Mikula Lukens, *King in DC* ([Washington, DC]: [Martin Luther King Memorial Foundation], 2011), 130–31.

54. "Council of Historians Selects"; Joanne Allen, "Chinese Sculptor Chosen to Carve Martin Luther King Memorial," Feb. 15, 2007, http://www.reuters.com/article/2007/02/16/us-king-sculpture-idUSN1521259820070216.

55. Jeff Nesmith and Allison Becker, "Black Sculptor Was Cut from King Project; Switch to Chinese Artist Who Reportedly Was Once an Assistant Is Called Business Decision by Foundation," *AJC*, June 6, 2007; Ariana Eunjung Cha, "A King Statue 'Made in China'? U.S. Critics Blast Selection; Artist Is Bewildered at Outrage," *WP*, Aug. 15, 2007; Ed Pilkington, "Chinese Sculptor Replaces Black Artist on Luther King [sic] Memorial," *Guardian*, July 23, 2007.

56. Nesmith and Becker, "Black Sculptor"; Patricia Cohen, "The King Memorial: Dreams at Odds," *NYT*, Sept. 24, 2007; Gil [Gilbert Young?], comment, May 4, 2007, on Native Son, "The Martin Luther King Memorial Controversy Update," May 4, 2007, *Native Son* (blog), https://nativeson.wordpress.com/2007/05/04/the-martin-luther-king-memorial-controversy-update/. Lei responded that none of the King statues by black artists that he knew were very good. "There may be a lot of sculptors in America who wanted this project and hope that I give up. I don't know. But I will do better than the other King sculptures" ("'Made in China' statue of US icon King to stand tall in Washington," Apr. 4, 2007, www.khaleejtimes.com/DisplayArticle.asp?xfile=data/todaysfeatures/2007/April/todaysfeatures_April7.xml§ion=todaysfeatures).

57. Lyle V. Harris, "Our Opinions: Honor King's Universal message," *AJC*, June 17, 2007; Hillman, comment, Aug. 18, 2007, on Valerie Strauss, "Sculpting Martin Luther King, Jr.," Aug. 17, 2007, *Raw Fisher* (blog), voices.washingtonpost.com/rawfisher/2007/08/sculpting_martin_luther_king_j.html; [Jack Marshall], "More Statue Ethics: The King Memorial Controversy," Aug. 20, 2007, *Ethics Scoreboard*, www.ethicsscoreboard.com/list/king.html. On the common white assumption that white views on racial issues are more credible than black ones—an assumption that affected nearly every monument discussed in this book—see Dyson, *I May Not Get There*, 48–49.

58. James Baldwin, *The Fire Next Time* (New York: Vintage, 1962, 1991); Dyson, *I May Not Get There*, 29; Strauss, "Sculpting Martin Luther King, Jr."

59. Harry E. Johnson, "King's Legacy Lives On in Diverse Team of Sculptors," *AJC*, Aug. 28, 2007, http://thememorialfoundation.org/content/press-release/kings-legacy-lives-diverse-team-sculptors; [Gloria D. Gibson], "King Monument Criticized over Mistakes," Aug. 28, 2007, *The Gibson Report* (blog) http://www.thegibsonreport.blogspot.com/2007/08/king-monument-criticized-over-mistakes.html; "Martin Luther King Jr Statue Controversy: Black Artists Protesting Selection of Chinese Artist for the Project," Aug. 3, 2007, Lee Bailey's Electronic Urban Report, www.eurweb.com (article no longer online); Gloria D. Gibson, comment, Aug. 31, 2007, on Native Son, "Martin Luther King

Memorial Controversy Update"; Lea Winfrey Gilbert, comment, Sept. 27, 2007, on Duane [Brayboy], "Here's a Solution," Sept. 4, 2007,. blackinformant.com/2007/09/04/heres-a-solution/; Clint Button, comment, Aug. 18, 2007, on Strauss, "Sculpting Martin Luther King, Jr." Most accounts of ROMA's departure attribute it to their inability to be paid in a timely manner. They were replaced by McKissack and McKissack, one of the oldest black-owned architectural firms in the nation.

60. Clint Button, comment, Jan. 6, 2008, on Native Son, "Martin Luther King Memorial Controversy Update"; G. D. Gibson, comment, Aug. 24, 2007, on Strauss, "Sculpting Martin Luther King, Jr."; Gilbert Young and Lea Winfrey Young, comment, Sept. 19, 2007, on Strauss, "Sculpting Martin Luther King, Jr."; Cynthia Gordy, "The MLK Memorial's Complicated History," *The Root*, Aug. 22, 2011, http://www.theroot.com/articles/culture/2011/08/martin_luther_king_memorial_the_story_behind_the_monument.html.

61. Ben Barrack, "Oba-Mao's Chinese MLK Monument Should Be Stopped," *Floyd Reports* (blog), Oct. 14, 2010, http://www.westernjournalism.com/oba-maos-chinese-mlk-monument-should-be-stopped/#8c4tsrGUV8tMUY4G.97. Barrack is an AM-radio talk show host in Texas. On contemporary accusations that King himself was a Communist, see, e.g., Aaron Milligan, "MLK monument to greed," Nov. 8, 2011, http://conservative-headlines.com/2011/08/mlk-monument-to-greed/ (conservative-headlines.com is the website of the Council of Conservative Citizens, the current incarnation of the [White] Citizens' Councils of the 1950s and 1960s).

62. Dee Amon-Ra, Massachusetts, "A Dream Deferred," Oct. 19, 2007, http://www.oped-news.com/Diary/A-DREAM-DEFERRED-by-Dee-Amon-Ra-071019-288.html; Native Son, "Martin Luther King Memorial Controversy Update"; Cha, "A King Statue 'Made in China'?"; NCFA, Feb. 15, 2007.

63. Becker, "Chinese Granite"; Brett Zongker, "Chinese Sculptor Picked to Carve Image for King Memorial," *WP*, Feb. 16, 2007.

64. mountshang, "Lei Yixin and the MLK Monument," Nov. 28, 2007,and Giotto, Eugene, OR, Jan. 29, 2008, "Lei Yixin and the MLK Monument," both at www.sculpture.net/commu-nity/ showthread.php?t=6089; Marc Fisher, "At This Point, MLK Memorial Needs a Fresh Start," *WP*, May 11, 2008; Blake Gopnik, "Martin Luther King Was White?" Aug. 22, 2011, *The Daily Beast*, http://www.thedailybeast.com/articles/2011/08/22/martin-luther-king-jr-memorial-falls-short-as-art-works-as-tribute-to-the-man.html; Isaacs, "Too Close a Copy."

65. [Gibson], "King Monument Criticized over Mistakes"; Giotto, "Lei Yixin and the MLK Monument"; Courtland Milloy, "King Memorial: One Expression, Many Interpreta-tions," *WP*, Aug. 21, 2011; Isaacs, "Too Close a Copy"; Nesmith and Becker, "Black Sculp-tor Was Cut from King Project."

66. Dyson, *I May Not Get There*, 283; Adolph L. Reed Jr., *W. E. B. Du Bois and American Politi-cal Thought: Fabianism and the Color Line* (New York: Oxford University Press, 1997), 7; Gray, "Martin Luther King Memorial on National Mall Approved"; "To Honor Dr. King," editorial, *Philadelphia Daily News*, Dec. 1, 1999.

67. Harris, "Our Opinions"; Jeanne C. Wolf, Miami, comment, Sept. 8, 2011, on McKenzie, "Chief Architect, Dr. Ed Jackson."

68. Edward Rothstein, "A Mirror of Greatness, Blurred," *NYT*, Aug. 25, 2011; Watkins, "Intentional?" While the *Washington Post* and other periodicals assigned art critics to review the monument, the *New York Times* assigned its museum critic.

69. Blake Gopnik, "Statue Whittles Away at King's Legacy," *WP*, May 10, 2008; Rothstein, "A Mirror of Greatness"; Barrack, "Oba-Mao's Chinese MLK Monument." The completed memorial was not to exceed thirty-eight feet above the plane of the terrace it occupied ("Martin Luther King, Jr. Memorial," *NCPCQ*, January, February, March 1999, 4).

70. Milloy, "King Memorial"; Courtland Milloy, "Having a Black Sculptor for King Would Have Been Nice," *WP*, Aug. 23, 2011; Robinson, "King as He Was."

71. Charles, comment, Oct. 17, 2011, Lavendertimes, comment, Oct. 16, 2011, William Jeffries, comment, Oct. 16, 2011, all responding to Watkins, "Intentional?" Reviewer Philip Kennicott noted that the memorial emphasized "the anodyne, pre-1965 King," not the "anti-war goad to the national conscience whose calls for social and economic justice would be considered rank socialism in today's political climate," although it could be argued that the "confrontational" statue (which Kennicott thought should be removed) implied the latter, if it did not make it explicit (Philip Kennicott, "MLK Memorial Review: Stuck between the Conceptual and the Literal," *WP*, Aug. 26, 2011).

72. Cha, "A King Statue 'Made in China'?"; Lisa Chiu, "Chinese Man Sculpts Martin Luther King Jr. National Memorial; Artist Lei Yixin Faced Controversy for Not Being an American," [ca. 2009], http://chineseculture.about.com/od/artinchina/a/MLKMemorial.htm.

73. Dyson, *I May Not Get There*, 3. On visual metaphors, see Noël Carroll, "Visual Metaphor," in *Beyond Aesthetics: Philosophical Essays* (Cambridge: Cambridge University Press, 2001), 347–48; David Summers, "Real Metaphor: Towards a Redefinition of the 'Conceptual' Image," in *Visual Theory: Painting and Interpretation*, ed. Norman Bryson, Michael Ann Holly, and Keith Moxey (New York: HarperCollins, 1991), 243, 245.

CHAPTER 4. A PLACE OF REVOLUTION AND RECONCILIATION

1. Alvin Adams, "Picture Seen around the World," *Jet*, Oct. 10, 1963, 36.

2. For varied readings of the photograph, see Taylor Branch, *Parting the Waters: America in the King Years, 1954–63* (New York: Simon and Schuster, 1988), 760–61, 764; Diane McWhorter, *Carry Me Home; Birmingham, Alabama: The Climactic Battle of the Civil Rights Revolution* (New York: Simon and Schuster, 2001), 371–75; and Martin A. Berger, "Race, Visuality, and History," *American Art* 24, no. 2 (2010): 94–99.

3. Michael Dobbins, telephone interview with author, Aug. 7, 2010.

4. On civil rights in Birmingham before the 1960s, see Glenn T. Eskew, *But for Birmingham: The Local and National Movements in the Civil Rights Struggle* (Chapel Hill: University of North Carolina Press, 1997), 53–121; Andrew M. Manis, *A Fire You Can't Put Out: The Civil Rights Life of Birmingham's Reverend Fred Shuttlesworth* (Tuscaloosa: University of Alabama Press, 1999), 76–161; and J. Mills Thornton III, *Dividing Lines: Municipal Politics and the Struggle for Civil Rights in Montgomery, Birmingham, and Selma* (Tuscaloosa: University of Alabama Press, 2002), 158–231. On the geography of Birmingham's early civil-rights movement, see Marjorie L. White, *A Walk to Freedom: The Reverend Fred Shuttlesworth and the Alabama Christian Movement for Human Rights, 1956–1964* (Birmingham, AL: Birmingham Historical Society, 1998).

5. Deed, Elyton Land Company to Mayor and Aldermen of Birmingham, Feb. 21, 1883; copy in Kelly Ingram Park Study file [hereafter KIPS], Birmingham Civil Rights Institute [hereafter BCRI], folder 22; Thomas Hughes Cox, "Reflections on a Place of Revolution and Reconciliation: A Brief History of Kelly Ingram Park and the Birmingham Civil Rights District," ms., July 1995, 7–11, KIPS, folder 1; "3 Parks 'Given' to City Are Now Worth $2 Million," *BPH*, Aug. 18, 1958; Allen R. Durough, *The Architectural Legacy of*

Wallace A. Rayfield: Pioneer Black Architect of Birmingham, Alabama (Tuscaloosa: University of Alabama Press, 2010), 115; John R. Hornaday, *The Book of Birmingham* (New York: Dodd, Mead, 1921), 68–69; Lucia Giddens, "The Happy-Go-Lucky Harlem of the South," *Travel,* July 1929, 40–41.

6. City Commission Resolution, Nov. 12, 1918, KIPS, folder 25; "Two City Parks Named for Heroes; Behrens and West Park Are Now Jordan and Ingram Parks Respectively," *BPH,* Nov. 13, 1918, KIPS, folder 25; "Monument and Park Will Be Dedicated to Marine War Hero," *BAH,* Oct. 10, 1932; "Kelly Ingram Park Dedication Chief Armistice Day Event," *BAH,* Nov. 12, 1932. Well into midcentury, West Park was the common name of the square.

7. Cox, "Reflections," 21–23; Eugene "Bull" Connor [sic] to Mrs. J. H. Berry, President, Park and Recreation Board, Oct. 25, 1961, KIPS, folder 8; "Recreation Edict Stirs Birmingham; Facilities May Be Closed to Avert Their Integration," *NYT,* Oct. 29, 1961; "If Public Wants Parks Kept Open, It's Time to Speak Up," editorial, *BN,* Dec. 10, 1961, KIPS, folder 25; Lou Isaacson, "City to Put 67 Parks in Mothballs Monday," *BN,* Dec. 31, 1961, KIPS, folder 25; "Birmingham Shuts Recreation Areas," *NYT,* Jan. 2, 1962. On the park closings, see William A. Nunnelley, *Bull Connor* (Tuscaloosa: University of Alabama Press, 1991), 112–17; Manis, *Fire You Can't Put Out,* 181, 226, 287–88; Thornton, *Dividing Lines,* 221–25, 254–64. The parks were gradually reopened beginning in April 1964 after the city council had repealed all segregation ordinances (Cox, "Reflections," 33).

8. Robin D. G. Kelley, *Race Rebels: Culture, Politics, and the Black Working Class* (New York: Free Press, 1996), 81; A. G. Gaston, *Green Power: The Successful Way of A. G. Gaston* ([Birmingham, AL]: A. G. Gaston Boys' Clubs, 1968), 74, 78; John Archibald, "Kelly Ingram is Dedicated for Major Role in Rights Battle," *BN,* Sept. 16, 1992.

9. Robert J. Norrell, "Caste in Steel: Jim Crow Careers in Birmingham, Alabama," *Journal of American History* 73, no. 3 (1986): 680, 684–86, 692; Kelley, *Race Rebels,* 79–82; Thornton, *Dividing Lines,* 146–49; 1950, 1965 Sanborn Maps of Kelly Ingram Park Neighborhood, KIPS; *BN* article by James Spotswood, May 8, 1963, transcribed in "Kelly Ingram Park: The Battleground," unsigned ms., Richard Arrington, Jr., Papers [hereafter AP], Birmingham Public Library, item 672.002.001.

10. Mitch Mendelson, "A Place in History; A Renovation Allows Kelly Ingram Park to Play Its Triple Role of Public Green Space, Monumental Lawn for the Civil Rights Institute and Commemorative Site in Its Own Right," *BPH,* Nov. 11, 1992; Edward LaMonte, telephone interview, Oct. 5, 2009.

11. "Birmingham: Closed Door or Key to Future?" *Southern Courier,* Jan. 1, 1966, 4; "Birmingham's Million Dollar Building," *Ebony,* June 1960, 25–28, 30, 32; Geraldine Moore, "Ingram Park Statues Planned to Honor Contributions of Two Black Women," *BN,* Nov. 15, 1978; Lynne B. Feldman, *A Sense of Place: Birmingham's Black Middle Class Community, 1890–1930* (Tuscaloosa: University of Alabama Press, 2000), 172–73, 179, 181–82, 189–90; Gaston, *Green Power,* 21–23, 26–28; Edward Shannon LaMonte, *Politics and Welfare in Birmingham, 1900–1975* (Tuscaloosa: University of Alabama Press, 1995), 45–46. On Gaston's career, see his autobiography, *Green Power,* as well as Carol Jenkins and Elizabeth Gardner Hines, *Black Titan: A. G. Gaston and the Making of a Black American Millionaire* (New York: One World/Ballantine, 2004).

12. Gaston, *Green Power,* 22; Thornton, *Dividing Lines,* 195, 200–201.

13. Thornton, *Dividing Lines,* 196–98, 230; Eskew, *But for Birmingham,* 124–27; Manis, *Fire You Can't Put Out,* 300, 305.

14. Manis, *Fire You Can't Put Out*, 335–36, 381–83, 385–86, 390–91; Eskew, *But for Birmingham*, 207, 286–88; Thornton, *Dividing Lines*, 301–2, 324, 334.

15. David Vann, interview with Blackside, Inc., Nov. 1, 1985, Washington University Libraries, Film and Media Archive, Henry Hampton Collection, transcript, http://digital.wustl.edu/van0015.0251.102(quotation); Eskew, *But for Birmingham*, 233; Jenkins and Hines, *Black Titan*, 194–96; Manis, *Fire You Can't Put Out*, 332, 337–38, 340, 352, 368, 386; S. Jonathan Bass, *Blessed Are the Peacemakers: Martin Luther King, Jr., Eight White Religious Leaders, and the "Letter from Birmingham Jail"* (Baton Rouge: Louisiana State University Press, 2001), 3–11.

16. Manis, *Fire You Can't Put Out*, 335–36, 381–83, 385–86, 390–91; Eskew, *But for Birmingham*, 207, 286–88; Thornton, *Dividing Lines*, 301–2, 324, 334.

17. Thornton, *Dividing Lines*, 193–94; Eskew, *But for Birmingham*, 75–76; Emory O. Jackson to W. Cooper Green, July 22, 1942, and Green to "Dear Jackson," Sept. 11, 1942, both in KIPS, folder 8.

18. Thornton, *Dividing Lines*, 261, 299; Eskew, *But for Birmingham*, 196–97; Birmingham Urban League, Inc., "History," viewed Sept. 9, 2010, www.birminghamurbanleague.net; Manis, *Fire You Can't Put Out*, 78, 84–86, 104, 120, 353; "Emory O. Jackson," *Encyclopedia of Alabama*, encyclopediaofalabama.org. Jackson, editor of the African American newspaper *Birmingham World*, had been considerably more militant in the 1940s and he initially endorsed the ACHMR's tactics in the 1950s, but he rejected Shuttlesworth's emphasis on direct action in the 1960s. A gray granite stele honoring Ruth Jackson was added to the array in 1998, underlining the message of the Tuggle and Fletcher memorials (see figs. 4–6). Gaston and most of the other members of the Fletcher-Tuggle Memorial Committee were dead by this time, and the organizing committee was composed (to the extent that I have been able to identify its members) of Jackson's beautician colleagues.

19. Jenkins and Hines, *Black Titan*, 194–96; Manis, *Fire You Can't Put Out*, 352, 368, 386; Eskew, *But for Birmingham*, 233; Branch, *Parting the Waters*, 486.

20. Mrs. H. C. Walls to Mayor George Siebels, Jr., Mar. 4, 1971, AP, 672.045.055; Floyd Dowling to Siebels, Apr. 7, 1975, KIPS, folder 8; John J. Drew to David Vann, Feb. 23, 1977, and Vann to Drew, Mar. 9, 1977, both in AP, 672.045.055. Siebels assured Walls that King could be honored only by the legislature and that there were "many great Americans and many great Southerners" who were more worthy of such recognition. He vented his irritation that "these Negroes" had chosen their own course of action in 1963 even though "we tried to explain as best we could exactly what our position was and I think they understood it all, but still they didn't want to understand it" (Siebels to Walls, Mar. 18, 1971, AP, 672.045.055).

21. Donald E. Blankenship, West Park/Kelly Ingram Park National Register Nomination Form, Mar. 5, 1982, and Mayor Richard Arrington Jr. to Ellen Mertins, Mar. 5, 1982, both in AP, 672.002.001; Howell Raines, "Valuing Our Place in Freedom's Quest," *BN*, Nov. 15, 1992; Michelle Chapman, "Statue to Honor King Will Be Placed in Park," *BPH*, Dec. 19, 1985.

22. Manis, *Fire You Can't Put Out*, 397–98, 434. Shuttlesworth's service as president of the SCEF in the 1960s alarmed some civil rights leaders, who feared being red-baited over his connection to the organization. On the SCEF's activities and white reactions to them, see John Egerton, *Speak Now against the Day: The Generation before the Civil Rights Movement in the South* (Chapel Hill: University of North Carolina Press, 1994), 529–30.

23. Kelley, *Race Rebels,* 78, 84,100; Branch, *Parting the Waters,* 782–83; Thornton, *Dividing Lines,* 378–69; Abraham Woods Jr. and Richard Arrington Jr. for the Martin Luther King Jr. Statue and Birthday Celebration Committee, form letter soliciting donations, Dec. 20, 1985, Marvin Y. Whiting Papers [hereafter WP], BPL; Val Walton and Chanda Temple, "Civil Rights Pioneer Addine Drew Dies at 87," *BN,* Aug. 12, 2003.

24. Mike Bennighof, "10,000 Gather to See Unveiling of King Statue," *BPH,* Jan. 21, 1986; Rick Bragg, "King Monument Stirs Memories of Past, Symbolic of Better Today," *BN,* Feb. 2, 1986; Renee C. Romano, "Narratives of Redemption: The Birmingham Church Bombing Trials and the Construction of Civil Rights Memory," in *The Civil Rights Movement in American Memory,* ed. Renee C. Romano and Leigh Raiford (Athens: University of Georgia Press, 2006), 96–134; Jennifer Fuller, "Debating the Present through the Past: Representations of the Civil Rights Movement in the 1990s, in Romano and Raiford, *Civil Rights Movement,* 176–90; Johnson, "From Rioting to Recreation"; Garland Reeves, "Can Conditions Have Changed So Much since 1963?" *BN,* Dec. 2, 1974.

25. "Ex-Mayor David Vann Dies at 71," *BN,* June 10, 2000; "David Vann, One of Birmingham's Rare Heroes Is Gone," *BN,* June 13, 2000; McWhorter, *Carry Me Home,* 282–83, 286; Eskew, *But for Birmingham,* 371–72n66.

26. David J. Vann, "Speech Delivered by Mayor David Vann, Duard Legrand Conference, November 15, 1978," typescript, David Vann Papers [hereafter VP], BPL, 113.20.23, 3–4; Vann, "Statement of Mayor David Vann Relative to the Testimony of Gary Thomas Rowe before the United States Senate Intelligence Committee," typescript, Dec. 9, 1975, VP, 113.12.32. Vann presented his narrative in several forms, but the Legrand Conference speech is one of the earliest and most exhaustive that I have seen. For a study of civic myths and rituals, see Edward Muir, *Civic Ritual in Renaissance Venice* (Princeton, NJ: Princeton University Press, 1981), which examines the "myth of Venice" and the rituals that inculcated it into Venetian political life.

27. Vann, "Speech," 7, 10–11; Thornton, *Dividing Lines,* 251–52, 254–55, 258.

28. McWhorter, *Carry Me Home,* 67, 91–101; Eskew, *But for Birmingham,* 111–12; Joe Nabbefeld, "Businessmen Talk Candidly about Segregation in '60s," *BN,* Nov. 20, 1992.

29. Vann, "Speech," 32; McWhorter, *Carry Me Home,* 67, 91–101; Eskew, *But for Birmingham,* 111–12; Thornton, *Dividing Lines,* 314–16.

30. Vann, "Speech," 40.

31. Jimmie Lewis Franklin, *Back to Birmingham: Richard Arrington, Jr., and His Times* (Tuscaloosa: University of Alabama Press, 1989), 109–33; Richard Arrington, *There's Hope for the World: The Memoir of Birmingham, Alabama's First African American Mayor* (Tuscaloosa: University of Alabama Press, 2008), 72–78; Thornton, *Dividing Lines,* 517–21.

32. Ted Bryant, "Voters Grant Arrington Third Term; Solid Black Support Helps Mayor Break City's Record Books," *BPH,* Oct. 14, 1987; Thomas Hargrove, "White Vote Inconsequential; Arrington Win Result of Black Support," *BPH,* Oct. 14, 1987; "Arrington's Mayoral Elections," *BPH,* Oct. 9, 1991.

33. Stephen Kipp, "Decade after Election, Mayor, City Survive," *BN,* Nov. 11, 1989; Andrew Kilpatrick, "Plaza Project 'World Class,'" *BPH,* Mar. 3, 1987; Ingrid Kindred, "Harbert Has 'Open Mind' about Downtown's Future," *BN,* July 31, 1988. Despite Harbert's pessimism about the city's prospects, his firm won a 40 percent stake in the construction of the BCRI, discussed below (BCRI Board Minutes, Oct. 17, 1991, WP).

34. Arrington, *There's Hope for the World,* 30–32, 35–43.

35. Dean Burgess, "Mayor Defends City Attempts at Annexation," *BN*, Apr. 20, 1985; Alan Kianoff, "Expanding City Limits Fulfills Arrington's Dreams," *BPH*, June 5, 1985; Howard Shatz, "Arrington Theme: Land Development," *BN*, Jan. 20, 1987; Richard Arrington Jr., *State of the City Addresses, Birmingham, Alabama, 1981–1991* (Birmingham, AL: Birmingham Public Library Press, 1991), 84, 95; Arrington, *There's Hope for the World*, 179–95.

36. Ron Casey, "The Election of Birmingham's Black Mayor," *Southern Changes: The Journal of the Southern Regional Council, 1978–2003* 2, no. 3 (1979): 11–14, http://beck.library. emory.edu/southernchanges/article.php?id=sc02-3_007; Arrington, *There's Hope for the World*, 197–212; Franklin, *Back to Birmingham*, 231–35; Eskew, *But for Birmingham*, 274–75, 294–95; Rick Bragg, "Since 1980, White-Collar Blacks Have Filled Many City Hall Jobs," *BN*, July 26, 1988; Doug Demmons, "Arrington: City Wants Black Economic Growth," *BN*, Mar. 27, 1988. The employment of black policemen had been one of the initial objectives of the Birmingham demonstrations, although that demand was dropped from the final agreement when Birmingham's white faction refused to negotiate anything relating to city government.

37. Dobbins telephone interview; David J. Vann, Memorandum to civil rights museum committee: Concepts for consideration, typescript, n.d. [ca. 1979], AP.

38. Mitch Mendelson, "Black Business District Fights for New Life," *BPH*, Jan. 28, 1981; "Nostalgia May be Slowing Fourth Avenue Rebirth, Says Planner," *BN*, Feb. 26, 1986.

39. Joint Venture of Angelos Demetriou and Associates and Pedro Cesar Costa, *Master Plan for Downtown Birmingham, Alabama*, draft, December 1980, "Design Concept," n.p., AP; Doug Demmons, "Arrington: City Wants Black Economic Growth," *BN*, Mar. 27, 1988; unsigned, undated partial typescript, WP. I borrow the term "ritual of incorporation" from anthropologist Bernard S. Cohn, who uses it to refer to practices in Mughal India designed to make an emperor's subjects feel part of the state (Cohn, "Representing Authority in Victorian India," in *The Invention of Tradition*, ed. Eric Hobsbawm and Terence Ranger [Cambridge: Cambridge University Press, 1983], 165).

40. Michelle Chapman, "Voters Shoot Down Bonds, Tax Hike," *BPH*, July 9, 1986; Thomas Hargrove, "Eager Foes Flocking to Polls Penciled Bond Issue's Defeat," *BPH*, May 11, 1988; Doug Demmons, "Déjà Vu: Voters Say 'No,'" *BN*, May 11, 1988; Demmons, "Arrington Ponders His Future," *BN*, May 12, 1988; "Soul-Searching Time" (editorial), *BN*, May 12, 1988; Chapman, "Surplus Funds Could Give Civil Rights Museum New Life," *BPH*, Apr. 14, 1986; Richard Arrington, Confidential memo to Birmingham City Council, Feb. 21, 1989, AP; Arrington, *There's Hope for the World*, 172–76. In 1988, 90 percent of white voters opposed the bond issue, while 80 percent of the few black voters supported it (Hargrove, "Loss Sows Political Doubts in Arrington," *BPH*, May 12, 1988). It is worth noting that a third bond measure, which proposed to fund all of the institutions included in the previous two efforts but with the civil rights museum omitted, passed in 1989 (Demmons, "Mayor Defends Loans, Pushes Bond Issue," *BN*, Aug. 28, 1989; Nancy Bereckis, "Institute Pins Hope on City's True Story," *BPH*, Aug. 6, 1991).

41. Mission Statement for Birmingham Civil Rights Institute, Aug. 20, 1986, t.s., AP; John Archibald, "Statues Tell City's Story; Kelly Ingram Park Redesign to Highlight Civil Rights Struggle," *BN*, July 8, 1992; Arrington, *There's Hope for the World*, 36–37, 42–43, 178; "Council to Rule on $915,615 Rights Museum," *BN*, Apr. 14, 1986.

42. A sidebar to the story involves DPM's fiscal management of the project, which led to a widely publicized trail that resulted in the conviction of Marjorie Peters, DPM's intermediary with the city (Arrington, *There's Hope for the World*, 118–22).

43. Odessa Woolfolk, interview with Thomas Cox, June 21, 1995, KIPS, fol. 9; Richard Arrington Jr., e-mail to author, Aug. 18, 2010; Birmingham Civil Rights Institute Mission Statement, June 5, 1990, typescript, AP.

44. American History Workshop, "Walking to Freedom: The Museum of America's Civil Rights Revolution: Program Statement," typescript, June 1987, 2, 4–5, 38, 48, "Civil Rights Institute 1990" file, AP.

45. *March to Justice: A Journey inside the Birmingham Civil Rights Institute* (Birmingham, AL: Birmingham Civil Rights Institute, 2009). The figures are depicted on 110–14.

46. Virginia Williams, Mayor's Office, memo to Hobson Riley, City Engineer, Mike Dobbins, Urban Planning Director, and Bill Gilchrist, Diversified Project Management, Dec. 5, 1990, AP. Grover and Associates changed names twice during the park planning process; I use GHH as an abbreviation for all variants of the name.

47. GHH, Freedom Walk Development Research: Preliminary Report, Sept. 13, 1989, 5–7, AP.

48. [GHH], "Appendix B, Birmingham Civil Rights District, Phase One. Design Concepts," typescript, Apr. 6, 1990, 2, KIPS (emphasis in the original). Although not attributed or explicitly associated with any other document, this seems to belong to the series of developmental reports created in 1989 and 1990 as the scheme evolved. Beginning in 2009, a series of informational markers extending along Fifth and Sixth Avenues North toward Linn Park and toward the sites of the major downtown department stores, respectively, realized some of the processional route proposed twenty years earlier. Silhouettes of striding marchers cut out of the metal signs picked up the walking theme (Joe B. Crowe, "Birmingham City Council Approves Langford Civil Rights Trail Plan," May 5, 2009, blog.al.com/spotnews/2009/05/birmingham_city_council_panel.html; Jeff Hansen, "First Stops on Birmingham Civil Rights Heritage Trail Open," *BN*, Aug. 18, 2009).

49. [GHH], "Appendix B," 2; GHH, "Freedom Walk," 7; F. Lawrence Oaks to Richard Arrington, May 26, June 16, 1982, AP.

50. [GHH], "Appendix B," 2–3.

51. Miwon Kwon, *One Place after Another: Site-Specific Art and Locational Identity* (Cambridge, MA: MIT Press, 2002), 84, 95.

52. [GHH], "Appendix B," 7–8.

53. [GHH], "Appendix B," 5.

54. [GHH], "Freedom Walk," 6; [GHH], "The Freedom Walk, Birmingham, Alabama, Research and Concept Development," submitted to the Honorable Richard Arrington Jr., Mayor, Oct. 20, 1989, 7, AP.

55. H. B. Brantley, "DPM Meeting Summary, Birmingham Civil Rights District and Kelly Ingram Park," meeting of Sept. 4, 1990, summary dated Sept. 25, 1990, AP; Arrington, *There's Hope for the World*, p. 176; Arrington e-mail; Grover E. Mouton III, "Birmingham Civil Rights Program District and Kelly Ingram Park Public Art Analysis," Aug. 30, 1990, WP; Odessa Woolfolk, "Memorandum No. 1 to the BCRI Board of Directors," Sept. 6, 1990, WP.

56. The other artists on the initial list included Magdalena Abakanowicz, Tina Allen, Houston Conwill, James Drake, John Dreyfuss, Lin Emery, Vernon Fisher, Audrey Flack, Sam Gilliam, Bryan Hunt, Ida Kohlmeyer, Robert Lobe, Raymond [Ray] Massey, Raymond Mason, John Rhoden, Robert Schoen, Eugenie "Ersy" Schwartz, Keith Sonnier, and Terry Weldon. At the committee's next meeting, William King and Sidney Simon were added. It is striking that seven of the artists were from Mouton's home city, New Orleans, or were born in Louisiana.

57. For expressionist figures in Holocaust memorials, see James E. Young, *The Texture of Memory: Holocaust Memorials and Meaning* (New Haven: Yale University Press, 1993),pp. 66, 94, 141; for examples of expressionist figures in war memorials, see June Hargrove, *The Statues of Paris: An Open-Air Pantheon; The History of Statues to Great Men* (New York: Vendome Press, 1989), 334–35; for abstraction, see Sergiusz Michalski, *Public Monuments: Art in Political Bondage, 1870–1997* (London: Reaktion Books, 1998), pp. 154–62. For a sense of the range of solutions and the dominance of abstraction in midcentury American memorialization, see Thomas H. Creighton, *The Architecture of Monuments: The Franklin Delano Roosevelt Memorial Competition* (New York: Reinhold, 1962).

58. Young, *Texture of Memory,* 11–13, 27–48. Young notes a similar insistence among Holocaust survivors on literal "truth" in monuments (*Texture of Memory,* 9, 297).

59. William Grimes, "Raymond Mason, Sculptor Who Focused on Street-Level Drama, Is Dead at 87," *NYT,* Feb. 25, 2010; Brantley, "DPM Meeting Summary," Sept. 4, 1990, meeting; Brantley, "DPM Meeting Summary, Birmingham Civil Rights District and Kelly Ingram Park," meeting of Sept. 27, 1990, summary dated Oct. 25, 1990, AP.

60. Brantley, "DPM Meeting Summary," Sept. 27, 1990, meeting. The artists dropped were Abakanowicz, Allen, Connell, Emery, Hunt, Kohlmeyer, Lobe, Massey, Schwartz, Sonnier, and Weldon.

61. Greg Garrison, "Sixteenth Street Baptist Church Unveils New Marker at Bomb Site in Birmingham," *BN,* Sept. 15, 2011. In 1964, just after the bombing, Phoenix artist John Henry Waddell created *That Which Might Have Been,* a sculpture in honor of the four girls killed at Sixteenth Street Baptist Church. Thirty years later the church considered purchasing an enlarged copy of the work, to be called *That Which Might Yet Be.* The work depicted four life-size young women, standing in a circle facing away from one another, representing "the unexpressed potential of their lives, in all their beauty and maturity," as a reporter summarized the artist's description. The problem was that the figures were nude. While Chris McNair, the father of one of the four girls, Mayor Arrington, and the pastor of Sixteenth Street Baptist all approved, many African Americans thought the nude statues of black women were "weighted with both historic and contemporary symbols of oppression." Even the *Birmingham News* criticized the choice, arguing that "Arizona is not Birmingham," and it was never installed. A member of the Phoenix church that commissioned the original work attributed the opposition in Birmingham to "a lack of sophistication out there" (Nick Madigan, "Controversy Erupts Over Civil Rights Memorial: Nude Statue Depicting Victims of 1963 Church-Bombing Is Criticized as Racist," *WP,* Aug. 17, 1997; "A Matter of Taste: Wouldn't Memory of Martyred Girls Be Best Served with Them in Sunday Attire?" *BN,* May 17, 1995; Dobbins e-mail).

62. LaMonte interview; Anne Sclater, "Kelly Ingram Park near End of Renovation," *BN,* Sept. 2, 1992; Dobbins interview; Arrington, *There's Hope for the World,* 177. The work is known around Birmingham as *Kneeling Ministers,* but *Three Ministers Kneeling* is the title Kaskey uses on his website (http://www.kaskeystudio.com/resume.htm). In 2009, shortly after the deaths of Porter and Smith, the statue was rededicated with a plaque identifying the three as the original models and describing their contributions to the movement. Shuttlesworth and Woods reportedly approved (Patrick Hickerson, "Civil Rights Statue Gains Plaque to Honor Ministers," *BN,* Jan. 9, 2009; Eddie Lard, "Birmingham's 'Kneeling Ministers' Statue Marks Revolution, Reconciliation," *BN,* Jan. 22, 2009).

63. The non-Birmingham Drake works discussed here are illustrated in *James Drake* (Austin: University of Texas Press, 2008).

64. Arrington e-mail; Lamonte interview; February 18, 1993, Report and Recommendations of the Footsoldiers Committee on the Grant Proposals of the Civil Rights Activist Committee, ms., WP; Minutes of the Board of Directors, Feb. 19, 1993, WP; Bob Blalock, "Civil Rights Institute Called 'Holy Ground,'" *BN,* Feb. 23, 1991.

65. Joe Nabbefeld, "Foot Soldiers for Civil Rights to Get Statue," *BN,* Feb. 17, 1996.

66. Dobbins e-mail.

67. Olivia Barton, "Mayor: Hiring Changes Could Open Old Wounds," *BN,* Apr. 16, 1985; Michael Brumas, "City Firefighters' Suit Could Change Affirmative Hiring," *BN,* Jan. 17, 1989. During the Carter administration, the Justice Department had supported the city in the long-running suit, but the Reagan administration switched sides and backed the anti-affirmative action side. This and the long-running investigation of Arrington himself led the Mayor to claim, with some justice, that the Reagan administration targeted black public officials (Bob Blalock and Peggy Sanford, "Happy Arrington Claims Vindication," *BN,* Nov. 13, 1992).

68. Blalock and Sanford, "Happy Arrington"; Nick Patterson, "Ingram Park Dedicated as Rights Monument," *BPH,* Sept. 16, 1992. Sanderson told reporters that it couldn't have been a racial crusade because "some other minority" would have taken Arrington's place, and he called Arrington "the most prominent racist I have ever met" (Blalock and Sanford, "Happy Arrington"). The *Birmingham Post-Herald* thought that racism was not the underlying cause of the US attorney's crusade but that it may have "had a part in keeping the investigation going longer than it should." It also saw "excessive prosecutorial zeal" and "perhaps some small degree of political partisanship" in the attorney's actions ("Case Closed, at Last," editorial, *BPH,* Nov. 14, 1992).

CHAPTER 5. WHAT CAN AND CAN'T BE SAID

1. Kevin Alexander Gray, "Same as It Ever Was: South Carolina and It's [sic] Flag," Dec. 21, 2002, *CounterPunch,* http://www.counterpunch.org/2002/12/21/south-carolina-and-it-s-confederate-flag/.

2. *CS,* Dec. 18, 1901, quoted in John M. Bryan, *Creating the South Carolina State House* (Columbia: University of South Carolina Press, 1999), 123.

3. The full text of the marker can be found in Robert S. Seigler, *A Guide to Confederate Monuments in South Carolina: "Passing the Silent Cup"* (Columbia: South Carolina Department of Archives and History, 1997), 236–37.

4. Siegel, *Guide to Confederate Monuments,* 216–21. The writer V. S. Naipaul has an illuminating passage in *A Turn in the South* in which he asks South Carolinians for their interpretation of the Confederate monument's inscription (Naipaul, *A Turn in the South* [New York: Vintage, 1989], 99–100, 106–8, 115).

5. Thomas J. Brown, "The Confederate Battle Flag and the Desertion of the Lost Cause Tradition," in *Remixing the Civil War: Meditations on the Sesquicentennial,* ed. Thomas J. Brown (Baltimore: Johns Hopkins University Press, 2011), 42–43, 53–68; Michael Sponhour, "Written in Stone: Can Panel Sketch S.C. Black History onto a Single State House Monument?" *CS,* Aug. 18, 1996. For a sympathetic but unflinching history of the battle flag's role over the last century and a half, see John M. Coski, *The Confederate Battle Flag: America's Most Embattled Emblem* (Cambridge, MA: Harvard University Press, 2005).

6. Coski, *Confederate Battle Flag*, 244–52; David Firestone, "Bastion of Confederacy Finds Its Future May Hinge on Rejecting the Past," *NYT,* Dec. 5, 1999; Dave L'Heureux, "Bring Down Flag, Travel Industry Says," *CS,* Feb. 1, 2000; Joseph S. Stroud and Kenneth A. Harris, "Down from the Dome: Amid Pomp and Ceremony," *CS,* July 2, 2000.

7. Aaron Gould Sheinin, "Flag Controversy in Background but Not Resolved," *CS,* July 1, 2005; Steven Yates, "After 'Flag Removal Day' in South Carolina: Will the Real Extremists Please Stand Up?" http://archive.lewrockwell.com/yates/yates8.html; Joseph S. Stroud, "NAACP Calls for Boycott of S.C.," *CS,* July 16, 1999; James T. Hammon, "Bond Says Boycott Should Continue," *CS,* Oct. 14, 2006; Ron Morris, "Confederate Flag Remains a Distraction to Sports," *CS,* Aug. 2, 2009; Morris, "Flag Still Costs State NCAA Spotlight," *CS,* Mar. 21, 2010; John O'Connor, "10 Years Later, the Flag Flies, the Debate Simmers," *CS,* July 1, 2010.

8. Carol Sears Botsch, "Minorities in South Carolina Politics," in *South Carolina Government: A Policy Perspective,* ed. Charlie B. Tyer (Columbia: Institute for Public Service and Policy Research, College of Liberal Arts, University of South Carolina, 2003), 320–21; "'Gamble' Ensnares RDA Plan; Senator Pressing for New Monument Vote," *CS,* May 23, 1996.

9. Coski, *Confederate Battle Flag*, 249; "Where Are They Now?," *CS,* July 1, 2005; Botsch, "Minorities," 321; Sponhour, "Written in Stone."

10. Sponhour, "Written in Stone"; Lee Bandy, "South Carolina Panel Approves African-American History Monument," *CS,* Dec. 15, 1998; "Donations Building Foundation for African-American Monument," *CS,* Aug. 15, 1999;, "Monuments—S.C. (African American)" vertical file, Richland County Public Library [hereafter RCPL], Columbia.

11. Sponhour, "Written in Stone." On Sellers's history, see Cleveland Sellers with Robert Terrell, *The River of No Return: The Autobiography of a Black Militant and the Life and Death of SNCC* (Jackson: University Press of Mississippi, 1990).

12. Citizens Advisory Committee Meeting Minutes, Jan. 23, 1997, 5, African American History Monument [hereafter AAHMC] Files.

13. Citizens Advisory Committee Meeting Minutes, Jan. 23, 1997, 5, AAHMC Files; AAHMC, A Report to the State House Committee, Apr. 1, 1997: Proposed Location and Design Prospectus for an African-American History Monument and Preliminary Study for an African-American Museum, AAHMC Files; Schuyler Kropf, "Black Memorial Raises Questions: What Focus? Should the State's Monument to Black History Depict a Particular Hero, or Defining Moment?," *Charleston Post and Courier,* Jan. 30, 1997. At the time I examined them in 2012, all AAHMC files were held in the office of then-lieutenant governor Glenn T. McConnell, South Carolina State House, Columbia.

14. Richard Farmer, "African-American History Debate Comes to Lander," *Greenwood Index-Journal,* Feb. 6, 1997, AAHMC Files; AAHMC Minutes, AAHMC Files, Jan. 15, 1997, 2; Kropf, "Black Memorial."

15. Thomas Brown, "Monumental Plans; Panel Gleans Varied Perspectives on Proposal," *Times and Democrat* (Orangeburg, S.C.), Jan. 30, 1997, AAHMC Files.

16. AAHMC, Report to the State House Committee, 4–5; Glenn McConnell to J. Verne Smith, State House Committee, Apr. 22, 1997, AAHMC Files. The mandate to survey South Carolina's black history derived from the original legislation, which specified that the AAHMC "shall make reasonable efforts to incorporate all eras of African-American history in the design" (1996 Act No. 457, §1).

17. "African American Monument Commission to Interview Artists April 9," *Augusta Chronicle,* Apr. 2, 1998; Kenneth A. Davis, Memo to the African-American History Monument Selection Recommendation Committee, Mar. 3, 1998, AAHMC Files;

Sid Gaulden, "African-American Monument Selected," *Charleston Post and Courier,* Apr. 10, 1998.

18. Gaulden, "African-American Monument Selected." Conwill and his collaborators had made other cosmograms for the Schomburg Center for Research in Black Culture (1991) and the Ted Weiss Federal Building [African Burial Ground] (1994), both in New York, and for the Harold Washington Library (1991), Chicago.

19. Jesse J. Holland, "Sculptor Chosen for Black Monument," Apr. 10, 1998, http://chronicle. augusta.com/stories/1998/04/10/met_225818.shtml#.VQungY7F9DA; AAHMC Minutes, Apr. 9, 1998, 2; John Michael Vlach, *The Afro-American Tradition in Decorative Arts* (Cleveland: Cleveland Museum of Art, 1978), 7–19.

20. AAHMC Minutes, Apr. 9, 1998, 3–4. By *Victorian architecture* I take Dwight to mean that he used traditional materials (bronze and granite) and traditional narrative figural sculpture. The curving walls with their terminating piers are also reminiscent of the kinds of plaza-framing backdrops against which late-nineteenth- and early-twentieth-century sculptors often set their works. The Booker T. Washington monument at Tuskegee University is an example (see fig. 19).

21. AAHMC Minutes, Apr. 9, 1998, 1, 5–6.

22. Ed Dwight, Proposal for the African American History Monument, Columbia, South Carolina, n.d. (ca. 1998), 1–2, AAHMC Files.

23. Reginald Brown, Charleston, to State Legislature, n.d. (ca. April 1998), AAHMC Files; Glenn McConnell to Brown, Apr. 23, 1998, AAHMC Files.

24. Jim Davenport, "Monument Taking Shape in Shadow of Controversy," *CS,* Aug. 7, 1999; Kenneth A. Harris, "South Carolina's Monument Panel Waits for Flag Fight to 'Cool Off,'" *CS,* Dec. 15, 1999; Harris, "Flag's Shadow Falls on a Monument," *CS,* Dec. 19, 1999; Valerie Bauerlein, "Granite, Bronze, and Triumph: African-American Monument to Be Dedicated Thursday Catalogs S.C. Blacks' Historical Journey," *CS,* Mar. 25, 2001; Chuck Crumbo, "African-American Monument Awes, Overwhelms Lunchtime Visitors," *CS,* Mar. 31, 2001.

25. Jim Davenport, "Ground Broken for $1.1 million African-American History Monument," Associated Press, May 11, 2000; Bauerlein, "Granite, Bronze, and Triumph"; "S.C.'s New African-American Monument Sits among Confederate Reminders," Associated Press, Mar. 23, 2001, available at: http://wc.arizona.edu/papers/94/121/01_93_m.html. Although Cobb-Hunter associated it with the 1960s, the Black Liberation flag was created by Marcus Garvey, whose early-twentieth-century Universal Negro Improvement Association was a conservative self-help movement.

26. Valerie Bauerlein, "History Embraced: 'There Are So Many Things that Need to Have Been Told," *CS,* Mar. 30, 2001. As noted, the design criteria dictated the shape in response to the shape of the flower bed that the monument replaced. Dwight's communications with the AAHMC refer to conflicts over financial and other authority over the creation of the monument. In a letter to McConnell in early 2000, Dwight expressed his desire "that the relationship between me and the Committee stay amicable and cooperative" (Dwight to McConnell, Feb. 16, 2000, AAHMC Files). After the completion of the monument, Dwight complained that he had not received his final payment and told McConnell, "I created a spectacular monument for you in spite of the total lack of trust and cooperation on the part of most of your Foundation [sic] members, all the ancillary problems, and not nearly enough funds to complete it. . . . I have never been treated so shabbily, and shown such a lack of appreciation

by a client in my 25 years of creating images (Dwight to McConnell, Nov. 2, 2001, AAHMC Files).

27. Davenport, "Monument Taking Shape in the Shadow of Controversy."

28. Marcus Rediker, *The Slave Ship: A Human History* (New York: Penguin, 2007), 311–17, 336–37; Marcus Wood, *Blind Memory: Visual Representations of Slavery in England and America, 1780–1865* (New York: Routledge, 2000), 16–19, 25–36.

29. Dwight to McConnell and the AAHMC, Aug. 1, 2000, AAHMC Files; AAHMC Minutes, May 24, 2001, 2–3.

30. Margaret N. O'Shea, "South Carolina Ready to Unveil Black Memorial," Mar. 27, 2001, savannahnow.com (content no longer online).

31. "The Monumental Scenes," *CS*, May 11, 2000; *The African American History Monument*, pamphlet, ca. 2001, distributed to State House visitors.

32. More specifically, this figure strongly resembles the figure of Harriet Tubman at Dwight's Underground Railroad Memorial (1994), Battle Creek, Michigan.

33. *African American History Monument*; Jacquelyn Dowd Hall, "The Long Civil Rights Movement and the Political Uses of the Past," *Journal of American History* 91 (2005): 1239, 1246.

34. Rayford W. Logan, *The Negro in American Life and Thought: The Nadir, 1877–1901* (New York: Dial Press, 1965); Crumbo, "Marker to Tell Black History."

35. Bertram Rantin, "Live Wire: African-American Monument's Images Interpretive, Group Says," *CS*, June 9, 2005.

36. Bandy, "South Carolina Panel Approves"; Crumbo, "African-American Monument Awes."

37. On the Colonial Revival, see Karal Ann Marling, *George Washington Slept Here: Colonial Revivals and American Culture, 1876–1986* (Cambridge, MA: Harvard University Press, 1988). On the nationalistic and sometimes nativist implications of romantic essentialism, see William B. Rhoads, "The Colonial Revival and the Americanization of Immigrants," in *The Colonial Revival in America*, ed. Alan Axelrod (New York: W. W. Norton, 1985), 341–61; Dell Upton, "Introduction" to Charles Morse Stotz, *The Early Architecture of Western Pennsylvania* (Pittsburgh, PA: University of Pittsburgh Press, 1995), xi, xiv, xvi–xvii; Dell Upton, *Architecture in the United States* (New York: Oxford University Press, 1998), 78–86.

38. Langston Hughes, *The Big Sea* (New York: Hill and Wang, 1940, 1993), 102–3; Stephen Ward Angell, *Bishop Henry McNeal Turner and African-American Religion in the South* (Knoxville: University of Tennessee Press, 1992); Wilson Jeremiah Moses, *The Golden Age of Black Nationalism, 1850–1925* (New York: Oxford University Press, 1978); Kevin K. Gaines, *Uplifting the Race: Black Leadership, Politics, and Culture in the Twentieth Century* (Chapel Hill: University of North Carolina Press, 1996); Richard Brent Turner, *Islam in the African-American Experience*, 2nd ed. (Bloomington: Indiana University Press, 2003); Martin Bernal, *Black Athena: The Afroasiatic Roots of Classical Civilization* (New Brunswick, NJ: Rutgers University Press, 1987); Molefi K. Asante, *The Afrocentric Idea*, rev. ed (Philadelphia: Temple University Press, 1998).

39. Crumbo, "Marker to Tell Black History"; Dell Upton, "Why Do Contemporary Monuments Talk So Much?" in *Commemoration in America: Essays on Monuments, Memorialization, and Memory,* ed. David Gobel and Daves Rossell (Charlottesville: University of Virginia Press, 2013), 16–18.

1. "A Joint Resolution to Create the Strom Thurmond Monument Commission and Provide for the Commission's Membership, Duties, and Related Matters," South Carolina General Assembly, 112th Sess., 1997–1998, Bill 407, Feb. 20, 1997; "S.C.'s New African-American Monument Sits among Confederate Reminders," *Arizona Daily Wildcat Online,* Mar. 23, 2001, http://wc.arizona.edu/papers/94/121/01_93_m.html; Timothy Noah, "The Legend of Strom's Remorse: A Washington Lie Laid to Rest," *Slate,* Dec. 16, 2002, http://www.slate.com/articles/news_and_politics/chatterbox/2002/12/the_legend_of_stroms_remorse.html; Ryan Mosier, "Monument Honors Strom Thurmond," *Carolina Reporter,* September 1999, carolinareporter.sc.edu (website discontinued).

2. Michael Janofsky, "Woman, 78, Says She Is a Daughter of Thurmond," *NYT,* Dec. 14, 2003; Amy Geier Edgar, "Family Accepts Woman's Claim of Thurmond Heritage," Dec. 16, 2003, http://abcnews.go.com/GMA/story?id=128137&page=1; Essie Mae Washington-Williams with William Stadiem, *Dear Senator: A Daughter's Memoir* (New York: HarperCollins, 2005), 212, 219. Washington-Williams's paternity had long been rumored and by the end of Thurmond's life, but before Washington-Williams's own announcement, it was openly discussed (Diane McWhorter, "Strom's black daughter," *Salon,* July 1, 2003, http://www.slate.com/articles/news_and_politics/politics/2003/07/stroms_skeleton.html).

3. "Thurmond's Black Daughter Added to Statehouse Monument," *Jet,* May 24, 2004; "Strom Thurmond's Daughter's Name Added to Monument," July 2, 2004, www.genealogyblog.com (content no longer online); Washington-Williams, *Dear Senator,* 220–21.

4. Some of these questions are addressed, with varying degrees of rancor, in McWhorter, "Strom's Black Daughter"; Brent Staples, "Essie Mae Washington-Williams Has Her Say," *NYT,* Feb. 6, 2005; Joseph Crespino, "The Scarred Stone: The Strom Thurmond Monument," *Southern Spaces,* Apr. 29, 2010, http://www.southernspaces.org/2010/scarred-stone-strom-thurmond-monument; and Osagie K. Obasogie, "Anything but a Hypocrite: Interactional Musings on Race, Colorblindness, and the Redemption of Strom Thurmond," *Yale Journal of Law and Feminism* 18, no. 2 (2006): 451–95.

5. Waterworks Visual Arts Center, "The Freedman's Cemetery Memorial: A Compassionate Symbol," viewed Jan. 6, 2007 (no longer online), www.waterworks.org.

6. Jim McNally, "Memorial at Cemetery to Be Dedicated Jan. 16," *Salisbury Post,* Jan. 8, 2006; Salisbury Historic Preservation Commission [hereafter SHPC], Minutes, Apr. 8, 2004, 9.

7. SHPC, Minutes, Apr. 8, 2004, 8–10, Aug. 12, 2004, 4.

8. SHPC, Minutes, Apr. 8, 2004, 9.

9. SHPC, Minutes, Aug. 12, 2004, 12.

10. Pat Cummins, "A Story of Native American Graves & The Graves of Slaves: The Hermitage Springs Site—Nashville, Tennessee," ms., Feb. 18, 2012; cbrl proposal 2008_kmb edits. Eventually the costs of construction delays and legally required salvage archaeology overwhelmed the developers and the site remains vacant. All sources referred to in this account of *Our Peace* are preserved electronically on the Hermitage's inhouse website or on CD-ROMs at the museum.

11. Resolution the Ladies' Hermitage Association, n.d., Reburial Resolution.doc, modified June 15, 2007; Marsha Mullin, oral communication, Aug. 12, 2013; Aaron Lee Benson, telephone interview with author, Feb. 4, 2014.

12. Our Peace/Circles and Trees/An aesthetic offering of understanding and reconciliation, lee benson memorial proposal.pdf; Benson interview; Request for Qualifications, The Hermitage, Home of President Andrew Jackson, Public Art Memorial Project, Hermitage RFQ memorial project.pdf, n.d.

13. Benson interview.

14. *Our Peace*, Hermitage5.ppt; Aaron Lee Benson, artist statement, Our Peace.doc, n.d. (file created Mar. 9, 2009); "Public Artwork Dedication Ceremony; Memorial for 60 slaves reinterred at The Hermitage," May 23, 2009, News Release Memorial 509–1.doc.

15. "Public Artwork Dedication Ceremony."

16. Benson interview.

Dyer, Horace, 58
Dyson, Michael Eric, 125, 130, 133

Edmund Pettus Memorial Bridge, 41
Egerton, Douglas, 70–71
Ellison, Ralph, 130
Ellsberry, Julius, *141*, 143, 144, 169
Elsner, Jaś, 106
Eskew, Glenn, 18
Estell, Bessie S., 144
Evans, Kimberle, 101, 107
Evers, Medgar, 105, 182; memorial to
 (Jackson, MS), 3

Farlow, Horace, 11
Farmer, Robert, 70, 72, 230n14
Farris, Isaac Newton, 123
Fausch, Erskine, 144
Faxon, Russ, 11; Korean War Memorial, 11,
 11, 14, 168
Felder, Hattie, 145
Ferillo, Bud, 184
Finney, Ernest, 193
Firehosing of Demonstrators (Drake;
 Birmingham, AL), 135, 164–65, *164*,
 165, 167
Fisher, Marc, 129
Fitch, Bob: photograph of Martin Luther
 King, Jr., 107, *108*, 121, 123, 236n22
Fitts, Alston, 41
Flack, Audrey, 161
Fletcher, Pauline Bray, 140–41
Fletcher, Tuggle, Ellsberry, and Jackson
 monuments (Birmingham, AL), 135,
 140, *141*, 143–45, 146, 157, 169,
 243n18
Fletcher-Tuggle Memorial Committee,
 144–45
"Follow the Drinking Gourd" (song), 207
Ford, Robert, 184
Forrest, Nathan Bedford, monument to
 (Selma, AL), 34, 35, *35*, 39–50; theft of,
 49, 226n56
Fort Pillow, TN, 40, 42
Fortune, Lydell, 73–74
Fourteenth Amendment, 74, 192
Fourth Avenue District (Birmingham, AL),
 156
Fourth Avenue Merchants Association
 (Birmingham, AL), 152
Frankenbush, J. W., 57

Franklin Delano Roosevelt Memorial
 (Washington, DC), 117
Franklin Square (Savannah, GA), 86, 88
Fraternal Café (Birmingham, AL), 144
Frazier, E. Franklin, 94
Freedman's Cemetery (Salisbury, NC), 202,
 203, 204
Freedmen's Memorial Monument
 (Washington, DC), 83
Freeman, Mack, 12
Friedler, Frank, 55
Friends of Forrest, 42–48; billboard,
 46–47, *47*
Friends of the Liberty Monument (New
 Orleans), 62, 64

Gabriel ("Gabriel Prosser"), 67–68, 69,
 70, 72
Gabriel's Rebellion, 67–68, 69, 70, 74,
 230n17
Gadsden, Walter, 134, 135
Gardner, Don, 89
Gardner, Edward, 146
Gardner, James, 87
Garner, Mark, 72
Garrow, David, 117
Gaston, A. G., 139–41, 143, 144, 147; Booker
 T. Washington Business College, 144;
 Booker T. Washington Insurance
 Company, 140; funeral home, 139; gas
 station, 140; Gaston Motel, 140; Gaston
 Building, 135, 140
Gaston, Minnie, 144
Gay, William, 202
Gibson, Althea, 195
Gibson, Gloria D., 126, 127
Gill, James, 60
Gillespie, Dizzy, 195
Gilliam, Sam, 16
Godwin, Abbe, 3, 11; *Martin Luther King, Jr.*,
 5, 101, 105, 113
Godwin, Pat, 26, 34, 39, 40, 42, 44, 45, 47
Goodacre, Glenna, 12
Goodman, Andrew, 2–3
Gopnik, Blake, 129, 130, 131
Gordon, Marcus, 19–20
Grady, Henry W., 32
Greek Slave (Powers), 83
Green, W. Cooper, 143
Green Square (Savannah, GA), 88
Griffith, D. W., 192

227n65; African American responses to, 53, 59; inscriptions, 52, 55, 61; vandalism of, 62

white Southerners, as ethnic group, 33, 45

white supremacy, 23, 24, 29, 31, 32, 34, 36, 45–47, 49–50, 52, 53, 57–58, 63, 139, 172–73, 212, 226n60, 228n78; monuments to, 15, *16*, 17, 25–65, *26*, *28*, *30*, 173

Whiting, Marvin, 159

Whyte, Stephen, 102–3

Wiggins, Lamont, 104, 109

William J. Fischer Housing Development (Fischer Projects; New Orleans), 56

Williams, Clarence, 43

Williams, Ellen, 26

Williams, Florence, 85

Williamson, Cecil, 34, 38, 45, 48, 225n48

Wilson, Peggy, 60

Wisdom, Betty, 57

Wood, Marcus, 186

Woodrow Wilson Park (Birmingham, AL), 139

Woods, Abraham, Jr., 134, 137, 145–47, 162–63, 247n62

Woodson, Carter G., 200

Woolfolk, Odessa, 158

Young, Andrew, 105

Young, A. P., 214

Young, Gilbert, 124, 125, 126

Young, James, 160

Young, Lea Winfrey, 126

Young, R. W., 214

Yow, Charles E., 44

Zimmerman, Elyn, 236n27